Taxidermy and the Gothic

Taxidermy and the Gothic

The Horror of Still Life

Elizabeth Effinger

ANTHEM PRESS

Anthem Press
An imprint of Wimbledon Publishing Company
www.anthempress.com

This edition first published in UK and USA 2024
by ANTHEM PRESS
75–76 Blackfriars Road, London SE1 8HA, UK
or PO Box 9779, London SW19 7ZG, UK
and
244 Madison Ave #116, New York, NY 10016, USA

© Elizabeth Effinger 2024

The author asserts the moral right to be identified as the author of this work.

All rights reserved. Without limiting the rights under copyright reserved above,
no part of this publication may be reproduced, stored or introduced into
a retrieval system, or transmitted, in any form or by any means
(electronic, mechanical, photocopying, recording or otherwise),
without the prior written permission of both the copyright
owner and the above publisher of this book.

British Library Cataloguing-in-Publication Data
A catalogue record for this book is available from the British Library.

Library of Congress Cataloging-in-Publication Data
A catalog record for this book has been requested.
2024930032

ISBN-13: 978-1-83999-026-7 (Hbk)
ISBN-10: 1-83999-026-0 (Hbk)

This title is also available as an e-book.

CONTENTS

List of Figures	vii
Acknowledgments	ix
Introduction	xi
1. The Two-Headed Kitten: The First Stitches of the Gothic	1
2. Taxidermy and the Horror of Being-There	41
3. Taxidermy and Taboo: Sex and Perversions	71
4. Taxidermy, Fungibility, and the Everyday Gothic Horrors of Black Life	101
Afterword: All Stitched Up	137
Bibliography	145
Index	159

LIST OF FIGURES

0.1 Angela Singer. *Sore I*. 2002–3. © Angela Singer.
Image courtesy of the artist. xxiii

1.1 Charles Willson Peale. *The Artist in His Museum*. 1822.
Image courtesy of Pennsylvania Academy of the Fine Arts. 15

1.2 Frontispiece and title page for Thomas Brown's
The Taxidermist's Manual. 16

1.3 E. Jones. *Walton Hall with Waterton and Some of His Animals*. Image
courtesy of Wakefield Museums & Castles, Wakefield Council. 26

1.4 William Hogarth. *Hudibras Beats Sidrophel and His Man
Whacum*. Etching and engraving for Samuel Butler's Hudibras,
February 1726. Image courtesy of The Lewis Walpole
Library, Yale University. 26

1.5 Unknown artist. *The Quacks*. Engraving, 1783. Image
courtesy of The Lewis Walpole Library, Yale University. 27

1.6 "About Taxidermy—1. The Principles Laid Down,"
Fun Magazine. 36.915 (22 Nov. 1882, p. 216). 29

1.7 "About Taxidermy—4. An Unappreciated Triumph,"
Fun Magazine 36.917 (6 Dec. 1882, p. 238). 30

2.1 Caravaggio. *Rest on the Flight into Egypt*. c.1597.
Galleria Doria Pamphilj. HIP/Art Resource. 50

2.2 Screenshots from *Psycho* (dir. Hitchcock). 54

2.3 Screenshot from *The Texas Chainsaw Massacre*
(dir. Hooper). 56

2.4 Close-up of Leatherface's taxidermy. Screenshot from
The Texas Chainsaw Massacre (dir. Hooper). 56

2.5 Screenshot from *A Classic Horror Story* (dir. De Feo and
Strippoli). 58

2.6 Elisa reflected in taxidermy's eye. Screenshot from *A Classic
Horror Story* (dir. De Feo and Strippoli). 59

2.7 Screenshot from *The Outside* (dir. Amirpour). 62

2.8 Screenshot from *Evil Dead II* (dir. Raimi). 64

2.9	Screenshot from *The Outside* (dir. Amirpour).	65
3.1	BDSM mouse from the British Academy of Taxidermy website.	75
3.2	Screenshot from *The Cabin in the Woods* (dir. Goddard).	87
3.3	Screenshot from *Tell Me Your Secrets*, episode 6 (dir. Polson).	93
3.4	Screenshot from *Tell Me Your Secrets*, episode 1 (dir. Polson).	98
4.1	Galápagos Island finch collected and preserved by Charles Darwin. Image courtesy of the Trustees of the Natural History Museum, London.	102
4.2	Kate Clark. *Little Girl.* © Kate Clark. Image courtesy of the artist.	111
4.3	Screenshots from *Get Out* (dir. Peele).	120
4.4	Screenshots from *Get Out* (dir. Peele).	125
4.5	Screenshot from *Get Out* (dir. Peele).	127
4.6	Screenshots from *Get Out* (dir. Peele).	130
A1.1	Polly Morgan. *Harbour.* 2012. © Polly Morgan. All Rights Reserved, DACS/Artimage/CARCC Ottawa 2024.	139
A1.2	Scott Bibus. *Snapping Turtle Eating Human Eyeball.* © Scott Bibus. Image courtesy of the artist.	140

ACKNOWLEDGMENTS

Writing a book can be a beast of a job, although this one was especially fun, thanks in no small part to the help of many.

For financial support, thanks to the Social Sciences and Humanities Research Council of Canada and the University of New Brunswick.

Much of studying taxidermy involves working with images, some of which are included in the book. Thanks to Kristen McDonald at the Lewis Walpole Library at Yale University and Janna King at Wakefield Museums and Castles for helping me acquire the images from their respective collections. Thanks to Scott Bibus, Kate Clark, and Angela Singer for granting permission to reproduce images of their art and for their enthusiastic responses to the book.

I'd like to thank Carol Davison, series editor, for her interest in my work and for her support over the years as it took shape, and Jebaslin Hephzibah at Anthem. I greatly appreciate the thoughtful feedback from the anonymous reviewers that helped strengthen this book.

The love and support of family and friends kept me stitched together as I worked on the book. Thanks to Helen Bruder and Harriet Fender for showing me badly stuffed badgers and their ilk in the Cotswolds and to Jeffrey Simpson and Suzanne Caines for the rollicking taxidermy-spotting tours and fun times together in East London. Cheers to Mary and Ed Effinger, Christopher Effinger and Melanie Abbott, and to Michelle Coupal and Kishanie Jayasundera for continual support, and to Mum Corrine for gifting me a hilariously "bad taxidermy" calendar to help keep track of my stuffed schedule. Thanks to Priscilla and Terry Pickhaver for lovingly minding our dogs, which made the research trips possible.

Thanks to my children, Lucy and Libby, who kept me from getting too stuffy. Thanks to my four-legged favorites, Langley ("Big Baby") and Shirley ("Tiny Terror"), who both helped and hindered the writing of this book, and who may one day find themselves taxidermied.

And a final thanks to my wife, Vicky Simpson, who read through the entire manuscript and provided thoughtful feedback, suffered by my side through many taxidermy-filled horror films, and always keeps our little (living) zoo happy and humming. This book is dedicated to her.

INTRODUCTION

Writing in 1753 to his friend Horace Mann, an incredulous-sounding Horace Walpole, the soon-to-be-father of the Gothic, shared the surprising ways he was spending his time:

> You will scarce guess how I employ my time; chiefly at present in the guardianship of embryos and cockleshells. Sir Hans Sloane is dead, and has made me one of the trustees to his museum, which is to be offered for twenty thousand pounds to the King, the Parliament, the royal acadamies [sic] of Petersburg, Berlin, Paris and Madrid. He valued it at fourscore thousand, and so would anybody who loves hippopotamuses, sharks with one ear, and spiders as big as geese! [...] You may believe that *those*, who think money the most valuable of all curiosities, will not be purchasers. (358–59)

Walpole was entrusted with safeguarding the taxidermy specimens belonging to the collection of the late Sir Hans Sloane. Yet taxidermy is absent from Walpole's own fantasy Gothic house-cum-museum, Strawberry Hill, particularly surprising given his professional proximity to stuffed hippopotamuses, one-eared sharks, and freakishly large spiders and his view of museums as "hospitals" for unique singularities including "Monstrous births, hermaphrodites, petrifactions" (Walpole, *Fugitive Pieces* 49). Walpole also had a penchant for collecting items we might consider the sister arts and objects of taxidermy, including wax models, books on embalming, objects made from animal hides (e.g., shields made from rhinoceros skin), and prints that depict taxidermy. While taxidermy is a strange absence at Strawberry Hill, in the Gothic tradition that Walpole would go on to inspire, taxidermy's uncanny presence—from its origins to our present day—looms large.[1]

1 *A Catalogue of the Classic Contents of Strawberry Hill Collected by Horace Walpole* lists numerous wax models and Thomas Greenhill's *Nekrokēdeia or The Art of Embalming* (1705). Diane Hoeveler notes that both Walpole and William Beckford had large and impressive cabinets of curiosity ("Introduction: A Gothic Cabinet of Curiosity" 1).

xii TAXIDERMY AND THE GOTHIC

One need only grab the remote to find evidence of taxidermy's ubiquitous presence in Gothic horror: in hallmark horror films like *Psycho, Evil Dead (I and II), The Texas Chainsaw Massacre (1 and 2),* and *Silence of the Lambs* to the more recent *Friday the 13th, The Cabin in the Woods, Taxidermia, Get Out,* and *A Classic Horror Story*; in television and streaming series like *Penny Dreadful, Bates Motel, Tell Me Your Secrets,* and *Guillermo del Toro's Cabinet of Curiosities*; and even in horror video games like *Heavy Rain Chronicles: Episode 1—The Taxidermist* and *Taxidermy.* Let's look a little closer at a few of these examples. In the genre-defining horror film *Psycho* (1960), a stuffed menagerie of taxidermied birds lines the walls of the Bates Motel office, perched above and behind the climactic conversations between Norman and Marion. In *Friday the 13th* (2009), Lawrence's late-night attempt to masturbate in the living room is thwarted when he becomes aware of a large moose mount. In *The Cabin in the Woods* (2011), a snarly looking wolf mount gets French-kissed by blonde bombshell Jules in a kinky game of Truth or Dare. In the horror drama television series *Penny Dreadful* (2014–2016), the seductive, secretive, and supernatural main character Vanessa Ives (who begins as a medium and eventually becomes the Mother of Evil) practices taxidermy as a child (Season 1), and falls in love with Dracula amidst a taxidermy-stuffed museum of natural history, filmed at the Natural Museum of Ireland, known as "the Dead Zoo" (Season 3). In the Amazon Prime series *Tell Me Your Secrets* (2021), multiple forms of negative encounters between characters, ranging from disappointing to dangerous and deadly, take place against the backdrop of taxidermy. In the metahorror film *A Classic Horror Story* (2021), gory, horrific violence takes place under the seemingly watchful glassy eyes of a stuffed stag mount. And, in Ana Lily Amirpour's *The Outside,* part of Netflix's horror anthology *Guillermo del Toro's Cabinet of Curiosities* (2022), Stacey, a bank-teller by day and amateur taxidermist by night misuses her taxidermy skills to murderous ends.

Even if we change the channel and flip to the news, taxidermy's affinities with Gothic horror are found there too. True crime's connections with taxidermy are strikingly serial: Jeffrey Dahmer, the "Milwaukee Monster," was fascinated with taxidermy and dissecting animals before going on to murder and dismember seventeen men; Charles Albright, the Texas "Eyeball Killer," was similarly obsessed with and trained in taxidermy as a child, a practice that informed the type of trophy that he kept from his killings as souvenirs: his victims' eyeballs. Still to this day, as I write this, a story about a sadistic Wisconsin nurse scavenging a patient's body parts for her family's taxidermy business has just made international headlines: "Nurse accused of amputating man's foot for her family's taxidermy shop" (*The Washington Post,* Nov 8, 2022). When it comes to our contemporary imagination, taxidermy's footholds (pardon the pun) in Gothic horror are clear to see.

INTRODUCTION

Taxidermy, *taxi* (to arrange) and *dermis* (skin), meaning the arrangement of skin, refers to the art or craft of preparing and preserving the skins of animals and stuffing and mounting them to give the appearance of the living animal. Flesh and organs are removed, and although sometimes the interior of a specimen contains the animal's bones to help recreate a lifelike shape, it is most often filled with foreign materials: wire, wood, Styrofoam, resin, plaster, or clay. Recreating the lifelikeness of the once living animal is the intended realist aesthetic of most taxidermy that line the walls of our own interiors, as hunting trophies or objects of natural history—in our homes, galleries, and museums (and cabinets of curiosities before that), retail stores, and even pubs and restaurants. In response to these "breathless zoos," as Rachel Poliquin describes them, we often respond to taxidermy with a mixture of wonder, awe, sadness, and sometimes also "ugly feelings," to borrow Sianne Ngai's term for feelings like disgust, anxiety, or even horror, particularly in Gothic horror texts where the encounter is uncanny and unsettling.

This book tells the story of the collusion between the Gothic and taxidermy, how the Gothic (or rather Gothic horror) in its myriad formations and deformations, as a tradition, aesthetic, and mode, has been since its origins quietly serving as a nebulous guardian over taxidermy. The problem this book identifies is that taxidermy's collusion with Gothic horror is omnipresent in a range of texts but overlooked in Gothic criticism. Critical scholarship on taxidermy, including representations of taxidermy in popular literature have been increasing in the last decade, with the appearance of exciting new books (e.g., Rachel Poliquin's *The Breathless Zoo* [2012], Giovanni Aloi's *Speculative Taxidermy* [2018], Elizabeth Young's *Pet Projects* [2019]), and a special journal issue of *Configurations* dedicated to the topic (ed. Bezan and McHugh 2019). And yet, few scholars are thinking about it in terms of *Gothic horror*. Thus, the Gothic tradition and a certain Gothic sensibility largely remain blind spots when thinking about taxidermy. This book works to redress this gap.

Imagine this book plotted like a *Wunderkammer* (German for "room of wonder"), those sixteenth-century European cabinets of curiosities that collected wonderful, odd, exotic natural, and cultural objects and served as the precursor to the modern museum. The first door you open affords a view of the entwined origins of discourses of the Gothic and taxidermy in the long nineteenth century, their curious points of contact, including shared narrative and rhetorical strategies and investments. This leads you to the second door that opens into a larger space, in which you will be confronted with the dizzying array of taxidermy in present-day Gothic horror, affording a view of how these discourses continue to be stuffed by one another. It is my hope that you will as Kirk does in *The Texas Chainsaw Massacre* (1974) run

eagerly toward this room of taxidermy and begin to see it awry (although I hope you won't "lose your head" in the same fashion as Kirk does).

Taxidermy and the Gothic share some of the same categorical vexations, as I will soon unpack in greater detail. *What is it?* is a question we ask of them both. The "Gothic" is notoriously difficult to define. From origins with fifth-century Visigoths, to an eighteenth-century phenomenon in architecture and literature that appears like a counterfeit medievalism, to a mode that extends to all contemporary arts, especially music, film, and fashion—the Gothic, or simply "Gothic" as it is sometimes called (there is no critical consensus here either) is remarkably protean and slippery, a powerful shapeshifter. Likewise, taxidermy has at its undead heart the ontological impossibility of reconciling itself as being alive or dead, animal or object. Moreover, as I aim to show, both are discourses deeply invested in the uncanny and the counterfeit.

Taxidermy is uncanny; it occupies a liminal zone between life and death, animal and object, temporalities of past and present, and spaces of the wild and domestic. That which is uncanny is the name, as Freud says drawing on Schelling, for "everything that ought to have remained [...] secret and hidden but has come to light" ("The Uncanny" 224). In the case of taxidermy, the dead body which ought to have been disposed of, buried, or otherwise made to disappear instead lingers, and remains preserved and placed back inside the space of the living. Taxidermy also serves as an uncanny reminder of the past. For if the Gothic, as Allan Lloyd-Smith reminds us, trades in "the repressed and denied, the buried secret that subverts and corrodes the present, whatever the culture does not want to know or admit" (1), so too does taxidermy. To be sure, taxidermy has many secrets. As we will explore in Chapter 1, many nineteenth-century prints and taxidermy manuals flirt with the mystery and secrets of this quasi-magical craft. Yet taxidermy, or rather taxidermy's history, holds still more secrets, one of which is the long and difficult relationship between black life and taxidermy, which, like taxidermy's collusion with the Gothic, also emerges in the nineteenth century and continues to murmur within the present (as I explore in Chapter 4).

Taxidermy can be furry, feathery, or scaly, though perhaps may be best described as "fuzzy"—a term that not only describes a fur- or feather-covered animal but also captures something of the difficulty in perceiving, identifying, and defining it, being something that is "blurred, indistinct [...] imprecisely defined" (OED). Sometimes the term taxidermy is used to describe any form of animal preservation, such as wet preservations, embalmed specimens that are pickled and preserved in jars; skull mounts, also known as European mounts, where only the skull and/or horns or antlers are mounted without the skin; and even the ancient Egyptians' process of mummification. Sometimes taxidermy crosses the species boundaries and

INTRODUCTION xv

extends to include human taxidermy. While material examples of this are infrequent (taxidermy historian Pat Morris tracks only seven examples of real human taxidermy [*A History of Taxidermy* 88–98]), they are always to disastrous ends, such as in the well-known case of Jeremy Bentham's Auto-Icon whose desiccated head and clothed skeleton continue to be preserved and on display at University College London. Other times the skin of the term stretches, and taxidermy becomes a metaphor for another medium that captures and preserves its subjects in lifelike conditions, like photography, or a figure for thought, such as a sign system for colonial logic (cf. Wakeham).

A word then on what counts in this book as taxidermy and what doesn't. As I use the term here, taxidermy is something quite specific: it is not wet preservations, not mere skulls, bones, or mounted antlers, and not mummification. Taxidermy, as taken up here, does not cross the species boundary to include examples of human taxidermy, despite being legion in contemporary horror films (e.g., *Silence of the Lambs, Beyond the Darkness, Taxidermia, Stuffed, The House That Jack Built*) enough to be the subject of their own book. Instead, I endeavor to stay with examples of the furry or feathery strange animal-object-thing itself and not enfold it back into the more familiar and familial forms of the human. Additionally, taxidermy here is not a mere metaphor, and I do not pursue readings that make the case for photography or film as metonyms for taxidermy. Finally, taxidermy for our purposes here also does not include what we might consider the by-products of taxidermy: designs or decor made out of animals, like fur coats, rugs, or animal furniture, such as horse hoof candlesticks, elephant stools, alligator cigar boxes (examples of Wardian Furniture, so named after the nineteenth-century London taxidermist Rowland Ward who popularized these productions)—something other studies have deftly taken up.[2] Instead, taxidermy throughout this book predominantly refers to a strange or "fuzzy" material animal-object-thing, a three-dimensional mount—furry, feathery, or scaly—that in the tradition of a hunting trophy is stuffed, mounted, and displayed in such a manner that one comes into an uncanny, unsettling encounter with it, one that horrifies us in its stuckness.

Like the term taxidermy, the term "Gothic" is also polysemous. And every book that wades into its murky waters inevitably begins with an acknowledgment of such. As Alexandra Warwick notes,

> The tangled question of 'what is Gothic?' has been rehearsed by many critics. [...] The arguments are well-known, but if there is any general

2 See Elizabeth Young's *Pet Projects* and Chapter 3 in Eva Hemmungs Wirtén's *Terms of Use*.

xvi TAXIDERMY AND THE GOTHIC

consensus, it seems to be that Gothic is a mode rather than a genre, that it is a loose tradition and even that its defining characteristics are its mobility and continued capacity for reinvention. (quoted in Castricano 37)

If questions over what is Gothic or the Gothic is already a critical tangle, bringing the question of horror into the mix can produce even bigger challenges—at least for scholars looking to tease apart and isolate these bodies. However, in the spirit of working against purity (for reasons I will soon unpack), an approach influenced by Alexis Shotwell and well suited to my topic at hand, I am less interested in holding Gothic and horror apart. That said, I do use "Gothic fiction" to refer to a tradition that extends from Walpole with a set of familiar conventions and tropes, suggesting as I do (in Chapter 1) that there are shared formal resemblances or rhetorical strategies between early exemplars of the genre and nineteenth-century taxidermy manuals. But more often, I deploy the more affectively charged composite term and mode of "Gothic horror," chosen for its emphasis on corporeality and visceral encounters, a rhetorical move that helps with the need Xavier Aldana Reyes identifies to "reclaim the importance of the body to the gothic text" (*Body Gothic* 2).[3]

And what a body it is! Indeed, in many iterations, some of which we will closely examine throughout this book, taxidermy is, I offer, another spectacular form of "the Gothic body," which Steven Bruhm defines as "that which is put on excessive display, and whose violent, vulnerable immediacy gives both [...] painting and Gothic fiction their beautiful barbarity, their troublesome power" (*Gothic Bodies* xvii). Stuffed and mounted and displayed inside homes or museums, taxidermy—the product of violence and gruesome processes—in its vulnerable, visceral immediacy stands motionless before us, as if breathlessly calling to us. It enacts and incites the very work of horror as Ann Radcliffe defined it, as that which "contracts, freezes, and nearly annihilates" our faculties, rendering us horrified, immobilized or stuck subjects ("On the Supernatural in Poetry" [1826] 149–50).[4] Thus, while "Gothic horror" helps keep

3 Other studies that treat "Gothic horror" include Halberstam's *Skin Shows*, Aldana Reyes's *Body Gothic*, and Bundock and Effinger's *William Blake's Gothic Imagination*, to name a few.

4 Radcliffe teases apart the operations of terror and horror. Terror involves obscurity whereas horror leaves little to the imagination: "Terror and horror are so far opposite that the first expands the soul, and awakens the faculties to a high degree of life; the other contracts, freezes, and nearly annihilates them" (149–50). As Steven Bruhm puts it, "Terror, then, is that carefully regulated aesthetic experience that can use intense feeling to seek objects in the world. [...] Conversely, horror 'contracts, freezes and nearly annihilates' the passions which lead to community, and forces the horrified spectator to enclose and protect the self" (*Gothic Bodies* 37).

INTRODUCTION xvii

the dimension of taxidermy's phenomenological horror in the forefront of our imaginations, sometimes I use "the Gothic" as shorthand for this, and trust you to feel the word "horror" stuck in your throat. Asking you to feel the word "horror" as something stuck in your throat is to court the unpalatable, a move that (in the same spirit as this book more broadly) works against what appears to be the increasing efforts to render taxidermy more palatable.

The Abjection and Apotheosis of Taxidermy

If taxidermy enjoyed great popularity in the long nineteenth century, as will be explored more fully in the next chapter, because of advances in preservation techniques, following the First World War taxidermy experienced what Alexis Turner calls "a long period of decline" when for decades it was the subject of "distaste and disapproval. As the backlash against the perceived persecution of wildlife continued, taxidermy was made a scapegoat, and collections were dismantled and dispersed, while saleroom prices sank to new lows" (18). Although the taxidermy industry itself began to show early signs of recovery in the 1970s, with the formation of national associations dedicated to the craft, such as the American National Taxidermists Association and the British Guild of Taxidermists, taxidermy had not yet shifted in the public imagination. Arguably, we could look to the first horror film, Alfred Hitchcock's *Psycho,* and its enormous cultural influence (and first on-screen depiction of the murderous taxidermist trope) as a reason for this delay. According to Turner, it wasn't until the new millennium when luxurious worlds of fashion, art, and commercial branding—major names such as Alexander McQueen, Ted Baker, Bergdorf Goodman, and Harrods, among others— began incorporating taxidermy into their art and marketing that the taste for taxidermy returned. Furthermore, we continue to see a concerted effort to purify and beautify the image of taxidermy. In the visually stunning documentary film *Stuffed* (2019), against the backdrop of quirky lighthearted music, a handful of taxidermists are shown to be humorous and humble nature lovers in innocent awe of animal beauty. The film, as one reviewer rightly puts it, "paints a giddy portrait" of taxidermists (Hansman n.pag).[5] The overstuffed

5 While they do not take taxidermy as their focus in the way the documentary film *Stuffed* does, other lighthearted depictions of taxidermy include *Sex in the City*'s bubbly Carrie Bradshaw (Sarah Jessica Parker) who twice dons a blue stuffed bird as a luxurious hairpiece, once for her lavish but ultimately botched wedding (*Sex and the City*) and again for the Met Gala (*And Just Like That,* Season 2); and, *Queer Eye,* a feel-good makeover show known for its profound transformations and breathing a new life into its made-over subjects, features episodes where taxidermy lines the walls.

walrus at London's Horniman Museum paints a similar picture: it has its own Twitter account @HornimanWalrus, and regularly offers anecdotes, jokes, and suggestive emojis that imbues the specimen with a larger-than-life personality. Spilling beyond museum walls, in 2022, British taxidermist duo Field and Young (Suzette Field and Eliot Young) were invited to create a taxidermy installation outside of the British Museum. Their "Fox in a Box" featured an ethically sourced dapper fox dressed in a suit, along with a few stuffed squirrels, making a phone call from inside an iconic red phone booth, which was filled with colorful fake flyers advertising sexual services. Viewers could eavesdrop on the fox's call by scanning a QR code. These are a few recent charming examples from the larger trend in taxidermy's comeback, projects that aim to distance taxidermy from any "negative aesthetics," that is, from what is "perceptually distressing, repellent, or painful" (Berleant 158).

On the contrary, scholarly engagements with taxidermy (cf. Poliquin, Madden, Milgrom, Aloi, McHugh and Bezan, Desmond) lean more into negative aesthetics, although, as I will soon suggest, the field still does not go far enough into the dark. The overall tone, and what has become the dominant mode in scholarly approaches to taxidermy, in the wake of Poliquin's seminal book *The Breathless Zoo*, is to see it as an art enmeshed with mourning and melancholia, an object that speaks to us of various losses and the desire to hang onto life even in death. In a field that we might now name "critical taxidermy studies"—a term that acknowledges its kinship with critical animal studies and capaciously includes the extant varieties of critical approaches, including "botched taxidermy" (Baker), "literary taxidermy" (McHugh, McHugh, and Bezan), and "speculative taxidermy" (Aloi)—taxidermy has become "good to think with,"[6] a way to understand human–nonhuman relationships, extinction events, and what it might mean to survive in our unraveling worlds.

Underpinning critical taxidermy studies is critical animal studies, which thoughtfully looks to rethink human–animal relations, often in the activist spirit of imagining a better world. As Susan McHugh writes in *Love in a Time of Slaughters*, taxidermy in literature can "address atrocities marked by human, together with animal, death on massive scales" (46) and "can foster a sense of respect, obligation [...] and love for the lost" (49). To be sure, in the wake of the Anthropocene and mass species extinction, we are increasingly thinking about our entangled, precarious interspecies lives. This "passionate immersion in the lives of [...] nonhumans," as Anna Tsing puts it ("Arts of Inclusion" 201),

6 This is a nod to anthropologist Claude Lévi-Strauss's well-known phrase about the animal (*Totemism* 1964).

INTRODUCTION

has given rise to not only critical animal studies but also the broader "multispecies studies," and the related field of "extinction studies," the latter of which focuses on massive, species-level death.[7] Taxidermy is the new animal.

To be sure, these critical approaches are invaluable for thinking through our more-than-human worlds, and taxidermy, as a transmogrification of the animal, is understandably an extension of these conversations. While I do not deny the importance of this scholarship that works to take seriously the question of taxidermy, I do in this book diverge from these studies by insisting that we also look to the shadows and follow those still darker hallways and corridors where taxidermy sits waiting. There is an ineradicable dark side to taxidermy, one in which Gothic horror is particularly invested, and this, too, is part of its story. If we are, as Deborah Bird Rose, Thom van Dooren, and Matthew Chrulew suggest, in many different fields and lines of thought working to offer "'thick' accounts of other-than-human ways of life" (4), part of this thickening must necessarily involve folding in the currently excluded bits. If we are to "stay with the trouble," as Haraway encourages us, critical taxidermy studies must grapple with taxidermy's collusion with Gothic horror and their long history of "reciprocal capture" (to borrow Isabelle Stengers's phrase).[8]

While in most scholarship taxidermy's Gothic sensibility appears to be an oversight, in others, it is outright disavowed. Stephen Asma in *Stuffed Animals and Pickled Heads* confesses to having "a little embarrassment about the macabre interest" (5). Dave Madden in *The Authentic Animal*, in searching to answer to his own question "Why am I drawn toward this thing [taxidermy] that repels so many others?" protests that "It's not, please believe, a goth thing" (3). Madden's autoethnographic comment revealingly shows his perception of taxidermy's association with the Gothic and its (sub)cultures, even if one that he immediately attempts to do away with. What exactly is the risk of it being "a goth thing"? Is this a fear of being (mis)identified through proximity with the various forms of darkness (sexual desires, deviancy, violence) long associated with Gothic horror? Gothic darkness or barbarism, as David Punter in *Gothic Pathologies* puts it, "is a matter of looking at the pressures which turn us into barbarians within, barbarians in relation precisely to the society and the body in which we were born" (17). Taken together, Asma and Madden's comments scratch at what Marina Warner calls the "prickly possibilities"

7 On the field of "multispecies studies," see Thom van Dooren, Eben Kirksey, Ursula Münster. "Multispecies Studies: Cultivating Arts of Attentiveness." *Environmental Humanities* 8.1 (2016): 1–23.

8 The term names "a *dual* process of identity construction [...] identities that coinvent one another each integrate a reference to the other for their own benefit" (Stengers 36).

afforded by the Gothic and the associative slippage that often occurs when thinking about the Gothic, goths, and the dark side of humanity (Warner *From the Blonde to the Beast* xvi). After all, as Punter reminds us, "Gothic is always that which is other than itself" (1).

The work of McHugh (including her collaboration with Bezan) appears aimed at establishing a narrative tradition and Bildung trajectory for literary representations of taxidermy that purportedly outgrow the affiliations with neurotic disturbances. Although McHugh and Bezan concede that the "literary histories of taxidermy have been squarely associated with shady characters" (134), they are keen to shift scholarly attention away from its "seediness" and toward its "seeds of resistance" (134). More specifically, McHugh suggests there is a shift in recent literary representations of the taxidermist away from the figure of a "murderous psychopath" (*Love* 50) toward those that avenge such a figure. McHugh makes this reading by gesturing to heroic figures who fend off the taxidermist-murderer (e.g., Stretch in *The Texas Chainsaw Massacre 2* and Clarice in *The Silence of the Lambs*) or even taxidermist-avenger figure in other texts (e.g., Liza in Alice Munro's short story "Vandals" among others). However, even if we undertake a feminist reading and see as heroic a character's successful effort to escape the chainsaw-yielding taxidermist-murderer, taxidermy remains in these texts and elsewhere yoked to violence and perversion. Furthermore, despite brief nods to horror films, McHugh does not look closely at Gothic horror, an examination that would yield a different analysis—as this book will show. Indeed, I argue that we have not moved beyond the supposedly "dying trope" (as McHugh calls it [*Love* 51]) of taxidermy's dark side. Quite the opposite. For as scholars of Gothic horror well know, the dead and dying are rarely (if ever) properly buried. If we turn toward rather than away from Gothic horror, we find how taxidermy remains a delightfully *undead* trope.

In fact, that taxidermy stubbornly survives as an undead trope and continues to serve (like the Gothic) as a dark mirror reflecting back our anxieties and horrors of life is something that some scholars vehemently attempt to expunge. Nowhere is this clearer than in Pat Morris's scathing comments on those scholars, artists, and film directors who have admitted to taxidermy's association with negative aesthetics and the work of horror (*A History of Taxidermy* 355–56). Morris shockingly dismisses the cultural value of horror film and admits to having a "pretentious theory" about why anyone might find taxidermy creepy or horrifying and have a "jaundiced view of taxidermy" (355): it is a sign that they are too much in the world of the arts rather than sciences.

Taken together, these diverse comments and this critical work can be symptomatic of the discourse's various investments and divestments, avowals and disavowals of Gothic horror, evidence of the ways much of taxidermy's

INTRODUCTION

representations in texts and film (outside the genre of Gothic horror) steer into and swerve away from the magnetic pull of Gothic horror.

What is going on here, I believe, is an effort to tidy up taxidermy. The macabre dimensions of taxidermy serve as the abject Gothic horror (as mode, genre, and affect) from the historical and literary corpus of taxidermy. Here, Julia Kristeva's theory of "abjection" is helpful, a concept that has long shaped Gothic studies since the publication of Kristeva's *Powers of Horror* (1980). For Kristeva, ghosts, leaky bodies, and corpses are some examples of what she calls the "abject," a term she assembles from *ab-ject*, a "throwing off" and "being thrown under." The abject is what we must "thrust aside in order to live" (3); it is that within us that is "in-between [...] ambiguous [...] composite" and must be cast off in order to maintain the stability, integrity and survival of us as an individual subject (4). Because, for Kristeva, our first encounter with abjection is the moment of our own birth—a point at which we are both inside and outside, alive and quasi-dead—we come to respond to subsequent encounters with threshold dead-and-alive conditions with an intense need to throw them off. Still, we are both fascinated and repulsed by this thing that we must throw off because it uncannily reminds us of our own origins. Our response to seeing a corpse is Kristeva's primary example of abjection at work; a corpse is "the utmost of abjection. It is death infecting life" (4). But a certain proximity to death also infects corporeal life in other ways: the living body—that leaking, shitting, pissing, bleeding, oozing body, with its processes of pollution and decay—is in proximity to the corpse, and it too is also a form of the abject. We can also add taxidermy to this list, an animal-object-thing that is ontologically unstable, always ambiguous, and composite. For as Kristeva notes, "abjection is above all ambiguity" (9).

Applying this concept of abjection, then, to the discourse of critical taxidermy studies, we find an effort to "throw off" taxidermy's associations with Gothic horror. It is an effort motivated to have taxidermy elevated to the status of the new animal, as a bloodless figure to take seriously, a figure that is good to think with, a furry figure of critique and speculation. We might view taxidermy's apotheosis as adjacent to the rise of object-oriented theories and the critical interest in flattened ontologies (that, to put it briefly, displace the hierarchical subject–object relationship with a more democratic object–object relationship). And yet, to paraphrase Claire Colebrook's observation in *Death of the PostHuman*, isn't it curious that we start to see ourselves as objects among other objects precisely at a time when we also enter the Anthropocene, a time when humans have caused planetary damage at an unrivaled scale? The apotheosis of taxidermy into a figure of critique extends the transformation of taxidermy into art. The attempted shift away from its associations with the work of Gothic horror—the blood,

guts, and gore, the negative aesthetics—and its ugly feelings are required if we are to see taxidermy as the art of a maestro rather than a murderer. If Gothic texts, as Fred Botting, writes, "are not good in moral, aesthetic or social terms" (2), and not geared at improving the world or its readers, Gothic figures by extension do not principally aim to offer recuperative solutions. Moreover, if "what counts" in Gothic texts is not primarily knowledge and understanding, Botting continues, but rather "the production of affects and emotions, often extreme and negative: fear, anxiety, terror, horror, disgust and revulsion" (6), we can perhaps understand this contemporary moment, where the critical ethos appears oriented toward finding solutions and more caring ways of surviving in greater entangled communities, as one where there is less excitement for Gothic negativity (at least for some).

And yet, taxidermy, which is and always has been since its origins, stained and stuffed by its proximity with Gothic horror—remains through this proximity, just as in the body's proximity to the corpse, a form of the abject. Taxidermy and Gothic horror remain stubbornly attached, each wearing the skin of the other.

Some taxidermy artists revel in this Gothic attachment, such as the Belgium-based duo Mothmeister, who channel the nineteenth century in their elaborate and macabre taxidermy-filled tableaux; and Sarina Brewer and Scott Bibus, two of the founding members of the Minnesota Association of Rogue Taxidermists (MART), a leading group of American artist-taxidermists pushing taxidermy in new, experimental directions. Brewer's taxidermy sculpture "Goth Griffin" was featured on the front page of *The New York Times*'s art section. Bibus's work foregrounds the blood, guts, and gore of taxidermy featuring specimens that are "stuffing" themselves in a variety of cheeky ways.

Taxidermy is a "dirty" discourse, ripe for Gothic horror. Taxidermy deals with abject, messy bodies, and is itself a messy discursive body. The gory and putrid-smelling craft of taxidermy—with its skinning, fleshing, preserving, and sewing—requires not only a strong stomach of the taxidermist, but patience. For there are frequent failures (e.g.,"botched" or "crap" taxidermy) such as the failure, intentionally or not, to realistically capture the lifelike animal—failures that can work to horrific or comedic ends. Taxidermy can sometimes force its viewers to confront the impurity of this discourse and forms of anthropocentric violence against animals, such as in the contemporary sculpture of taxidermy artists like Bibus, Polly Morgan, and Angela Singer. Especially noteworthy here is Singer's artistic blood-stained deer mount, titled *Sore I* (see Figure 0.1), that boldly captures the violence of the hunted animal by staging the subject—with its dripping blood, bulging glassy eyes, and hacked-off antlers—in such a manner

INTRODUCTION xxiii

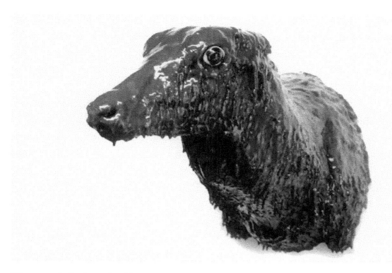

Figure 0.1 Angela Singer. *Sore I.* 2002–3. © Angela Singer. Image courtesy of the artist.

that refuses to erase the violence of the animal's death. Here, as Elizabeth Young rightly says of this work, "the viewer cannot avoid the visceral violence of taxidermy, as the animal—flayed and bloody—looks back" (*Pet Projects* 89).

Moreover, the growing backlash against collecting and displaying taxidermy, which has led many museums to deaccession or to destroy specimens or at least display apologetic placards next to mounts, speaks to the recognition of taxidermy's role in environmental destruction, domination, and colonial violence and the public's unwillingness to gaze upon these objects of negativity. Taken together, taxidermy is a messy, "dirty" practice.

Dirt, as Mary Douglas defines it in *Purity and Danger* (1966), is "matter out of place," a disordering of things. As a dirty, impure practice, taxidermy is structured against purity, and this, I wager, is part of its affective power. Here, I follow Alexis Shotwell, who writes in *Against Purity: Living Ethically in Compromised Times* (2016) that "To be against purity is [...] not to be for pollution, harm, sickness, or premature death. It is to be against the rhetorical or conceptual attempt to delineate and delimit the world into something separable, disentangled, and homogenous" (15). Taxidermy materially and symbolically embodies impurity, entanglement, and heterogeneity.

In a related vein, Gothic horror, as is well known, has long been associated with filth. From Wordsworth's dismissal of Gothic fiction, those "sickly and stupid German tragedies" in the Preface to *Lyrical Ballads*, to beautiful virgins defiled (or nearly defiled) and saintly figures demonically corrupted,

subterranean, dirty, cloistered spaces, filthy urban and rural spaces, and paradises corrupted into eco-hellish holes. In the visual tradition, from Piranesi's darkly sketched staircases leading nowhere from his *Carceri d'invezione* (1761), to Goya's cadavers, and Blake's writhing bodies and viscera that take on surreal lives of their own, filth is everywhere.

And yet, if the blood and guts can be cleaned, washed, and scraped away from the material bodies of taxidermy, taxidermy itself as a practice (the discursive body of it) never fully comes clean. It remains symbolically mired in the filth, a potent image of Gothic horror, a dirty discourse that speaks to our fascination and repulsion with the unassimilable and abject. Moreover, as William Cohen and Ryan Johnson write in *Filth: Dirt, Disgust, and Modern Life,*

> When polluting or filthy objects are thought of as trash, waste, junk, or refuse, they become conceivably *productive,* the discarded sources in which riches may lie, and therefore fecund and fertile in their potential. [...] The potential for this reimagining means that the regenerative fantasy hovers at the edge of the filth that excludes it. In this way too, filth seems at once to occupy one side of the subject/object divide and to undo the opposition itself. (x)

Taxidermy, in all its dirtiness, is a fertile site/host, staining the sheets and screens of Gothic horror. It undoes ontologies and categories and shows itself to be powerful in its ability to disorder ideas we have of bodies, identities, and knowledges.

There are a few scholars who prove the exception to this critical abjection. Jeffrey Niesel, in "The Horror of Everyday Life: Taxidermy, Aesthetics and Consumption in Horror Films" (1994), offers the earliest analysis of taxidermy's representations in Gothic horror. Niesel argues that the practice of taxidermy (a scope that also includes human taxidermy) in *Psycho, The Texas Chainsaw Massacre 2,* and *The Silence of the Lambs* is associated with the psychopathology of serial killers:

> taxidermy, because it takes the fetish to its logical end (murder), exposes connections between consumerism, aesthetics, and patriarchy and shows these systems contribute to creating relationships of violence particularly in the effort to render feminine subjectivity silent. (61)

Niesel owes much to Haraway's earlier reading in her essay "Teddy Bear Patriarchy: Taxidermy in the Garden of Eden" (1984), which sees taxidermy as a tool for crafting American patriarchal identity, and connects it to other

INTRODUCTION xxv

systems of violence largely aimed against women. However, what we will come to see, in the Gothic horror texts that taxidermy continues to populate (especially since the time of Niesel's essay), are the ways that taxidermy constellates the persistence or "stuckness" (a form of "still life," I am suggesting) of everyday horrors, whether the horror of existence itself (the focus of Chapter 2), the ineradicability of perversions (Chapter 3), or the ubiquitous horror of systemic racism and microaggressions (Chapter 4).

Subarna Mondal, in an essay principally focused on Hitchcock's *Psycho*, also offers some analysis of taxidermy's larger connection with the Gothic, arguing that "grotesque preservation" is the "common thread" between the two discourses (2).[9] As Mondal rightly notes, "deformity, alterity, liminality, grotesquery, transgression and excess are all common features shared by both taxidermy and the Gothic" (2). As Mondal continues:

> Be it an ancestral curse, a ruined mansion, a familial secret, a demented aristocrat, or a decayed body in a closet, the Gothic always preserves. It may be seen as a form of taxidermy: the taxidermy of the spatial, the temporal, the psychological, and the corporeal. (3)

And yet, we should also remember that Gothic horror (like taxidermy) is also marked by the *failures* of this preservation, as many scholars have explored.[10] For the curse returns, the secret comes out, the body falls out of the closet, or the suspected scandalous letter turns out to be a laundry list. Indeed, one of the long-enduring elements of this "highly unstable genre" as Jerrold Hogle calls it, is the oscillation between contradictory states, fears, desires, and ideologies ("Introduction" 1). A similar contradictory tendency defines taxidermy, a discourse also shrouded in failure and the attendant horrors of this.

David Annwn Jones's *Gothic Effigy: A Guide to Dark Visibilities* (2018) is a rich sourcebook and reference guide for Gothic visual works, which includes a brief section on taxidermy. Jones mentions Gothic texts featuring taxidermy across multiple genres (short stories, novels, film, television series, sculpture) from

9 For her, *Psycho*'s taxidermy works to call attention to the materiality of the human body, staging Mrs. Bates, Norman, and Marion all as "taxidermic recreations."

10 See Elizabeth Napier's *The Failure of Gothic* (1987) and George Haggarty's "Gothic success and gothic failure: formal innovation in a much-maligned genre." In Caserio, Robert L, and Clement Hawes. *The Cambridge History of the English Novel*. CUP, 2011. 262–76. Moreover, as Jodey Castricano notes, "Philosophically, aesthetically, psychologically ... spiritually, it would appear Gothic fails to make the grade" (*Gothic Metaphysics* 8).

the Victorian age through to our contemporary moment, beginning with Sir Walter Potter, citing texts by Bulwer-Lytton, Dickens, and Henry James, before moving onto Neo-Victorian Gothic novels, including Joanna Scott's *The Manikin* (1996) and Kate Mosse's *The Taxidermist's Daughter*.[11] While Jones notes that a "range of Victorian and more recent writers found taxidermy to be a powerful metaphor for the forbidden arts and transgression" (96), deeper explanations are left for future scholars.

Sarah O'Brien dedicates a chapter of her media history book *Bits and Pieces: Screening Animal Life and Death* (2023) to the appearance of taxidermy in Black horror films and television series. For O'Brien, cinema and television, which are the core focus of her book, extend the work of slaughterhouses and taxidermy; for her, both taxidermy and television are "domestic media," forms of "armchair tourism" (9) that produce ways of making animal life and death visible, that reassemble the animal form before our eyes, and can transform threatening figures into "nonthreatening forms of difference into the home" (12). She tracks how taxidermy and television are both anchored in "the project of imperialism and its attendant vicarious visual pleasures, the legacies of which persist today in a racialized, acquisitive gaze that is seldom recognized as such" (9) and reads Jordan Peele's film *Get Out*—a text I also examine—among other texts that use the trope of the "Blackbuck" (the hypersexualized Black male) to show how black male bodies are collected and consumed.

Christy Tidwell, in her entry on "ecohorror" for *The Posthuman Glossary* (2018), another reference guide, offers some brief but insightful comments on taxidermy's presence in ecohorror narratives. For Tidwell, taxidermy serves as yet another signifier of "environmental disruption" (116). Taxidermy's ontological uncertainty "highlights horror's already existing anxieties about the nonhuman, death and the lines between categories such as human/nonhuman, life/death and animate/inanimate" (116). Here, Tidwell reads taxidermy through Mel Y. Chen's animacy hierarchy, in which sentient, animated life is valued the most, while inanimate objects are at the bottom: "Taxidermied animals illustrate this [bottom] end of the scale, as do many horror film monsters (zombies, vampires, animal monsters), while the humans who star in the films exist at the opposite end of the animacy hierarchy" (116). While Tidwell rightly reads taxidermy as monstrous in these narratives, I quibble with her placement that flattens taxidermy's difference. After all, taxidermy moves very differently from zombies, vampires, and animal

11 Annwn Jones misattributes the plot of Bulwer-Lytton's *A Strange Story* to *The Haunted and the Haunters*.

INTRODUCTION xxvii

monsters, which is to say it (usually) doesn't. Instead, in its horrifying stasis and what I describe as its nocturnal ontology (a notion I develop in Chapter 2), taxidermy is more akin to other uncanny things, such as the dark or existence itself (Levinas's *il y a*), rather than monsters that actively feast upon, crawl, fly, moan, and hotly pursue their human victims. Moreover, that taxidermy uncannily taps into our own horrors of existence, any animacy hierarchy that might attempt to hold humans on the opposite end ultimately fails.

Although taxidermy in the Gothic horror texts considered in this book works to signal different horrors than those articulated by Tidwell—my reading explores how it clings to various fixations, obsessions, and blockages (in short to existential and libidinal economies)—there is food for the future in considering how these economies are also horrifically bound to an irreparably damaged nature. I suspect the ecoGothic and ecohorror genres will continue to be rich places where we find representations of taxidermy's dark side, as these are both genres that emphasize "the strangeness and horror of living in the Anthropocene and of engaging in less-than-positive ways with the nonhuman world" (Tidwell and Soles 14). Although I do not focus in this book on ecoGothic horror, the larger argument that I do advance here over taxidermy constellating the horror of existence can (and I hope will) be extended in such a direction. Taxidermy, we might say, mutely speaks, in part, to our current growing fears and anxieties over *being stuck*—including being stuck in an ecological death spiral, as a result of the various maimings (e.g., mass species loss, climate crises, pandemics) that mark our life now in the Anthropocene.[12] We are, as Dawn Keetley and Matthew Wynn Sivils astutely note, "a culture obsessed with and fearful of a natural world both monstrous and monstrously wronged" (3), obsessions that reflect this stuckness. Now, more than ever before, we recognize our shared fate with more-than-human forms and find in taxidermy's frozen faces a reflection of both our own culpability and inescapability.

Taxidermy and the Gothic is the first full-length study of taxidermy's collusion with Gothic horror. Through a comprehensive collection of Gothic horror texts (in the broadest sense of that term) that significantly feature taxidermy, this book offers a composite, transhistorical, transmedial analysis that stretches from the long nineteenth century to the present. This book both draws on original archival research and theorizes taxidermy anew: it argues that taxidermy, this strange animal-object-thing, where

12 On the Gothic's importance to the Anthropocene, see Jodey Castricano's *Gothic Metaphysics* (2021) and Justin Edwards, Rune Graulund, and Johan Höglund (eds) *Dark Scenes from Damaged Earth* (2022).

it appears in Gothic horror, terrifyingly constellates the horror of being-there or being stuck. Despite being everywhere in Gothic horror and yet almost nowhere in its scholarly criticism, taxidermy in Gothic horror is a powerful undead trope, an uncanny dark mirror reflecting some of our greatest fears about existence, a catachrestic figure breathlessly whispering to us about the horrors of life itself and the inescapability and ineradicability of the human animal's dark sides, from perversions to systemic racism. Redressing such gaps in Gothic horror studies and challenging the purifying "stratification" of critical taxidermy studies—in Deleuze and Guattari's sense of stratification as "giving form to matters, of imprisoning intensities or locking singularities into systems of resonance and redundancy" (*A Thousand Plateaus* 40)—this book aims to open up, expose, and linger with taxidermy's messy imbrication with Gothic horror, a more troubling form of "staying with the trouble" (to riff on Haraway's phrase).

The Structure of the Book

Throughout this book, we find some examples of such troublesome taxidermy in well-known Gothic fiction and Gothic horror films and in more obscure corners ranging from the long nineteenth century to the present. Because taxidermy largely disappears from popular taste from the end of the long nineteenth century until the mid-to-late twentieth century, in what might feel like a long-held breath, my book tracks a similar trajectory leaping from the end of the Victorian era to the 1960s–present.[13] Each of the book's four chapters, imagined as an overstuffed drawer in a cabinet of curiosity, explores a different concern: from making taxidermy (Chapter 1), looking at taxidermy (Chapter 2), touching taxidermy (Chapter 3), to transforming/becoming taxidermy (Chapter 4). However, in keeping with the spirit of the cabinet of curiosity, the concerns and contents of these chapters also messily spill over and overlap with one another. For example, *Psycho* appears in both Chapters 2 and 3, and the discussion in Chapter 3 of the series *Tell Me Your Secrets* takes up concerns of both looking and touching, both the unnerving gaze of taxidermy and the sexual perversions and secrets that cling to those associated with this figure. And, by the time we arrive at Chapter 4, the culmination of the book, the themes of objectification and exploitation of certain bodies (e.g., female, black, queer) explored in the three previous chapters come to a head,

13 However, some contemporary Gothic fiction centrally featuring taxidermy is set during the span of the two World Wars such as Kate Mosse's *The Taxidermist's Daughter* (2014) and Jane Healey's *The Animals of Lockwood Manor* (2020).

INTRODUCTION xxix

as if bits and pieces from those other drawers have spilled over and sunk down into this final drawer. Let's take a closer inspection of these drawers.

In Chapter 1, I examine the emergent knowledge practice of taxidermy in the long nineteenth century. Taxidermy, as one critic suggests, "was a magical mix of science, art, and theatre, an incomparable tool for displaying the wonder and beauty of animals" (Milgrom 5). Yet this was perhaps taxidermy's ego ideal, what it liked to imagine itself capable of being. For frequently, taxidermy was extremely self-aware of itself as an amateur art and a fledgling practice, one that was more often marked by failure, botched specimens, and a thoroughly Gothic sensibility. This chapter also establishes the genealogy for the entwining of gothic horror and taxidermy. After all, the time of the late Victorian Gothic revival was also the time of what Alan S. Ross calls the "golden age of taxidermy" (1030). Focusing on a range of nineteenth-century taxidermy manuals published between 1820 and 1890, with special emphasis on Thomas Brown's *The Taxidermist's Manual* (1833) and Walter Manton's *Taxidermy without a Teacher* (1882), I identify three key features of this emergent knowledge practice: first, taxidermy treatises sometimes deployed Gothic narrative techniques, like evasive prefaces, counterfeit authorship, reliances on the provisional ("as if"), and detours around showing the body laid bare; second, the taxidermist was figured as a morally ambivalent and even monstrous figure akin to a Victor Frankenstein; and third, the actual taxidermied animal was frequently described as hideous, rendering it much more often an object of horror than an object of beauty.

Having established the historical roots and the shared rhetorical strategies and investments of the Gothic and taxidermy, Chapter 2 then turns to theorize the affective resonances between these discourses in contemporary Gothic texts. Here, I argue that taxidermy is thoroughly Gothic insofar as it embodies the horror of situatedness, of being stuck or "being-there"—a concept of stuckness that I extend in new directions from Levinas's description of the horror of existence (the *il y a*). Taxidermy offers a unique phenomenology of the frozen, open- or closed-mouthed, snarling or sleeping specimen with its inhuman glassy eyes, what I call, borrowing Derrida's phrase, taxidermy's "bottomless gaze," that ultimately captures the impossibility of escape. Although Derrida, inspired by an encounter with his own housecat, uses this phrase in *The Animal That Therefore I Am (More to Follow)*, to refer to the living animal's impenetrable, unknowable gaze, an experience like looking into the abyss, I extend it to the even more estranging and frozen look of taxidermy. Reading taxidermy with this phenomenological approach offers a new line of thinking about taxidermy beyond the dominant mode of mourning and melancholia and helps situate taxidermy in the tradition of body horror. The chapter reads about the horror of being-there in a range of

horror films that home in on taxidermy's dark bottomless gaze: *Psycho* (1960), *The Texas Chainsaw Massacre* (1974), *A Classic Horror Story* (2021), and Ana Lily Amirpour's *The Outside* from Guillermo del Toro's horror anthology *Guillermo del Toro's Cabinet of Curiosities* (2022).

In Chapter 3, I consider how taxidermy hides other horrors and becomes frequently aligned in Gothic horror with the existence and persistence of sexual taboos, transgressions, and perversions, with the horror of dark desires or things that ought not to be there but that remain. Many twentieth- and twenty-first-century Gothic texts tend to depict those with a taste for taxidermy as perverts, looking to escape the rules and expectations of the social world (the reality principle, as Freud calls it). If taxidermy perverts or violates the natural processes of death, decay, and disappearance, beneath it lies a secondary and more unsettling alignment of taxidermy with perversion, especially in the Gothic horror tradition. Many Gothic horror texts align taxidermy—that is, representations of taxidermists, the craft of taxidermy, and the taxidermied specimens themselves—with dark desires or sexual perversions. In multiple registers, then, taxidermy, as represented in Gothic horror, is intensely "polymorphously perverse" (to borrow Freud's phrase), stuffed and stitched up with ontological and libidinal uncertainty.[14] This chapter concentrates on taxidermy's alignment with some of the most shocking social taboos, including matricide, bestiality, and rape. In this chapter, informed by psychoanalytic theories (Freud, Lacan, and those in their wake), I expose the bad romance between taxidermy and perversions through three case studies: *Psycho* (1960), *The Cabin in the Woods* (2011), and the Southern Gothic tele-series *Tell Me Your Secrets* (2021). If one of the principal features of the Gothic, according to Eve Kosofsky Sedgwick in *The Coherence of Gothic Conventions*, is that the self is "massively blocked off from something to which it ought to normally have access" (12), taxidermy in these texts participates in the blockages—and subsequent releases—of forbidden desires, identities, and knowledges.

14 Freud in "Three Essays on Sexuality" sees the child as naturally "polymorphously perverse" for the way he can find sexual pleasure from any object or part of the body, that is, until he has internalized the social expectations of civilized society. In my use of the phrase, I am channeling the fluid, protean, ever-changing state, the slippery surface of Freud's concept, in thinking about the shifting constellation of taxidermy with perversion. Taxidermy is slippery or polymorphous, as are the various transgressions, pleasures, and perversions with which it enters into association across Gothic horror texts (and beyond). Apart from a discussion of childhood in *Psycho*, I do not use Freud's concept with aberrant infantile behavior in mind.

INTRODUCTION
xxxi

The final chapter homes in on how taxidermy's horror of being-there forms a potent constellation with racialized bodies and black horror. I return again to the twin golden ages of taxidermy and the Gothic, as the nineteenth century sets the stage for a difficult relation between taxidermy and black bodies: from the nearly forgotten black taxidermist, John Edmonstone, who trained Charles Darwin, through to real-life cases of preserved and taxidermied black bodies (of the Hottentot Venus and El Negro), to the figure of the black taxidermied body-object-thing in H. G. Wells's "The Triumphs of a Taxidermist." As these examples show, taxidermy plays a role in the biopolitical enmeshment of blackness and animality and contributes to what Zakiyyah Iman Jackson in *Becoming Human* calls the "history of blackness's bestialization and thingification: the process of imagining black people as an empty vessel, a nonbeing, a nothing, an ontological zero, coupled with the violent imposition of colonial myths and racial hierarchy" (1). And yet, taxidermy also shares with blackness what Jackson theorizes as black(ened) being's ontological plasticity, its capacity to be simultaneously "everything and nothing," the "privation and exorbitance of form" (35). For Jackson, and for artists who turn toward taxidermy to explore the horrors of antiblack racism and microaggressions, the plasticity of blackness is both a site of critique and creative possibility. Indeed, in our contemporary moment, taxidermy's black bodies have returned with a vengeance in Gothic horror. This is shown in my close reading of two texts where taxidermy is used to focalize the everyday horror of black existence: Claudia Rankine's genre-bending collection *Citizen: An American Lyric* (2014), which features a photograph of a specially commissioned taxidermy sculpture by Kate Clark, and Jordan Peele's horror film *Get Out* (2017). Taxidermy in both texts forges an identification with black life and its attendant horrors. It is a figure that is both ontologically plastic and what I describe as having a strange "nocturnal ontology" (in Chapter 2). And yet, taxidermy is simultaneously and paradoxically also a horrifying figure for stuckness. Where Rankine's *Citizen* explores the affect of this association, with an emphasis on the stuckness and breathlessness of black and taxidermic bodies, Peele's *Get Out* imagines what it might look like when taxidermy and black life get unstuck—that is, get a second shot at life, get out, and get revenge.

The Unstuffed

But there are many other places where taxidermy's dark side shines, and so a word on what cannot be stuffed into this book. As this book focuses predominantly on popular film, and lest readers think taxidermy might only be encountered there, let me briefly consider a few contemporary Gothic

xxxii TAXIDERMY AND THE GOTHIC

horror novels where taxidermy appears as central, but that I do not have room to address at length here. Take, for example, British horror writer Adam Nevill's *The House of Small Shadows* (2013). There, the protagonist Catherine Howard, who is reeling from having lost her job and recently divorced, accepts a project for an auctioneer to appraise an odd collection of Victorian curiosities by the late collector MH Mason, considered England's greatest taxidermist. Arriving at Red House in Herefordshire, England, Catherine meets with Mason's heir and niece, Edith. Mason's art, reminiscent of Walter Potter's, includes anthropomorphic taxidermy puppets, such as hundreds of rats arranged in a taxidermic tableau of a battle of the Somme. Mason also made movies with his taxidermy puppets. Despite being terrified by the Red House and its taxidermy, Catherine refuses to leave—trapped, it seems, by a kind of psychic stuckness of her own.

In Kate Mosse's *The Taxidermist's Daughter* (2014), a Gothic thriller set in Sussex in 1912 (the same place of the famed Walter Potter), the protagonist Connie Gifford lives with her father, an aged and alcoholic taxidermist whose work has fallen out of fashion. Connie, who struggles with amnesia as a result of a mysterious childhood trauma is also a skilled taxidermist. A woman, whose body is found close to Gifford's house, has been strangled with a taxidermist's wire, and Connie suspects her father of the crime. As Connie unravels the mystery, her traumatized memory also returns. The specter of incest persists despite the revelation that the trauma at the core of the novel belongs not to Connie but to another girl, Cassie, who worked for Connie's father, and who serves as another kind of taxidermist's daughter, one seeking revenge against the group of men who raped her ten years earlier. In an interesting melding of genres, most of Mosse's chapters end with excerpts drawn from Sarah Bowdich Lee's taxidermy manual *Taxidermy, of the Art of Collecting, Preparing, and Mounting Objects of Natural History*, which was an influential handbook on taxidermy (as I discuss in Chapter 1) first published anonymously in 1820, and acknowledged as "Mrs R Lee" in the sixth edition in 1843. If, as Mary Orr notes, "Sarah Bowdich's *Taxidermy* was the first major work on the subject in English, as well as in other European languages, to be authored by a woman" ("The Stuff of Translation" 27), then we might well consider Bowdich herself to be taxidermy's forgotten daughter or even its mother. The theme of lost mothers and daughters is one that the novel itself plays with. These excerpts from Bowdich, which offer insights into the craft of taxidermy, are immediately followed by diary entries of the novel's murderer, eventually revealed to be Cassie.

In Julia Elliott's *The New and Improved Romie Futch* (2015), a part Southern Gothic tale and part dystopian satire, a divorced and financially struggling

INTRODUCTION

xxxiii

South Carolina taxidermist named Romie Futch undergoes experimental neurosurgery that results in intensive knowledge in the humanities, such as an encyclopedic knowledge of Foucault, being implanted (a cheeky spin, to be sure, on biopolitics). Armed with this new enhancement, Romie's taxidermy and personal life are revolutionized, and he creates intricate dazzling animatronic taxidermy dioramas that would make Walter Potter proud.

In Elizabeth Macneal's *The Doll Factory* (2019), a Gothic historical novel set in 1850s London, a taxidermist named Silas Reed runs a curiosity shop and sells creepy taxidermy to the Pre-Raphaelite Brotherhood who use them as props for their paintings. Silas becomes obsessed with a young painter, Iris Whittle, who has a deformed collarbone and has started modeling for the Brotherhood, and he attempts to abduct her for his collection.

In Kristen Arnett's quirky Sunshine State Gothic novel *Mostly Dead Things* (2019), Jessa is a Floridian lesbian taxidermist in her thirties, whose father has recently committed suicide at the family taxidermy shop that has been in the family for generations. Jessa struggles with this inheritance and with what her knowledge of taxidermy means for her struggles with identity and relationships. Like wrangling with the skins of animals, Jessa struggles to shape and secure narratives, bodies, and desires of her own and those around her. Queerness, family romance, and perversion abound here. Jessa is still in love with her first love, Brynn, who marries Jessa's brother Milo (and abandons them both). Jessa holds onto the secret that she and Brynn are still involved even after Brynn is with Milo. But most spectacularly, it is Jessa's mother who steals the spotlight by making erotic art out of taxidermy from the shop.

Polly Hall's *The Taxidermist's Lover* (2020) is a Gothic romance about a protagonist, Scarlett, who attempts to understand her obsession with the rogue taxidermic creations of her older lover, Henry. Written in an epistolary style reminiscent of *Frankenstein*, the story is addressed to Henry (the "you"), drawing the reader into some uneasy identifications, especially when taxidermy and eroticism blend together: "When we made love, I'd somehow taste the essence of the creatures you'd been handling—the quick, acrid bite of a fox, the feathery scratch of an owl, the smooth perfume of someone's beloved pet cat" (10). Specters of love triangles and incest also haunt the narrative.

Jane Healey's *The Animals at Lockwood Manor* (2020) is a queer Gothic romance set in 1939 and tells the story of Hetty Cartwright, an assistant at London's Natural History Museum, who is tasked with overseeing the transportation and safeguarding of the Museum's taxidermy from the city to a countryside home, Lockwood Manor, as the city anticipates bombing.

At Lockwood Manor, a quintessential haunted house, the taxidermy moves and disappears; Major Lockwood is the tyrannical Gothic father; and his sickly daughter Lucy isolated at the Manor comes to fall in love with Hetty. The central drama revolves around Hetty's attempt to solve who is tampering with the taxidermy, and if Lucy can summon the vitality to break from her life in stasis.

In T. Kingfisher's *The Hollow Places* (2020), a novel inspired by Weird fiction and based on Algernon Blackwood's story *The Willows* (1907), the horror-loving protagonist Kara, in her mid-thirties and in the middle of a divorce, has moved into a spare room at the Glory to God Museum of Natural Wonders, Curiosities, and Taxidermy in Hog Chapel, North Carolina, that is owned by her uncle Earl. This museum, which Kara remembers fondly from her childhood, and her room smacks of whimsical decor, including her favorite taxidermy specimen, an elk's head, named "Prince." Whimsy turns weird when Kara and her friend stroll through the museum and its walls twist, turn, and become dirty, and the two strangely wander through a hole in the wall that leads them to emerge into a new location that resembles a muddy embankment, complete with willow trees and water, just as in Blackwood's story, but peppered with military bunkers.

Finally, in Elizabeth Kilcoyne's *Wake the Bones* (2022), a Southern Gothic YA novel, the protagonist Laurel Early, a college dropout, returns home to the family tobacco farm in the small town of Dry Valley, Kentucky, where she intends to resume her life as a taxidermist and farm hand. However, Laurel must grapple with the legacy of her mother's mysterious death and her supernatural powers. Laurel herself has powers: she is able to know how a dead animal died when she touches it. Laurel and her friends (including two gay boys in a relationship) must tackle the intergenerational monster that brings the farm and dead animal bones to life.

As these descriptions from Gothic fiction published within the last decade alone reveal, there is plenty of skin left to stretch here for future scholarship, work that would also help bridge the fields of Gothic horror studies and critical taxidermy studies. It is my hope that this book will inspire that work.

Stitching and Fleshing: Taxidermy as a Model for Reading

The reading that I offer in this book takes taxidermy as a model for reading, both stitching together surfaces and closely peeling flesh from bones—or "fleshing" as taxidermists call it. In other words, it commingles modes of surface reading or distant reading (Best and Marcus; Felski) and

INTRODUCTION

the prioritizing of surfaces in the Gothic (Sedgwick) with close reading. As Stephen Best and Sharon Marcus write in advocating for surface reading,

> the moments that arrest us in texts need not be considered symptoms, whose true cause exists on another plane of reality, but can themselves indicate important and overlooked truths. [...] what lies in plain sight is worthy of attention but often eludes observation—especially by deeply suspicious detectives who look past the surface in order to root out what is underneath it. (18)

Similarly, as Rita Felski notes, "Instead of brushing past surface meanings in pursuit of hidden truth, [the critic] dwells in ironic wonder on these surface meanings, seeking to "denaturalise" them. [...] Insight, we might say, is achieved by distancing rather than by digging" (n.pag.). Allowing our attention to be drawn to taxidermy, that is so frequently a ubiquitous part of Gothic horror's *mise-en-scène* or background, and brushing against it rather than past it, begins with acts of noticing.[15] I follow Evan Calder Williams in resisting the "whom-is-threatening-whom mode of reading" and instead "letting our eyes be drawn to background patterns and flows, to aberrations of form and intrusive details" ("Sunset with Chainsaw" 32). This also means largely taking our eyes off the traditional conventions of examining a medium's form (such as the cinematography, editing, and other techniques in film) to allow the complex constellation of Gothic taxidermy across a range of narrative surfaces to become visible. My aim is to stay with the taxidermy, which lines the backdrop of Gothic horror texts and anamorphically leans into the foreground. This ubiquitous, intrusive, and uncanny figure that I argue is a catachresis for the horror of existence shows the ways that the background menacingly prevails. And in undertaking close readings of key texts belonging to Gothic horror, readings that also draw on the insights from psychoanalysis (as many studies of Gothic horror do), I preserve those modes of reading that some have dismissed as dead, outmoded, and in need of deaccession—not unlike the charges leveled by some against taxidermy today. This approach of mixing these modes of surface and depth readings is another instance of my refusal to separate and disentangle bodies of knowledge, a method in keeping with how the Gothic and taxidermy are both structured against purity.

15 I am thinking here of Heather Love's description of Sedgwick's mode of reparative reading (contra paranoid reading) that trades "hypervigilance for attentiveness [...] acts of noticing, being affected, taking joy, and making whole" (238).

xxxvi TAXIDERMY AND THE GOTHIC

Each chapter here engages with the long-entangled histories and shared family resemblances between the discourses of Gothic horror and taxidermy from the long nineteenth century to our present-day moment. It is as if each chapter offers a different perspective or point of view of a taxidermy specimen, each chapter calling attention to the seams and sutures where these bits of discursive skin (the long nineteenth-century and present-day texts) meet. In working to show what is hidden in the hide, this project follows in the spirit of my previous work in exposing other unacknowledged Gothic bodies, such as making the case for William Blake's place as a Gothic master. It is not as great a leap from Blake to taxidermy as you might expect. In fact, anyone who has spent time looking at Blake's surprisingly and delightfully terrible illustration of a tiger for his well-known poem "Tyger" may well wonder whether Blake himself had botched taxidermy in mind with that design. (Move over Stoned Fox!) This book, as in that work, similarly runs its hands over the bodies, forgotten and half-moth eaten in the corner, that have been stuffed by the Gothic. In sum, my reading, *heimlich* and *unheimlich*, toggles between surface and close reading, distance and digging, background and foreground, and between temporalities, modes, and mediums.

Taxidermy's Queer Bedfellows: Animals and Objects

This book not only enters into conversation with critical taxidermy studies, in hopes of stuffing it with Gothic horror, but also with the recent nonhuman–animal and object-oriented approaches to Gothic horror, respectively. As Ruth Heholt and Melissa Edmundson note in their introduction to *Gothic Animals* (2020), in much of the Gothic tradition, anxieties run wild about the animal within, "our animal other, a Gothic double associated with the id: passions, appetites, and capable of a complete disregard for all taboos and any restraint" (5). And yet, they note, "To date though, there is little written about actual embodied animals and the Gothic, although they pervade our fictions, imaginations, and sometimes our nightmares" (8). Gothic horror, as they rightly observe, includes not only the extreme, shocking encounters with the animal but also—and more importantly for our interest here—the more insidious and quietly unsettling ones, such as when we are undone by the gaze of the animal famously described by Derrida.

In Gothic horror, as Heholt and Edmundson rightly suggest, our unsettling, uncanny encounters with the animal need not be an encounter with the monstrous and can instead be akin to what Valdine Clemens calls "creature-terror," a terror generated through "a viscerally uncanny encounter; a brush with the 'other' that shifts perception, creates discomfort and uncertainty" (Heholt and Edmundson 7). Just as we experience

INTRODUCTION

xxxvii

the animal's uncanniness in these quiet, everyday encounters that are often "usual, mundane, and too frequent to note" (7), so too is the encounter with taxidermy in Gothic horror.

Thus, it is more in the kindred spirit of "creature-terror," uncanny encounters that create negative affects and ratchet up terror and horror, that encounters with taxidermy and the horror of its bottomless gaze in Gothic horror provoke—a line of thought I develop in Chapter 2. As we will see, taxidermy's breathless, gnawing horror is one that shares something with the work of terror, to recall Radcliffe's description: "Terror and horror are so far opposite, that the first expands the soul, and awakens the faculties to a high degree of life; the other contracts, freezes, and nearly annihilates them" (149–50). On the one hand, terror terrorizes, a kind of setting on edge that enervates thought, sending it in directions that often provoke existential fear and dread. On the other hand, horror viscerally and explicitly shows and shocks, offering a view of corporeal transgressions and violations, of insides spilling outside, of death into life—a view that can paralyze, or in Radcliffe's terminology "freeze" us. Inside/outside, death/life, and human/nonhuman, are just some of the boundaries along which horror operates. Horror, as Darryl Jones writes, "occurs at the boundaries of these clear category distinctions, where our sense of certainty, integrity, unity is suddenly profoundly challenged, destabilized" (12). Taxidermy, as we will see, is in bed with both terror and horror.

Although taxidermy is not a synonym for the animal, and I intentionally refer throughout this book to taxidermy as an "animal-object-thing" to intentionally keep its ontology in troubling torsion, a shadowy "nocturnal ontology" as I also describe it, borrowing the term from Dylan Trigg, I nevertheless see this work here as also complementing scholarship that tracks animals throughout Gothic horror.[16]

Taxidermy, like that ghastly horse head in Fuseli's *The Nightmare*, has long been part of Gothic horror's furnishings, emerging from behind the velvety curtain and haunting the scene of Gothic horror. Trading Fuseli's velvet curtain for *Psycho*'s shower curtain, Marc Olivier takes an object-oriented approach to horror film. In *Household Horror* (2020), Olivier prioritizes objects to unsettle the traditional dominance of human subjects in horror scholarship,

16 Bill Brown writes that objects become "things" when "they stop working for us" (4), and as a result, "the story of objects asserting themselves as things [...] is the story of a changed relation to the human subject and thus the story of how the thing really names less an object than a particular subject-object relation" (4). Instead, helping to keep my preferred "animal-object-thing" name for taxidermy a sufficiently shadowy concept, I refer to its nocturnal ontology.

treating innocuous household objects—microwaves, remote controls, beds, sewing machines (to name some of the objects he considers)—instead as "beings that surpass the roles given to them as props or decor" (3). Very much at home among these household objects, taxidermy has a strangely menacing power of its own, and like Olivier, I too bring attention to an overlooked inanimate object, with most of my close readings also drawn from Gothic horror films. Yet unlike Olivier, I turn less to technologically determined explanations underpinning the horror. I offer an overarching argument for the particular horror that this strange animal-object-thing we call taxidermy constellates in Gothic horror. As Jodey Castricano in *Gothic Metaphysics: From Alchemy to the Anthropocene* (2021) writing in a vital materialist vein reminds us, the Gothic since its inception "has not only insisted but also ensured that we do not forget that we live in a sentient world" (200). Like Olivier and Castricano, I see the Gothic as both a mode and genre hospitable to the agency of objects and things, one that invites reflection upon what Castricano calls "the mystery of our relations" (201). In short, my work explores a particularly dark corner within Gothic horror where this strange "animal-object-thing" sits uncannily in the margins and backgrounds, and about which we have to date said very little, and contributes to posthumanist, new materialist, object-oriented, and more-than-human directions in studies of Gothic horror.

Taxidermy's "Stuckness"

But what is so compelling about this dark corner? Who or what do we encounter in taxidermy? What is its allure, both visually and conceptually? And, what becomes visible in these material encounters? These are the questions that arise in observing encounters with taxidermy in Gothic horror texts, as characters repeatedly struggle to tear their gaze away from taxidermy. Helen Gregory and Anthony Purdy, following Steve Baker, suggest that what invests taxidermy with conceptual power is its visceral connection to authenticity: "what makes taxidermic sculptures compelling is that, despite the ways in which the animals have been manipulated by the artists, the authenticity of the skin retains an auratic quality that speaks to us of their past existence even as they look blindly back at us with their false eyes" (82). For them, this is how taxidermy differs from photography or film; the actual skin tethers it to the Real, to the past life of the animal before it became an animal-object-thing. For them, the Benjaminian aura of realness and authenticity clings to taxidermy, so much that it even ultimately overrides the smaller breaches in authenticity, such as with the problematic feature of glass eyes. Against such a reading, I argue that taxidermy's glassy bottomless gaze is no surmountable obstacle. Rather, it is the very irreparable

INTRODUCTION

tear, the *punctum* that cannot be papered over and returned to the realm of authenticity. The bottomless gaze holds it in an unending nocturnal ontology of animal-object-thing. Indeed, moving against their reading that prioritizes taxidermy's authenticity, I read taxidermy, particularly as it functions in the narratives of Gothic horror, as fascinating and vexing for its fakery, for its counterfeit constructions, and for the fear (not just wonder) that clings to its phenomenology. We never forget it is stuffed; we encounter it in its stuckness.

In taxidermy's appearance within Gothic horror, we do not admire the authenticity of a taxidermic specimen; instead, we glimpse a dark mirror, finding our own fear(s) stuffed and mounted in a talismanic figure that cathects the very horror, our horror, of existence itself, of being-there. Jane Desmond comes closest to understanding taxidermy in these terms: "This remodelled hide once belonged to a particular, unique subject with a life history that in this moment of copresence directly and materially intersects with our own. This effect may be especially potent when the creative presence is mammalian, sparking a physical sense of parallelism, or one of great symbolic density for the viewer" ("Vivacious Remains" 264). This symbolic density helps explain why taxidermy captivates us. And for many taxidermist-artists and critical animal studies theorists, this is why taxidermy might help us rethink our encounters with animals.

Taxidermy in Gothic horror is not primarily aimed at bringing us into an ethical encounter with the animal, and in this sense, it stands at a distance from what Aloi calls "speculative taxidermy," the dominant strain of contemporary artistic taxidermy found in galleries. Speculative taxidermy emphasizes our mutual vulnerability, one that is ultimately aimed at helping us to rethink human–animal relations, or, in Desmond's words, to "move us to action in the world outside of the gallery" (264). Although Aloi claims to take Timothy Morton's notion of "dark ecology" as the conceptual "backdrop" (28) for speculative taxidermy—a notion of ecology that, as Morton writes, "puts hesitation, uncertainty, irony, and thoughtfulness back into ecological thinking," a thinking that "includes negativity and irony, ugliness and horror" (quoted in Aloi 28)—there is a general paucity of ugliness and horror in his book that is otherwise the most extensive theorizing of taxidermy to date. We see this absence of horror also in Aloi's selections of material specimens and artwork. As such, readers might view our work as strikingly different cabinets of curiosity, each chock full of fur and feathers.

In this book, as in the many drawers of Gothic horror, taxidermy consistently pursues darker ends (horror, shock, disgust), geared at ratcheting up anxieties and fears, obversely constellated around freezing action, a potent catachrestic image for the phenomenological horror of being-there.

TAXIDERMY AND THE GOTHIC

Desmond proposes a concept that extends beyond speculative taxidermy, and that might be useful in thinking about taxidermy's function in Gothic horror. What she calls "speculative interspecies physicality," which is a kind of "translational phenomenology," the taxidermist-artist uses

> the evidentiary power of "real" material to invite the imagined habitation of that animal body by the viewer—the skin/fur then becomes not simply the tactical interface with our human touch, but the site of our imagination of the feeling of a gliding hand across "our" fur, or the teeth of a nuzzling other member of a horse herd, the push back of the earth against the keratin of our hooves, the heat of warm air sucked in through opened nostrils. This is a different kind of speculation, a transspecies speculation. (265–66)

Literature, Desmond continues, is one place we encounter this kind of speculation, where we can imaginatively enter into the sensorial experience of being an animal. As I've already noted, Desmond, like others, too narrowly roots this in twentieth-century literature, ignoring a much longer tradition that also includes Gothic horror. However, to Desmond's point on taxidermy's "translational phenomenology," this omission matters because in Gothic horror such speculation takes a radically different form. Observe how in Desmond's thought experiment of transspecies speculation this imagined transcorporeality produces an affect more wondrous than worrisome. The imagined feeling her taxidermy incites is a pastoral animal phenomenology; she imagines what it feels like to have one's fur stroked, to be nuzzled, and to inhale warm air. In short, this kind of charming encounter with taxidermy engenders warm and cuddly feelings about what it might mean to be that animal.

But in Gothic horror, there are no pretty ponies and no such snuggles; here, the speculation that taxidermy invites from us is aimed at very different ends. In this speculative interspecies physicality, the animal-object-thing becomes the site of our imagination of the feeling of body horror, of being disemboweled, of being evacuated, of being stuffed and mounted, rendered frozen, immobile, and placed on display, to be alive in death, to be unblinkingly stuck, to be radically transformed, to feel a scream stuck in one's throat, to be in stasis forever.

Despite Desmond's dreamy pastoral thought experiment, she nevertheless appears to hold the door open for the work of horror when she acknowledges that

> creative works can engender change, through articulating reimagined futures or sparking the jolt of unforgettable affective response, the kind

INTRODUCTION xli

> that makes us *draw in our breath, or stand, struck immobile* in the moment
> of encounter with the work, with the dead animal trace, our mind and
> heart both racing. (266, my emphasis)

This breathless response engendered by taxidermy will sound familiar
to readers and viewers of Gothic horror. For it is a response we also crave
in Gothic horror. As Steven Bruhm puts it, "We seem to want these [Gothic]
fictions from the inside out; we crave them not for their distance but for
their immediacy, for they make our hearts race, our blood pressure rise, our
breathing become shallow and quick, and our stomachs roll" ("Contemporary
Gothic" 272).

Encountering taxidermy in Gothic horror, then, can redouble this affect,
especially when as readers or viewers we are forced to become or identify
with this strange animal-object-thing that is taxidermy. The camera shots
in *The Cabin in the Woods* from the point of view of the taxidermied wolf
seductively force us to imagine being the taxidermied wolf making out
with blonde bombshell Jules (discussed in Chapter 3). Keith in Amirpour's
The Outside, who is kind, level-headed, and the only character we likely relate
to, ends up taxidermied by Stacey (discussed in Chapter 2). Chris in *Get
Out* is repeatedly confronted and aligned with taxidermy and is meant to
meet a similar fate as the stuffed stag during the Coagula transplantation
procedure, when he is to be physiologically hijacked by white consciousness
(discussed in Chapter 4). If taxidermy, as Laura White notes, traditionally
"places viewers in positions of control over animals and over time by allowing
them to engage in visual consumption without the threat of interruption or
of the object of the gaze returning the look, a position they could not occupy
with living animals" (145), in the Gothic mode taxidermy disrupts this power
dynamic. It terrifyingly returns and even consumes the traditional authorial
gaze of the viewer, bringing the human body under the same strictures of
becoming an object rather than a subject of mastery.

Gothic horror uncannily complements the work that McHugh and Bezan
propose of analyzing "taxidermic forms and fictions" in hopes of developing
"a new paradigm of reading flesh" (qtd. in Desmond 259), a project
that Gothic horror writers have long been pursuing.[17] McHugh and Bezan
suggest that narrative representations of taxidermy operate differently from
material forms, enjoying a "more profound provenance as it reflects on
the wide range of human-animal relations" and "regularly circulate among

17 As horror writer Clive Barker famously quips, "Everybody is a book of blood;
wherever we're opened, we're red."

popular audiences, and are copied and proliferated on the wide scales of bestselling novels and blockbuster films. Perhaps most conspicuously, they pick up surpluses of meaning as they mirror and/or explode socio-historical narrative structures" (135). However, if we consider Gothic horror in these literary histories, as I argue that we ought to, we find taxidermy's entrenched association with horror, danger, and perversion. It is worth remembering that when it comes to taxidermy, as with the Gothic, simply closing our eyes doesn't make the monster disappear. We aren't ready just yet to throw out (Rosemary's) baby with the bathwater.

Conclusion: Stuck in the Now

In Gothic horror, taxidermy has been quietly accumulating, accruing interest and surpluses of meaning that, as I am arguing in this book, summarily constellate around the phenomenological horror of existence, of being-there, of stuckness. Our anxieties and fears over stuckness (in its various guises) become cathected onto taxidermy, itself an ontologically dubious and potently talismanic figure for stasis. This stuckness is everywhere embodied in the stasis of taxidermy: from the unblinking eyes to the frozen frame, and the breathless mouth. In this strange, inhuman materiality of taxidermy, we find, as if stuffed inside it, a nocturnal ontology: what Levinas describes as the horror of anonymous being, of existence itself.

To think about taxidermy's presence in Gothic horror at this moment demands, however, as with any consideration of the contemporary Gothic, that we contend with Gothic's slippery surfaces. For inevitably any consideration of origins in the Gothic is, as Bruhm puts it, "to look into a triptych of mirrors in which images of the origin continually recede in a disappearing arc" ("The Contemporary Gothic" 259). Put otherwise: to understand the origin of taxidermy's place in the contemporary Gothic necessarily sends us into a dizzying pursuit, where images and figures of Gothic taxidermy cascade and crash into one another, a complexity further exacerbated by their entwined origins in the long nineteenth century.

Still, as many scholars have noted, every moment has its monster. If the Gothic feeds on and into our anxieties (sociopolitical, cultural) of a given milieu—such as aliens and invasion fears during the Second World War, queer and racial terror during the 1960s, ecohorror in the Anthropocene—how might we understand Gothic horror's seemingly increasing taste for taxidermy? To answer this, we must first begin by considering what the contemporary Gothic looks like. Bruhm, in reflecting on some of the hallmark features of the contemporary Gothic, suggests that what becomes "most marked in the contemporary Gothic—and what distinguishes it from

INTRODUCTION xliii

its ancestors—is the protagonists' and the viewers' compulsive return to certain fixations, obsessions, and blockages" ("Contemporary Gothic" 261). For Bruhm, this is framed in terms of psychoanalysis, the impact of which upon the contemporary Gothic is unrivaled. However, going beyond psychoanalysis, this emphasis on fixations and blockages also dovetails with the materiality of taxidermy. After all, the transformation of the animal into an animal-object-thing is made possible through taxidermic acts and processes involving various fixations and blockages. Still, taxidermy often comes to itself serve as a site for other fixations, as I explore in the subsequent chapters. Jessa's mother makes erotic art using taxidermy in Kristen Arnett's novel *Mostly Dead Things*; Frank, a murderous taxidermist, has a threesome with his taxidermied wife and another woman in Joe D'Amato's horror film *Beyond the Darkness*; Jules enjoys a deeply sensual kiss with a taxidermied wolf in *Cabin in the Woods*, to name but a few examples. And, taxidermy also serves as a site of blockages, from Norman's stunted development and Marion's failed escape plan that unfold against the backdrop of taxidermied birds in Hitchcock's *Psycho* to Lawrence's interrupted masturbation in *Friday the 13th* (2009), to Emma and Tom's spoiled sex in *Tell Me Your Secrets* all because of the creepy gaze of taxidermy; to the secret sexual desires and histories of taxidermy-shrouded John and Peter in *Tell Me Your Secrets*; and to Stacey's inappropriate taxidermied duck that further ostracizes her from her coworkers in Amirpour's *The Outside*.

Taxidermy, as the subsequent chapters will explore, is one of the compulsive returns that Gothic horror itself continues to make. It now even hits us over the head, appearing, for instance, within the opening shot of *A Classic Horror Story* (2021), serving as a calling card for horror itself, in this "metahorror" film (a horror film about horror films) that stitches together many of the tropes that are essential to any horror story. Gothic horror's taxidermic repetition compulsions, as it were, stage the persistence or "stuckness" of everyday horrors, whether the horror of existence itself, the ineradicability of perversions, or the ubiquitous horror of systemic racism and microaggressions. Gothic horror, itself "a curious admixture of attraction and repulsion" (Carroll *The Philosophy of Horror* 161), is a fertile space in which to find some of our deepest fears over the horrors of existence mounted and displayed.

Chapter 1

THE TWO-HEADED KITTEN: THE FIRST STITCHES OF THE GOTHIC

Alfred Russel Wallace, writing in the popular *Macmillan's Magazine* (1869), complains about the number of "imperfect, badly prepared, and badly arranged" taxidermy, those "immature, ragged, mangy-looking specimens one often sees in museums, stuck up in stiff and unnatural attitudes, and resembling only mummies or scarecrows" (247). Such taxidermy, Wallace continues, is "positively repellent, and we feel that we never want to look upon it again" (247). If too much of museum taxidermy resembles Gothic monsters that ought to be abjected, the amateur specimens fare no better. As Christina M. Colvin notes, the "strange, uncanny, or awkward forms of many examples of amateur [taxidermy] mounts call attention to their own poor construction and therefore question any simple claim that taxidermy unambiguously demonstrates the mastery of the human over the animal" (66). Evidently, in this "golden age of taxidermy" (Ross 1030), not all that glitters is indeed gold. These darker contours were, thus, more in keeping with taxidermy's tendencies, with things as they monstrously are.

Like a car crash, it is hard to look away from the wreckage of some taxidermy, such as the two-headed kitten created by the nineteenth-century self-taught taxidermist, Walter Potter. Potter, the darling of much scholarship on taxidermy, is best known for his cute anthropomorphic taxidermy done in a whimsical vein—kittens getting married, birds conducting a funeral, squirrels playing cards, frogs frolicking on the playground—often staging scenes from beloved nursery rhymes and stories. Animals he killed to create. But this Janus-faced kitten, this lesser-known piece, more frightful than friendly, helps tell the story of the darker side of taxidermy. This chapter shows how taxidermy's furry feet pad their way through the Gothic nineteenth century.

Scholarship on nineteenth-century taxidermy tends to consider it in comparison to the work of traditional collection (re)formation, preservation, and display practices (cf. Morris, Wonders, Yanni) and to highlight its ability to disrupt taxonomy and the organization of collections (cf. Ritvo, Spary).

Still, more work remains to be done on taxidermy's intersection with other dominant literary and cultural discourses of the day, such as the Gothic. As Sarah Bezan and Susan McHugh note, "Stretched, stitched, and stuffed, taxidermy hides themselves *hide, conceal, and secret away their stories*" (134, 132). While Bezan and McHugh never address the Gothic, the Gothic is a rich place to locate taxidermy's long literary and cultural history.

With Potter's taxidermied kitten as its muse, this chapter has two heads. The first briefly looks at the appearance of taxidermy in long nineteenth-century Gothic narratives, Charles Maturin's *Melmoth the Wanderer* (1820) and Edward Bulwer-Lytton's *A Strange Story* (1862). The second focuses on a range of nineteenth-century taxidermy manuals published between 1820 and 1890, with special emphasis on Thomas Brown's *The Taxidermist's Manual* (1833) and Walter Manton's *Taxidermy without a Teacher* (1882). There, I identify three key features of this emergent knowledge practice: first, taxidermy treatises sometimes deployed Gothic narrative techniques, such as shared narratological techniques like evasive and moody prefaces, counterfeit authorship, reliance on the provisional ("as if"), and detours around showing the body laid bare. Second, the taxidermist was figured as a morally ambivalent and even monstrous figure akin to Victor Frankenstein; and third, the actual taxidermied specimen was frequently described as hideous, rendering it much more often an object of horror than an object of beauty. Furthermore, stuffed within these two heads/sections is a larger matrix made up of diverse texts including stories and essays in popular periodicals—including Charles Badham's "Taxidermy in Rome" and H. G. Wells's "The Triumphs of a Taxidermist"—taxidermy specimens, prints, and paintings—from Hogarth to Waterton—that all speak to the connection between the Gothic and taxidermy. The significance of what follows is a more complex picture of the nineteenth-century taxidermic imaginary. Contrary to some accounts that overstate the period's comfort and ease with it (cf. Amato), this chapter's impure matrix of texts assembled from a robust range of genres and media offers evidence of both the period's own ambivalences and discomforts, its "ugly feelings" (channeling Sianne Ngai), with the art of taxidermy and its practitioners, and the emerging constellation of taxidermy with the Gothic.

Taxidermy to Terrify: Godwin, Maturin, Bulwer-Lytton

William Godwin, anarchist-philosopher and author of several Gothic novels (cf. *Caleb Williams, Fleetwood, Mandeville, St. Leon*) offers an early example of taxidermy figured as Gothic horror. In his influential *Enquiry Concerning Political Justice* (1793), Godwin explicitly likens the barbaric feudal system and related system of aristocratic titles to taxidermy:

THE TWO-HEADED KITTEN

The feudal system was a ferocious monster, devouring, wherever it came, all that the friend of humanity regards with attachment and love. The system of titles appears under a different form. The monster is at length destroyed, and they who followed in his train, and fattened upon the carcases of those he slew, *have stuffed his skin, and, by exhibiting it, hope still to terrify mankind* into patience and pusillanimity. (337, my emphasis)

Although no critic has identified it as such, this is undoubtedly a reference to taxidermy. "Stuffed" and "exhibited" with the aim of inducing terror, Godwin imagines the transformation and persistence—the death and yet powerful afterlife—of a barbaric system that plays out in the new system of titles. Taxidermy, as Godwin imagines it here, is a manifestation and spectacle of something undead, the horror of that which ought to be destroyed nevertheless still clinging to life, the aim of which is to terrorize.

While Godwin's own Gothic novels turned to what we might consider the "sister arts" of taxidermy rather than taxidermy proper, such as puppets and waxwork, most vividly toyed with in *Fleetwood* (1805), other Romantic Gothic novels, such as Charles Maturin's popular *Melmoth the Wanderer* (1820) explicitly appealed to taxidermy.

Melmoth is a complicated Gothic tale, with numerous tales nested within it, that principally tells the Faustian story of an academic, Melmoth, who gains an extra 150 years of life by making a deal with the Devil. When one character Alonzo Monçada escapes from prison, he follows a secret subterranean maze and stumbles upon a chamber belonging to a Jewish scholar named Adonijah. Through a crack in the door, Monçada glimpses the entire interior of the apartment, contents which include maps, globes, anatomical instruments, books and scrolls, and four large skeletons. Additionally,

Interspersed between them were the stuffed figures of animals I knew not then the names of,—an alligator—some gigantic bones, which I took for those of Sampson, but which turned out to be fragments of those of the Mammoth,—and antlers, which in my terror I believed to be those of the devil, but afterwards learned to be those of an Elk. Then I saw figures smaller, but not less horrible,—human and brute abortions, in all their states of anomalous and deformed construction, not preserved in spirits, but standing in the ghastly nakedness of their white diminutive bones; these I conceived to be the attendant imps of some infernal ceremony, which the grand wizard, who now burst on my sight, was to preside over. (Maturin 263)

Maturin's description of the admixture of taxidermy, elk antlers, and posed human and animal skeletons in this "terrible vault" (263) is a Gothic spectacle. Although this scene's morbid décor prominently featuring terrifying taxidermy has escaped critical attention, this atmospheric space, with its emphasis on taxidermy's affective power to agitate and horrify the viewer, serves as a primal scene for taxidermy's presence in Gothic horror narratives.

Indeed, echoes of *Melmoth*'s taxidermy appear in cosmic horror writer H. P. Lovecraft's story "The Hound" (1924), where two highly intelligent grave-robbers create within their house a "nameless museum [...] a blasphemous, unthinkable place, where with the satanic taste of neurotic virtuosi we had assembled an universe of terror and decay to excite [their] jaded sensibilities" (97). This museum, reminiscent of Adonijah's subterranean chamber in Maturin's novel, was "a secret room, far, far underground":

> Around the walls of this repellent chamber were cases of antique mummies alternating with comely, lifelike bodies perfectly stuffed and cured by the taxidermist's art, and with headstones snatched from the oldest churchyards of the world. Niches here and there contained skulls of all shapes, and heads preserved in various stages of dissolution. (Lovecraft 98)

However, where taxidermy appears in Lovecraft and Maturin as an element among a Gothic subterranean spectacle associated with virtuosic knowledge—and the passions and perversions of such pursuits—in other Gothic texts it plays a more substantial role, such as Edward Bulwer-Lytton's (1803–1873) less critically visited occult Gothic novel *A Strange Story* (1862).

A Strange Story, a plot inspired by William Godwin's *St. Leon* (1799), tells a story about occult knowledge used to prolong life.[1] Early in the novel, the protagonist Dr. Allen Fenwick, a stern medical doctor informed by materialism, and whose favorite phrase is "common sense" (6), pays a house visit to the dying Dr. Lloyd, a rival physician who unfashionably believes in mesmerism and clairvoyance. Fenwick finds Lloyd's stately home littered with taxidermy, and his description of it is "splendidly creepy," as one critic rightly observes (Huckvale 193).

We learn that Dr. Lloyd, before becoming a "tolerable physician," had been "a learned naturalist," and spent "the privations of his youth" annually

1 *A Strange Story* was first published in Dickens's *All the Year Round* between August 1861 and March 1862. David Annwn Jones in *Gothic Effigy* (2018) misattributes the plot of *A Strange Story* to another of Lytton's stories, *The Haunters and the Haunted*.

THE TWO-HEADED KITTEN

building up his "zoological collection of creatures, not alive, but, happily for the beholder, stuffed or embalmed" (3). This earlier, secret side to Lloyd is cast as a deviation in Lloyd himself, associated with development gone awry; taxidermy taken up alongside the various deprivations or losses of Lloyd's youth symptomatically links it to something pathological—a longstanding feature of the Gothic. Indeed, early on in this Gothic narrative, Lloyd's taxidermy embodies what David Punter finds in the Gothic, namely "an experience of friction, of homelessness, of disanimation which encourages a notion of animation on a 'different' site [...] which might involve accepting different depths, different sinkages" (*Gothic Pathologies* 220). When Lloyd dies, his taxidermy collection changes location, incorporated into the mayor's collection and the town's museum, and continues to enjoy an uncanny afterlife in the narrative's events with a liveliness that surpasses that of the "attendant imps" in Maturin's *Melmoth*.

The first sighting of *A Strange Story*'s taxidermy, when Fenwick arrives at Lloyd's manor, is thoroughly Gothic in description, and is a passage worth quoting at length:

> A February night, sharp and bitter; an iron-gray frost below, a spectral melancholy moon above. I had to ascend the Abbey Hill by a steep, blind lane between high walls. I passed through stately gates, which stood wide open, into the garden ground that surrounded the old Abbots' House. At the end of a short carriage-drive the dark and gloomy building cleared itself from leafless skeleton trees,—the moon resting keen and cold on its abrupt gables and lofty chimney-stacks. An old woman-servant received me at the door, and, without saying a word, led me through a long low hall, and up dreary oak stairs, to a broad landing, at which she paused for a moment, listening. Round and about hall, staircase, and landing were ranged the dead specimens of the savage world which it had been the pride of the naturalist's life to collect. Close where I stood yawned the open jaws of the fell anaconda, its lower coils hidden, as they rested on the floor below, by the winding of the massive stairs. Against the dull wainscot walls were pendent cases stored with grotesque unfamiliar mummies, seen imperfectly by the moon that shot through the window-panes, and the candle in the old woman's hand. And as now she turned towards me, nodding her signal to follow, and went on up the shadowy passage, rows of gigantic birds—ibis and vulture, and huge sea glaucus— glared at me in the false light of their hungry eyes. (Bulwer-Lytton 10)

The exterior of the house and setting help set the Gothic mood. Inside, the numerous taxidermy specimens are eerily lit by moonlight and candlelight,

6 TAXIDERMY AND THE GOTHIC

appearing in the "false light" to have "hungry eyes" (10). The menacing-looking birds and the open-jawed anaconda, all enormous specimens, function as the "great objects, and terrible" (Burke 103) of the Burkean sublime.[2] The dramatic staging of the anaconda, however, is noteworthy. Stuffed and posed vertically, the anaconda is stretched out in such a way that it extends across multiple levels of the house. It is a scene that calls to mind Blake's enormous snakes—from his illustration of the strung-up and skinned anaconda for John Gabriel Stedman's *Narrative, of a Five Years' Expedition, against the Revolted Negroes of Surinam* (1796) to his illustration for "Night the Third" in Edward Young's *Night Thoughts* (c.1795–1797), the latter of which Bulwer-Lytton greatly admired. In fact, Bulwer-Lytton, in *The New Monthly Magazine* (1830), praised Blake's illustrations in *Night Thoughts* as "at once so grotesque, so sublime" (qtd in Bentley 4).

The frightening taxidermy continues to play a role throughout the story. It is the "somewhat ghastly, though instructive" décor at the Mayor's ball (Bulwer-Lytton 123). The charismatic sorcerer Margrave tells stories about the taxidermy, blending fact and fiction, and playfully attempts to make them come to life:

> Many of these grim fellow-creatures he declared he had seen, played, or fought with. He had something true or false to say about each. In his high spirits he contrived to make the tiger move, and imitated the hiss of the terribly anaconda. All that he did had its grace, its charm; and the buzz of admiration and the flattering glances of ladies' eyes followed him wherever he moved. (124)

But if taxidermy is momentarily cast as fun and flirtatious, part of a high-society soiree, it quickly takes a darker turn, careening into a Gothic spectacle. At the ball, Sir Philip Derval dramatically emerges from the shadows of a taxidermied elephant to put both Margrave and Fenwick in a trance, conducting this experiment on a seat beneath the taxidermied anaconda. While Margrave "became stiff and rigid, as if turned to stone" (134)—a description itself reminiscent of taxidermy—Fenwick takes more effort in being induced. Enter Derval's magic lamp that emits a "dazzling vapor"—an image that recalls the frontispiece design to Thomas Brown's popular *The Taxidermist's Manual* (1833) to which we will later return in this chapter.

2 Burke writes: "The sublime [...] always dwells on great objects, and terrible" (103). "The large and gigantic, though very compatible with the sublime, is contrary to the beautiful" (143).

THE TWO-HEADED KITTEN

A Strange Story's most vivid scene involving taxidermy comes during Fenwick's strange trance, when the taxidermy around him comes alive:

> I turned my sight towards the dead forms in the motley collection, and lo, in my trance or my vision, life returned to them all! To the elephant and the serpent; to the tiger, the vulture, the beetle, the moth; to the fish and the polypus, and to yon mockery of man in the giant ape.
>
> I seemed to see each as it lived in its native realm of earth, or of air, or of water; and the red light played more or less warm through the structure of each, and the azure light, though duller of hue, seemed to shoot through the red, and communicate to the creatures an intelligence far inferior indeed to that of man, but sufficing to conduct the current of their will, and influence the cunning of their instincts. But in none, from the elephant to the moth, from the bird in which brain was the largest to the hybrid in which life seemed to live as in plants,—in none was visible the starry silver spark. I turned my eyes from the creatures around, back again to the form cowering under the huge anaconda, and in terror at the animation which the carcasses took in the awful illusions of that marvellous trance; for the tiger moved as if scenting blood, and to the eyes of the serpent the dread fascination seemed slowly returning. (Bulwer-Lytton 136–7)

Fenwick is terrified at witnessing the animation of "the dead forms in the motley collection," the movements of the tiger smelling blood, and the "dread fascination" in the snake's eyes. That this scene of taxidermy's re-creation later haunts him in his dreams—"the phantasmagoria of the naturalist's collection revived" (147), a nod here to *Frankenstein*—is emblematic for taxidermy's function within the Gothic more broadly, speaking to the sustained affective power afforded to taxidermy in Gothic narratives.

Thus, hinted at in Godwin's *Enquiry* and more taken up in these two Gothic novels, *Melmoth* and *A Strange Story*, the constellation of taxidermy with the sensational, the occult, and Gothic horror glimmers. Next, we examine how this constellation also takes shape outside of the Gothic canon and in the discourse of taxidermy, from nineteenth-century taxidermy manuals geared at instructing an amateur audience to take up this art, and in other popular periodicals and objects from visual and material history.

Counterfeit Introductions: Prefaces and Names

Both Gothic and taxidermic texts in the long nineteenth century make use of prefaces to announce their aesthetic intentions. Horace Walpole's *The Castle of Otranto* (1764) and Clara Reeve's *The Old English Baron: A Gothic Story* (1778)

8 TAXIDERMY AND THE GOTHIC

are two seminal examples of Gothic prefaces that work to (mis)shape their readers. I begin with the case of Walpole, who, as I noted in the Introduction, held a professional relationship to taxidermy (being tasked with guardianship of Sir Hans Sloane's taxidermy as a museum trustee), something he got a rise out of. The Preface to the first edition of *Otranto* deceives and misdirects the public by passing as a found translation of an Italian Renaissance text.[3] Initially, readers were falsely told it was a text originally penned by an Italian monk, Onuphrio Muralto, from the Church of St. Nicholas at Otranto, and later translated by the antiquarian scholar William Marshal. Reeve's Preface performs another kind of curious move, sending the reader not forward into the story it introduces, but rather backward to Walpole's *Otranto* if only to disavow the earlier text:

> This Story is the literary offspring of the Castle of Otranto, written upon the same plan, with a design to unite the most attractive and interesting circumstances of the ancient Romance and the modern Novel. [...] It is distinguished by the appellation of a Gothic Story, being a picture of Gothic times and manners. [...] I beg leave to conduct my reader back again, till he comes within view of the Castle of Otranto. [...] the machinery is so violent, that it destroys the effect it is intended to excite. (Reeve 2–3)[4]

Although Reeve approves and follows Walpole's technique of blending romance with the realist novel, Reeve is critical of *Otranto* for favoring excesses and sensationalism. Nevertheless, Reeve, who like Walpole also initially deployed a misleading Preface that claimed to be a found translation, jettisons her reader at various turns back to *Otranto* in a dynamic of both attraction and repulsion and of identification and incorporation. In both of these early Gothic texts, then, the prefaces violate their categorical identities, seemingly wearing less of their own skin than those of others.

Moreover, the prefaces in both these early Gothic texts are the sites where contested, counterfeit authorship plays itself out. Particularly for women writers across diverse genres, from the literary to the scientific, authorial identities were often concealed, hidden beneath the skin of pseudonymity or

3 The misrepresentations are in fact doubled in Walpole's Preface to the first edition. As Frederick S. Frank notes in his introduction to the Broadview edition of *Otranto*, Walpole uses "two antithetical pseudonyms" (16). In a later edition, Walpole uses the Preface to confess his literary forgery.

4 This is the preface to the revised second edition of her novel, published in 1778 as *The Old English Baron*.

THE TWO-HEADED KITTEN

anonymity. While anonymity was common until the end of the nineteenth century in England and served various purposes across different genres, women, as Emily Kopley notes, "had particular reasons to choose anonymity, in columns and on spines: to act modestly, to guard against slander and injury, and to gain a hearing" (4). In the case of the genre of the Gothic, this was no exception; many of the century's best-known Gothic novels, from Shelley's *Frankenstein* (1818) to Brontë's *Wuthering Heights* (1847), were first published anonymously or pseudonymously.

Taxidermy texts experienced similar gendered concealments around authorship. One of the most influential taxidermy manuals, *Taxidermy: or the Art of Collecting, Preparing and Mounting Objects of Natural History. For the Use of Museums and Travellers*, published anonymously in 1820, went through numerous revised editions before the sixth edition (1843) properly crediting its authorship to Sarah Bowdich (Lee), who coauthored and co-translated many treatises with her first husband (Thomas Edward Bowdich [1791–1824]), but whose name was frequently left off the title page. As Mary Orr notes, "Sarah Bowdich's *Taxidermy* was the first major work on the subject *in English*, as well as in other European languages, to be authored by a woman" (27, emphasis original). The slipperiness around counterfeit authorship toyed with in the prefaces speaks to the deeper anxiety underpinning both discourses of Gothic fiction and taxidermy: namely that identities are unstable—that bodies, like names, are unstable markers of identity not to be trusted. Curiously, Bowdich also dabbled in writing fiction herself. Her Gothic story "Eliza Carthago" includes a note describing her preservation of a tarantula and submission of it to the British Museum.[5]

Yet perhaps most interestingly, within the prefaces of some taxidermy texts, writers deployed similar rhetorical strategies as their Gothic fictional counterparts. For example, Walter Manton's *Taxidermy without a Teacher* (1882) adopts the Gothic convention of inviting the reader to follow the taxidermist-author into a dark, secret space:

> Well, here we are at last. Please turn the key in that door—to keep all inquisitive priers out—for the process into which I am about to initiate you is something of a secret, shrouded by the thin veil of mystery.

5 The Gothic story first appeared in *Forget-Me Not* 57–64 (1829) and later included in Bowdich's *Stories of Strange Lands; and Fragments from the Notes of a Traveller. By Mrs. R. Lee (Formerly Mrs. T. Edward Bowdich)*. London: Edward Moxon, 1835. Katherine Harris includes this story in *The Forgotten Gothic: Short Stories from the British Literary Annuals, 1823–1831*. Zittaw, 2012.

> You have come to me to-day [sic] to learn something of the art of Taxidermy, so we will take up, for your first lesson, bird skinning and mounting. (13)

Manton's narrative voice uses the preface to establish this text and taxidermy more broadly not as the space of Enlightenment but of enclosure. It leans into the convention of the gothic house that encloses the chosen victim while excluding others and also stands as the site of intimate and disturbing revelations to otherwise transgressive secrets. Like Sir Bertrand becoming locked in the house as the heavy door shuts behind him, the reader of this manual ominously enters taxidermy's inner sanctum.[6] Moreover, this is an art that can't be conventionally taught—after all, as the title tells us, we are in *terra nullius* "without a teacher"—but rather one to be supernaturally acquired through initiation.

The Speculative "As If"

Another common rhetorical strategy in both nineteenth-century taxidermy manuals and the Gothic is the insistence on the speculative, the "as if," as both a narrative technique and as a worldview. As Verity Darke observes, albeit without reference to the Gothic, "The use of storytelling techniques in the taxidermy manual invests these devices with the power to reanimate, undermining the objectivity of the taxidermy specimen" (14). Focusing on the manuals of taxidermist Montagu Browne, Darke notes that he

> frequently uses "as if" to allow the substitution of one body for another, creating tension between living and dead animal. [...] Each of Browne's twenty uses of "as if" continue to tease the boundaries between subject and object, life and death, creating an uncanny tension between dead form and live animal [...] the narrative's perspective enables the taxidermy mount to be both dead and alive at once. (14)

The Gothic, too, derives narrative force from its insistence on the "as if." Indeed, it is a variation on what Jerrold Hogle famously identifies as the Gothic's "counterfeit" nature and origins, as in buildings designed to look as if they were older (a defining feature of Neo-Gothic architecture) or even in the case

6 I refer, of course, to the fictional fragment included with the essay by John Aikin and Anna Laetitia Aikin (later Barbauld) "On the Pleasure Derived from Objects of Terror; with Sir Bertrand, A Fragment" (1773) in *Miscellaneous Pieces in Prose*, London: Joseph Johnson, 119–37.

THE TWO-HEADED KITTEN

of the first Gothic story, *Otranto*, a story, as discussed earlier, misrepresented to look as if it were a found translation. Even in parodies of the Gothic, such as Jane Austen's *Northanger Abbey*, the Gothic is blamed for causing its sensitive readers, like the young Catherine Morland, to view the real world as if it were like the one in the Gothic novels she enjoys reading.

To be sure, the act of envisioning life, as Michael Saler puts it, "not in essentialist, 'just so' terms but rather in provisional, 'as if' perspectives" (7) may be the very heart of all fiction. Even more fundamental than that, imagination and idealization are at the heart of human thought (not just fiction), as philosopher Kwame Anthony Appiah argues in *As If: Idealization and Ideals*. However, in the mode of the Gothic, such a provisional perspective takes on an unsettling, uncanny register along the boundaries of life and death, with the "as if" working in threatening ways to not only deceptive but dangerous ends. Exploring the dark side of the provision, of lingering in the "as if," is part of the thrill of the Gothic. To make the dead to look as if they were alive, or the counterfeit to look as if it were authentic, is a shared investment of both Gothic fiction and taxidermy.

Showing and Telling: Evacuated Insides and Spectacular Outsides

Taxidermy manuals and the Gothic also intersect in the treatment of subjectivity, in what we might think of as an evacuated interiority. After all, the taxidermied specimen necessarily has its internal organs and flesh removed. This process of removing the animal's interior amounts to a "loss of interiority, of subjective self and identity" (Darke 17), which is also a hallmark feature of the Gothic. The various interiors of the Gothic—that is, its unseen, uncanny, and psychological aspects—continue to enthrall us and generate an enormous affective force of the Gothic.[7] However, as Xavier Aldana Reyes reminds us, "the gothic is also inherently somatic and corporeal" (*Body Gothic* 2). Indeed, these interiors that are frequently evacuated—haunted as they are by dreams, fantasies, absences, and half-remembered things—are jarringly set against the spectacular exteriority of the Gothic and taxidermic body. As Steven Bruhm writes, "The 'Gothic body' is that which is put on excessive display, and whose violent, vulnerable immediacy gives. [...] Gothic fiction [its] beautiful barbarity, [its] troublesome power" (*Gothic Bodies* xvii). Also emphasizing its corporeality, Ellen Moers identifies the Gothic's aim at "get[ting] to the body itself, its glands, muscles, epidermis, and circulatory

7 According to Robert Mighall, "[p]sychology dominates criticism of the Gothic" (xi).

12 TAXIDERMY AND THE GOTHIC

system, quickly arousing and quickly allaying the physiological reactions to fear" (90). Taken together, the Gothic is doubly invested in suggesting or displaying often violently victimized bodies, and, in turn, seeks to produce intense physiological, corporeal responses within the reader's body—a dynamic that is also at work in taxidermic productions.

The taxidermic body, similarly subject to excessive display as the Gothic body, is a body inscribed both inside and out by violence. The taxidermic diorama, a popular form of displaying taxidermic bodies, as Pauline Wakeham writes, "as a Western invention that renders a spectacle of otherness permanently paused for the fascinated surveillance of the white spectator [...] subordinates its object matter to a fetishistic colonial gaze" (4). Put otherwise: the viewer extends the same colonial gaze that violently captured and killed it in the first place.

However, just as Gothic novels, like Radcliffe's *The Mysteries of Udolpho*, both "invok[e] and avoi[d] the immediate suffering of the mutilated body" (Bruhm 40)—such as showing a pile of bloody clothes rather than the mangled corpse itself—these nineteenth-century taxidermy manuals, despite being practical guides on the preparing and mounting of animal skins, frequently make detours away from representations of the mutilated animal body. The same Gothic tendency to summon and suppress the body is at play in taxidermy texts, a torsion between gruesome step-by-step descriptive instructions on how to kill with seldom an illustration to visually support. Indeed, the majority of illustrations tend to be of the tools themselves. Moreover, when a body is illustrated, notably absent is any bodily viscera; instead, a perfectly clean skin is offered. Indeed, these nineteenth-century taxidermy manuals follow the precedent already evident in early modern texts, including works in comparative anatomy, where illustrations "isolate salient characteristics, remove background, and eschew three-dimensional modelling" (Acheson 7). Curiously, instead of looking to more contemporary models of anatomical illustration, such as Jan van Rymsdyk's illustrations to William Hunter's *The Anatomy of the Human Gravid Uterus Exhibited in Figures* (1774), which strikingly include folds of skin, flayed membranes, and sliced limbs of the dead pregnant body in a scene that has been compared to butchery (see Jordanova), taxidermic manuals revert to earlier models. Unlike the flayed body with peeled-back skin and organs on display, the illustrated taxidermied body is an empty, flat, two-dimensional body. Like the heap of clothes where one expects to find the corpse in Gothic fiction, precisely what is missing here in these manuals is the violated body itself. At most, some illustrations and detailed instructions in nineteenth-century taxidermy manuals reveal a constructed interior of the taxidermy specimen held up by long metal wires shoved

THE TWO-HEADED KITTEN

through the frame. Thus, it is more than simply the loss of interiority but the supplanting of that interiority—blood, guts, muscles, organs—with counterfeit materials, such as wire, flax, tow, and cotton.[8]

While the body itself is invoked but disavowed in taxidermy manuals, in dioramic presentations, it is another story, for here we are inescapably confronted with the material body. Such an encounter can create, as Jane Desmond writes, "a nearly paralyzing moment of encounter, one that tenses our own muscles, may cause bile to rise, inspire a sharp intake of breath, and perhaps compel an intense desire to look away" ("Vivacious Remains" 264). Desmond's description recalls Moers's account (cited earlier) of the affective power of the Gothic and helps sharpen the collusion between these discourses: both the Gothic and taxidermy are enervated modes of storytelling. Indeed, as Robert Marbury writes, "Taxidermy in all of its forms is a sculptural storytelling technique" (12). Similarly, Merle Patchett places the taxidermist in a storytelling tradition: "the skilled practitioner [taxidermist] can therefore be regarded as a storyteller re-enacting the rhythm of a practice that has developed through repetition as it has been passed on from generation to generation" (413).

In traditional taxidermy mounts, one of the enduring stories that gets retold is what Donna Haraway, in one of the earliest scholarly articles on taxidermy, calls the coherent story of "nature's unity" through "the unblemished type specimen" ("Teddy Bear" 34). And yet, against this idealized narrative, as Darke notes, "taxidermy manuals reveal the painstaking process of construction that fractures this clarity" (15). While Darke notes that both "taxidermy manual and literary text combine similar representational strategies to move towards an understanding of the body, intertwining 'literary' techniques (characterization, analogy, and storytelling) with typically 'scientific' attributes (close observation and analysis of the body)" (24), we can extend this and see more pointed connections between the rhetorical strategies of the taxidermy manual and the Gothic. Thus, just as taxidermy's detailed and difficult process of construction is recalled in these nineteenth-century manuals, reminding us just how belabored and artificial such a narrative of nature's unity is, so too does the Gothic, more than any other genre or mode, frequently offer us its fragmented fruits. The Gothic, as Cyndy Hendershot notes, "fragments stable identity and stable social order" (1).

8 William Swainson's *Taxidermy: With the Biography of Zoologists* (1840) offers a particularly detailed set of instructions on dismembering, preserving, and mounting animals.

In the Hands of the Dangerous Taxidermist: Cultivating Counterfeit Bodies

Another gothic narrative technique that taxidermy treatises deploy is a fetishistic lingering on one particular body part: the taxidermist's hand. Like the "invisible hand" found in Adam Smith or Walpole's *Otranto* (recall the invisible hand that presses against the door, barring Manfred from reaching Isabella), taxidermists' hands were shrouded, in some texts, by a quasi-supernatural force.

The ever-present threats, as these taxidermy manuals consistently announce, are "coarse and vulgar minds and clumsy fingers" (Manton, *Taxidermy without a Teacher* 10). The preface to *Taxidermy without a Teacher* asks this rhetorical question:

> what is more revolting to a delicate appreciation, than to see these bright creatures, so marvellously constructed by our all-wise Father, tortured into life-like attitudes by one who acts merely as an automaton and has no sympathy with his work otherwise than to gain a livelihood? (10–11)

Clumsy fingers become a synecdoche for a vulgar mind, for one who would sadistically torture the already dead body, and who seems to share the same degree of sensibility as his or her badly stuffed object. But more than just having a good skin to work with, the stuffer, in addition to chemistry, required an intensive knowledge of drawing, modeling, and anatomy "to enable the stuffer to place his subject in a position both natural and striking" (Manton 3). Thus, it is a refined, artistic hand that the taxidermist must have.[9]

It is this same polymathic quality of the taxidermist with particular emphasis on his talented hands that is depicted in a painting by Charles Willson Peale, an American taxidermist and artist and founder of two art academies and the first US natural history museum. In his 1822 self-portrait, "The Artist in His Museum" (see Figure 1.1), Peale stands at the center of the painting staring directly at the viewer, with one hand drawing back a luxurious red velvet curtain (recalling Fuseli's *The Nightmare*) and the other hand outstretched, motioning to us to enter or follow. On the table next to him is an artist's palette, while in the foreground is a stuffed American turkey

9 It strikes me that the associative power of having good hands and intensive knowledge about the body is at work in the case of taxidermy appearing in other medical professional settings, such as dentist offices, as found in the 1789 illustration of the interior of Marshalls, a famous dentist shop near Berwick Street in Soho. Image: Wellcome Collection. Wellcome Library no. 16585i. https://wellcomecollection.org/works/b8kp5u9e.

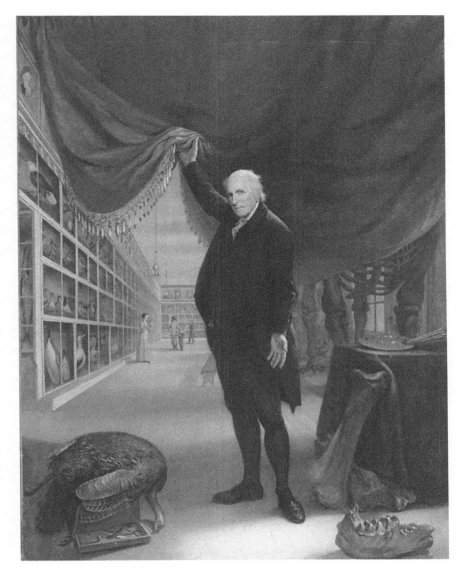

Figure 1.1 Charles Willson Peale. *The Artist in His Museum*. 1822. Image courtesy of Pennsylvania Academy of the Fine Arts.

beneath which is an open case of taxidermist tools. Behind him, on the other side of the curtain, are floor-to-ceiling rows of taxidermied birds in glass cases. Peale's outstretched hand near the center of the painting triangulates itself between the palette and the taxidermy tools, and we wonder what dreams or nightmares lie beyond the curtain.

16 TAXIDERMY AND THE GOTHIC

Putting in words what Peale's painting visually suggests, William Hornaday in *Taxidermy and Zoological Collecting* (1891) argues that the "ideal taxidermist must be a combination of modeler and anatomist, naturalist, carpenter, blacksmith, and painter. He must have the eye of an artist, the back of a hod-carrier, the touch of a wood-chopper one day, and of an engraver the next" (108). And yet, in taxidermy, he admits, "a little knowledge is a dangerous thing" (109). As Hornaday passionately writes, "Do not leave a specimen looking as if a coal-heaver had finished it. [...] There is no inferno too deep or too hot for a slovenly, slatternly taxidermist" (114).

The precarious power of the practice of taxidermy is even suggested by the frontispiece illustration to Thomas Brown's *The Taxidermist's Manual* (1833) (Figure 1.2).[10] It is an image of a magic lantern into which a steady

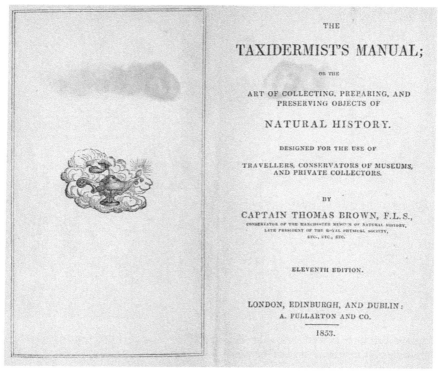

Figure 1.2 Frontispiece and title page for Thomas Brown's *The Taxidermist's Manual*.

10 This was an enormously popular book going through 34 editions. The image of the magic lantern is not there in the first, second, or third edition; it does appear in the 5th edition.

THE TWO-HEADED KITTEN

hand carefully pours a dark liquid, with billowing clouds of smoke or vapors expand outward from the lamp. Why this image is of interest here is because of what it symbolizes about the practice of taxidermy: it might be a science and an art, but it is also something of a mystical, magical practice. Like the hand pouring the dark liquid into the lamp, the taxidermist pours a strange concoction of materials and dangerous chemicals into the emptied-out body of the animal. If this is the lamp from which a genie will emanate, so too, if done properly, might something magical happen if taxidermy is done right. However, as the text makes clear, even some of the best stuffed specimens amounted to failures insofar as they are "deformed and glaringly artificial productions, devoid of all the grace and beautifully turned points of living nature" (Brown 3). Taxidermy, it seems (as yet another way to read this frontispiece image) is also about unfulfilled wishes.

Whose hand is this on the frontispiece design? The ambiguity here reflects how nineteenth-century taxidermy manuals framed taxidermy as a democratic craft, suitable for all ages and genders.[11] According to the 1891 London census, of the 369 taxidermists, 122 of them were women (Youdelman 38).[12] Additionally, women's hands were also working behind the scenes (and so not captured in this census data), as often in a small taxidermy business the wives and daughters helped with related tasks, such as with the "preparation of ornamental vegetation or with painting case interiors" and running a subsidiary business as a "plumasier," trimming clothing and accessories with beautiful feathers (Morris 210). Women were especially encouraged to take up the art of taxidermy, as their fine dexterity and eye for the beautiful were thought to make them naturally well suited for taxidermy, as many of the texts argue. With women making up nearly a third of the taxidermists in London alone, it is unsurprising to also find them in the pages of the age's periodicals.[13]

11 Across the Atlantic, the American naturalist and taxidermist Martha Maxwell (1831–1881) achieved fame in the 1870s as the earliest example of a woman "who acquired and prepared animal specimens," unlike other female naturalists who left the "messy, dangerous, and bloody work of animal study to their male counterparts" (McCown's "Introduction" in Dartt 4).

12 However, as Rex Merchant notes, in the mid- to late-nineteenth century, many taxidermists had other jobs, including "greengrocers, policemen, umbrella makers and numerous other tradesmen who practised taxidermy part time" (29). Merchant's book includes an alphabetical list of over 650 nineteenth-century taxidermists.

13 For example, see Ludlow, F. H. "The Taxidermist's Story."

Beastly Female Taxidermists in "Taxidermy in Rome"

One noteworthy story to feature female taxidermists that is also steeped in Gothic conventions and the counterfeit is "Taxidermy in Rome" (1847), a story published in *Blackwood's Edinburgh Magazine*. It tells the first-hand account of an unnamed doctor who travels to Rome to visit two accomplished female taxidermists, Annetta Cadet and her mother, "two humble foreigners of the gentler sex, who have passed their whole lives in the study and practice of taxidermy"(293), who "think nothing of braving any amount of heat, fatigue, and inconvenience; and such adepts are they in this art, that when stuffed, their birds, beasts, and reptiles seem to have received new life at their hands" (293). However, there is little that seems gentle about these women, as the narrator unravels his tale.

The heroic, masculine rhetoric of the narrator's introductory description of these skilled taxidermists is not the only unusual description. In his observations of arriving uninvited at their house (No. 23, Via della Vite), he knocks and is welcomed in by a mysterious unseen female voice that tells him to enter and wait in the reception room, an invitation that he describes as a "Little-red-riding-hood invitation" (293). Already, these comments reveal that the female taxidermist is framed as a beastly figure, a wolf in sheep's clothing. As the narrator waits, he describes the room's décor, which includes "a score or two of queer-looking pictures, (for the most part without frames,) [...] strange landscapes [...] and allegorical subjects, treated with an equal perversity" (293–94). Two paintings in particular catch the narrator's eye, the first of which features the mythical lovers Diana and Endymion. The symbolism of this painting within the taxidermists' home is profound: in the story of Diana and Endymion, Diana steals a kiss from the sleeping Endymion, who awakens and falls in love with her, an encounter that upsets Zeus. Zeus forces Endymion to choose between instant death or perpetual slumber, the latter of which will forever preserve his youth. In choosing perpetual slumber, a kind of immortalized stilled life, Endymion shares an affinity with taxidermy.

The second painting that the narrator lingers on is a portrait of a "naked nymph with a pretty face, and a torso half hidden" whom he considers "not penitent enough for a Magdalen" (294), a comment that both avows and disavows the Madonna/whore paradigm so sensationally deployed in Gothic fiction. The half-hidden torso of this sexualized woman bears earlier traces of the eroticized Madonna painting in Lewis's *The Monk*, and Geraldine's half-obscured bosom in Coleridge's queer Gothic poem *Christabel*, the latter of which was called, by one anonymous reviewer, "the most obscene poem in the English Language" (qtd in Elfenbein 188).

THE TWO-HEADED KITTEN

The appearance of these "queer-looking pictures" is a calling card of the Gothic, and further helps to situate this story within the genre. As Kamilla Elliot writes in *Portraiture and British Gothic Fiction* (2012), "Gothic fiction is the mother ship of literary picture identification—no other literary period or genre is so pervasively, didactically, and obsessively concerned with it" (6). In more than 100 Gothic texts, Elliot finds that portraits and miniatures are motifs and objects that appear more frequently than other classic Gothic tropes, such as convents, secret passageways, and ghosts, among others. Furthermore, the taxidermists' strange paintings that are all treated "with an equal perversity," with their echoes of other well-known Gothic sensations and scandals, work to ratchet up the family resemblances between taxidermy and the Gothic. As such, before the narrator even meets the taxidermists, the atmosphere or aura of the space of taxidermy and the adjacent arts (those perverse paintings) have unnerved him.

The narrator finds himself further undone by the appearance of the female taxidermists. Cadet's hair is messy, "mixed with bits of feather and other extraneous elements," and enters holding "a half stuffed hawk" in one hand and an arsenic-soaked sponge in the other. The speaker describes this as a horrific spectacle, at least on first glance: "Our eyes had never rested upon so wild, so plain, so apparently hopeless a slattern; but these unpromising appearances were soon forgotten, and amply made amends for by the intelligence of her remarks, and the sprightliness of her conversation" (294).

While the beastly appearance of this female taxidermist is tempered by her linguistic prowess, the speaker continues to find other unsettling aspects of the visit. The space of the women's house itself is something unsettlingly liminal, and seemingly takes on a monstrous agency of its own: it was "something between a shambles, a museum, and a tanyard, and exhaled in consequence the mixed effluvia of decomposing flesh, alcohol, tannin, and the oil of petroleum" (294). Like a terrified visitor to a haunted house that runs away, the narrator leaves though not for long, returning several times yet. The taxidermists later regale him with insights on the craft, and a story of a badly stuffed Brazilian lion—what is arguably a veiled reference to Sweden's Lion of Gripsholm Castle, which was poorly stuffed in 1731 by a taxidermist that had never seen a living lion.[14] The story concludes with Cadet and her mother also proudly showing off their collection of living snakes and telling stories of the snakes' vicious natures, bodily secretions, and dangerous encounters. Cadet and her mother read like a more charming,

14 This lion is currently enjoying a second life as a meme and sensational account of crap taxidermy.

20 TAXIDERMY AND THE GOTHIC

defanged version of Carathis, Vathek's mother in William Beckford's *Vathek* (1786), who similarly excels in occult knowledge, collects snakes (although Carathis uses them in gruesome experiments to both poison and cure guests), and is at home with noxious odors.[15]

With these details—an unexpected guest, a foreign land, a disturbing house with unsettling interior, a mephitic atmosphere, a dead father, talismanic figures, ominous animals, a mother–daughter pair, strange paintings— the story deploys Gothic tropes and conventions that would have been immediately recognizable to readers of the Gothic and of *Blackwood's* more generally, a monthly literary and political magazine, established in 1817, that not only helped transform and promote the short story but also the Gothic tale.[16] Even though "Taxidermy in Rome" does not appear in the later *Tales from Blackwood*, it nevertheless deploys common literary devices and Gothic tropes, and is stylistically indistinguishable from the other *Tales*. It is important to remember that, as Robert Morrison and Chris Baldick note, this magazine "often blurred the distinction between fact and fiction" (xii). *Blackwood's* was "an exciting blend of raucous humour, penetrating intelligence, arrogant ultra-Toryism, and Gothic terror. There was nothing else like it, and it secured enormous popularity and influence" (Morrison and Baldick vii). Heightening the uncertainty was its anonymous authorship. The author of this story, Charles David Badham (1805–1857), an English

15 According to Eliza Bourque Dandridge, Carathis's "tolerance and even preference for the mephitic manifests in her beloved 'laboratory' of horrors in which the 'potency of the exhalations' of her faithful 'negresses' nearly but not quite overpowers her. [...] Her entourage, both bestial and human, likewise exhibits an affinity with the insalubrious environment" (438).

16 *Blackwood's*, as Wendell Harris notes, "provided the century's first steady and respectable market for short fiction. From its first issue, which included a tale by James Hogg, short fiction appeared regularly, the editors happily maintaining a preference for the tale which could be published entirely in a single issue. However, even in *Blackwood's* fiction was at first offered in a modest, somewhat disguised form. In the first volume, under the editorship of James Cleghorn and Thomas Pringle, fiction duly beginning 'Mr. Editor' appeared in the section devoted to 'Original Communications.' Such sections made up large portions of the respectable older monthlies such as the *Gentleman's Magazine*, and it was not unknown for fiction to enter their pages through that back door. Though *Blackwood's* was not long in throwing off the older format, it was not for some time easy to distinguish an essay from a tale until one was well into it. In fact, more than one nonfiction piece was reprinted in the *Tales from Blackwood* collections. The tradition of introducing a story by an account of how the narrator came to observe or hear of the events he describes was long popular among the contributors, even though the introductions are generally as fictional as the stories they preface" (Harris 22–23).

THE TWO-HEADED KITTEN 21

physician, writer, entomologist, and mycologist, who wrote a series of stories
for the magazine about his travels in Italy, was only posthumously revealed,
in keeping with the magazine's policy of anonymity.[17]

Like the counterfeit nature of the Gothic, a genre which from its Walpolean
origins attempted to pass itself off as something else, tales in *Blackwood's*
were often not what they seemed.[18] Thus, the enthralling Gothic sensibility
of "Taxidermy in Rome" not only blurs the lines of genres, so typical of
the *Blackwood's* tale, but further casts taxidermy and its practitioners, and
in this case women, as Gothic art and artists.

Charles Waterton and His Taxidermic Creations

Taxidermists, male and female, fictional and otherwise, are thus
cast as dangerous artists, with skilled hands but perhaps dangerous
minds—a Frankenstein of sorts. After all, "Victor Frankenstein," as Elizabeth
Young rightly observes, "is like a taxidermist manipulating different corpses"
(*Pet Projects* 90). And yet, this was an association that some nineteenth-
century taxidermists already saw and welcomed. Leaning into this Gothic
legacy, Charles Waterton, one of the century's eminent taxidermists, calls
for his fellow "stuffers" (as taxidermists were colloquially known) to "possess
Promethean boldness, and bring down fire, and animation as it were, into
[the] preserved specimen" (Waterton, *Wanderings* 308). Such a description
wonderfully encapsulates the ambivalences in the figure of the taxidermist;
s/he is someone who is sensitive, knowledgeable, and emboldened with an eye
(and hand) for beauty and detail, and yet also someone who could be swept up
by a certain mania or enthusiasm and be incited to unnecessarily kill his or
her own pet out of the desire to stuff it. In fact, as another taxidermy manual
cautions, "It is not necessary, I may say, however, to kill your [pet] squirrel
in order that you may show your skill in stuffing him; for the pretty little
animal may be bought either alive or dead for about a shilling" (Gardner 13).
Other manuals cautioned the same against killing the family dog. At stake
here, then, is the same anxiety as in the Gothic, namely an "over-abundance
of imaginative frenzy," the same threat that "[p]assion, excitement and
sensation" could "transgress social proprieties and moral laws" (Botting,
Gothic 3). Indeed, as Patrick McGrath suggests, the Gothic's "*raison d'être*
is transgression," and it identifies limits "so as then to assault them" (157).

17 Eleanor McNees argues that Badham's stories in *Blackwood's* influenced Dickens.
18 There is a similar challenge with H. G. Wells's taxidermy-infused Gothic tale
 "The Triumphs of the Taxidermist" in deciphering the authenticity of the story.

Waterton's call in his popular *Wanderings in South America* (1825) for taxidermists to channel their inner Frankenstein was more than a rhetorical flourish. He himself was arguably the century's Byronic taxidermist, someone "mad, bad and dangerous to know," possessed with an imaginative frenzy. Waterton, the "Hercules of taxidermy," as one critic called him (Aldington 90), was also a naturalist and adventurous traveler. He was a friend of Sir Joseph Banks, and of Jane Loudon (author of the Gothic story "The Mummy"), and his work was widely read by people including Charles Dickens and Charles Darwin. Waterton transformed his home, Walton Hall, in West Yorkshire, into a museum. Visiting Walton Hall became a tourist attraction, accounts of which appear in popular periodicals of the time, though many came equally to see Waterton himself, considered "one of England's great eccentrics" (Carroll 130).

Waterton lived in such a way that displayed the anxieties over an overabundance of passion for taxidermy. Waterton's bedroom doubled as his taxidermy workshop: "The bedroom contained no bed—since the death of his wife Waterton had preferred to sleep on the floor—but it did contain tools and a menagerie of half-resurrected birds and animals, for it was here that Waterton prepared his taxidermic specimens" (Carroll 139). George Harley, a visitor at Walton Hall, reports his shock at entering Waterton's bedroom to find a "dead rabbit" and a stuffed "baboon, swinging in the air, suspended from the ceiling by two strings" (Harley, *Selborne Magazine* 165). Waterton dramatically proceeds to throw bones at Harley's feet and grabs a taxidermied "large-sized barn-door cock, and saying 'Catch!' pitched it across the room into [Harley's] hands" (167) like a wayward football. Like a Victor Frankenstein transforming his university bedroom into his "workshop of filthy creation" (Shelley 81), Waterton simultaneously corrodes symbolic spatial and species boundaries in his adventures in taxidermy.[19]

While the bedroom-*cum*-taxidermy workshop may be the most extreme example of these boundary violations, it was by no means the only one in the house. As his close friend and physician Richard Hobson observes, "The moment you enter [Waterton's] mansion, you are immediately and

19 Sometimes, the blurring of boundaries occurred with living animals, too. According to one of Waterton's close friends, Richard Hobson, in 1861, when Waterton visited London's Zoological Gardens, he entered the den of a "large orang-outang, from Borneo, which was reputed to be very savage. [...] The meeting of these two celebrities was clearly a case of 'love at first sight,' as the strangers embraced each other most affectionately; nay, they positively hugged each other, and in their apparently uncontrollable joy, they kissed one another many times, to the great amusement of the numerous spectators" (Hobson 65).

THE TWO-HEADED KITTEN

forcibly struck with the peculiarity, the variety, and the rarity of objects" (134–35). Of special interest in Waterton's home, for Hobson, is a special taxidermied sheep head, which Waterton had purchased from a Scarborough taxidermist and displayed "at the foot of the grand staircase," and which freakishly featured a horn growing out of one ear (135).[20] But Waterton was perhaps best known for not only collecting monstrosities but both criticizing and creating them, too.

Waterton was one of the more famous taxidermists, innovative in his methods of stuffing without wire by using mercury instead to harden and preserve the skin after scraping out the insides. Harley reports how, having made the mistake of complimenting Waterton's "stuffed" animals, Waterton became incensed and grabbed one of the taxidermic specimens in his home, a polecat, and pulled its head off to showcase the emptiness of the preserved body (*The Selborne Magazine* 116).

Waterton sharply criticizes taxidermic specimens found in many museums, writing in *Essays on Natural History*:

> Now I should call upon any one of these, who have given to the public a mode of preserving specimens for museums to step forward and show me how to restore majesty to the face of a lion's skin, ferocity to the tiger's countenance, innocence to that of the lamb, or sulkiness to that of the bull, he would not know which way to set to work: he would have no resources at hand to help him in that operation. [...] He could produce nothing beyond a mere dried specimen shrunk too much in this part, or too bloated in that; a mummy, a distortion, a hideous spectacle, a failure in every sense of the word. (*Essays* 300–1)

And yet, despite being highly critical of these "hideous spectacles," these shrunken or bloated taxidermic "failures," Waterton himself dabbled in making rogue taxidermy: that is, taxidermy of fantastical animals using bits and pieces of various animals. As Pat Morris writes, Waterton's

> imaginary creatures [...] are often quite complex and their components and construction baffled Waterton's visitors and defied elucidation by his biographers. They are very conspicuous among his collection, but less so in his biographies. Indeed, the various books about Waterton barely mention these things, despite their obvious importance to their creator. (*Charles Waterton* 67)

20 Much of Waterton's collection can be found at Stonyhurst College in Lancashire.

Waterton's "taxidermic satires," as Michelle Henning calls them (673), are the stuffed equivalents of the work of British graphic satirists James Gillray and Thomas Rowlandson. One biting piece, titled "John Bull and the National Debt" featured parts of a porcupine stuffed into a tortoiseshell with a humanlike face. The story it tells is an allegory of England; overburdened with the weight of the national debt, it succumbs to six devils and is crushed beneath the giant helmet and symbolic weight of the past, not unlike Otranto's unaccomplished Conrad. In another piece, "Martin Luther after His Fall," Waterton (who was a Catholic) gives a young gorilla some horns and a human face with a "slightly mocking or Mona Lisa smile" (Henning 674) uncannily resembling the incubus from Fuseli's painting *The Nightmare*.[21]

In "The Nondescript," another rogue specimen, Waterton devilishly plays with the specimen's origins and authenticity. Like the ghost of the counterfeit that haunts the very origin of the Gothic, the counterfeit was frequently on display here. In *Wanderings in South America*—where an illustration of the Nondescript serves as its frontispiece design—he gives a description of how he hunted the creature he calls the "Nondescript." Yet the "Nondescript" was Waterton's own rogue creation made from the skin of a howler monkey; it was a specimen that he sometimes claimed was a new species he had discovered, and other times admitted it was modeled on a customs officer who taxed him on the import of animal skins. This taxidermic creation involved crafting a stylized human face out of the backside of the monkey—giving a whole new meaning to the subgenre of "crap taxidermy."[22]

21 This was also reportedly the first gorilla to be displayed in England (Blackburn 194–95).

22 Crap taxidermy is another form of what Steve Baker in *The Postmodern Animal* dubs as "botched taxidermy," when the animal "is present in all its awkward, pressing thingness" where "things appear to have *gone wrong* with the animal, as it were, but where it still *holds together*" (55–56). Yet, perhaps the most botched specimen that we encounter in these nineteenth-century manuals is the one that is spectral—an absent presence: the human. Curiously, the most abject specimen marginally encountered in these taxidermy treatises is the human, who is frequently invoked only to be disavowed. As Sarah Bowdich in *Taxidermy* explains: "All the efforts of man to restore the skin of his fellow-creature to its natural form and beauty have hitherto been fruitless; the trials which have been made have only produced mis-shapen hideous objects, and so unlike nature, that they have never found a place in our collections" (20). While the skeleton or parts of the human could be preserved, the attempts at preservation and artful mounting of the human seem to have produced the most horror of all.

THE TWO-HEADED KITTEN

Waterton's various "devils," small reptiles, are often anthropomorphized with human faces. Especially terrifying is "The Sordid Devil," a toad given implanted teeth, long sharp claws, and two horns on its head. It is the stuff of nightmares. And, in a fluffier vein, his "Noctifer, the Spirit of the Dark Ages," looks like an owl–chicken–eagle hybrid. Waterton's practice, as Stephen Bann suggests, "aptly illustrates the way in which the themes of creation and monstrosity are intertwined in the culture of the nineteenth century" (13).[23] Even Waterton's persona, in addition to his taxidermic practice, illustrated this. Waterton's ungentlemanly physical appearance and sartorial choices—a short haircut that was unusual for men at that time, ugly hats, short socks, clumsy shoes, and ill-fitting coats—a look that, according to one source, made him look like a recently released prisoner (Carroll 153–55)—collectively reinforced the image of the taxidermist as a mad dog. It was an impression redoubled by Hobson's personal experience of once being bit in the leg by Waterton pretending to be a dog (Hobson 172).

The strangeness of Waterton's taxidermy is poignantly captured in an unfinished watercolor painting made by Waterton's friend and artist Captain Edwin Jones, who accompanied Waterton on some of his travels (Figure 1.3).[24] The painting captures this strange combination of Waterton's wild style and rogue taxidermic creations, as selections from Waterton's monstrous creations assemble along the bottom foreground of the painting, while Waterton majestically rides off on the back of an alligator toward Walton Hall, in what Carroll calls "a parody of a typically picturesque scene" (160).

While the image of Waterton riding the alligator speaks to the tradition of the hunt, and the fantasy of dominion over the natural world, it also carries with it the much deeper tradition of the occult. Stuffed alligators and crocodiles, as Fiona Haslam notes, feature in many seventeenth-century Dutch paintings as figures of quackery closely associated with the salamander, "a creature accredited in alchemic theory with the *elixir vitae* and believed to live in fire" (112). Even Shakespeare references a dodgy apothecary's "alligator stuff'd and other skins / Of ill-shap'd fishes" in *Romeo and Juliet* (qtd. in Haslam 109). The taxidermied alligator continues to appear in this manner in William Hogarth's work, such as his *Hudibras Beats Sidrophel and His Man Whacum*, for Samuel Butler's *Hudibras*, prominently suspended and presiding over the scene that visually brings violence, occult knowledge, and taxidermy together (Figure 1.4).

23 Stephen Bann sees Charles Waterton's taxidermy as forming "a curiously illuminating counterpoint to Mary Shelley's imagined world" (7).

24 The painter is sometimes identified as Edward Jones. However, the *ODNB* identifies Jones as Edwin.

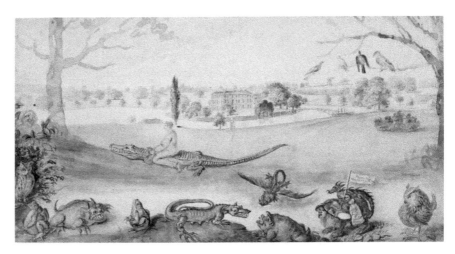

Figure 1.3 E. Jones. *Walton Hall with Waterton and Some of His Animals.* Image courtesy of Wakefield Museums & Castles, Wakefield Council.

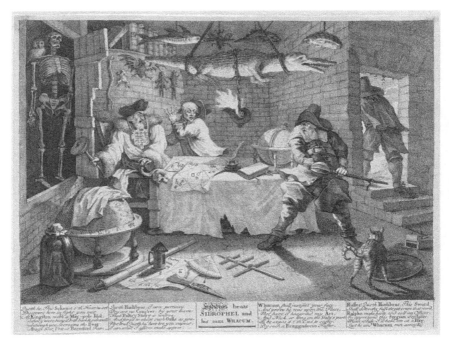

Figure 1.4 William Hogarth. *Hudibras Beats Sidrophel and His Man Whacum.* Etching and engraving for Samuel Butler's Hudibras, February 1726. Image courtesy of The Lewis Walpole Library, Yale University.

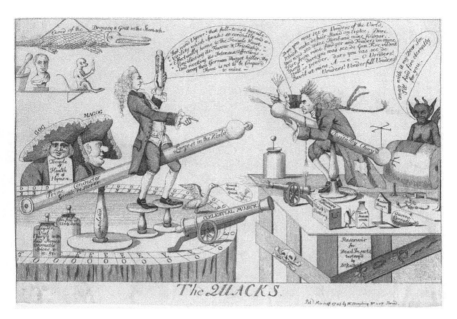

Figure 1.5 Unknown artist. *The Quacks*. Engraving, 1783. Image courtesy of The Lewis Walpole Library, Yale University.

More taxidermied alligators appear in Hogarth's *Marriage-à-la-Mode* (III. *The Inspection*), 1745, where it is suspended along the upper left-hand ceiling of the quack doctor's office, and in an unknown artist's satirical print, *The Quacks* (1783) (see Figure 1.5) that targeted two well-known quack doctors, Gustavus Katterfelto and James Graham.[25]

Thus, Jones's unfinished watercolor of Waterton riding a crocodile suggestively plays into this tradition of the stuffed alligator and taxidermy's occult associations more generally, which are only intensified by the menagerie of rogue taxidermic monsters on parade along the bottom of the painting.

To be sure, Waterton, the madman of taxidermy, was considered, at least by some, as strange and counterfeit as his taxidermic creations. In one review in the *Literary Gazette* (May 12, 1827) that appears beneath a short review of William Raddon's engraving for Fuseli's *The Nightmare*, Waterton is listed alongside other contemporary madmen, quacks, and hoaxes. These include poet-artist William Blake, who caricatured a flea's

25 There is also a taxidermied wolf head in Hogarth's *Marriage-à-la-Mode (III. The Inspection)*. Thanks to Fiona Haslam's book for calling my attention to these images.

28 TAXIDERMY AND THE GOTHIC

ghost; Dr. Samuel Eady, a "medical swindler operating in London during the mid–1820s"; Robert Warren, a blacking manufacturer; and Charles Wright, the "purveyor of sham champagne" (Whitehead, pars. 5, 6). And yet, this image of a disorderly and dangerously deceptive taxidermist continues to spread throughout the nineteenth-century popular imaginary. Consider, for example, taxidermy's appearance in popular nineteenth-century periodicals.

"About Taxidermy," Fun Magazine

"About Taxidermy" (1882) is a five full-page illustrated jab at all aspects of taxidermy, serialized across weekly issues in *Fun*, a comic magazine that rivaled *Punch*. On the first page, the magazine's titular mascot, a clown named Fun, ventures to acquire knowledge of taxidermy from a professor (Figure 1.6).

The clown named Fun "always had a feeling that some deep, changeless, though esoteric principle must govern these remarkable, weird efforts. Ever overjoyed to learn from those who display true intelligence, Fun conjured a professor of the strange art to divulge to him its secret principles" (36.914 [15 Nov. 1882] 206). What the professor discloses to the intrepid student is that "universal similarity" between animals exists but "a series of blunders and accidents have irreparably marred this design; it therefore rests with the Taxidermist to restore the universal similarity. [...] Bones are an abuse which has crept in, and should be suppressed" (206). This is not only a jest at Darwinian science but at the ambitions of taxidermy to intervene into and correct nature. In this oversimplistic schema, taxidermy appears an art of devolution rather than evolution.

Even the art of arranging taxidermy is parodied here. Showing a stuffed tiger next to a stuffed dog, the professor explains that "the sole difference between animals [...] is the difference of *habits*—expressed by posture" (206). And with the view that the secret principle of universal similarity is quite simple—that all animals have a head, body, legs, and tail—the taxidermic practice of swapping parts easily allows the taxidermist to create a new animal: "take the dog: add antlers, remove the collar, and screw in a shorter tail, and he becomes a *deer*. Again, take the dog shown before: remove the legs, ears, and tail, affix flappers—and you have a seal!" (206). The earnestness of the taxidermist-professor seemingly displaying "true intelligence" is hilariously undercut by the absurdity of the argument and principles and the illustrations of hideously stuffed animals that appear to stare back at the reader.

The second issue focuses on "unreason in [taxidermy's] clients" and makes fun of the gullibility of clients. The third issue (36.916 [29 Nov.

1882] p. 233) pits the "misinformed naturalist," who has a more complex understanding of nature, against the taxidermist, who is driven to reduce to commonalities. The taxidermist in this vignette stuffs the naturalist's giraffe and ostrich, taking creative liberties to remove two legs of the giraffe, equally divide the tail feathers, and create necks of equal lengths.

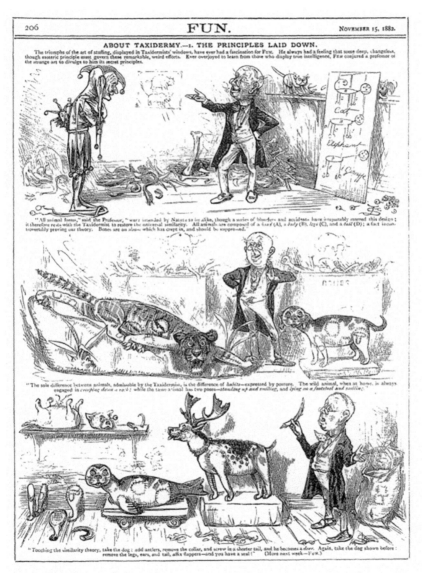

Figure 1.6 "About Taxidermy—1. The Principles Laid Down," *Fun Magazine*. 36.915 (22 Nov. 1882, p. 216).

In the fourth illustration (Figure 1.7), subtitled "An Unappreciated Triumph," the taxidermist-professor complains, again, about nature's "many and glaring" failures of animal skins "to be filled out to their fullest extent" (238). The taxidermist-professor demonstrates his special air

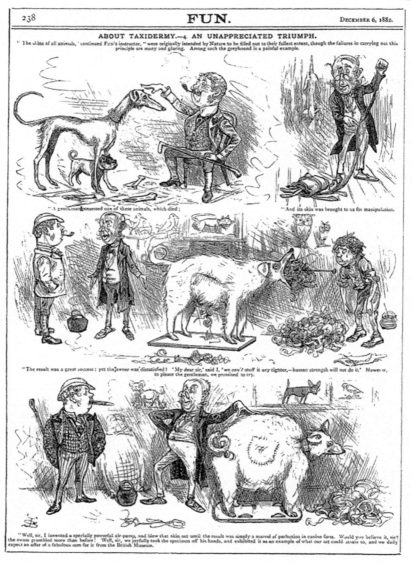

Figure 1.7 "About Taxidermy—4. An Unappreciated Triumph," *Fun Magazine* 36.917 (6 Dec. 1882, p. 238).

THE TWO-HEADED KITTEN 31

pump invention that overstuffs what originally looks like a slender Scottish Deerhound and turns it into a monstrously bloated specimen, anticipating the fate that would soon befall the real-life Horniman walrus.[26] The professor proudly exclaims it is "an example of what our art could attain to, and we daily expect an offer of a fabulous sum for it from the British Museum" (238)—a jest at both the ideal of taxidermy and the notorious pantheon of bad taxidermy at the British Museum.

The "many and glaring" failures of museum taxidermy were widely noted throughout the long nineteenth century. William Swainson in *Taxidermy: Bibliography and Biography* (1840) writes,

> During the two preceding centuries, the art of preserving animal bodies, otherwise than in spirits, was but little understood; and to this cause, more than to any other, must be attributed the partial or total destruction of those extensive collections of animals made by Sir Hans Sloane, and the great naturalists who lived about the same period; collections, whose existence we now only read of—for they have nearly passed away "from the things that be." [...] In the British Museum, there are, it is true, vast numbers of specimens, but the majority are so old and faded, that two thirds might be cast out with much advantage. (26–27, 73–74)

Swainson reveals how in less than the span of a hundred years of opening its doors, the British Museum, founded on Sloane's enormous collection of over 71,000 items, was plagued by badly preserved taxidermy. Referencing lines from Sir Walter Scott's poem *The Lady of the Lake* (1810), Swainson suggests that taxidermy does not escape the ravages of time and is also "blotted from the things that be" (Canto III, 1:5). Swainson here equates taxidermy with the lost generations from Scott's poem, "stranded wrecks" that are "weak and withered of their force" (III, 1:8, 6), erased or blotted out from the world that currently exists. Even Waterton, Swainson's rival, agrees, similarly complaining in *The Illustrated London News*, "Were you [...] to pay as much attention to birds as the sculptor does to the human frame, you would immediately see, on entering a museum, that the specimens are not well done" (October 11, 1851: 14).

More pointedly, taxidermist James Gardner writes in *Bird, Quadruped, and Fish Preserving: A Manual of Taxidermy for Amateurs* (1865) "If you want to see

26 The Horniman Walrus, originally from Canada, is a curiously stuffed wrinkle-free walrus that was first displayed in 1886 at the Colonial and Indian Exhibition in South Kensington, London. It remains a celebrity today, still on display at the Horniman Museum, London, with its own Twitter account.

32 TAXIDERMY AND THE GOTHIC

how badly fish can be preserved, go to the British Museum" (31). Even the
Animal Preserver to the British Museum, John Gould, admitted before the
1836 Select Committee on the British Museum that "the specimens are not
in the best state of preservation, they are not so good as I have seen at other
collections, and they are not in that perfect state in which I should like to see
them" (Sauer 127). Indeed, the British Museum sounds not unlike the fictional
Cadet's mephitic home in Rome. With its thousands of specimens that were
destroyed from within by insects, the "thousands of unmounted skin [that]
sat rotting in the basement," and its periodical attempts "to put an end to
the contagion by making a bonfire of its rotting specimens" (Colley 72), the
Museum reads like a house of horrors, a Frankensteinian "workshop of filthy
creation" (Shelley 81).

 In the fifth and final illustrated vignette of "About Taxidermy," subtitled
"The Lifelike Pet," Fun visits a woman who has had her beloved pet
spaniel taxidermied, which judging from the shock and repulsion of Fun
is a horrifying sight. While the lady herself seems blind to the horrors of
her tender taxidermy, as the narrative projects into the future, when both
Fun and the lady have aged, Fun is clearly no less repulsed and horrified by
the taxidermic creation, which looks ever worse for wear, with its glass eyes
popped out of its head, its fur nearly all lost, and its patchy seams showing.
If taxidermy is an art of suspending time, of immortalizing life in death,
an Endymion-like perpetual slumber, it is also, as this satirical print shows,
a source of unending horror.

H. G. Wells's "The Triumphs of a Taxidermist"

Darker still are the representations of taxidermy and taxidermists found in
H. G. Wells's (1866–1946) "The Triumphs of a Taxidermist" (1894). This short
story was originally published anonymously in the *Pall Mall Gazette* (March 3,
15, 1894) and then included in Wells's first short story collection, *The Stolen
Bacillus and Other Incidents* (1895). In both its form and content, this story plays
with the notion of fakery and the counterfeit and offers a rare (and disturbing)
close-up of the taxidermist.

 "The Triumphs of a Taxidermist" recounts an interview between
the narrator named Bellows and an older, unnamed taxidermist that takes
place one evening at the taxidermist's home. The taxidermist, after some
drinks, proudly tells Bellows of his dubious accomplishments: having faked
a stuffed great auk by using the feathers of other birds; having crafted
a specimen of an extinct species of bird, done in the interest of advancing
science; and even having forged his own rogue taxidermy, making up an
imaginary animal and claiming it to be a species of New Zealand bird

THE TWO-HEADED KITTEN 33

that only an old German pamphlet makes reference to. The taxidermist gleefully shares how he tricked a local collector, Javvers, into purchasing this counterfeit creation from him. The taxidermist also admits to having done human taxidermy, turning a black man into a coatrack, and suggests it is a third option to cremation and burial.

"The Triumphs of a Taxidermist" begins by deploying a rhetorical strategy familiar to readers of both Gothic fiction and taxidermy manuals: with a promise to disclose a great secret. Note the story's very first sentence: "Here are some of the secrets of taxidermy" (47). But the secrets will not be directly or easily given up, rather the scene must first be set and the right frame of mind established. As our narrator, Bellows, discovers, it is in the liminal, slightly uninhibited state between sobriety and drunkenness that lets the taxidermist's tongue loose. Not quite drunk and not quite sober, the taxidermist teeters somewhere between being like a quasi-magician who is foolishly giving up his trade secrets, showing the mechanics behind the magic, and a friend darkly confessing to a secret that would otherwise stay buried. In giving up his trade secrets, it is as if we glimpse into a secret society—it is as if we are reading a page out of a *Geheimbundroman*, a secret society novel, a subset of the Gothic popular at the end of the eighteenth century.

If it is difficult to place the taxidermist on either side of this line (drunk/sober), and identify what compels this boastful confession, these tensions are only redoubled in the story's myriad representations of fuzzy boundaries, spaces, times, and categories. We might expect that whatever story will unfold here will be as curious as the spaces and bodies in which it was told, with form and content mirroring each other. Consider, for instance, the taxidermist's domestic space. Bellows and the taxidermist sit together in the taxidermist's den, which is also his library, and "his sitting and his eating-room—separated by a bead curtain, so far as the sense of sight went, from the noisome den where he plied his trade" (47). The cramped quarters here recall Charles Waterton's own eccentric home, and the way Waterton's own bedroom doubled as his taxidermy workshop, with his taxidermic creations staged in humorous and disturbing ways around the room. But beyond invoking the infamous Waterton, Wells's image of the thin bead curtain, a poorly permeable boundary between the spaces, only faintly hides the visual conflation of these spaces, and it does nothing to prevent the foul smell from wafting through.

The smell of taxidermy here is worth briefly lingering over, contributing as it does to the story's uncanny atmosphere. After all, taxidermy's odors, its miasmas, are often noted, even in contemporary accounts of the practice. To call attention to the smell is to invoke the stink of death, the meat of the matter. If, as Hsuan Hsu notes, "smell stages material interrelation and environmental intimacy," Wells, by calling attention here to the stench

of this taxidermic-domestic space, shows the unavoidable seepage and connection between spaces, bodies, activities, and practices. "Olfaction," writes Hsu invoking Stacey Alaimo, can serve as "a site of trans-corporeal vulnerability" (28). Trans-corporeality, for Alaimo, names "the material interconnections of human corporeality with the more-than-human world" (*Bodily Natures* 2). The way that the smell of taxidermy spills out of one room into another, from animal-object body to human body, reveals taxidermic and human bodies to be corporeally open to one another, to be a trans-corporeal constellation. When it comes to smells, especially foul ones associated with animal carcasses, we are disgusted and infringed upon by alterity. As Adorno and Horkheimer write, "when we see we remain what we are; but when we smell we are taken over by otherness. Hence the sense of smell is considered a disgrace in civilization, the sign of lower social strata, lesser races and base animals" (184).

This blurring of senses, atmospheres, boundaries, states, and spaces within the narrative dovetails with the story's formal blurring of genres. In its original publication context in *The Pall Mall Gazette*, Wells's story was nestled alongside nonfiction prose, and advertisements for other books and cleaning products. As Zoé Hardy rightly notes, this publication detail enables the reader to (mis)read the story as a journalistic piece on taxidermy, as a factual interview between Bellows and the unnamed taxidermist—a detail reinforced by the story's original subtitle: "A Confidential Conversation" (Hardy, par. 1). Thus, just like taxidermy itself, with its fuzzy existence at the intersection of life and death, striving to counterfeit the appearance *as if* it were still alive, the positioning of Wells's story in and among these bits of journalism, interviews, and advertisements blurs the parameters of the genre so that the reader may not be sure of whether these words are fictitious. To be sure, Wells's strategy of courting misreadings and ambiguity in these formal ways recalls how earlier Gothic fiction toyed with questions of authenticity, such as in counterfeit prefaces (cf. Walpole's *Otranto*, Beckford's *Vathek*).

In addition to the text's fuzzy spaces—both internally (the noisome interiority of the taxidermist's home) and externally (the publication context in *The Pall Mall Gazette*)—the taxidermist's body is another potent site of disgust and corporeal and categorical breach. In Bellows's account of the taxidermist's body, we learn everything from his toes to his nose are outdated and out of fashion. Bellows's disgust here is palpable: the taxidermist's shoes looked to be "the holy relics of a pair of carpet slippers," and his trousers were "a most horrible yellow plaid, such as they made when our fathers wore side-whiskers and there were crinolines in the land" (47), his velveteen coat is caked with grease (48), and he smokes a dirty pipe with "a bowl of china showing the Graces" (48). Moreover, his glasses were "always askew, the left eye glaring

THE TWO-HEADED KITTEN

nakedly at you, small and penetrating; the right, seen through a glass darkly, magnified and mild" (48). As grease meets Graces (those classical figures for charm, grace, and beauty), the taxidermist embodies a strange hodgepodge of styles. This emphasis on the fuzziness or soupiness of spaces and bodies in this story, the senses, and its materiality, contributes to Bellows's (and our) sense here of taxidermy's disgustingness. As Carolyn Korsmeyer and Barry Smith write, "Seeing, touching, and smelling all grasp the materiality of objects, which is where the central qualities of the disgusting reside" (15).

And yet, it is not simply that the taxidermist is out of fashion, or that he is dirty, but he is also a figure whose vision is divided (left and right eyes seeing differently), a figure who both looks distorted and whose look/gaze is distorted. He is a strange mixture of aesthetics, styles, and times, and a figure who himself sees the world in a distorted way through his ever-askew vision. But it is the sexual, libidinal description of his vision that intensifies our disgust. The taxidermist's left eye that glares "nakedly [...] small and penetrating" brings with it sexual associations, of carnal appetites, making sex and death live in the same space of the taxidermist's gaze. This description suggests an aggressive libidinal energy to the taxidermist's gaze—a gaze that is beastly, falling upon both animal and human bodies—and places him in the Gothic's long tradition of dark, occluded vision. This resonance between the emerging science of taxidermy and the Gothic in Wells's tale gestures to the relationship between empirical knowledge and the Gothic at the time. After all, the Gothic emerges as a reaction against Enlightenment science, and returns us to the shadows, to the spaces where vision becomes obscured. As Martin Willis explains, "the Gothic mode was founded on a particular epistemology of vision closely related to scientific observation. [...] The Gothic asked questions of empiricism's objective vision, offering a series of alternative ways of seeing that instead suggested potential weakness in observation" (156). Against such ocular clarity, the Gothic "created a subjective Gothic vision which concentrated on transgressive vision, vision's ambivalence and the relation between vision and the imagination" (Willis 156).

In Wells's story, the taxidermist's libidinal gaze arouses even greater discomfort when he describes the range of bodies (real and counterfeit) he has stuffed, described in a half-drunken, half-boasting account. The taxidermist boasts, "I have stuffed elephants and I have stuffed moths, and the things have looked all the livelier and better for it. And I have stuffed human beings—chiefly amateur ornithologists" (48). He immediately follows this by declaring he stuffed a black man once, staging him "with all his fingers out and used him as a hat-rack, but that fool Homersby got up a quarrel with him late one night and spoilt him. That was before your time. It is hard to get skins, or I would have another" (48). This claim makes Wells's

taxidermist exceptional, indeed. He has done multiple human taxidermies ("chiefly ornithologists"). Real human specimens were rarely done, and never done well enough so as to be mistaken for a real, live human (which is implied in Homersby getting into a fight with the specimen).

Taxidermy in Wells's story is designed to feel strangely out of time. The taxidermist's physical appearance (from his outdated fashion choices), the collision of spaces within his apartment, and the way he speaks of his past (rather than current) specimens, all these elements give the atmosphere of being outdated. The taxidermist, like his specimens, is an uncanny relic of the past, half-dead to the present. The story, in effect, casts great suspicion on the figure of the taxidermist, someone who violates time, bodies, and orders of things, a figure skilled enough to get away with forgeries—in short, a craftsman of the counterfeit. Moreover, there's a thin line here in Wells's story between the taxidermist's ability to spin stories and tell tales (the work of fiction) and his ability to make up animals, transform materials, turning parts into wholes. There's connective tissue here between these creative activities (telling tales and stuffing skins)—*technē* in the sense of craft or art of doing—a point that both the content of Wells's story and its publication context, one that invites us to (mis)read it as a real interview with a taxidermist, cheekily reinforce.

As we will see across the remaining chapters, echoes of Wells's taxidermist continue to be felt in Gothic horror texts in the slippery, dangerous nature of the taxidermist who is the ultimate craftsman of the counterfeit. Beneath the surface of things, the first glance of appearances lies something darker and deceptive. By the end of the nineteenth century, as Wells's story suggests, taxidermy is already seen as outdated, a practice predicated on illusions, forgeries, and various violations of decorum, aesthetic sensibility, and orders. Taxidermy is a thinly veiled art of the counterfeit, not unlike its Gothic cousin, an association that continues to thrive.

The Excesses of Afterlife

If there was something potentially dangerous and unruly in the taxidermist—someone who might become so overwhelmed by the desire to stuff that one might kill one's own beloved pet—something of that unsettling quality clings to the taxidermied specimen itself. The aliveness of taxidermy has, in quite practical terms, always been part of its vexation. Life was always both the goal and the obstacle. Recall the afterlife that is still very much "alive" insofar as poorly preserved specimens inevitably hosted bugs, which one nineteenth-century manual calls "the taxidermist's great enemies" (Manton, *Taxidermy*

THE TWO-HEADED KITTEN

without a Teacher, 15). As we have already discussed, nineteenth-century museums knew too well how taxidermic specimens, as precarious bodies still vulnerable to disease/dis-ease in death, are never quite dead enough. As Thomas Brown writes:

> It is to be lamented, that even to the present day chemists have not discovered means of effectually resisting the universal law of decay, which, by certain fixed operations, reduces every kind of organised matter to its original elements. Methods have been devised of arresting for a time the progress of decay, but these seem gradually to lose their effect, and ultimately become mutilated and decomposed. Animal substances are subject to the ravages of thousands of minute animals. (*The Taxidermist's Manual* 2)

Mutilation, decay, decomposition—the language over the horrors of the imperfect state of taxidermy rings familiar for readers of the Gothic, a discourse obsessed with the "grotesque, diseased or modified body" (Spooner 8).

While life continues to plague death, with "thousands of minute animals" gnawing away at the preserved specimen, one taxidermy manual goes so far as to imagine the specimen taking on even greater life, having the ghostly ability to speak from beyond the grave. James Gardner's manual imagines what a taxidermied squirrel would say, if it could speak:

> Suppose a squirrel could speak in our language—it has doubtless one of its own, a squeak and a cry like a kitten—it might say something like this:
>
> It took six boys to catch me;
> And then I bit them so,
> That they were forced to choke me,
> Or else to let me go.
> And now I'm dead they've stuffed me,
> To let all people know
> How brave and active they were all,
> And what six boys could do! (10–11)

Apart from the curiosity that this imaginary stuffed squirrel squeaks and cries in rhyming verse, the squirrel's stuffed body announces itself as a miniature mock-heroic monument to the so-called bravery of the six boys. Clearly, then, this squirrel is also thoroughly stuffed with irony. For the Victorian reader, such a passage would have recalled not only the satirical

38 TAXIDERMY AND THE GOTHIC

taxidermy of Waterton but also the cuter, anthropomorphic critters by Hermann Ploucquet and Walter Potter.[27]

Ploucquet, the taxidermist at the Royal Museum in Stuttgart, famously exhibited his anthropomorphic taxidermy at the 1851 Great Exhibition at the Crystal Palace in London. His taxidermy tableau *Reynard the Fox* stages the story from the medieval beast epic that had been recently reimagined into a 12-part poem by Goethe (cf. *Reineke der Fuchs* [1794]). Ploucquet popularized this style of whimsical anthropomorphic taxidermy and influenced the British hotelier-turned-self-taught taxidermist Walter Potter, who also fitted stuffed kittens and birds into complex dioramas inspired by scenes from nursery rhymes and children's stories.[28]

However, there is a darker underbelly here, another line of thought murmuring beneath Gardner's rhapsodizing rodent. This shocking scene of taxidermy that comes alive to speak also reminds us of taxidermy's place within the familiar shadows of Gothic fantasies, wherein an otherwise inanimate object becomes imbued with the vestiges of life, as with a painting that moans, a statue that bleeds, or a corpse that moves.[29] In fact, toggling to an example from contemporary horror film, this is precisely what converges

27 Potter's taxidermy was continuously displayed from 1861 until 2003 (Amato 217).

28 Given how much scholarly attention has been paid to Potter and his literary-themed taxidermy—indeed, we could even say the field is "overstuffed" by attention to him—I sidestep him and the vein of whimsy in favor of the overlooked Gothic sensibilities. It is worth noting, however, that even if Potter's best-known taxidermic vignettes do not enact scenes from Gothic texts, his work is finding itself brought into the Gothic fold by some contemporary taxidermists and Gothic horror auteurs. For example, American taxidermist Cassandra Carr created "Mice Manor," a black dollhouse that featured anthropomorphic taxidermied mice depicting a different real-life serial killer or character from Gothic horror, including a Buffalo Bill mouse (from *Silence of the Lambs*) and a Lizzie Borden mouse. https://www.atlasobscura.com/places/mice-manor. Most disturbingly, Lars von Trier's horror film *The House that Jack Built* (2018), gestures to Potter, not only by sharing its title with one of Potter's taxidermic tableaux (based on the nursery rhyme) but also in featuring graphic human taxidermy, using children themselves, rather than just children's stories, as taxidermic source materials. The film's disturbing scene when Jack taxidermies a child, wiring a smile on the body, further reinforces the film's connection to Potter's whimsical taxidermy.

29 Moreover, humor, including laughter, often appears in Gothic texts to signal the monstrous. As Hannah Simpson notes, Gothic texts "include laughter that the modern Western reader or spectator is conditioned to identify as inappropriate and unpredictable to render their characters unsettlingly non-human—unsettling not only because of their monstrous status and behavior, but also because they engage in the laughter that much theory claims as a uniquely human activity" (16).

THE TWO-HEADED KITTEN 39

in Sam Raimi's *Evil Dead II: Dead by Dawn* (1987) when the taxidermy deer mount terrifyingly comes alive; the taxidermy's monstrously maniacal laughter sets off a chain reaction of hysterical laughter in other objects in the cabin, as well as in the main character, Ash.

By way of closing, as we have seen, taxidermy's Gothic sensibility murmurs throughout the nightmarish rogue taxidermy creations by Waterton, and representations of taxidermy in Gothic fiction, and "family resemblances" between the Gothic and taxidermy treatises. Relatedly, taxidermy's appearance in Gothic narratives dovetails with how many Gothic texts at this time are teeming with animal figures that perversely attempt to "stuff" themselves, by various transgressive means, into the human form and frame, from H. G. Wells's *The Island of Doctor Moreau* (1896) to Richard Marsh's *The Beetle* (1897) to Bram Stoker's *Dracula* (1897). Moreover, as we have seen, stories and satirical prints in popular nineteenth-century periodicals represented the figures of taxidermy and the taxidermist as something perverse, deceptive, and an art of the counterfeit, and often did so while deploying Gothic elements and conventions. In all these ways, the long nineteenth century laid the foundation for taxidermy's ubiquitous presence in contemporary Gothic horror.

What I present here is a more complex picture of the nineteenth-century taxidermic imaginary. Contrary to some accounts that overstate the period's comfort and ease with it (cf. Amato), this matrix of diverse texts explored in this chapter ranging from Gothic fiction, taxidermy manuals, stories and essays in popular periodicals, taxidermy specimens, and paintings offers evidence of discomfort with taxidermy and growing constellation of it with the Gothic.

Chapter 2

TAXIDERMY AND THE HORROR OF BEING-THERE

In 1798, Elizabeth Moody, English poet and literary reviewer, published the poem "An Address by a Gentleman to His Dead Dog; Which Was Stuffed, and Placed in a Corner of His Library" as part of her collection, *Poetic Trifles*. And yet, despite the collection's title, I suggest that we can brush against the grain and read this poem seriously as adumbrating the complexities and dark side of taxidermy, still in its infancy.

> Yes, still, my Prince, thy form I view,
> Art can again thy shape renew:
> But vain I seek the vital flame
> That animated once thy frame.
> Extinct the vivifying spark,
> That tongue is mute—those eyes are dark.
> In vain that face I now explore;
> It wooed me with its love,—no more.
> No more thy scent my steps shall trace
> With wagging tail and quicken'd pace.
> No e'er again thy joyful cry,
> Proclaim thy darling master nigh.
> Alas! thy shade alone remains,
> Yet Memory all thou wast retains;
> Still on thy living image dwells
> And all the winning fondness tells.
> She courts the muse to spread thy name
> Beyond life's little span of fame.
> Well pleas'd could verse stern death defy,
> And bid that *Prince* may never die.

If, Moody's poem suggests, the art of taxidermy might capture the shape or form of the pet named Prince, it fails to capture the "vital flame"

of the "vivifying spark" that is now "extinct." The speaker "explores" the taxidermied dog's face, a description suggesting the uncanny as it flickers between registers of the familiar and unfamiliar, as fur gives way to fuzziness. Prince, it seems, is now stuffed with uncertainty. *Just who or what is Prince now?* we might imagine the speaker wondering. The "Yes… / But" of the first stanza (which will find a rejoinder in the "Yet… / Still" of the second stanza) like a response to a question also reveals the way taxidermy calls to and disappoints the speaker. Taxidermy's ontological fuzziness and its failures are here, and elsewhere, part of its dark side.

The speaker, paying closer attention to the stuffed dog, lingers on the mute tongue and dark eyes. Twice the speaker proclaims the search for life to be in vain (3, 7). The face that once "wooed […] with its love" is starkly announced, with the severing line of the em-dash, as "— no more." Gone, it seems, is the animal's ability to "proclaim" (12) or announce, whether through movement or sound (wagging tail, quickened pace, joyful cry), the speaker's own existence. Thus, as the poem suggests, one of the ghastly consequences of taxidermy is the existential crisis it provokes in human.

As such, we might imagine this speaker not in mourning, as one critic reads it (Madden 27), but rather like a philosopher in malaise. Like Derrida, naked and unnerved by his cat's gaze (but also spurred into thought), this poem's speaker, inspecting the taxidermy that stands, sits, or even curls sleeping in the corner of his library, is also struck by its stasis and its vexatious gaze, one that following Derrida I will also call "bottomless." Indeed, as I will soon explain, this bottomless gaze of taxidermy is one of its strange and signature attractors for Gothic horror, a signifier for its "nocturnal ontology" and site upon which we locate a "creature-terror" that is both our own and not our own, a terror over alterity—that can take the form of the animal, the nonhuman, or inhuman—that is both external to us and, more terrifyingly, within us. What taxidermy captures is the horror of existence, or what Levinas calls the *il y a*.

For what remains of the animal in Moody's poem is something fuzzy: its shade (13). This partial darkness or obscurity of the animal—the alterity and unknowability of the animal, the bottomlessness of its gaze—is what continues to exist. Put otherwise: taxidermy stands as an overstuffed metaphor for existence in Levinas's sense, for "the dark background of existence" (Levinas, *Existence* 55). True to Susan McHugh's observation that "fictional taxidermies are hard to find" ("Taxidermy's Literary Biographies" 144), the poem's taxidermy is otherwise partially obscured, tucked away in the corner of the library, where, by the second stanza, we imagine it will continue to liminally exist.

The speaker's scrutiny of the taxidermy in the first stanza ultimately gives way in the second stanza to its disavowal. The remainder of the poem

TAXIDERMY AND THE HORROR OF BEING-THERE 43

sees the speaker turn away from taxidermy, finding it opposite to the work of memory that retains and "Still on thy living image dwells" (Moody 15). It is not taxidermy but memory that courts the poetic Muse here, inspiring the speaker to pen this poem, that the speaker celebrates as successfully securing immortality: "Well pleas'd could verse stern death defy" (19). By turning away from taxidermy, shirking from the bottomless gaze of its "dark eyes" and finding other arts better suited, Moody's poem captures taxidermy's shortcomings and its dark side. Gothic horror, however, turns not away but toward taxidermy's bottomless gaze, heeding its breathless call.

In what follows, I consider the experience of horror in the material encounter with taxidermy. I follow Evan Calder Williams in resisting the "whom-is-threatening-whom mode of reading" and instead "letting our eyes be drawn to background patterns and flows, to aberrations of form and intrusive details" ("Sunset with Chainsaw" 32). With this mode of reading, taxidermy, which lines the backdrop of Gothic horror texts, terrifyingly leans into the foreground. This ubiquitous, intrusive, and uncanny figure that is a catachresis for the horror of anonymous existence shows the ways that the background menacingly prevails.

With its inhuman materiality that gives body to its nocturnal ontology, taxidermy calls to us. Taxidermy's allure (for us and for characters in Gothic texts) is similar to what Jane Bennett says of a storm grate that caught her attention one day: "Glove, pollen, rat, cap, stick. As I encountered these items, they shimmied back and forth between debris and thing—between, on the one hand, stuff to ignore [...], and, on the other hand, stuff that commanded attention in its own right, as existents in excess of their association with human meanings, habits, or projects. In the second moment, stuff exhibited its thing-power: it issued a call, even if I did not quite understand what it was saying" (*Vibrant Matter* 4). In "calling" to Bennett, these items reveal their "thing-power," that "strange ability of ordinary, man-made items to exceed their status as objects and to manifest traces of independence or aliveness, constituting the outside of our own experience" (xvi). Like these things assembled together on the grate, taxidermy in Gothic horror oscillates between being background decor or debris that goes unnoticed and being vibrant matter. To be sure, taxidermy, where the trace of aliveness profoundly clings—that *still life* where *life still* appears to live—exerts a thing-power. While taxidermy's thing-power can provoke feelings of wonder, awe, or melancholia (as others have explored), this chapter and book at large delves into the darker underbelly to explore the particular and underrepresented affect of horror, an affect felt deepest in Gothic horror. For here, I argue, the material encounter with taxidermy and its thing-power is terrifying and speaks to the phenomenological horror of existence, of being-stuck or being-there.

Taxidermy's Nocturnal Ontology

As we have already considered, taxidermy is ontologically indeterminate, an assemblage of animal, object, and thing, uncannily both alive and dead at the same time. And yet, for all its profound otherness, it is horrifyingly close to us, because not only are we its origin but also because it looks back at us, reflecting to us a deeper, inescapable horror: that of existence itself.

Here, we can turn to Levinas to better understand the horror of being-there. Although he is principally known for his ethical philosophy that privileges the face-to-face encounter with another human, his early *Existence and Existents* (1947) explores a much darker phenomenology targeting the faceless, anonymous dimension of existence.[1] The darkness of Levinas's early thinking on existence helps to explain why and to what ends taxidermy so persistently and uncannily lines the background (and foreground) of Gothic horror.

It may come as a surprise for some scholars of Levinas to link him as I do here in the same breathless breath to taxidermy. After all, Levinas has a murky relationship to animals. Levinas controversially claims the human face to be "completely different" from the animal (qtd. in Llewelyn 65).[2] Cary Wolfe suggests that Levinas's account of ethics disregards the animal by seeing it as having no face, which under Levinas's philosophy of the face as the site of the ethical encounter means that the animal "cannot be an other" (*Animal Rites* 65).[3] Derrida, perhaps his most influential reader, and whose ideas also shape my thinking here on taxidermy, argues that Levinas "did not make the animal anything like a focus of interrogation within his work" (*The Animal* 105). Still others (cf. Matthew Calarco, David L. Clark) read Levinas against himself and find in his thought a way for animals to ethically encounter humans. And yet, as it relates to our discussions here of taxidermy, there is no problem with Levinas's (in)hospitality toward the animal proper, for there is a different concept in Levinas beyond the animal that comes closer to capturing taxidermy's function in Gothic horror. In other words, taxidermy

1 For others who attend to a similar latent horror in Levinas's work, see Dylan Trigg's *The Thing* and Tom Sparrow's *Levinas Unhinged.*

2 Elsewhere Levinas appears to close the gap between species, and much has been written on Levinas and the hospitality toward animals in his thinking. Levinas's essay "The Name of a Dog," for example, grants ethical force to the dog Bobby that he otherwise reserves for the human face. See Matthew Calarco's *Thinking through Animals* (2015) for a sympathetic reading.

3 For Levinas, the other is another human being. Ethics begins with the face-to-face encounter of the self with an other human being, where the other takes priority. The face is prioritized as the site of speech.

TAXIDERMY AND THE HORROR OF BEING-THERE 45

is a different sort of beast; it is a different *animot*.[4] For in taxidermy's ontological uncanniness, its strange animal-object-thingness, it is already more than a mere cognate for the animal. Indeed, it is *something*—though what exactly we cannot say for certain—that is more terrifying, and in that inhuman materiality, that uncertain existence, it comes closer to the Levinasian horror of the night.

Levinas interrogates the dark side of existence in *Existence and Existents*, a short text that, as one critic rightly notes, could even "be described as a horror story" (Buckingham 59). Here, Levinas asks us to undertake a thought-experiment and "imagine all beings, things and persons, reverting to nothingness" (51). And yet even in nothingness, writes Levinas, "Something would happen, if only night and the silence of nothingness. [...] This impersonal, anonymous, yet inextinguishable 'consummation' of being, which murmurs in the depths of nothingness itself we shall designate by the term *there* is" (52). For Levinas, we exist as beings (as "existents") within or against an inhuman sense of existence, which he describes as the *il y a* or "there is." The *il y a* hangs about us like a "dark background" (55). This darkness, analogously compared to night, the existence of existence, as it were, is always there; indeed, it is the very experience of being itself. However, it is something we might only fleetingly become aware of, such as in the experiences of fatigue or insomnia, or the childhood fear of the dark. This strange experience of the anonymous being, of this inhuman, impersonal dimension of existence is one that haunts us from within, and in precisely these horrifying terms: "The rustling of the *there is* [...] is horror" (55). For it is in the experience of the *il y a*, the confrontation with a kind of nocturnal "rustling" (55) that makes us suddenly aware of the *il y a*, that we confront an "indeterminate menace" (54). When we experience these states, such as insomnia, nauseatingly stuck awake in between sleep and consciousness, we experience the horror of existence. It is in such a night, as Simon Critchley puts it, that "we no longer regard things, but where they seem to regard us. [...] In the *il y a*, I am neither myself nor an other, and this is precisely the abject experience of horror" (*Very Little* 67). Existence, then, is like a house of horrors writ large.

4 "Animot" is Derrida's neologism to replace the singular noun *l'animal* that reduces all animals to one singular animal. *Animot* attempts to capture the plurality of animals, a feature that becomes audible when said out loud. Derrida: "We have to envisage the existence of 'living creatures,' whose plurality cannot be assembled within the single figure of an animality that is simply opposed to humanity" (*The Animal* 47).

As Levinas clarifies in a later interview, this experience of anonymous inhuman existence is felt in the childhood fear of the suffocating darkness and terrifying sound of that nocturnal silence:

> My reflection on this subject starts with childhood memories. One sleeps alone, the adults continue life; the child feels the silence of his bedroom as 'rumbling.' [...] It is something resembling what one hears when one puts an empty shell close to the ear, as if the emptiness were full, as if the silence were a noise. [...] *Existence and Existents* tries to describes this horrible thing, and moreover describes it as horror and panic. (*Ethics and Infinity* 48–49)

The horror of Levinas's account of existence registers in its sublime description: the menacing darkness in which boundaries dissolve and individual things lose their distinct identities, the deafening silence, the feeling of the abyss around us and even *within* one's own body. As Levinas continues, in this "impossibility of escaping wakefulness" felt during insomnia "is something 'objective,' independent of my initiative. This impersonality absorbs my consciousness; consciousness is depersonalized. I do not stay awake: *'it' stays awake*" (49, emphasis added). This "thing," this impersonal, anonymous thing (the *il y a*) that is both not us but is within us, that can be quasi-experienced and described, allows us to see what Dylan Trigg calls Levinas's "weird realism" (52), where the materiality of the subject

> is not annihilated by the eruption of the *il y a* but instead pushed to the surface in its strange facticity. Materialism, we can say, survives the twilight. The result is a partly-formed subject, which is present to itself while also being simultaneously conscious of its own effacement. (52–53)

In this light, then, we find Levinas's thought open to body horror, thinking the force of this uncanny inhuman, anonymous thing. But if the *il y a* horrifies for the way it can make itself felt within the body, for foregrounding the materiality even in the face of effacement, it is the persistence of this inhuman force that is most terrifying.

The even greater horror of the *il y a* comes with its inescapablility, with knowing of our "condemnation to perpetual reality, to existence with 'no exits'" (*Existence* 58). This is the experience of being itself, of being-there. We are ourselves perpetually haunted by the "rumbling" of the dark background of existing, which we feel as a "density, an atmosphere, a field" (59) that overwhelms us. As Levinas elsewhere puts it, we feel the fullness

TAXIDERMY AND THE HORROR OF BEING-THERE 47

of this impersonal, indeterminate sense of nothingness: "This absence of everything returns as a presence, as the place where the bottom dropped out of everything, an atmospheric density, a plentitude of the void, or the murmur of silence" (*Time and the Other* 46). Most torturously, the *il y a* keeps us in its grip. As Will Buckingham puts it, the *il y a* "impresses itself upon us without ever annihilating us, threatening to swamp us without ever actually doing so: the horror is all the worse because it always threatens to destroy us, but continually pulls back from the brink of doing so" (61). After all, death would ultimately be an escape, a release from the horror of existence that clings to those existing. The ongoingness of existence is a kind of preservation in life, existence without ex-stasis (the ability to be outside oneself).

Levinas's thought here moves against Heidegger. Put briefly, Heidegger's core idea is that Being is defined by anxiety toward death, the horror of anticipating a future time when we will exit existence and enter nothingness. Conversely, for Levinas, "Horror is nowise an anxiety about death" (*Existence* 56); we live with the horror of never exiting existence, of being stuck in life. It is, in short, the horror of still life, the "horror of immortality, perpetuity of the drama of existence, necessity of forever taking on its burden" (58). Levinas points to multiple examples in literature, including those that draw on the Gothic (Shakespeare, Poe, Huysmans, de Maupassant, Blanchot). And indeed, we continue to find this horror of interminable existence in countless scenarios in Gothic horror, such as in the fear of being hijacked by an alien thing, a mysterious virus, or a sadistic surgical procedure, hollowed out of one's consciousness and subjectivity, rendered as not oneself but still not dead, stuffed as it were into anonymous existence.

While the night of insomnia is the best-known example of Levinas's anonymous existence, what is of interest for us here, in light of taxidermy, is the formal iterations of night. As Levinas notes, there are "different forms of night that occur right in the daytime" (*Existence* 54). For example, we feel these impersonal forces when we are exhausted and "things and beings strike us as though they no longer composed a world, and were swimming in the chaos of their existence," in the work of poets and writers where "beings and things that collapse into their 'materiality,' are terrifyingly present in their destiny, weight and shape," in short when authors make "things appear to us in a night" (54–55).[5] Taxidermy, I offer, could be added to this list.

5 Maurice Blanchot, an author and philosopher who earlier took up the concept of the *il y a* in similar ways as Levinas, more emphatically explores the *il y a* as the space of literature.

48 TAXIDERMY AND THE GOTHIC

Within Gothic horror, material encounters with taxidermy bring us into a strange phenomenological experience not unlike that of the Levinasian night. We can think of taxidermy as an imago of the *il y a*, a catachrestic image for the *il y a* stuffed with fur, feather, and dark glassy eyes. For catachresis, as Calvin L. Warren puts it, *"creates a fantastical place* for representation to situate the unrepresentable" (145, orig. emphasis). In taxidermy's nocturnal ontology, this different form of night, we uncannily find the rustling of our own capture or stuckness within existence. Being-there is being-stuck in life, a point often hammered home with characters, who have initially closely approached the taxidermy that haunts the dark background, and come to find themselves restrained by and/or tortured under the watchful eyes of taxidermy. Taxidermy presents us with a stuffed, three-dimensional embodiment of this "existence with 'no exits'" (Levinas, *Existence* 58), the horrifying inescapability of life that still lives in still life. While taxidermy in Gothic horror often results in death for those who enter into an encounter with it, the greater horror it secretly, breathlessly hides beneath its hide is the way it more terrifyingly scratches at the insidious and interminable horror of existence—of violence and violations without end.

Furthermore, as we see in characters' close encounters with taxidermy in Gothic horror texts, this horror within taxidermy seeps out through a minute particular: the dark glassy, unblinking eyes. These eyes and their attendant "bottomless gaze," I offer, serve as taxidermy's horrifying *punctum* in Roland Barthes's sense of a powerful detail within the image that "wounds" or "bruises" the viewer—a feature repeatedly emphasized in Gothic horror.[6]

Bottomless Gaze

To understand the "bottomless gaze" of taxidermy, we turn to Derrida. In his essay, "The Animal that Therefore I Am (More to Follow)," Derrida reflects upon the estranging yet everyday experience of being seen naked by his cat. Filtering this intimate experience through a counter-reading of Levinas (who, to recall, sees the animal as having no face), Derrida recognizes the animal as having a face and thus a gaze. The cat's unnerving gaze in this naked face-to-face encounter is, for Derrida, bottomless. We might think of this as a gaze that invites an endless falling (we could imagine it like Chris falling backward into the abyssal space of

6 *Punctum*, Barthes writes in *Camera Lucida*, is a "sting, speck, cut, little hole. [...] A photograph's *punctum* is that accident which pricks me (but also bruises me, is poignant to me)" (27).

TAXIDERMY AND THE HORROR OF BEING-THERE 49

the Sunken Place in Peele's horror film *Get Out*): for we are never able to land upon, with confidence, what exactly that gaze means. It is a gaze that is, as Derrida puts it, "at the same time innocent and cruel perhaps, perhaps sensitive and impassive, good and bad, uninterpretable, unreadable, undecidable, abyssal and secret" (12). This groundlessness or bottomlessness of the animal's gaze disrupts Derrida, producing in him a terror response, a "dizziness" (17) in this "instant of extreme passion" (12):

> As with every bottomless gaze, as with the eyes of the other, the gaze called 'animal' offers to my sight the abyssal limit of the human: the inhuman or the ahuman, the ends of man, that is to say, the bordercrossing from which vantage man dares to announce himself to himself, thereby calling himself by the name that he believes he gives himself. And in these moments of nakedness, as regards the animal, everything can happen to me, I am like a child ready for the apocalypse, *I am (following) the apocalypse itself*, that is to say, the ultimate and first event of the end, the unveiling and the verdict. (12)

In the inability to decipher the gaze, to know what is behind or at the bottom of this look, which points to the larger inability to know the other, the animal reveals to Derrida the demarcating line of the human. In those dark, bottomless eyes—eyes that I offer are not unlike the dark eyes of the taxidermy in Moody's poem or in Gothic horror texts—Derrida feels his own passivity and finitude ("everything can happen to me" [12]) and the failure of human efforts (thinking being the main one) to erect discrete, inviolable boundaries. Indeed, this experience appears to jam or suspend thinking, as Derrida notes this encounter confronts him with "an existence that refuses to be conceptualized" (9). Perhaps it is in this sense of being "like a child," of not having the ability to conceptualize this encounter, that Derrida feels further estranged from himself. I follow Jacques Khalip's reading of this animal figure as one that "blankets the inhumanness, the nothingness that corrodes the various taxonomies we ordinarily establish in the service of maintaining the social and political legibility of things" (321). As Khalip suggests, the bottomless animal gaze serves as a scene of thought's ends rather than beginnings, emerging as something "that isn't properly alive, but *unlived* [...] queerly recalcitrant and autonomous, an inhuman materiality that disasters human optics altogether" (322).

The enormity of this affective response, the sublime swelling of this moment to the brink of an interior apocalypse, upon recognizing the "abyssal limit" in the bottomless gaze, eventually passes, and Derrida can return to reading, writing, and living alongside animals without this existential frisson. That is,

until the next time. After all, this is a repeated scene for Derrida, an instance, I offer, of everyday horror.

What Derrida's description of his naked encounter with his cat's bottomless gaze reveals is the vertiginous moment in which Derrida experiences a profound undoing of human exceptionalism, human power/knowledge, and even ontological stability, all feelings associated with cosmic horror. This charged account, I offer, also describes a scene that Gothic horror repeatedly returns to and exploits particularly with regard to taxidermied animals, namely that flickering just below the surface, perhaps in the backdrop of our everyday lives—whether mounted on the walls of cabins or stuffed in the corners of libraries—a terrifying encounter with the animal (or "animal-object-thing") lies in wait.

But before we turn our eyes to taxidermy in Gothic horror, to help visualize this experience of ontological undoing via the bottomless animal gaze that can happen even in mundane moments of our lives where we might least expect it, let us briefly consider Caravaggio's *Rest on the Flight into Egypt* (c.1597) (Figure 2.1). Here, I offer, we see the abyssal bottomless

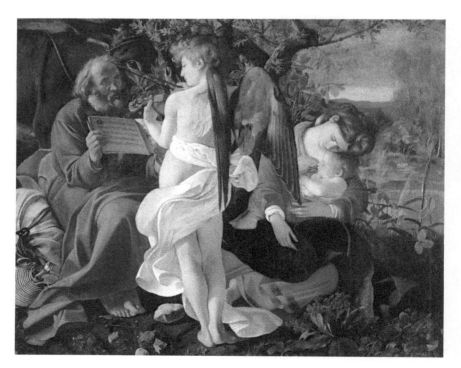

Figure 2.1 Caravaggio. *Rest on the Flight into Egypt*. c.1597. Galleria Doria Pamphilj. HIP/Art Resource.

TAXIDERMY AND THE HORROR OF BEING-THERE

gaze at work. The painting depicts a scene of Mary peacefully resting with the infant Jesus in her arms, while Joseph holds a musical score for a youthful angel who stands, luminously painted, in the center of the painting playing the violin. Tucked away, almost imperceptible in the busy upper-left quadrant of the painting is the detail or *punctum* that introduces unrest: the large animal eye, emerging out of the dark background. Caravaggio offers this dark eye as the most prominent part of the donkey, with much of the rest of the face hidden behind the brush. Furthermore, this eye is the sole object that appears to look outward at the viewer. As Jean-Christophe Bailly says of this painting, the donkey's eye "creates a hole in the painting" producing the effect that "*someone* is looking at us" (32). Whereas Bailly is "struck by another beauty and another gentleness" of the donkey (32), this animal gaze is one of "pure pensivity" (33), I read this scene otherwise. The large black eye is an unquiet thing lurking in the dark background, its presence interrupting the otherwise pastoral scene. Rustling in the background, in between the faces of Joseph and the angel, it watches not only this entourage but us, too. Complicating readings of this gaze (like Bailly's) that would find in it a sweet watchfulness is what I see as the painting's association of the gaze to violence as staged in the unnerving proximity of the angel's bow to the eye. Ratcheting up the affective unrest and intensity of the scene, the musical bow that invokes the hunting bow (objects with a long-entwined history) plays dangerously close to the large animal eye.[7] Admittedly, it is equally possible that the bow is not near the eye but only appears as such because of our vantage point and the chiaroscuro effect. And yet, regardless of whether these objects (eye and bow) are actually touching, the fact that they appear to be and visually occupy the same space is enough for the animal's gaze, coupled with the sharp line of the bow's razor-like edge (like the terrifying scene in Dali's *Un Chien Andalou* [1929]) to fill the scene with anxiety. Indeed, in the background of violence, *viol*, one can also hear the *violin*.

The specter of violence that haunts the background of this painting now tears through it into our foreground. I am less interested in tethering this violence to specific events (e.g., King Herod's plan to kill Jesus and the Massacre of the Innocents) or linking it to the fear of death than in reading it for the affect of its formal structure: that is, for the way the background conditions the foreground, for how this stages the horror of the *il y a*,

7 Some scholars suggest the historical co-development of musical and hunting bows can be dated to c.13,000 BCE through a cave painting at Les Trois Frères in France that depicts a shamanistic bison-human playing a hunting bow. Elsewhere, Plutarch describes Scythians playing music on their hunting bows (Friedmann, *Musical Aesthetics*, 116).

capturing here something of the restlessness of anonymous existence—what for Levinas is the existence of existence itself—that is always rustling in the background, producing the horrifying sense of being submerged in the nocturnal shadows of existence itself. It is, rather, an image that speaks to the horror of existence, of life, of the larger existential unrest that persists even in rest. In this "undetermined menace," the subject/"I" is stripped of its subjectivity, undone by what Levinas calls "an *impersonal vigilance*" (*Existence* 55) of this "dark background" of existence, analogously rendered by this sole dark insomniac animal eye, neither subject nor object but a horrifying nonhuman gaze.

Recalling Derrida's injunction of the bottomless animal gaze and its invocation of the apocalypse ("I am like a child ready for the apocalypse, *I am (following) the apocalypse itself*" [*The Animal* 12]), the bottomless gaze portends calamity, some great revelation or disclosure, but of what exactly cannot be said. After all, to quote Derrida again, this bottomless gaze is yoked to "an existence that refuses to be conceptualized" (*The Animal* 9). In short, the paradoxical unrest that haunts Caravaggio's painting, then, anticipates the similarly disturbing affect of taxidermy in Gothic horror.

Taxidermy's Bottomless Gaze in Gothic Horror

While taxidermy appears ubiquitous in Gothic horror texts, hidden in plain sight, it serves within them as a strange attractor, forming a constellation with the text's dark desires and energies. The gaze of taxidermy, especially as it appears in Gothic horror texts, fittingly extends Derrida's concept of the animal's bottomless gaze. In numerous texts, it is the close-up detail of a mount, often a glassy eye, that serves as the taxidermic specimen's signature and arguably most unnerving feature. I turn now to a few scenes across a range of horror films that home in on the horror of taxidermy's bottomless gaze: *Psycho* (1960), *The Texas Chainsaw Massacre* (1974), *A Classic Horror Story* (2021), and Ana Lily Amirpour's *The Outside* from *Guillermo del Toro's Cabinet of Curiosities* (2022).

But while taxidermy serves to ratchet up terror and hugs the line as a monstrous animal-object-thing with its nocturnal ontology, it unnerves and gets under our skin for the uncanny ways it is also strangely like us. This uncanny encounter and identification heavily revolves around the eye, that site of the bottomless gaze. "The eye," as Peter Hutchings explains, "is the principal human organ for horror cinema. Directors will frequently use close-ups of the eyes of victims, wide and helpless, and monster, narrowed and aggressive, to accentuate the genre's sado-masochistic thrills" (112). The close-ups of taxidermy's eyes in Gothic horror, those wide and glassy

TAXIDERMY AND THE HORROR OF BEING-THERE 53

dark eyes, establish it as dilated, as another kind of viewer that takes it all in. But these vacuous eyes blur the line between seeing (and by extension knowing) everything and nothing, another kind of horror at the dissolution of boundaries. Taxidermy intensifies the bottomlessness of the animal's gaze. Its gaze is a kind of inhuman materiality that slides across the encounters between the subjects and objects. And, just as in the encounter between Derrida and his cat that arrests him (eye contact that makes him confront the radical alterity of the nonhuman other), the encounter that characters in Gothic horror texts have with taxidermy, through the taxidermic gaze, similarly invokes categorical and even existential crises.

As we have seen in the previous chapter, the uneasiness of taxidermic eyes predates Hitchcock; recall how they are already there glimmering in the fiction of Bulwer-Lytton and H. G. Wells. However, we might trace the filmic constellation of taxidermy's horrifying gaze to Hitchcock's *Psycho* and its infamous motel shower scene, a scene that has garnered much scholarly attention. Some critics read this scene that visually links a montage of wide-open eye figures—the eye-ball-shaped shower head, and the wide-open eye of Marion that dissolves into the gaping black tub drain—as an image of birth, the shower as a defiled womb (Rothman 313–17), but it is more strikingly a scene repetitively staging stasis. I offer that we should read the scene as extending the gaze of the film's earlier scenes of taxidermy in Norman's office, where dozens of taxidermic eyes stare unblinkingly at Marion, and where we are meant to understand Marion (and Norman) as akin to taxidermy: stuck and flightless. As Norman famously says to Marion, "Do you know what I think? I think that we're all in our private traps. Clamped in them. And none of us can ever get out. We scratch and claw, but only at the air, only at each other. And for all of it, we never budge an inch." The power of *Psycho*'s shower scene also tells us something of the affective power of taxidermy: these glassy eyes serve, like the tub drain, as an orifice that suck us in, an un-living, inhuman object-thing with a bottomless gaze (Figure 2.2). The strangely inhuman materiality of this bottomless gaze flows from *Psycho* into Gothic horror films produced in its wake.

Moving in the blink of an eye, as it were, from *Psycho*, that kickstarted Gothic horror film's obsession with taxidermy, we turn now to *The Texas Chainsaw Massacre* (dir. Tobe Hooper, 1974), a film where closely looking upon taxidermy appears to be the first (mis)step (literally here) toward an untimely death. The film revolves around a group of five friends, who, led by Sally (Marilyn Burns) and her brother Franklin (Paul A. Partain), take a road trip to visit Sally and Franklin's grandfather's grave that might have been vandalized. On their travels, they also visit their family's old farmhouse and discover a family of cannibals living at the taxidermy-filled Sawyer farmhouse

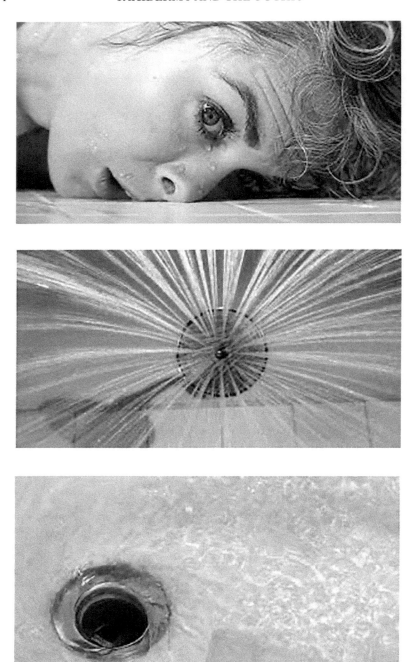

Figure 2.2 Screenshots from *Psycho* (dir. Hitchcock).

TAXIDERMY AND THE HORROR OF BEING-THERE 55

next door, including Leatherface (Gunnar Hansen), who wears a mask out of human skin and gruesomely murders the friends (with the exception of Sally, who barely escapes). The psychotic Sawyer family, we learn, used to work at the local slaughterhouse, and they perversely apply those techniques on humans, slaughtering them for meat to eat.

Taxidermy dazzlingly enters the film—mounted against a pop of red accent wall amidst an otherwise dark and gloomy scene in the Sawyer family farmhouse. It is a rich red that reminds us not only of blood but also of the taxidermist's red curtain in Charles Willson Peale's 1822 painting *The Artist in His Museum* (discussed in Chapter 1). And indeed, Leatherface in his farmhouse emerges here like an iteration of Peale, a taxidermist-artist-curator in his own museum, stuffing animals and mounting them for display in a space recalling the tradition of the cabinet of curiosity, albeit a dangerous artist who perversely stuffs himself in gorging on his visitors.

This film suggests that by looking upon taxidermy, by brushing against it this way, one risks becoming consumed by it. This is on display in the film's encounter with taxidermy. When Sally's friend Kirk (William Vail) enters the Sawyer farmhouse, he immediately sees taxidermy and skulls that are mounted, floor to ceiling, on a bright red wall at the end of the dark hallway. The camera shot here appears to stutter in a choppy succession of close-ups on the taxidermy, a technique that ratchets up anxiety.

Although in the film it is difficult to see any other taxidermy beyond the central deer, the screenplay describes the wall as being "crowded with stuffed animal heads. [...] There are deer, elk, moose and bear and various other game animals and also the heads of domestic animals, a cow, a pig, a horse and a goat and a number of heads to [sic] small to be distinguished at the distance" (Hooper script 51) (Figure 2.3). Far from fearful, Kirk, the script notes, "is delighted; he pokes his head into the hallway for a better look" (51). When Pam (Teri McMinn) ignores his invitation to join him in looking ("Come look [...] come look"), he ventures in alone into the belly of the beast. Indeed, with its hanging hides and red orifice-like wall of taxidermy, the farmhouse is like an animal that Kirk enters.

In the film, Kirk appears more revulsed than "delighted," and as he runs toward the taxidermy, he trips and stumbles at the threshold. As Kirk raises his eyes, Leatherface jumps out and stands between Kirk and the taxidermy, killing Kirk with sledgehammer blows to the head. Leatherface visually takes the place of taxidermy by eclipsing it. With Leatherface standing as taxidermy's substitute, we see once again taxidermy aligned with danger, perversion, and unnatural death (Figure 2.4).

Other encounters with taxidermy in the film include those with Pam and Sally (Marilyn Burns). Pam does eventually enter the house and

Figure 2.3 Screenshot from *The Texas Chainsaw Massacre* (dir. Hooper).

Figure 2.4 Close-up of Leatherface's taxidermy. Screenshot from *The Texas Chainsaw Massacre* (dir. Hooper).

although she does not see the same room of taxidermy that "delighted" Kirk (as Leatherface has closed the door), she encounters "crudely stuffed cats" among other corporeal human and animal horrors in the living room (53). Sally, another friend in the group, later finds in the grandfather's room "crudely stuffed and bloated cats and dogs [with] their mouths and eyes sewn shut" (76).

Sally's taxidermic encounter with stuffed companion species is unusual. First, it is a practice that, as we examined in the previous chapter,

TAXIDERMY AND THE HORROR OF BEING-THERE 57

was already frowned upon for producing monstrous results in the nineteenth century (as parodied in *Fun* magazine). However, the film's representation is especially horrifying in that these stuffed companions have been doubly silenced: dead, with the organs of perception and communication also sewn shut. If animals, especially those we are close with, like cats and dogs, "'hail' us animal people," as Donna Haraway puts it (*When Species Meet* 278), the film's sewn-up former favorites gesture to an attempt to foreclose such possibilities, to deny the animal's ability to call to us. And yet, what ultimately lives on (like Leatherface) despite this disavowal is taxidermy's vital presence in Gothic horror. Thus, we might say that, like Leatherface stepping into view and eclipsing the taxidermy, something monstrously alive hides beneath or behind taxidermy's stilled surface—a trope to which Gothic horror repeatedly returns. Indeed, many of these elements—the deer taxidermy, the red wall, the sledgehammer, and the fact that the torture occurs beneath the taxidermy—reappear in *A Classic Horror Story*.

In *A Classic Horror Story*, the tables have turned. Here, it is not that looking upon taxidermy is a fatal misstep, but rather that taxidermy unsettlingly looks back. *A Classic Horror Story* (dir. Roberto De Feo and Paolo Strippoli, 2021) is a film that pays homage to taxidermy's Gothic horror origins with its many nods to *The Texas Chainsaw Massacre*, *The Cabin in the Woods*, and *Midsommer*. Set in southern Italy, *A Classic Horror Story* follows five strangers who rideshare an RV and end up crashing into a tree (Figure 2.5). When the strangers awaken, the road has disappeared and they find themselves lost in a forest with nothing around but a seemingly abandoned cabin in a clearing, which belongs to a murderous mafia cult and becomes the site of brutal sacrificial violence, as the strangers struggle to get out alive, mostly to no avail. Only one of the strangers, the protagonist Elisa (Matilda Lutz), manages to escape. The shocking revelation is that one of the strangers, Fabrizio, who owns the RV and has coordinated the rideshare, is an amateur snuff filmmaker working for the cult and has orchestrated and secretly filmed all the horrific events in hopes of producing a classic horror story.

Taxidermy looms large in *A Classic Horror Story*. The opening shot of the film is a close-up of a taxidermied stag mounted on a red-stained cabin wall. As the camera pans down, we see a woman bloodied and bound to the table beneath the taxidermy. A menacing hooded figure enters the cabin dragging a large, heavy sledgehammer, and the film cuts away just as the figure swings the hammer at her legs. As viewers, we are uncertain of the time of this event. Is this past, present, or future violence? Like the uncanniness of taxidermy (both past and present, both dead and alive), the film's opening scene uses taxidermy to symbolically align it with danger and temporal disorientation.

Figure 2.5 Screenshot from *A Classic Horror Story* (dir. De Feo and Strippoli).

After this opening hook, we do not encounter the taxidermy again until the group of strangers have crashed their van and stumble upon the cabin. When Elisa slowly enters the cabin, she immediately sees the taxidermy—the same mount from the opening scene. As if called by it, she walks directly toward it and arrives in a close face-to-face encounter. The camera shot, with a close-up of the taxidermy's dark red glassy eye recalling a globule of blood, shows the reflection of Elisa and her enchanted gaze (see Figure 2.6). Initially, Elisa's response itself seems suspended, recalling Edmund Burke's description of sublime "astonishment" as "that state of the soul, in which all its motions are suspended, with some degree of horror. In this case the mind is so entirely filled with its object, that it cannot entertain any other, nor by consequence reason on that object which employs it" (Burke 101). Immediately following this complex shot—in what is a triangulated gaze between Elisa, the taxidermy, and the camera—Elisa turns away from the taxidermy and continues exploring the cabin.

Let us linger on this triangulation of Elisa, the taxidermy, and the camera. For it redoubles what is a key feature in Gothic horror's material encounters with taxidermy: the emphasis on looking. These encounters invite us to read them as scenes of identification, moments that stage the tensions between

Figure 2.6 Elisa reflected in taxidermy's eye. Screenshot from *A Classic Horror Story* (dir. De Feo and Strippoli).

blindness and insight and reflect back the horrors that await the onlooker who, like the taxidermy staring back, is (often unknowingly) stuck.

In showing the reflection of Elisa's face in the taxidermied stag's eye, the scene enables us to see what might be a process of identification between Elisa and taxidermy. If Elisa, who was traveling via the rideshare RV to have an out-of-state abortion, was already at risk of being stuck, having to carry an unwanted pregnancy, now the more absolute existential threat of being stuck to violently die at the cabin hangs pregnant in the air. Taxidermy forces us to encounter the possibility that we ourselves might be objects or prey, just as those coded as female or non-white often are aligned with the animal.

Elisa's attempt to solve the mystery of the cabin and why they have ended up here repeatedly brings her before the taxidermy—a figure that we, as viewers, associate with insight or knowledge, as it has witnessed violence (as we know from the film's opening scene) and will continue to do so, including witnessing Elisa's own eventual torture later in the film. Even the form of her torture, being nailed to a wheelchair, reifies the horror of being stuck that is symbolically associated with taxidermy. Yet already here in Elisa's first material encounter with taxidermy, pinned under the taxidermy's unblinking gaze, an enthralled yet expressionless Elisa stares back. It is a scene that for us too is bottomless, generating more questions: What does Elisa see? The taxidermy or herself? What does the taxidermy see? And indeed, with the eventual disclosure that the whole scene is being filmed for a snuff film, this scene does see.

60 TAXIDERMY AND THE GOTHIC

The questions this scene provokes are not unlike those that arise in arresting encounters with the animal gaze. Is the agent of anxiety or horror in such an encounter the animal or ourselves? Where Derrida aligns animal alterity with the abyss felt in this gaze, a gaze that speaks to an existence that lies beyond conceptualization, Žižek renders that abyss the human's own, the horror of finding one's own abyss in that reflection. As Žižek, in response to Derrida, asks: "What if the perplexity a human sees in the animal's gaze is the perplexity aroused by the monstrosity of the human being itself? What if it is my own abyss I see reflected in the abyss of the Other's gaze"? (*Less Than Nothing* 414). The reflection of Elisa's own face in the glassy eye coupled with her blank expression enacts this very thing.

Elisa's blankness suggests that her subjectivity becomes suspended, rendering her taxidermy's uncanny double. As Žižek notes, "the horror of coming face to face with my double is that this encounter reduces me to the object-gaze" (*Enjoy Your Symptom* 121). In this scene, Elisa is strangely taxidermy-like. While we, like Elisa, know that the taxidermy is not another subject looking back, and that it remains a strange inhuman-object-animal-thing, we nevertheless have the gnawing feeling that it is looking back at us from these glassy bottomless eyes. One way to better understand the dynamics at play here is to turn to post-Lacanian psychoanalysis. This disturbing sense that the object is somehow returning the gaze is what Žižek calls the "object gaze," a "kind of empty, a priori gaze that cannot be pinpointed as a determinate reality [...] the object returns the gaze from this blind spot" ("I Hear You with My Eyes" 90).[8] The terrifying effect of this encounter to us as subjects is nothing short of an undoing of our sense of bodily and psychic integrity. The sense of being gazed upon by something external to ourselves leaves us haunted by the sense that our vision is not really our own. We become aware of the alterity of the gaze in the unsettling realization that, as Žižek puts it, "I can never see the picture at the point from which it is gazing at me" (*Looking Awry* 125). (It is the same for the voice, but we will sidestep that point for now). The gaze of the object, he argues (extending Lacan), is "a stain," a stubborn object that "prevent[s] me from looking at the picture from a safe, 'objective' distance, from enframing it as something that is at my grasping view's disposal" (125). The stain spreads, and we do not go untouched. We find it in the classic Gothic horror film scenario in which "the subject sees the house, but what provokes anxiety is the indefinable feeling that the house

8 Lacan adds the gaze and the voice to Freud's list of partial objects. For Lacan, the gaze and the voice belong more on the side of the object rather than the subject, as they are not properly placed within us, always seeming to arrive from elsewhere.

TAXIDERMY AND THE HORROR OF BEING-THERE 61

itself is somehow already gazing at her, gazing at her from a point that totally escapes her view and thus makes her utterly helpless" (126).

Such a convention, of an object uncannily looking back (e.g., haunted houses, portraits, dolls), is everywhere in the Gothic tradition, dating back to its Walpolean origins. And it continues to play a recurrent role in close taxidermic encounters within Gothic horror, where again the lesson repeatedly hits home (like a bloody sledgehammer to the head!): that it is dangerous to look upon taxidermy for it enthralls with a gaze that is bottomless, violent, and undoing, a gaze that reveals the horror of anonymous existence, of being stuck (within our finite, fleshy bodies). Paradoxically, this uncanny animal-object-thing that is taxidermy, oft-overlooked and dully lining the background, something stuck between life and death, comes to foreground our own horror over existence. To put it otherwise: taxidermy breathlessly speaks to the strangeness and horrors of life from which we cannot escape.

Where in the first taxidermic encounter of the film we see (in Elisa's reflection) the abyss of the human reflected in the abyssal gaze of taxidermy, we later also hear it, as articulated in the sounds of horror, namely the screaming and squelching "acousmatic" sounds (sounds that one hears without seeing their source). When the first of the travelers, Mark, is being tortured on the table, the camera eventually cuts away from his body and closes in instead on the taxidermied stag's face. The stillness and muteness of the taxidermy provide a stark contrast to the sounds of torture: the rattle of shackles, screams, thuds, and squelching. Unseen sound, as Mladen Dolar says of the acousmatic voice, "is so powerful because it cannot be neutralized with the framework of the visible, and it makes the visible itself redoubled and enigmatic" (*A Voice* 79). At the end of the scene, when the torture is complete, the lighting on the taxidermy changes, and we are left with the taxidermy in a dramatic chiaroscuro as the scene's sole visual object, enigmatically signaling the dark side of taxidermy.

The sense that taxidermy is impossibly attempting to "tell us something," to speak to the film's characters (or to us) like a Philomela is further intensified not only by the discovery of a young girl upstairs in the cabin whose tongue has been cut out but also when taxidermy appears to be secretly participating in the transmission of information. For instance, later in the film after Elisa discovers Fabrizio's secret earpiece and confronts him in the cabin, Fabrizio turns and speaks directly to the taxidermy, saying "Take her," at which point the cabin door bursts open and masked torturers enter and grab Elisa. Fabrizio's direct address to the taxidermy, following the earpiece discovery, allows for the possibility that taxidermy may be part of the surveillance or filmmaking apparatus. In other words, this old moth-eaten taxidermy may be "bugged" in more than one way. This scene serves

as a repetition (with a difference) of Elisa's earlier taxidermic encounter and works to further intensify our uncertainty over its function (friend or foe? sympathetic or sadistic?), a suspicion that remains in suspension as taxidermy continues to hold its thing-power.

Ana Lily Amirpour's *The Outside*

The bottomless gaze and nocturnal ontology of taxidermy speak to the various ways that characters in Gothic horror are stuck in an existence that is thoroughly horrifying. While we, as viewers, may cringe in its appearance in gory films, such as *A Classic Horror Story* or *The Texas Chainsaw Massacre*, where taxidermy is most closely aligned with sights and sounds of violence and torture, in other texts, where taxidermy's affective force is more unsettling than frightening, the appeal to taxidermy's glassy bottomless gaze nevertheless persists. This is the case with Ana Lily Amirpour's *The Outside*, a film belonging to *Guillermo del Toro's Cabinet of Curiosities* (2022) (Figure 2.7).

Partly due to its timely release date coinciding with Halloween, and partly due to Guillermo del Toro's status as one of the living masters of Gothic horror, it comes as no surprise to see *Guillermo del Toro's Cabinet of Curiosities* (2022) as the number one viewed Netflix show in October/November 2022. In homage to Hitchcock, del Toro soberly introduces each of the eight short horror films and their directors that make up his anthology; as he does this, he also selects an item that relates to the film he introduces from a towering and intricate wooden cabinet, drawing on the tradition of the *Wunderkammer*.

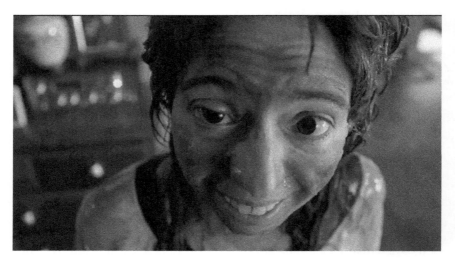

Figure 2.7 Screenshot from *The Outside* (dir. Amirpour).

TAXIDERMY AND THE HORROR OF BEING-THERE 63

The films and their directors, like the disparate items in a cabinet of curiosity, are curated by del Toro. Taxidermy appears in the series trailer and in two of its eight short films, as background decor in Keith Thomas's *Pickman's Model* and prominently in the foreground in Ana Lily Amirpour's *The Outside*, the latter of which is the remaining focus of this chapter.[9]

The Outside tells the story of Stacey (Kate Micucci), an ugly duckling who struggles and ultimately succeeds to become a beautiful swan, but at gruesome costs. Stacey, a meek and mousy bank teller by day and a skilled amateur taxidermist by night, is invited to a Christmas party at a coworker's swanky house. Her not-so-secret Santa gift, a freshly killed and taxidermied duck, is poorly received by her vain and catty coworkers, and it is at this party that she feels the pressure to fit in and to indulge in a new skincare lotion, "Alo Glo." (The name a likely nod to other A-list beauty pyramid schemes, like Avon and Arbonne). The late-night infomercials for Alo Glo psychotically promise to transform her and bring out the "new Stacey"—the infomercial host (played by Dan Stevens) appearing to speak through the television directly and personally to Stacey. Despite a horrible allergic reaction to the product, Stacey breaks out in red, blistery patches that she scratches until bloody, and the multiple attempted interventions by her mild-mannered husband, Keith (Martin Starr), Stacey persists to lather her broken and bloodied skin in the mysterious lotion. After ordering a large case of lotion online, Stacey hides it in her basement taxidermy workshop, where one day she discovers the lotion has oozed everywhere and taken on a humanoid form of its own. Pygmalion-like Stacey sensually embraces this dripping lotion figure under the watchful eyes of the taxidermy, and then kills her husband with an axe, before proceeding to have a sensual bath with/in the lotion form. As she bathes, Stacey's orgasmic sounds suggest the lotion is entering her, transforming her outside from the inside. (It is a much sexier iteration of Buffalo Bill's infamous jingle "it rubs the lotion on its skin" from *Silence of the Lambs*). Stacey emerges, strutting down the hallway to the bedroom (with the song "You Sexy Thing" by Hot Chocolate playing) and sloughs off her thick lotion/skin in front of a mirror to reveal a beautiful Stacey beneath. With her new skin, Stacey then drags her husband's body to the basement and proceeds to taxidermy him. Then, she positions his finished form seated on the couch in front of the television—a place we habitually see him sitting and eating—and she heads off to work. Now, Keith sits there stuffed not on

9 *The Outside* is based on the teleplay by Haley Z. Boston, and the webcomic "Some Other Animal's Meat" (2016) by Emily Carroll: http://www.emcarroll.com/comics/meat/.

finger foods from the freezer, but with Stacey's handiwork, taking his place in her diorama of domesticity alongside her other furry friends.

At the bank and in her new appearance, Stacey is finally accepted by her coworkers who coo over her and praise her transformation; Stacey now looks like them and she indulges in their gossipy conversations. If we, as viewers, feel disappointment in this scene, such a feeling quickly changes into discomfort. For the film ends with an uncomfortable, lengthy scene of Stacey laughing alongside the other women. The camera closes in on just Stacey, who laughs too long, all while contorting her face and looking directly into the camera. It is a scene reminiscent of the scene in *Evil Dead II* when the taxidermy deer mount begins hysterically laughing, and the maniacal laughter goes on for far too long (see Figure 2.8). We are reminded that we cannot trust the outside, and the inside is no better; the promises of improvement (physical but also personal, moral) of achieving a new-improved-self are as slippery as Stacey's face.

Stacey is the latest in the long tradition of the taxidermist as a counterfeit and dangerous Gothic figure. While this is thinly disguised by the film's initial presentation of her as meek, mousy, and hardworking, we soon see we have been duped. The unsteadiness, the volatility of Stacey by the end of the film, stands in stark contrast to the film's opening, where Stacey is quietly established as a sure shot. Early in the film, not only do we see her shoot a duck out of the sky in a single shot, but the vast menagerie of various stuffed animals in her house—birds throughout the living room and bedroom, foxes and other critters in the basement—all establish Stacey as talented and skilled

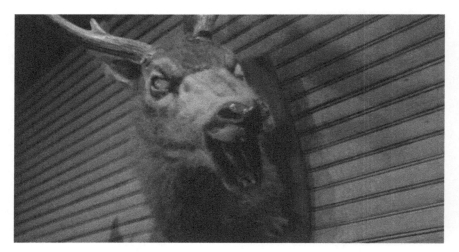

Figure 2.8 Screenshot from *Evil Dead II* (dir. Raimi).

in this unusual hobby. But the steadiness quickly slips. When Stacey hears a noise while home alone at night, she strangely grabs an axe (the one she will later use to kill her husband). This begs the question: Why would such a skilled shooter not grab a gun? Looking for the intruder (there isn't one, in the end), Stacey heads to the basement, affectionately asking a taxidermied fox if he saw anything. This more fuzzy than frightful conversation with taxidermy is nevertheless suggestive of Stacey's numerous transgressions to come, such as the way she will blur boundaries with the infomercial, by psychotically talking with (not simply "to") the television; with the lotion figure in the sexy bath-time scene, by being pleasurably penetrated by it; with the practice of taxidermy, in her object-choice perversely shifting from animal to human; and, ultimately, with the camera itself, by laughingly turning her gaze from her coworkers toward us, the viewers (see Figure 2.9).

Tearing out the insides and replacing them with Styrofoam and carefully stitching up the skin, Stacey's taxidermic practice positions interiority as rejectamenta, and the exterior skin as beautiful. However, in herself, she finds the inverse: the exterior requires alteration to match an inner transformation she feels she has already undergone. She is purportedly, as Keith tells her, beautiful on the inside. If we are initially set up to believe that Stacey's mousey exterior belies her majestic inner beauty, such an easy allegorical reading is undermined by her obsession with taxidermy. Her passion for taxidermy, for stuffing and preserving beautiful skins, suggests that Stacey may have always idealized the exterior. The troubling question that the ending appears to answer in the affirmative is this: Is Stacey just like

Figure 2.9 Screenshot from *The Outside* (dir. Amirpour).

her coworkers, after all? Is she actually a wolf in sheep's clothing? Or, to use a more appropriate animal metaphor: Is she just an odd duck, through and through?

That Stacey is an odd duck is further reified by her particular choice and treatment of taxidermic specimen for her secret Santa gift. She strangely taxidermies the recently shot duck, which she affectionately calls "handsome," at the kitchen table rather than in her workshop, an early signal of boundaries being breached. As she does her work, she excitedly tells an unimpressed Keith (who stands at the microwave cooking his frozen dinner) of her invitation to the Christmas party with coworkers who for decades have socially frozen her out. Stacey gifts this taxidermy duck to her coworker who talks frequently about her sex life and inevitable divorce. Stacey tells the woman that this duck can be "loved forever," taxidermy here standing as a substitute figure for romantic love. But, to put it crassly, to exchange a duck for a f*ck, the metonymy implied here in Stacey's explanation, reveals something perverse in Stacey's logic. We suspect there is something more (desirous) lurking behind Stacey's big, bulging, often unblinking eyes, evocative of taxidermy glass eyes—a kind of bottomless gaze—as she trance-like watches the infomercial and observes (or perhaps even fantasizes about) her soft pornstar-ish coworkers sensually applying lotion to one another. And yet, the uncertainty around whom or what exactly Stacey desires is slippery, like the lotion itself.

The Outside uses taxidermy to reify the phenomenological horror of being-there, of being stuck. Stacey, ultimately, is afraid of being stuck as an odd duck, stuck on the outside, stuck in her own skin. And this fear drives her to violent, perverse, and extreme ends. Of course, the film can be read as cultural commentary on the slick promises of expensive creams, serums, retinols, and peptides and the way consumers guzzle them down, a cautionary tale about the dangers of associating beauty with morality, radiant skin with a beautiful soul. "The beautiful," says Kant, though one can easily imagine it being a line uttered from the hypnotic Alo Glo spokesman, "is the symbol of the morally good" (*Critique of Judgment* section 353; 180). However, I want to suggest that it is the horror of being stuck that terrifies Stacey. Moreover, how the film constellates taxidermy into this phenomenological horror is consistent with how taxidermy largely appears to function in Gothic narratives.

Amirpour's film is appropriately named, for no better word than "outside" defines Stacey's life. She is afraid of the outside: when home alone at night, she is afraid of home invasion. She calls the police. The officer who answers (whom we only later learn is Keith, her husband) flatly tells her to calm down. Initially in that exchange, we do not glean any sense of intimacy or care between the two, implying an emotional distance that is another form

TAXIDERMY AND THE HORROR OF BEING-THERE

of the outside. Moreover, Stacey is someone who specializes in beautiful outsides (taxidermy), who herself does not feel beautiful on the outside, and who is socially on the outside of her coworkers.

The greatest horror for Stacey is being stuck, and more specifically being stuck on the outside—of remaining socially excluded, of the lotion not penetrating the outside of her skin, of being stuck like a taxidermic specimen in an environment, unable to change. Yet the truest horror of the film is the horror that the outside is also the feeling of the inside. After all, the boundary between inside and outside is, like skin, membranous and porous. As when the "dark background" of anonymous existence oozes into our experience, that terrifying inescapability of night (Levinas), there is no way for Stacey to keep the feeling of emptiness on the outside. Even Stacey's name itself discloses this central crisis. While Stacey can be associated with the ancient Greek words for resurrection and steadfastness, her name also shares a homologous association with "stasis," meaning inactivity or stagnation, and in a pathological sense that is especially relevant to the work of taxidermy, stasis also means the "stagnation or stoppage of the circulation of any of the fluids of the body" (OED 1.a).

In both public and private sides of her life, Stacey trades in stoppages or blockages. As a bank teller, Stacey regulates the flow of currency, while as a taxidermist she manages bodily fluids. Moreover, these seemingly disconnected spaces of Stacey's work (outside: bank, inside: taxidermy) ooze together in a little known historical connection. Some taxidermists preferred to use damaged paper currency in preparing their specimens. The famed nineteenth-century taxidermist William Hornaday held the opinion that the best papier-mâché, which was used to cover the manikin before the skin was applied, was a pulpy mash made from "mutilated paper currency" from Washington's Bureau of Engraving and Printing (*Taxidermy and Zoological* 152; qtd. in Young 106). If taxidermy was already associated with the counterfeit, the use of damaged paper bills—money removed from official circulation—to construct material mounts further reifies this. It now looks like an "animal" that is no longer an animal made from "money" that is no longer money.

Taxidermy constellates this fear of being-stuck, of being stuck living an empty life. But if taxidermy involves the evacuation of a messy interiority and its replacement with a counterfeit emptiness—Stacey uses Styrofoam, a plain, white, lightweight substance—the chronically glassy gaze that Stacey has throughout the film deceptively suggests that she herself is also already empty. (Curiously, it is only after Stacey has thoroughly saturated herself with the lotion in the bath, when the outside Alo Glo perversely seeps inside orifices, do her eyes finally lose their bulbous unblinking look).

If the eyes are "the window of the soul" (as the cliché goes), Stacey's glassy eyes suggest a vacuous Styrofoam interiority. Taxidermy and taxidermist are uncannily alike, both having a bottomless gaze that is a window into nothingness. The horror here is in how horrifyingly close taxidermy, in its evacuated interiority, can be to human existence.

The horror of being stuck as constellated in figurations of taxidermy resonates with other hallmark fears of the Gothic, such as being stuck in our bodies and stuck in the past. As Chris Baldick notes, "while the existential fears of Gothic may concern our inability to escape our dying bodies, its historical fears derive from our inability finally to convince ourselves that we have really escaped from the tyrannies of the past" (xxii). Taxidermy, as something that uncannily looks full of life and yet is radically stuffed with artificial materials (e.g., styrofoam, tow, wire), also invokes the fear of the foreign body. This, as David Punter notes, is another key feature of the Gothic: "The notion of the foreign body comes to remind us that we have always crawled into somewhere else to make our home [...] we become increasingly aware that our apprehension of foreign bodies, of strange intimations that all is not well with our occupancy (of the world, of our body) is at a deeper level predicated on our growing awareness that we ourselves are the foreign body" (*Gothic Pathologies* 219). As so many Gothic horror narratives gruesomely explore, within our own corporeality, as in taxidermy, death and multitudes of inhuman foreign bodies are already within. That which is outside or seemingly behind us proves to be always closer than it appears.

The foregrounding of taxidermy and its related associations of "being stuffed" in *The Outside* remind us that while plenty of Gothic conventions draw on models of the depth (e.g., the repressed, the buried), much of the Gothic's "strongest energies inhere in the surface," as Sedgwick tells us (12). For in the Gothic, it is often something on the surface that comes to disrupt the ability of the self to gain deeper insight, access, or knowledge: "The self and whatever it is that is outside have a proper, natural, necessary connection to each other, but one that the self is suddenly incapable of making" (13). This roadblock, caused by the surface, then produces "a doubleness where singleness should be" (13). In *The Outside*, we never quite reach the depth, whether of inner beauty or of the moral goodness, that we expect to find in Stacey; instead, the interiority of Stacey turns out to be a more horrifying extension of the outside. Put otherwise: the inside turns out to be another slippery, well-lotioned surface extension of the outside.

Moreover, while the surface is the site where much Gothic horror adheres, it is also the site of the animal. As Ron Broglio notes, "According to a long cultural and philosophical tradition, animals do not engage in the self-reflexive thought that provides humans with individual and cultural depth

TAXIDERMY AND THE HORROR OF BEING-THERE 69

of being; instead, animals are said to live on the surface of things" (*Surface Encounters* xvi). Broglio's shorthand for the various "shortcomings" of animals, when compared to humans, is what he calls "living on the surface" (xvi). This reduction or flattening of the complexities of animal worlds into "a thin layer [...] as a life on the surface of things has legitimated any number of cruel acts against animals" (xvii). Taxidermy, we might say, doubly lives on the surface, its "life" even more reduced than still living animals.

The breathlessness of taxidermy not only finds a visual corollary with Stacey's unblinking eyes (and later Keith's eyes, after he is taxidermied) but also enacts the experience of reading and viewing Gothic horror. Describing the stasis or breathlessness experienced by reading Ann Radcliffe's fiction, one eighteenth-century reader, Nathan Drake, reported feeling "apprehension that suspends almost the faculty of breathing" (362). Sir Walter Scott described Gothic tales as being capable of inducing in their readers "gasping and breathlessness, chills, prickling hair on the neck, a sensation of immobilisation and panic, the convulsive tensing of 'nervous fibres', followed (usually) by exquisite feelings of relaxation and relief" (Castle "The Gothic Novel" 697). These readerly experiences are often echoed in the characters themselves. The characters in Henry James's *The Turn of the Screw* share in this experience, as the opening line of the novel begins: "The story had held us, round the fire, sufficiently breathless" (154). Indeed, as J. M. S. Tompkin suggests, "For the first time reading was an exercise to be undertaken with bated breath" (250). In sum, encountering Gothic horror was experienced as a form of stilled breath or life, accounts that strikingly resonate with the unsettling experiences we have with taxidermy. As Jane Desmond descriptively puts it, in a rare instance of a scholarly admission of taxidermy's darker energies, taxidermy "can create a nearly paralyzing moment of encounter, one that tenses our own muscles, may cause bile to rise, inspire a sharp intake of breath, and perhaps compel an intense desire to look away" ("Vivacious Remains" 264).

Scholarship on taxidermy (coming principally out of critical animal studies) either fails to see or outright disavows the Gothic sensibility of taxidermy, as I have already suggested in the Introduction. Even the undoing, bottomless gaze of taxidermy comes to be a feature from which some scholars attempt to look away. For instance, Helen Gregory and Anthony Purdy, following Steve Baker, suggest that what invests taxidermy, even rogue or artistic taxidermy (or what they term "new taxidermy"), with conceptual power is its visceral connection to authenticity: "what makes taxidermic sculptures compelling is that, despite the ways in which the animals have been manipulated by the artists, the authenticity of the skin retains an auratic quality that speaks to us of their past existence even as they look blindly back at us with their

false eyes" (82). For them, this is how taxidermy differs from photography or film; the actual skin tethers it to the Real, to the past life of the animal before it became an animal-object-thing. For them, the Benjaminian aura of realness and authenticity clings to taxidermy to the extent that it even overrides the smaller breaches in authenticity, such as with the problematic feature of glass eyes.

However, I argue that taxidermy's glassy bottomless gaze is an insurmountable obstacle, particularly for characters in Gothic horror narratives. Rather, this gaze is the very irreparable tear, the *punctum* that cannot be papered over and folded back into the realm of authenticity. Instead, as I have been suggesting, Gothic horror texts enable us to see how through the bottomless gaze of this animal-object-thing oozes an unending nocturnal ontology. Thus, moving against the reading that prioritizes taxidermy's authenticity as indexically pointing to a real animal, I read taxidermy, particularly as it functions in Gothic horror, as fascinating and vexing for its fakery, for its counterfeit constructions, and for the fear (not merely wonder) that clings to its phenomenology. We never forget it is stuffed; we encounter it in its stuckness.

Across these texts, Gothic horror's taxidermic repetition compulsions, as it were, principally explore the dark pleasures and even darker pains of being-there or stuckness. The genre, itself "a curious admixture of attraction and repulsion" (Carroll 161), is a fertile space in which to find some of our deepest fears over the horrors of existence mounted and put on display. In taxidermy's appearance within the Gothic, we do not admire the authenticity of a taxidermic specimen; instead, we repeatedly glimpse a dark mirror, finding our own fear(s) stuffed and mounted, a talismanic figure that cathects the very horror, our horror, of existence itself, of being-there. Phenomenological horror, and our anxieties and fears over stuckness (in its various guises), become cathected onto taxidermy, which is itself an ontologically dubious and potent figure for stasis. The horror of still life is that life still persists, that an inhuman anonymous existence still lives behind individual life itself.

What exists in these examples we have considered of taxidermy's appearance in Gothic horror is the way taxidermy stages the horror of being-there, of being stuck in existence. This stuckness is everywhere embodied in the stasis of taxidermy: from the unblinking eyes to the frozen frame, and the breathless mouth. Furthermore, as we look at this strange, inhuman materiality of taxidermy, we find, as if stuffed inside it, a nocturnal ontology: the Levinasian horror of anonymous being, of existence itself.

Chapter 3

TAXIDERMY AND TABOO: SEX AND PERVERSIONS

Taxidermy can invite tender thinking about the fragility of bodies, human and nonhuman alike, and the myriad ways we can be beautifully, or monstrously, made and unmade under the hands of another. As novelist Kristen Arnett, in an essay for *Hazlitt*, writes:

> I've thought about taxidermy the way I've thought about my own body. A site of violence, a thing I've curated, tended, flesh that other people have touched and marveled at, an organism hollowed out, rubbed, constructed with purpose. Taxidermy is queering; it is an othering, and that is also me, a thing queered up and fucked up and positioned with intent. ("The Year in Taxidermy" n.pag.)

Speaking to the violence and curation of her body, the ways her body has been touched and "fucked up," a body that is both heimlich and unheimlich to herself, Arnett teases out the intimacies—the pleasures and the pains—and identifications between taxidermy and herself.

While it is possible to imagine taxidermy being included among those "pleasurable practices" that Stacey Alaimo suggests "may open up the human self to forms of kinship and interconnection with nonhuman nature" (*Exposed* 30), it is even easier to imagine the darker underbelly of this exposure. Indeed, what Gothic horror's treatment of taxidermy reveals is the polymorphous perversity within taxidermy, offering us a view of the dark side of kinship and corporeal horrors of interconnection, a dark side that becomes visible in the material encounter with taxidermy.

This chapter interrogates taxidermy's affinity in Gothic horror with the taboo, with the horror of dark desires that ought not to be there but that nevertheless remain. Many twentieth- and twenty-first century Gothic texts show a tendency to depict those with a taste for taxidermy as perverts, that is, those looking to bypass the demands of the external world (the reality principle, as Freud puts it). In Alice Munro's short story, "Vandals," an

example of the Southern Ontario Gothic, taxidermy becomes aligned with pedophilia; in Norma Lazo's short story "The Taxidermist (The Father)" (2003) a taxidermist father sexually abuses his own daughter; and a similar specter of incest and cycles of abuse haunt Kate Mosse's Gothic historical novel *The Taxidermist's Daughter* (2014). In Vietnamese-American writer Ocean Vuong's autobiographical novel *On Earth We're Briefly Gorgeous* (2019), a horrifying encounter with taxidermy constellates Vuong's childhood abuse at his mother's hands, and the weight of the past that we each carry within us: "taxidermy embodied a death that won't finish, a death that won't finish, a death that keeps dying as we walk past it to relieve ourselves" (3). And much has been made in the media over the fact that convicted pedophile Jeffrey Epstein's New York City mansion was decorated with a taxidermied tiger and poodle and cases of artificial eyeballs. As the above examples suggest, taxidermy, whether in fiction or reality, finds itself bound to the stories we tell of the unspeakable and the horrors we inflict on other humans.

Taken to its most extreme ends, taxidermy and human horror appear in numerous body horror and slasher films under the guise of *human taxidermy*—what we might consider the most taboo subset of taxidermy. For example, the gruesome Italian horror film *Buio Omega* (*Beyond the Darkness* [1979], dir. Joe D'Amato) tells the story of a taxidermist named Frank who taxidermies the body of his dead wife (Anna) and returns her beautiful corpse to their bed. In this film, the dead lover is enjoyed, as Patricia MacCormack puts it, "through tender acts of taxidermy, and the entrails are used as libidinal objects, sorrowful reminders and ecstasy-inducing aspects of the lover" ("Necrosexuality" 349). Not only does Frank continue to desire Anna, but he seduces other women, his victims, in the bed that contains taxidermied Anna in it at the same time. Indeed, one victim, a jogger, discovers Anna's corpse in the bed at the very moment she reaches orgasm—a scene that heavy-handedly conflates death and sexual pleasure. In *Taxidermia* (2006, dir. György Pálfi), a film that partly explores the story of a young, lonely, anorexic-looking taxidermist, who not only taxidermies his obese dead father but ultimately invents an elaborate mechanical apparatus that enables him to self-taxidermy (with its overtones of the masturbatory fantasy of self-stuffing). And, in the award-winning short film *Stuffed* (2021, dir. Theo Rhys), a horror comedy opera, a lonely taxidermist explores her desire to stuff a human when she meets and falls in love with a man who, afraid of aging, volunteers to be her specimen. Still, this subset of human taxidermy loses sight entirely of the animal-object-thing itself and is relatively small when compared to the plethora of erotic encounters set against, and sometimes even with, nonhuman animal taxidermy in Gothic horror.

TAXIDERMY AND TABOO

This chapter pursues the darkest alleyways to where we find conventional taxidermy, that strange animal-object-thing, rubbing up against some of the most shocking, contemporary social taboos: incest, bestiality, and rape.[1] In this chapter, I expose the bad romance between taxidermy and perversions in three films: *Psycho* (1960), *The Cabin in the Woods* (2011), and the Southern Gothic tele-series *Tell Me Your Secrets* (2021). There is here, as might be expected, overlap between the concerns of the last chapter (on looking) and those of this one (on touching). Taxidermy in these texts participates in the libidinal economy, in the blockages and releases of forbidden desires, identities, and knowledges. The chapter brings together psychoanalytic insights on perversion and its substructures (including fetishism and voyeurism) as they are constellated in Gothic horror's representations of taxidermy, drawing on the work of Freud, Lacan, and Élisabeth Roudinesco. Although psychoanalysis never addresses taxidermy, its uncanny kin—the animal—has long scratched at its door. From Freud's famous case studies involving fantasies about animals (e.g., Rat Man, Little Hans, and Wolf Man), we see the ways animals serve as projections of some of our darkest desires. Taxidermy in the texts explored in this chapter, I offer, serves as a potent projection of dark libidinal energies, thus extending the psychopathological work of the animal and, paradoxically, giving it still more life. Taxidermy intensifies our psychic investments in the animal by making it visible and giving it a fixed form. That is, in its stasis, taxidermy stands for the ineradicable nature of these desires, ratcheting up the symbolic force of the animal and paradoxically giving it more life or force than the living animal itself. But lest you think that it is only in Gothic horror where taxidermy becomes titillating, let us consider three noteworthy examples from material culture.

Taxiderm-erotics

Exhibit A: In 2011, the London Natural History Museum (NHM) launched a popular, award-winning exhibition dedicated to sex in the natural world, titled *Sexual Nature*. Among its displays and attractions, which even included a "Snail Sex Show," were taxidermy mounts depicted having sex. With a glowing red neon sign of the word "SEX," and sounds of moaning (coming from a video installation playing Isabella Rosseilini's short films from her online video series *Green Porno* in which she performs animal mating habits),

1 And while much could be said about the confluences between taxidermy and queerness more broadly, I am not interested in pathologizing queer in a chapter informed by psychoanalytic ideas on perversion.

these taxidermied animals, especially posed in sexual positions, appear as frozen furry actors in a pornographic tableau that might make Sir Walter Potter blush.

Exhibit B: In 2016, working in a similar spirit as the NHM's sexy exhibition, one Russian taxidermist made the headlines of *The Guardian* for his taxidermy exhibition titled "Secrets of Animals' Intimate Lives." This "sexhibition," as it might better be called, featured taxidermied animals—everything from badgers, racoons, and hedgehogs to wolves and warthogs—having sex. Some animal rights activists called for the exhibition to be canceled, citing it as nothing more than a perverse spectacle: "This exhibition is a just a perversion. How else can you describe it? Why do we need to see the sex lives of animals in this way? It is bad enough seeing this stuff on the Internet but using dead animals is just sick" ("Russian Taxidermist").[2] However, these educational taxidermy sexhibitions are not the only place we encounter taxidermy's tantalizing brush with the erotic.

Exhibit C: In 2017, the British Academy of Taxidermy, an amateur society based in London, hosted a special Valentine's Day workshop for couples to make pornographic mouse taxidermy. (Forget about couple's yoga or that cooking class!). According to the website description!, at the workshop, participants would learn to skin and prepare two mice and then pose them in "the most erotic, delightful, delicious poses imaginable. Give your loving imagination free reign and place the mice in YOUR favourite position. Ideal gift for the neglectful partner. Props Provided—or bring your own: nothing is too filthy (trust me, we've done it) or use ours" (n.pag.). Some of the pictures of the randy anthropomorphized mice include couples in BDSM ball/gag and rope play (see Figure 3.1).

Flora Gill, a sex and dating columnist for GQ Hype, took her long-time boyfriend to the pornographic taxidermy class as a way to spice up their sex life. What they created was a kinky taxidermy tableau featuring one mouse with a strap-on dominating another, replete with a ball gag in its mouth.

The class initially prompted some anxieties for Gill: "What if, I worry, this doesn't just stop at a quirky date, but sparks a rapacious addiction to the hobby and our house becomes filled with stuffed cadavers. What if we become that couple everyone used to be friends with and now avoids [...]" (Gill, n.pag.). It is a joke, to be sure. And yet, this humorous and short-lived worry does reveal an anxiety that taxidermy might create other monstrous

2 Pavel Glaskov, the taxidermist, defended his exhibition as a form of popularizing science and was not deterred by the accusations of being a pervert. In 2020, the exhibition, renamed "Two of Every Kind," expanded to include 250 pieces from his private collection.

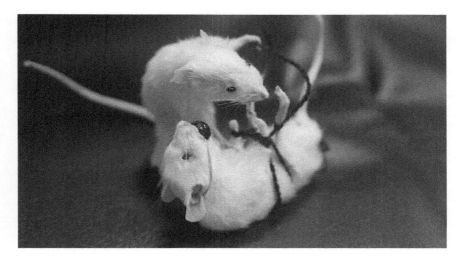

Figure 3.1 BDSM mouse from the British Academy of Taxidermy website.

appetites, that it could become a gateway that unlocks new pleasures, and sparks "a rapacious addiction," that is, something pathological. Thus, even in this glib remark, we see what is perceived to be a short step from taxidermy as an amateur practice to pathology. Taxidermy is bound (and gagged) with the taboo and brings with it the promise (or threat) of seduction.

I begin this chapter with these material examples as touchstones for exposing the various pleasures and pains, delights and discomforts, that arise when taxidermy comes into contact with the erotic. Taxidermy, as we have already considered, is uncanny, flitting along the liminal spaces between animal and object, life and death, steeped in a shared convention with the Gothic for the uncanny, for the counterfeit, and for corporeal horror. But while its corporeal horror might often play out along the lines of death—that is, of preserving and displaying life in death—there is another line of horror to which taxidermy in the Gothic is repeatedly drawn: namely libidinal energies, or erotic desires, in particular transgressive, taboo ones. While taxidermy's libidinal energies manifest in a variety of forms and modes—from traditional taxidermy posed in sexual positions, sexy artistic taxidermy, even erotic acts performed with taxidermy, to taxidermy as an aphrodisiac or prophylactic—in each case it provokes affects ranging from disgust to discomfort.

We find sustained attention to this erotics, this "taxiderm-erotics" as I call it, in both items of material culture and fictional worlds, whenever taxidermy is repeatedly brought into intimate proximity with eros. The fact that this proximity shocks is perhaps unsurprising given how challenging it is to think about the erotic lives of animals or interspecies eroticism

(zoophilia, bestiality), even when these creatures are alive. Taxiderm-erotics is an unnerving space that we can think of as an arresting and arousing "contact zone," to borrow Mary Louis Pratt's term for "social spaces where cultures meet, clash, and grapple with each other, often in contexts of highly asymmetrical relations of power," a space that makes bedfellows of the unlikeliest of figures (33–34).

Gothic horror revels in this contact zone. As this chapter explores, taxidermy in Gothic horror is increasingly triangulating sexual transgressions. Indeed, it is in Gothic horror narratives, especially popular films and series, where these taxiderm-erotic energies are darkest and, arguably, easiest to see. Next, we consider a brief account of perversion and taxidermy's relation to it before turning to these constellations in three key Gothic horror case studies.

Perversion

Perversion is a polymorphously perverse word: it twists and turns, writhing and wrestling, ultimately refusing a stable, fixed meaning. It is perhaps best thought of as a shadowy term or container, its form and content ever in flux. In a general sense, perversion means a deviation, violation, or transgression from the acceptable, natural order of things.

In psychoanalysis, the discourse that has spilled more ink on the subject than any other, perversion holds a special place. Freud famously called children "polymorphously perverse" as a way of describing how the free-floating eroticism, the wild sexual tendencies of the child, comes to be seen as perverse by the adult world. But even within psychoanalysis, there is disagreement over perversion. Whereas for Freud perversion is bound up with infantile sexuality, for Lacan it is less polymorphous and comes to be more linked with paternal law. Perversion is *père-version* (to draw on one of Lacan's famous neologisms), that is, a mode of relating to paternal authority, the Law of the Father.[3] Still others in psychiatry have abandoned the term entirely

3 Lacan principally discusses perversion in his *Seminars VII* and *XXIII*, and "Kant with Sade," although references to "pére-version" can be found elsewhere, such as *Seminar XVII* and "Spring Awakening" (34). In Lacan's late thought, perversions are versions of the father, "versions toward the father as a product of the metonymic chain of signifiers" (Lee "Perversion After Freud" 110). As Žižek writes, "Lacan prefers to write *perversion* as *père-version*, i.e., the version of the father. Far from acting only as symbolic agent, restraining pre-Oedipal, 'polymorphous perversity', subjugating it to the genital law, the 'version of' or turn toward, the father is the most radical perversion of all" (*Looking Awry* 24).

TAXIDERMY AND TABOO

in favor of "paraphilia" (meaning love [philia] beside or beyond [para]) to refer to sexual desires or attraction to unusual sexual objects or practices, a term that in 1980 replaced "perversion" in the third edition of the *Diagnostic and Statistical Manual of Mental Disorders* (Dean 111).

While this chapter is loosely informed by psychoanalytic discussions of perversion, it unfaithfully strays away from any one father (Freud or Lacan) and avoids the easy game of spot-the-perversion from sexology's list of individual perversions.[4] Instead, I use "perversion" in the more general, polymorphous sense of an awful disordering of things—awful in the dual sense of awful and awe-inspiring, or "wonder mixed with fear" (Olivier 1).[5] For it is easy to see how taxidermy perverts the natural order of things: it is a practice of creating life in death, of refusing natural biological processes of the decay and disappearance of the animal's surface. This craft categorically and ontologically transforms—sometimes faithfully (i.e., a well-preserved, realistic specimen), and other times unfaithfully—the animal into a strange animal-object-thing. It stealthily cloaks a deeper ontological violation, what I described in Chapter 2 as a "nocturnal ontology," that is, the dark anonymity of being, the horrifying quality of life itself, or what Levinas calls the *il y a*.

Thus, while perversion here need not necessarily be sexual, as we will see in this chapter, this awful disordering is frequently libidinally charged. Frequently fomenting beneath this general sense of taxidermy's perversion or violation of natural processes of death, decay, and disappearance, there lies a secondary and more unsettling alignment of taxidermy with perversion, especially in the Gothic horror tradition. Many Gothic horror texts align taxidermy—that is, representations of taxidermists, the craft of taxidermy, and the taxidermied specimens themselves—with dark desires or sexual perversions. In multiple registers, then, taxidermy as represented in Gothic horror is intensely polymorphously perverse, stuffed and stitched up with ontological and libidinal uncertainty.

Perversion, according to historian and psychoanalyst Élisabeth Roudinesco, is at the core of what it means to be human: "Be it a delight in evil or a passion for the sovereign good, perversion is the defining

4 Richard von Krafft-Ebing in *Psychopathia Sexualis* sorted perversion into the four subcategories of sadism, masochism, fetishism, and "contrary sexual instinct" (homosexuality).

5 The "awfulness" of perversion resembles what Marc Olivier describes as the blending of wonder and fear in a work of horror: "Horror recovers the wonder and fear of objects in a way that approaches the sincerity of a child frightened by the shapes of objects in the dark" (*Household Horror* 1–2).

characteristic of the human species: the animal world is excluded from it, just as it is excluded from crime" (*Our Dark Side* 4). But if perversion is reserved for our species, a regrettable mark of human exceptionalism, those who engage in it or are labeled as perverts are those who are often described as almost having crossed the species boundary, as being something not quite human, something monstrous, something certainly unlike us. Perverts, Roudinesco writes, are "accursed creatures [who] have inspired plays, novels, stories and films because of our continued fascination with their strange, half-human, half-animal status" (2). What these stories show is "the nightmare of a never-ending infinite reassignment that reveals, in all its cruelty, what human beings try to disguise" (2), which is the negativity at the heart of us, the dark side of humanity. Roudinesco traces the history of perversion from the Middle Ages, where perversion was originally a "way of upsetting the natural order of the world and converting men to vice" (3), to the twentieth century. While we no longer believe in a divinely ordered world, perversion persists in faces and forms that shift over time. Nevertheless, perversion remains tethered to perversity: "whatever form it takes and whatever metamorphoses it has undergone, it still relates, as it always has done, to a sort of negative image of freedom: annihilation, dehumanization, hatred, destruction, domination, cruelty and *jouissance*" (Roudinesco 4).

However, as Roudinesco notes, perversion is also connected with "creativity, self-transcendence and greatness," and, in this sense, it is not simply the negative image of freedom but rather also "the highest form of freedom, as it allows the person who embodies it to be both executioner and victim, master and slave, barbarian and civilized man. Perversion fascinates us precisely because it can sometimes be sublime, and sometimes abject" (4). Thus, it is in the way that perversion sublimely speaks, in the same breath, to the extremities of freedom—the highest and lowest—that explains its allure. It is, as I've put it above, an awful disordering of things.

Historically, the fascination with perversion emerged most intensely in the long nineteenth century, that same time of those twinned golden ages of the Gothic and taxidermy. This was the time of the repressive hypothesis, as Foucault famously describes in *The History of Sexuality*, when sex and sexuality transform into a "perpetual discourse" (33) spoken about "*ad infinitum*, while exploiting it as *the* secret" (35). This, says Foucault, was the dawn of the modern age of perversions:

> Nineteenth-century 'bourgeois' society—and it is doubtless still with us—was a society of blatant and fragmented perversion. […] It is possible that the West has not been capable of inventing any new pleasures, and

TAXIDERMY AND TABOO

it has doubtless not discovered any original vices. But it has defined new rules for the game of powers and pleasures. The frozen countenance of the perversions is a fixture of this game. (*History of Sexuality* 47–48)

Perversion is the very story of modernity's growth, as Foucault tells it. "Modern society is perverse" (47), he writes, a diagnosis rooted in what he sees as the explosive proliferation of perversions or "manifold sexualities" in the nineteenth century:

> The manifold sexualities—those which appear with the different ages (sexualities of the infant or the child), those which become fixated on particular tastes or practices (the sexuality of the invert, the gerontophile, the fetishist), those which, in a diffuse manner, invest relationships (the sexuality of doctor and patient, teacher and student, psychiatrist and mental patient), those which haunt spaces (the sexuality of the home, the school, the prison)—all form the correlate of exact procedures of power. [...] These polymorphous conducts were actually extracted from people's bodies and from their pleasures; or, rather, they were solidified in them; they were drawn out, revealed, isolated, intensified, incorporated, by multifarious power devices. (47–48)

For Foucault, who uses the terms perversion and sexuality interchangeably, the multiplication of sexualities is a deviation (or perversion) from an understanding of one ideal(ized) form of sexuality. Moreover, he suggests, it is not that these "polymorphous conducts" always existed in the shadows and just suddenly came to light, but rather that in the nexus of these new power relations that were invented in the nineteenth century alongside new institutions and discourses, new ones were formed. These conducts, actions, and movements then came to be calcified, classified, or "frozen" (to use Foucault's phrase) into an identity.

Let us linger on this description of the frozen face of perversions. Does the frozenness imply that there is something impotent or powerless in perversion's face? Or, does the frozenness suggest, on the contrary, the power of horror? To be sure, the frozenness speaks to the work of biopolitics, of the various techniques generated to regulate bodies and understandings of the self. Frozen connotes the notion of temporarily immobilizing something otherwise inchoate to mount an attempt at apprehending it. The nineteenth century, in Foucault's analysis, is the epoch wherein actions distill into identity, when perversions freeze into an identification, a face ("the pervert"). The effect of immobilizing perversions, however, is to normalize them and

80 TAXIDERMY AND THE GOTHIC

shore up an identity.[6] Put otherwise: the pervert, as a biopolitical creation, was stuffed and mounted by the hands of nineteenth-century sexology.[7]

Moreover, we can glimpse here the connection between the creation of the pervert, of the freezing of perversions into static, identifiable, and recognizable and thus classifiable forms, and the taxidermied animal. Indeed, such a description here of the "frozen countenance" of the perversions smacks of the very look of taxidermy, the phrase becoming something of an image for thought here with taxidermy standing as a visual analogy, a frozen symbolic embodiment of perversion. And, as we will soon explore, taxidermy becomes in many Gothic horror texts a metonym for perversion, especially sexual perversion.

But if animals are excluded from perversion, as Roudinesco suggests, taxidermy surely complicates this and brings them into the fold. Like the pervert standing liminally between species and inspiring stories of species-crossing, taxidermy itself prowls at the crossroads between categories: animal or object? dead or eternally alive? decadent or disgusting? sublime or abject? "Both/and" is the answer. Taxidermy stands as violations, frozen between categories and states (animal/object, life/death, decadent/disgusting) but also spaces—with once "wild" animals "out there" in nature now standing as silent, tamed, forever well-behaved creatures in interior spaces, from living rooms to museum halls. In these ways, then, all taxidermy might be said to be perverse in the oldest sense of the term, as a "way of upsetting the natural order of the world" (Roudinesco 3), violating life's temporality.

It is perhaps taxidermy's violation of time that renders it a timeless object with which to think through other forms of perversion. After all, perversion, as Patricia MacCormack puts it, is principally "a duration" that "proliferates trajectories, resonating far beyond its courses, intended or not. [...] What perversion resonates is the redistribution of self through sensation and perception, a transformation of subjectification and signification" ("Perversion" n.pag.). Perversion's alternation to duration is another way of understanding perversion as upsetting the order of things. This is especially helpful to think about the force of taxidermy, which in its stasis has its own strange duration and uncanny temporality. A mount, for example, can look frozen in movement. What MacCormack identifies as perversion's redistribution of the self is an apt description of what occurs in the act of

6 As Foucault famously says, "The sodomite had been a temporary aberration; the homosexual was now a species."

7 Richard Sha in *Perverse Romanticism* (2009) offers a different history and argues that Romantic literature and science were already perverse in the sense of celebrating pleasure beyond reproduction, "purposiveness" rather than "purpose."

TAXIDERMY AND TABOO

taxidermy, wherein the animal is transformed into an uncanny object-thing: insides are turned outside, the invisible made visible, flesh unfolded before our voyeuristic eyes. All these corporeal transformations and violations are made in taxidermy and in the practice of storytelling and inventing new worlds. To that end, Gothic texts, particularly film, are a rich site for finding perversion more generally, for in film we glimpse other worlds with our own eyes. As MacCormack puts it, "One of film's great promises is impossible worlds, worlds unrealisable in the everyday, which fold us within the unperceivable cinema allows us to perceive. Perhaps this is why cinema seems an appealing realm through which to think experiments in perversion" (n.pag.).

Titillating Taxidermy: Three Case Studies

Psycho

In numerous Gothic horror films, taxidermy gets constellated with libidinal energies that are sometimes blocked or short-circuited and at other times released. The text that first cultivates taxiderm-erotics is Alfred Hitchcock's *Psycho*.[8] Norman Bates, *Psycho*'s motel manager and taxidermist, sets the stage for cinematic and televisual representations of horrifying taxidermists, the figure who weds together the association of taxidermy, Gothic horror, and perversion in the popular imagination.[9]

Despite the film's canonical status, and the abundance of scholarship on it and the various objects in Hitchcock's films, surprisingly little attention has been dedicated to its taxidermy. Mladen Dolar theorizes there are two types of Hitchcockian objects: one that vanishes and does not need to be visually represented, and a second type that conversely "is a fascinating, captivating, bewitching, spell-binding object which necessarily possesses

8 If, as some critics claim, the horror film was invented with Hitchcock's *Psycho* (1960), then the very genre is predicated on murder and taxidermy. Hitchcock's interest in taxidermy, however, predates *Psycho*; it is already there in his episode "The West Warlock Time Capsule" (part of *Alfred Hitchcock Presents*, Season 2, Episode 35), which tells the story of a taxidermist who enacts revenge on his brother-in-law, whose unexpected and lengthy visit interrupts his domestic life and strains his marriage. Taxidermy works differently to comedic ends in Hitchcock's *The Man Who Knew Too Much* (1956).

9 Many Gothic horror texts pay homage to *Psycho* and its taxidermy. In Stephen King's novel *It*, the secondary character Elmer Curtie runs a bar named *The Falcon*, which is decorated by avian taxidermy made by Curtie's dead brother.

82 TAXIDERMY AND THE GOTHIC

a kind of materiality and a certain lethal quality" ("Hitchcock's Objects" 45). Taxidermy in *Psycho*, I offer, is of this latter class. Dolar, writing from a Lacanian lens, sees this second bewitching object as Lacan's "Thing," "the object of the drive, the presence incorporating a blockage around which all the relations circulate" (46).[10] Exploring rings, necklaces, keys, and lighters across Hitchcock's oeuvre, Dolar misses an opportunity with taxidermy in *Psycho*, which in its form and content embodies such a blockage. But it is not just that Dolar misses taxidermy, but that such a strict Lacanian approach would also miss other horrifying dimensions about the object in itself. As Marc Olivier shows, in his reading informed by the theory of object-oriented ontology, *Psycho*'s infamous shower curtain adds "plasticity and toxic modernity" to the film, shower curtains representing "plastic at its worst" (*Household Horror* 303). Like Olivier's attention to the ubiquitous objects of horror films that bring their own affective force to the work, my reading of taxidermy in *Psycho* hinges, in large part, on the taxidermy itself and the phenomenological horror it embodies of being-there. And yet, taxidermy's phenomenological horror is further ratcheted up when also fused with the insights of psychoanalysis.

While we have already considered how *Psycho*'s taxidermy embodies the horror of being-there (in Chapter 2), this film also helps establish taxidermy's association with eros and particularly its dark side. For here taxidermy slides into place within another constellation in the mid-twentieth century that linked psychopathy with perversions. As Robert Genter argues, reading the film against the cultural and political backdrop of post-war America, *Psycho* taps into the popular image of the psychopath as sexually deviant that by 1960 had already taken hold in the American imagination, an imagination that had already been steeped in popularized forms of psychoanalysis (135–37). Taxidermists, ever since H. G. Wells's depiction of the figure in his Gothic short story "The Triumphs of the Taxidermist" (1894), have long been considered weird, slippery, counterfeits. However, *Psycho*'s Norman Bates brings this figure's dark libidinal energies and the dangerous consequences of coming into contact with this figure clearly into focus.

Our first sense that something is awry is when Norman invites Marion to join him for dinner in his motel parlor room, which in contrast to the rest of the sparsely decorated motel is stuffed (pardon the pun) to the ceiling with taxidermy. Birds, big and small, make up this motel menagerie, as Norman

10 Michel Chion in *The Voice in Cinema* reads the acousmatic voice in *Psycho* as a thing, like Lacan's "objet (a)"—"objets petit autres," objects with a small degree of otherness, objects that the child previously understood as parts of itself (cf. the gaze, the penis, feces).

TAXIDERMY AND TABOO

fills all his time with avian taxidermy, a detail that renders him both voracious and selective. Moreover, this activity does not merely pass but rather fills *all* his time, a detail he shares with Marion, shifts it from a hobby to an obsession, setting the stage for us to see taxidermy as pathological.

While any kind of obsession (e.g., monomania, bibliomania, nymphomania) quickly sends us into the terrain of pathology, the fact that Norman's particular obsession is taxidermy is important.[11] For taxidermy is, I offer, another form of "the imagos [...] of the Gothic aesthetic" (Bruhm "Picture This" 270), to use Steven Bruhm's phrase for what Lacan calls the "images of castration, mutilation, dismemberment, dislocation, evisceration, devouring, bursting open of the body, in short, the *imagos* that I have grouped together under the apparently structural term of *imagos of the fragmented body*" (qtd. in Bruhm 270). Norman's obsession with taxidermy, itself an art steeped in the imagos of the fragmented body and the Gothic, becomes a gateway for other kinds of pathologies and perversions that he and others within the film are caught within.

Like the taxidermy that lines his parlor, suspended between life and death, animal and object, Norman is also caught between victim and victimizer, hunted and hunter. On the one hand, he sits across from Marion Crane (her name alluding to the bird, known for its elaborate mating dance and associated with joy, love, and life), watching her as she eats. Norman is like a bird of prey—those very specimens he enjoys transforming into taxidermy. His observation of Marion, his predilection for "stuffing birds," and the sexual connotations of this statement, all cast Norman as the hunter. On the other hand, numerous features ranging from Norman's physical appearance and mannerisms to the camera shots of Norman being overshadowed by taxidermy, all work to render Norman more akin to Marion, that is, a victim himself. While some critics have compared Norman to a cat or a wolf, he is undeniably bird-like: he (Anthony Perkins) is sleight with fine features and is frequently shown throughout the film eating, such as pecking at the bag of candy corn when the detective Arbogast shows up at the motel.[12] But most powerfully of all, it is the parlor scene, of Norman shot from below, that shows

11 For a good overview of obsession, see Lennard Davis's *Obsession: A History* (2008).

12 Norman has a different physical appearance in Bloch's novel. Stephen King sees Norman as a wolf: "Only instead of growing hair, his change is effected by donning his dead mother's panties, slip, and dress—and hacking up the guests instead of biting them" (*Danse Macabre* 76). Critics have already read these mannerisms as queer. See Doty, Alexander. *Flaming Classics: Queering the Film Canon*. New York: Routledge, 2000. 155–89; Greven, David. *Psycho-Sexual: Male Desire in Hitchcock, De Palma, Scorsese, and Friedkin*. Austin: University of Texas, 2013.

84 TAXIDERMY AND THE GOTHIC

the taxidermied owl looming overhead of Norman that most render him a small bird in the clutches of a bigger bird of prey. In fact, this is the shot used when Norman tells Marion about his mother.

During this conversation, arguably the most important one of the film, what Marion articulates is the unnaturalness or deviancy of Norman, a forty-year-old man still living at home under the thumb of his mother. (Little does she actually know how much worse it is!). The heart of the concern here and the horror of what this touches upon is the horror of being-there, of being stuck. Indeed, as Norman says to her, in the now-famous lines of the film: "People never run away from anything. You know what I think? We're all in our private traps, clamped in them, and none of us can ever climb out. We scratch and claw, but only at the air, only at each other, and for all of it we never budge an inch."

The breathlessness of taxidermy, with its glazed eyes and frozen faces, impresses upon the conversation between Norman and Marion and charges it with an intensity that unsettles Marion. Evident in Norman's enigmatic speech, taxidermy also embodies the very condition that people, living ensnared in their private traps (such as debt), find themselves in. In never budging an inch, in not achieving their desired freedoms, people are caught in a deathly existence, a stasis embodied in the work of taxidermy.

In fact, Marion herself, at this precise moment in their conversation, seems to have a personal revelation of sorts and announces that she will return to Phoenix in the morning (presumably to face the consequences of her crime). She sees the inescapability of her action, the ultimate futility of her struggle having recognized the various traps she's been struggling in: a job with which she is unhappy and is subjected to sexist, misogynistic treatment; an affair with a soon-to-be divorced man (Sam) living out of town, whose debts delay their own relationship that she struggles to extricate herself from; and, finally, her theft of the company money to solve Sam's debts, the guilt of which now haunts her as she tortures herself by imagining what people will say about her. While much has been made of Norman's quip to Marion—"We all go a little mad sometimes"—the deeper horror at the heart of this scene, and the horror visually constellated with the film's taxidermy, is less about madness/psychopathy and more that there is no escape from the violence of life.

Norman's psychic state shocks the film's main characters. Marion and then later Sam become unnerved when Norman defends his preference for his mode of existence. If Marion and Sam are like living animals rattling against the bars of their cages, Norman is like taxidermy, stuffed and sitting pretty. According to Hitchcock, in his conversation with Francois Truffaut, the film's taxidermy is a symptom of Norman's masochism:

TAXIDERMY AND TABOO

85

> Obviously Perkins [Norman Bates] is interested in taxidermy since he'd filled his own mother with sawdust. But the owl, for instance, has another connotation. Owls belong to the night world; they are watchers, and this appeals to Perkins' masochism. He knows the birds and he knows that they're watching him all the time. He can see his own guilt reflected in their knowing eyes. (qtd. in Truffaut 211)[13]

That Norman is also Mother, having incorporated her within his psyche after he violently killed her so as to absolve himself of guilt, means that stuffed inside Norman is also Mother. As the psychiatrist, following his diagnosis of Norman, punningly says at the end of the film, Norman had "a mother half" to him.

Our initial sense, like Marion's, is that Mother watches over him, that she is an overbearing presence in his life like the stuffed owl above Norman. However, this is ultimately an illusion, a camera trick. Norman is also the owl, stuffed from within, having introjected his dead mother, an act of sharing psychic space that also suspends the vitality of Norman's own life. In this sense, then, Norman is doubly stuffed, and his parlor room becomes a symbolic manifestation of his crowded and stuck psychic interiority.

The film uses taxidermy to signal violations of psychic spaces and states. While the most enigmatic scene of taxidermy occurs in the motel's parlor room, a space situated between the office and the guest rooms, only one other instance of taxidermy appears in the film: Norman's bedroom. Where the rest of the house is a strong aesthetic contrast to taxidermy, filled with neoclassical sculpture and paintings (an Apollonian veneer set against the Dionysian motel), the one sole piece of taxidermy that seems misplaced is in Norman's bedroom, which itself feels out of place and time as a seemingly preserved child's bedroom. We get a glimpse inside this room only when Lila Crane, Marion's sister, is searching the house for Mother. As she snoops around Norman's room, the camera tracks to a few objects: a child's stuffed animal, and a book with no cover design. However, especially jarring is the contrast between the shot of a stuffed toy animal and a taxidermied owl (with its wings tucked close to its body). This invites us to see the continuum between the stuffed animal toy of childhood, that "transitional object" in psychoanalyst Donald Winnicott's sense (an object that the child uses to ease separation from the mother and negotiate the demands of the external world), and

13 Even in the theatrical trailer that Hitchcock did for the film, in which the director takes viewers on a tour of the set, we visit Norman's motel parlor room, identified as his "favorite spot," filled with his taxidermy as the director points out key specimens (crow, owl).

Norman's adult obsession with taxidermy.[14] By placing this taxidermied owl in the background of Norman's bedroom, Hitchcock uses taxidermy both to signal the pathological and to undercut it, exposing its roots in the common and healthy childhood love for stuffies. Norman's room is preserved, suspended between both versions of Norman himself (child and adult), a site where horror comes home to roost—or, perhaps more terrifyingly, has always been nesting.

The progression of transgressions in the film, a trajectory that moves from adultery, theft, murder, and eventually to psychopathy, comes in many ways to be a fitting model for how taxidermy's association with perversions plays out in the oeuvre of Gothic horror. From the seeds planted here in *Psycho*, taxidermy's association with perversion ratchets up in more contemporary treatments, where taxidermy itself even comes to be a participant in steamy scenes.

The Cabin in the Woods

Taxidermy can titillate and cultivate the erotic. Arguably, the steamiest treatment of taxiderm-erotics plays out in an extended scene in the horror comedy *The Cabin in the Woods* (2011). The film (dir. Drew Goddard and produced by Joss Whedon) revolves around a group of college friends who go on holiday to a remote cabin in the woods, which, unbeknownst to them, is an experiment controlled by an underground lab (Figure 3.2). The friends, each of whom represents a different stock figure (the whore, the virgin, the jock, the scholar, and the fool), are forced to battle zombies. As Goddard and Whedon have explained, the film was aimed at reinvigorating the slasher film and critiquing torture porn.

The scene of interest to us takes place one evening at the cabin, when Jules, a beautiful blonde college student, passionately makes out at length (in a scene running nearly two minutes!) with a taxidermied wolf head as part of a game of "truth or dare." This scene is both shocking and suggestive for her college friends (and us the viewers) as multiple perversions and pleasures possibly collide here, such as scopophilia (the pleasure of looking) and zoophilia (the sexual love of animals). "Sex with animals," writes Joanna Bourke in *Loving Animals* (2020), "is one of the last taboos, the final bastion of human exceptionalism. The prohibition of what is sometimes called

14 Winnicott's concept of the transitional object is a cornerstone of the British object relations school of psychoanalysis. See Winnicott, Donald W. "Transitional Objects and Transitional Phenomena; a Study of the First Not-Me Possession." *The International Journal of Psycho-Analysis* 34.2 (1953): 89–97.

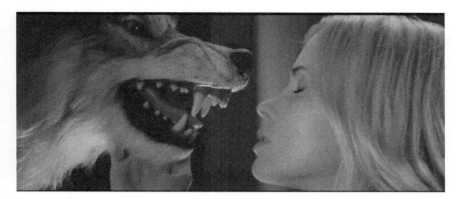

Figure 3.2 Screenshot from *The Cabin in the Woods* (dir. Goddard).

'bestiality' distinguishes the human subject from the animal object" (12). Taxiderm-erotics, my term for the unlikely contact zone between taxidermy and eros, garners some of its shock by flirting with this taboo.

The scene in question begins with a close-up of Jules's bare legs, as she struts (to rock music) toward the taxidermy mount on the wall. The camera shot from below pans up her legs, past the cut-off jean shorts, to the back of her head. She appears visually arrested by the stuffed wolf, flashing her eyes wide and mouth slightly open to show her teeth, a scene that visually echoes the wolf's face. Jules then plays out a flirtatious encounter, conjuring an imaginary conversation with the wolf, as if he has called out to her. We imagine the wolf's response in the quick camera cuts to the wolf's head. Jules says, while toying with her long hair, "Who, me? [...] Yes, I am new in town, how did you know? [...] Oh my god, that is so sweet of you to say, I just coloured it. [...] No no no, there's no need to huff and puff, I'll let you come in." Gesturing with the line "huff and puff" to the nursery rhyme, Jules thus casts herself in the position of one of the three little pigs. To be sure, this association with the pig—symbolically the unclean, most abject of all animals—reinforces the erotics of the scene, making Jules one very dirty girl.[15] And, as Kristeva notes, "*Choïros*, in Greek, means both 'vulva' and 'pig'" (*Severed Head* 31), reinforcing how etymologically and erotically charged this scene is of taxiderm-erotics.

With the sexual overtones of that last line, the invitation to let the taxidermy *come in* clearly understood here to be a sexual, corporeal penetration of her body, Jules embraces the taxidermy and deeply kisses it, running her tongue

15 On the pig, see Mary Douglas's *Purity and Danger*.

88 TAXIDERMY AND THE GOTHIC

along its, licking its teeth and the inside of its mouth, and lovingly petting it. Her friends and boyfriend now look on with expressions of disgust. Jules, who appears to have gotten lost in the moment, who has truly become ex-static, that is, gone outside of herself, concludes the intimate embrace with a quiet "Thank You" whispered to the taxidermy. As she turns away from it, she now has a changed expression, self-surprise, and she appears to spit some hair, or the taste of it, out of her mouth. As the others in the group start to slowly and half-nervously clap, what is clear from this scene is that Jules has gone too far with this dare; she has crossed a line, become too intimate, and has seemingly enjoyed herself with this extended perversely pleasurable performance, something akin to interspecies necrophilia. As Kristeva says, "the power of horror would be nothing without the horror of the feminine" (*Severed Head* 110). What this lengthy, kinky scene delivers is a horrifying exchange or transference between Jules and the taxidermied wolf. It ratchets up the affective intensity of the film, as we now wonder if there is not something wolf-like about Jules herself, and what she might be capable of while in this secluded cabin.

To put it in psychoanalytic language, this steamy taxidermic encounter recalls the totemic meal and the devouring of the ancestor by the primal horde, part of Freud's mythologizing of perversions and the paternal function in *Totem and Taboo*. This is when the totem animal, considered a special member of the group or clan, is collectively killed and eaten, an act that allows its symbolic power to be incorporated by those participants. For Freud, the totemic meal is a way to understand how killing and eating the tyrannical father figure becomes a way to internalize the father's power, a way of explaining how "the dead father became stronger than the living one had been" (*Totem* 143). As Kristeva notes,

> Basically, Freud tells us that eating the father-tyrant, who arbitrarily possessed all the women and all the power, might have been the only way to internalize his power: not by suppressing it but by perpetuating it in modifying it, by stripping it from the father to exercise it collectively in his place. Eating the father, his brain, head, entire body, finally amounts to eliminating his arbitrary nature and, through this new violence, creating [...] social bonds in place of barbarity: a culture in the place of tyranny. (Kristeva *The Severed Head* 13–14)

Jules, in her deeply sexual, ecstatic encounter with the dead stuffed animal head, has transformed death into eroticized life, a symbolic incorporation that is the modification and perpetuation of this power rather than the extinguishing of it. Indeed, her kissing intensifies into a kind of devouring.

It is a kind of erotic violence enacted against the totem animal, collectively witnessed by the group of college friends during a highly ritualistic game ("Truth or Dare"). And, as she spits out the taste of taxidermy and rejoins the rest of the group on the couches, Jules appears to have reinforced social bonds through this shocking corporeal interspecies intimacy with the stuffed beast. She may be the biggest, baddest wolf of all—a version of the father (Lacan's *père-version*).

Tell Me Your Secrets

In the seedy world of Gothic horror, paternal figures are oftentimes beastly: dangerous and unpredictable and their authority and benevolence are unstable. There is no shortage of bad dads in Gothic horror, beginning with the genre's founding father himself: Manfred from *The Castle of Otranto* has not only usurped the castle of Otranto that rightfully belongs to Alfonso but ruthlessly attempts to marry and rape his daughter-in-law, Isabella, chasing her throughout the castle. Manfred also accidentally kills his own daughter, Matilda—this, after offering her up to Isabella's father, Frederic, in a trade for Isabella. While no one else in *Otranto* rivals the degree of dastardliness as Manfred, Frederic, who we are expected to see as the more redeemable foil to Conrad, initially and disappointingly agrees to Manfred's daughter-swap proposal (Frederic later changes his mind but not of his own rational mind; he is supernaturally pressured to do the right thing).

There are also unsanctimonious religious father figures. In Matthew Lewis's *The Monk* (1796), Father Ambrosio gives into his desires for the demon-in-disguise gender-bending Rosario/Mathilda, uses magic to nearly rape Antonia (his sister unbeknownst to him), and murders his own mother. In Radcliffe's *The Italian* (1797), Father Schedoni commits shocking crimes: murdering his brother, raping his brother's wife, and encouraging and nearly carrying out the Marchesa's desire to murder her almost-daughter-in-law. Beyond these unheavenly fathers, in Coleridge's Gothic poem *Christabel*, Sir Leoline, who appears as an old, soft-hearted doting father throughout most of the poem, shockingly discards his beloved daughter, Christabel, and abruptly exits the fragmented poem with Geraldine (who reminds him of her father, his old friend). And, in Mary Shelley's *Frankenstein*, there are multiple instances of failed fathers, such as Victor abandoning the Creature and failing to play a formative role in its development, which itself is an echo of Victor's own neglect at the hands of his father. As Dale Townshend notes, "For all its need to conserve the paternal function," the Gothic from its origins has consistently demonstrated a "lurid fascination with the enjoyments of the perverse father" ("Love in a Convent" 15).

Paternity's identification with transgressions and perversions continues in contemporary Gothic horror narratives, especially so in those involving taxidermy. What brings bad dads, taxidermists, and their macabre creations together in so much Gothic horror? They are yoked together by sharing the association of being accursed creatures, figures who disrupt social respectability, boundaries, and the order of things.

In *Tell Me Your Secrets* (2021), one thing that taxidermy is doing is entering into a conversation about sexual perversions. One of the show's central characters, John, is a formerly incarcerated but supposedly reformed serial rapist. However, as the show unfolds, we learn that John continues to actively struggle with his desires. With taxidermy lining so many walls in this series, often in the background shots of John (a technique that recalls Hitchcock's shots of Norman Bates in *Psycho*), the horror here is that life and its dark desires cannot be eradicated or rehabilitated but rather live on.

Tell Me Your Secrets, written by Harriet Warner and directed by John Polson, appeared on the Amazon Prime Video streaming service in 2021. It threads together the stories of three different individuals, all connected by a violent event in the past. Karen Miller, who was arrested with her serial killer boyfriend Kit for the murder of nine women, but who suffers with amnesia and can't remember what happened, has been released into Witness Protection. With her new identity and name, Emma Hall establishes a new life in the small, Southern town of St. James, with the help of her prison psychiatrist, Pete Guillory. Mary Barlow, whose daughter was one of the murdered women, doesn't believe Karen's story and upon learning of Karen's participation in the Witness Protection program, pursues Karen/ Emma, going to increasingly dangerous and ethically dubious lengths to get a confession from her, including hiring a recently released convicted serial rapist, John Tyler, to track her down. Meanwhile, not long after Karen/Emma arrives in St. James, one of the young women she befriends, Jess, disappears and turns up dead, and Karen/Emma is trying to solve the mystery—one that places taxidermy at the heart of the plot—gradually regains some of her memories and is able to understand her traumatic past.

If one of the principal features of the Gothic, according to Eve Kosofsky Sedgwick, is that the self is "massively blocked off from something to which it ought to normally have access" (12), *Tell Me Your Secrets* has this in spades: from Karen/Emma who struggles with memory loss to other characters who are desperately trying to block something off in themselves, whether dark sexual desires from rearing their head again (as in the case of the supposedly reformed serial rapist John Tyler) or sexual scandals from ever coming to light (as in the case of psychiatrist Pete Guillory's long-term secret relationship with a former underage patient). Even the town of St. James attempts to

TAXIDERMY AND TABOO

keep aspects of itself blocked off, with its carnivalesque Festival of St. Jerome serving as a release valve, allowing the pent-up deviancies and dark energies of the town's citizens to burn off—quite literally, as the festival culminates with a giant bonfire.

Tell Me Your Secrets is a series in which things are not what they seem, where stuffed in the character of one is a frightening other. The grieving mother Mary, who is hardly like her religious namesake, is a Machiavellian monster. Mary's supposedly innocent murdered daughter, Theresa, is revealed to be the real accomplice to Kit's murders, the one who attempted to kill Karen and who we learn (in the final episode) is still alive after she kidnaps Karen's young daughter. The trusted family friend and swim coach, Ed Jennings, is revealed to have been secretly sexually abusing Theresa. The presumed monster, Karen/Emma, having served jail time, who throughout the show seems to exert a kind of sexual charm over all the young women and men she encounters, turns out to be a victim herself in multiple ways. The seemingly "good guy" psychiatrist, Pete, not only appears to blur the lines of professionalism in his relationship with Karen/Emma but is revealed to be married to a former underage patient and is involved with a group that harvests eggs from young women (for reasons unknown). The town's mayor is secretly having affairs with underage girls the same age as his own daughter and is also part of the group harvesting their eggs. And a "reformed" serial sex offender, John, eventually shows us that those desires remain. In a series where each character appears to wear the skin of another, the repeated appearance of taxidermy symbolically reinforces the counterfeit nature of identity.

However, taxidermy promises to serve as more than a metaphor here, more than a reminder of the counterfeit nature of identity—again, a reading already installed in Hitchcock's *Psycho*. Instead, taxidermy's role in *Tell Me Your Secrets* is more extensive and complicated than in *Psycho*,[16] taking on a thickened presence that complements its new setting: the South, a place where, as Stephen King writes, "there is something frighteningly lush and fertile in the Southern imagination" (*Danse Macabre* 311). Here, taxidermy gets its hands dirtier. Karen/Emma is like taxidermy, given a second life albeit one that is stuck in the grip of the past, and she must directly engage with taxidermy to solve Jess's disappearance.

Taxidermy is intrinsically woven into the storyline of Karen/Emma as she investigates Jess's disappearance, and it initially appears that it will play a role in resolving the larger mystery around the deaths of the town's young women. After Karen/Emma is mysteriously and

16 *Psycho* is set between Phoenix, Arizona and Fairvale, California.

violently attacked in the bayou by a hooded figure (episode 1), she later discovers that a pin still lodged in her leg is none other than a taxidermy pin, a connection she makes when she notices a similar one sticking out of a taxidermy mount in the cabin (episode 6). At the same moment, Karen/Emma becomes aware that this is not just any cabin procured by the FBI, but rather Pete's personal cabin, a point reinforced by a picture that hangs on the wall amidst the taxidermy. Suddenly, we realize that he may have been Karen/Emma's unknown attacker.

When Emma turns the taxidermy mount (from which she pulled the pin) over, she finds a sticker on the back. With her hand partly obscuring the sticker, she recognizes the name ABEL, the same name anxiously uttered by the now-dead girl, Jess, the name that also appears to invoke dread in Jess's friends, something like a boogeyman. When asked about it, Tom, Karen/Emma's police boyfriend, explains that the taxidermist at ABEL taxidermy, Andrew Bellvue, has long been dead. Taxidermy comes to a head in these scenes of Karen/Emma with the deer mount, which leads her to venture to the now defunct ABEL taxidermy shop, its name more than just an abbreviation of Andrew Bellvue's name (A.Bel), but also an evocation of the biblical figure of Abel, the youngest son of Adam and Eve, who was slain by his older brother Cain. But since *Tell Me Your Secrets* is a series where figures whose associations with religious namesakes are far from them (recall, again, the Machiavellian mother Mary),[17] a series where other identities are stuffed inside another, we simply do not trust that this taxidermist, Andrew Bellvue, is the "good son" as he is in the Old Testament, whose sacrifices make God happy, or that this taxidermist is actually dead (Figure 3.3). Moreover, the irony of Bellvue's name ("beautiful view") is not lost here either: the taxidermy shop is a scene of anti- or anesthetics (a numbness, a lack of feeling, and absence of beauty) rather than aesthetics (sense perception, beauty), a point reinforced by the emphasis on the shop's taxidermic pins/needles.[18]

Like the easily recognizable Gothic trope of the haunted house, the taxidermy shop is in a state of abandonment, with covered windows, layers of dust, and all the shop's contents in a state of disarray. Even the specimens appear badly preserved with obvious evidence of the ravages of time. As Karen/Emma rifles through drawers, she discovers pins identical to those used on her. She also discovers a cell phone (Jess's) plugged in charging. Thus, despite the shop's initial appearance of abandonment, we know it is actively

17 Some of the most villainous characters in the series have religious namesakes: Peter and John.

18 On how the Gothic explores ambivalent representations of the anesthetized body, see Steven Bruhm's *Gothic Bodies*, especially Chapter 5.

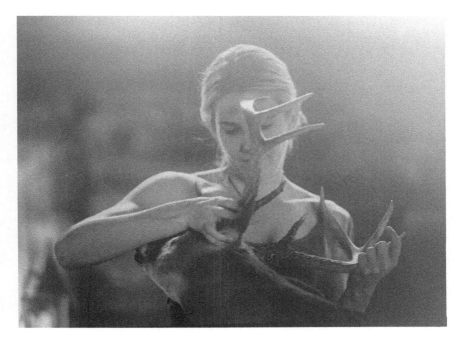

Figure 3.3 Screenshot from *Tell Me Your Secrets*, episode 6 (dir. Polson).

being used, the phone uncannily signaling that there is still life here among the still(ed) life.[19]

In a related vein to the unexpected appearance of the cell phone are the scene's unsettling camera shots. In what creates an atmosphere of suspense and anxiety, the camera shoots this scene from or behind the partially dilapidated wall. As we watch Emma rifle through the drawers, we as viewers are placed in the position of watching from either the wall or behind the wall, a technique that recalls the Gothic trope of the haunted portrait with its moving eyes. Taken together, this camera shot, which strikingly calls attention to itself, and the presence of the cell phone potently remind us of the taxidermy workshop as a site of commingling, of mixed media, where different bodies and materials merge, an association we already find in nineteenth-century taxidermist Charles Waterton's bedroom-*cum*-taxidermy workshop (discussed in Chapter 1).

Recalling the thin line between haunting and hunting, this scene confronts us with medial objects or *techne* (the mysterious camera shot, the cell phone,

19 On the Gothic register of media, see Jeffrey Sconce's *Haunted Media* (2000).

94 TAXIDERMY AND THE GOTHIC

taxidermy) that speak to the historical collusion between hunting and visual technologies, such as in the case of Etienne-Jules Marey's chronophotographic gun, considered a precursor to cinema. Developed in the 1880s, the gun captured stages of movement otherwise imperceptible to the human eye, and it looked strikingly like a modified sawed-off shotgun. Indeed, the chronophotographic gun makes similar investments as taxidermy. If Marey's gun sought to capture rapid minute stages of human and animal movement, to freeze in frame a bird's otherwise continuous movement of flight, taxidermy likewise captures the lifelike frozen movement of the animal, to paradoxically capture movement in stasis.

The camera shot raises the question: Is this point of view from the wall-mounted taxidermy, or from someone hiding behind the wall, the same person who is likely in possession of Jess's cell phone? In the oscillation of these two possible gazes, what becomes conflated is the danger and threat of the potential attacker and the taxidermy on the wall. Not only is it a case of feeling watched by taxidermy (as other characters at other points in the show note, such as Tom complaining to Karen/Emma he can't have sex in the cabin with the taxidermy watching), but in this scene that anxiety, that feeling is shown to be a real possibility. Put otherwise: it is no longer just that taxidermy gives one the uncanny feeling of being watched, but that now we know (through the visual proof of the cinematic gaze) that taxidermy really is watching—this time dangerously unbeknownst to Karen/Emma. And the bigger threat of this watching is that it veils a bigger, more dangerous threat of bad touching: in this case, the omnipresent threat of rape and murder.

Invoking the presence of some kind of unsettling, unknowable "it" or object, the camera shot makes us acutely aware of the scene's objects, and especially the taxidermy. In Gothic horror, the concept of some "thing"—an "it"—creates what Marc Olivier calls "object awareness" (5), a function that is twofold: "first, it introduces a paranoia about objects that points to the larger truth that all objects are unknowable, and second, it flattens ontology—that is, it returns people to the community of objects" (5). As viewers, we are made to see from the perspective of the taxidermied object; we are able, even for a moment in this strange scene, to imagine ourselves stuffed and mounted, looking with a taxidermic gaze. Once again, taxidermy obliquely calls attention to the background, and in this case even allows us to identify with it through the shot that allows us to don its gaze—stuffing us (even if just fleetingly) into the body of another.

This form of looking is also a perverse kind of touching. If, as Maurice Merleau-Ponty says in *The Phenomenology of Perception*, "My entire bodily existence is implicated in my vision" (235), in looking through the eyes of

taxidermy we take on that corporeality, too. Put otherwise, in the blurred vision of this scene, one in which we can imagine what it is like to be taxidermy uncannily watching Karen/Emma, we experience being in this community of stuffed and mounted things. This camera shot induces the feeling of being stuck as we are forced to inhabit the gaze that imprisons us from behind or on the wall, a gaze that watches Karen/Emma's movements but itself remaining fixed.

And yet, we are also horrifically cast into the possible point of view of someone hiding behind the wall, a possible attacker/killer. As such, this scene doubly suspends us; we are suspended in our disbelief in imagining what it is like to adopt a taxidermic gaze, and suspended in our uncertainty in deciding what the shot might mean. It could also just as likely be the viewpoint of a potential aggressor, something darker, dangerous, perhaps something even more horrific and human hiding behind those horrific objects hanging on the wall.

But following this disorientation, this potential ontological flattening in which we assume a taxidermic gaze, we do not arrive at any answers. We have the sense that there is depth to taxidermy—the sense that something (what exactly we can't say)—is there, haunting the workshop, and more broadly haunting the exchanges between Karen/Emma and others, but ultimately it remains silent, stuffed, an object that frustrates.

The stitches here are showing. Part of the trouble that taxidermy in *Tell Me Your Secrets* presents is that there are too many loose threads, in what some critics chalk up to simply a matter of bad writing, and others to a deliberate plotting for a second season. Despite the myriad instances of taxidermy that appear to play a substantive role in the mysterious events going on in St. James, ultimately these signs are dead ends. For by the end of the series, taxidermy has been discarded and has not provided Karen/ Emma (or us, the viewers) with answers. We are left wondering: Who owns ABEL taxidermy? What is the connection to the harvesting of human eggs? Who has taken and killed Jess? Who attacked Karen/Emma with the tools of taxidermy? If in *Psycho*, we have the taxidermist (Norman Bates) and his specimens proudly on display, confessing it consumes all his time, in *Tell Me Your Secrets*, we have a phantasmatic taxidermist who never steps out of the shadows. Taxidermy remains an enigma at the narrative center. It appears that taxidermy has served—if the animal metaphor can be allowed—on the surface as a red herring. After all, none of these taxidermy-related clues solved the mystery of who dunnit. There is no grand discovery that taxidermy pins were being used or a taxidermist was the village murderer. We are left asking the question: Have we gone from much ado about stuffing to much ado about nothing?

96 TAXIDERMY AND THE GOTHIC

Rather than dismiss it as a case of bad writing, there is another way to understand the bad stitching: that taxidermy here intentionally frustrates closure, extending anamorphically from the background into the foreground as an excessive hermeneutical obstacle. As "the materialization of a surplus knowledge," anamorphosis functions as "a form of suspense—it suspends the ostensive meaning of a picture or situation" (Myers 99). Thus, taxidermy as anamorphosis, as a bloated, overstuffed figure, creates suspense and materializes the difficulty of and desire in moving forward.

Thus, in this way, taxidermy in this series is bound to eros on two levels: first, in terms of its content (its alignment with the sexual perversions and taboos, as seen by the characters with whom taxidermy shares the screen, namely Karen/Emma, John, and Pete), and second, in producing pleasurable detours or swerves in the erotics of reading, or what Peter Brooks in *Reading for the Plot* calls "narrative desire." As Brooks argues, applying Freud's framework from *Beyond the Pleasure Principle* of the life and death drives onto the reading experience, the aim of reading (like life itself) is always for answers, resolutions, closure, the end (death), and yet it is deeply unsatisfying if realized too soon. Just as one desires a good death, one desires a good narrative ending. The thickened middle and the various swerves, detours, and dilations of the plot are critical to "textual erotics," and are necessary features in ultimately cultivating the narrative desire for the end. As Brooks says, "The desire of the text (the desire of reading) is hence desire for the end, but desire for the end reached only through the at least minimally complicated detour, the intentional deviance, in tension, which is the plot of narrative" (104).[20]

With the pleasures of detours and dilations in mind, then, taxidermy in *Tell Me Your Secrets* fails to deliver us to narrative closure; it refuses to speak, as it were. This refusal not only creates a series of suspenseful or even frustrating swerves or detours that defer a clear resolution or narrative closure but also suspends our ability to "pin" down this figure—a detail the show flirts with in foregrounding the taxidermic pin.[21] Such a suspension paradoxically keeps taxidermy alive, haunting the series/scenes well after the camera has moved on.

Instead, then, taxidermy creates a series of flashes of insights, the impression that answers are within reach, flashes that ultimately fade into the dark. Despite appearing, on the surface of things, to hold the answers to the central

20 Brooks is interested in "the motor forces that drive the text forward, of the desires that connect narrative ends and beginnings, and make of the textual middle a highly charged field of force" (*Reading* xiii–xiv).

21 In a different mode, the taxidermy artist Kate Clark also uses taxidermy pins to deliberately call attention to the constructed nature of her creations. See Chapter 4.

TAXIDERMY AND TABOO

97

storyline, taxidermy in this series withholds and sends us on a series of detours and dead ends. It manages, as it were, to hold its breath, despite our expectations that it will eventually speak and tell the secrets and/or the truth. In this sense, then, the narrative function of taxidermy in *Tell Me Your Secrets* resembles the form of taxidermy itself, echoing the mystery, uncanniness, and counterfeit nature of taxidermy. Taxidermy's narratological immobility reifies the very phenomenological horror of taxidermy, which is the horror of being-there or stuckness. In this series, taxidermy ratchets up the horror of dark desires not going away, and the anxiety of secrets—whether of one's truth, one's words, or one's voice—getting lodged in the throat.[22]

It is fitting that a show about secrets would feature taxidermy, a craft that, as we explored in Chapter 1, has always been shrouded in mystery and tainted by the whiff of the counterfeit.[23] For just as taxidermy both terrifies and fascinates by appearing both dead and alive, *Tell Me Your Secrets* teeters between the horror of secrets that might remain untold and those that might not. Karen/Emma suffers from trauma-induced amnesia, her memory that seemingly keeps its own secrets; Mary worries that the truth about what happened to her missing daughter will never be told without Karen/Emma's confession, but also worries that her own illegal and immoral activities won't stay a secret; and Mary eventually discovers the former sexual abuse of her daughter at the hands of the trusted swim coach.

While taxidermy largely stuffs up the narrative, there are nevertheless illuminating moments or flashes where it works to show the violent triangulation of power/knowledge—Foucault's concept, outlined in *Discipline and Punish,* for the way power is intimately constituted and consolidated by accepted forms or "regimes" of knowledge. Flickering in the background, taxidermy in *Tell Me Your Secrets* signals the danger of how power/knowledge is produced, namely through the collusion of forces and regimes that are often more insidiously similar than their skins would suggest. Taxidermy accomplishes this by appearing at key junctures to help visually stitch together the ways the enforcement apparatus of a disciplinary society—the penal system and the medical system, particularly psychiatry—exerts itself violently: reshaping and reforming the individual through the promise of a second chance or second life.

For example, when Karen/Emma wanders around the cabin, attempting to piece together details about her new post-incarcerated life, taxidermy is in the shot. When Karen/Emma has conversations with Pete about her

22 This is the "object voice" as Žižek and Dolar describe it.

23 Indeed, we could look as far back as 1799, when one zoologist thought the newly discovered platypus could have been a counterfeit creation by a taxidermist (Ritvo 4).

new identity and ongoing memory loss, taxidermy also appears in many of the scenes. But the most unnerving scene comes when Karen/Emma and John, who have met at the local dive bar, return to the cabin for more drinks. There, with the taxidermy presiding over them, in a scene that is reminiscent of *Psycho* in both its form and content, John attacks Karen/Emma.[24]

Prominently featured in the background of these shots is the frozen, mute taxidermy. The mediation or triangulation of taxidermy in these scenes with Karen/Emma, Pete, and John serves to show how perversely the medical system and the penal system are two sides of the same coin. For we come to see, against the triangulating figure of taxidermy frequently included in the shots with these characters, how the FBI prison psychiatrist, Pete, whose taxidermy-filled cabin is the safe haven for the memory-recovering Karen/Emma, is eerily similar to the supposedly reformed serial rapist, John. Pete and John, two figures who ought to be morally and professionally opposed, are shown over the course of the series to be murkily alike, more like two apostles of a bad religion (Figure 3.4).

Figure 3.4 Screenshot from *Tell Me Your Secrets*, episode 1 (dir. Polson).

24 Even the casting choice of Hamish Linklater to play John resembles the slender build of Norman Bates.

TAXIDERMY AND TABOO

In these scenes, taxidermy helps to stitch together the implications of being caught in the crosshairs by John and Pete, metonyms for the penal and medical systems, respectively. For here, taxidermy in these intensive scenes becomes even more deeply aligned with Karen/Emma herself, who, as I suggested earlier, is like taxidermy in being given a second life, albeit one that is largely stuck. The cabin's silent but seemingly watchful taxidermy that presides over the unsettling scenes serves as an uncanny Philomela figure, simultaneously standing as a reminder and a harbinger for the ways Karen/Emma is caught in the crosshairs of multiple violent systems.[25] By repeatedly appearing in the scenes with Karen/Emma, taxidermy visually reinforces the identification. For Karen/Emma's so-called second life, her fresh start, combined with her memory loss, eerily resembles a state of suspended preservation.

Thus, the real anxiety that the show's taxidermy visually works to stage is the collusion between bodies of/in power and the insidious violence that operates in the background. It is, in other words, the horror of being-there. In their relationships with both these particular characters, women in particular are contending with coercive forms of power/knowledge—psychically, in the case of the mind-games played by the psychotherapist, and physically, in the case of John (but also Emma's serial killer boyfriend, Kit)—and get drawn into these forms, too, such as in the way Emma/Karen cannot remember if she participated in the violent killings alongside her boyfriend, or Mary, who slides from grieving mother of a missing girl into a dangerous murderer herself.

Overall, the treatment of taxidermy in *Tell Me Your Secrets*, and its association with dark desires and perversions, situates it as a recent case in a longer cinematic line that begins with Hitchcock's *Psycho* and that carries through other popular horror films, such as *The Cabin in the Woods*. If *Psycho* introduces taxidermy's "polymorphous perversity" and ensconces it as a trope of modern Gothic horror in film, subsequent films, such as *The Cabin in the Woods* and the series *Tell Me Your Secrets*, reify the association. Although no one locks lips with taxidermy in *Tell Me Your Secrets*, taxidermy more complexly appears to voyeuristically watch over the libidinally charged exchanges and encounters between Karen/Emma and others, becomes symbolically linked with Karen/Emma, and steps out of the background and into the foreground to serve as a plot device. The show visually triangulates taxidermy with the horror of being-there: of being given a "second life" only to find it is a lifeless one, of dark desires that on the surface have disappeared but that stubbornly and secretly

25 In Ovid's *Metamorphoses*, Philomela, who is raped and silenced by having her tongue cut out, is also left imprisoned in a cabin by Tereus.

remain, and of being caught in the crosshairs of a disciplinary apparatus. And perhaps even more perversely, insofar as it involves us as viewers, the show enables us to briefly experience what it might be like to be taxidermied, as we become stuffed and pinned by the camera shot that appears as it were the gaze from one of the taxidermy mounts. It affords us a bottomless gaze, enabling us to indulge in the fantasy and horror of being stuffed and suspended—showing us what it might be like to look through glass eyes.

Chapter 4

TAXIDERMY, FUNGIBILITY, AND THE EVERYDAY GOTHIC HORRORS OF BLACK LIFE

Racialized human faces, made with black and brown hides of various hues, shaved and stitched together with bright shiny silver pins, are affixed to the bodies of lions, antelopes, sheep, bears, and coyotes, among other animals. These hybrid taxidermy sculptures by Kate Clark, with their human faces and animal bodies, not only nuzzle the thin fuzzy line between species, bringing the human and the animal into intimate proximity but also breathlessly speak to the historical associations between blackness and animalization. Black American poet Claudia Rankine specially commissioned a taxidermy sculpture by Clark to be photographed and included within her *Citizen: An American Lyric* (2014), a book-length poem about race and anti-black racism and microaggressions in contemporary America. Donning a taxidermy mask (made by Clark), black hip-hop artist Desiigner transforms into a half-man-half-panda in the music video's final scene for "Panda" (2016).[1] And, in the black horror film *Get Out* (2017), taxidermy exists in a strange constellation with the main protagonist, Chris Washington, a black man who ultimately weaponizes a taxidermy mount to escape from a veritable house of horrors. Taken together, these examples suggest that taxidermy is enjoying something of a black renaissance. As this chapter will argue, taxidermy is emerging as a constellation that cuts across genres to capture the pervasive horror of black existence.

As the first part of this chapter explores, the long nineteenth century sets the stage for a difficult relation between taxidermy and black bodies. From the nearly forgotten black taxidermist John Edmonstone, who trained Charles Darwin, through the real-life cases of preserved and taxidermied black bodies (of the "Hottentot Venus" and "El Negro"), likely inspiration for the stuffed black man-turned-coatrack in H. G. Wells's Gothic tale "The Triumphs of

1 Clark used black bear and antelope hides rather than a real, endangered panda.

a Taxidermist" (1894), black bodies have inhabited the world of taxidermy since its golden age—a golden age it shares with the Gothic. And yet now, in our contemporary moment, taxidermy's black bodies have returned to Gothic horror with a vengeance. In the next two parts of this chapter, I focus on two key texts where taxidermy constellates the horror of black existence: Claudia Rankine's genre-bending prose poetry collection *Citizen: An American Lyric* (2014), which includes a photograph of a specially commissioned taxidermy sculpture by Kate Clark, and the horror film *Get Out* (2017, dir. Jordan Peele).

Taxidermy's Black History

Black bodies feature prominently in the history of taxidermy; they are there in the handiwork of some of the best-known, most influential taxidermy specimens, such as Darwin's finches—those birds collected from the Galápagos Islands in 1835 by Darwin and his colleagues during the second voyage of the H.M.S. *Beagle* (1831–1836) and whose variations in plumage, body, and beak size and shape would be part of the evidence that Darwin gathered for his theory of evolution (Figure 4.1).[2] Yet while Charles Darwin is a household name, and his stuffed finches, pigeons, and mockingbirds remain some of the most important specimens for how Darwin came to track evolutionary changes in the animal world, the man who trained Darwin in the art of

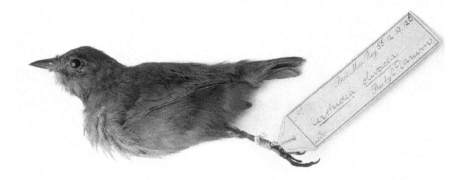

Figure 4.1 Galápagos Island finch collected and preserved by Charles Darwin. Image courtesy of the Trustees of the Natural History Museum, London.

2 See Darwin's *Journal of Researches*, now known as *Voyage of the Beagle*, for an account of the finches.

TAXIDERMY, FUNGIBILITY, AND GOTHIC HORRORS 103

taxidermy has all but been erased from this history. In the 1820s, while Darwin was a medical student at the University of Edinburgh, he was privately tutored in the art of taxidermy by John Edmonstone (sometimes spelled "Edmonston") who was a former enslaved man from British Guiana. Edmonstone had extensively trained Charles Waterton (another nineteenth-century taxidermist, discussed in Chapter 1), and accompanied him on some of his expeditions in South America. Edmonstone came to Edinburgh a free man, and set up shop as a "bird-stuffer" at 37 Lothian Street, close to the university and just a few doors down from where the young Darwin himself would live as a student.[3] As Darwin wrote in his autobiography:

> A negro lived in Edinburgh, who had travelled with Waterton, and gained his livelihood by stuffing birds, which he did excellently: he gave me lessons for payment, and I used often to sit with him, for he was a very pleasant and intelligent man. (*Autobiography* 22)

Darwin wrote in a letter to his sister (29 January 1826): "I am going to learn to stuff birds, from a blackamoor [sic] I believe an old servant of Dr Duncan: it has the recommmendation [sic] of cheapness, if it has nothing else, as he only charges one guinea, for an hour every day for two months" ("Letter no. 22"). Edmonstone, who was "the first black [Darwin] encountered" (Lander 78), remains unnamed both in Darwin's account and in much of the scholarly work on Darwin until the late 1970s. To date, little remains are known about Edmonstone, including how many others he trained in the art of taxidermy.[4] This erasure of Edmonstone—the erased black hand behind "evolution's white ladder," to borrow a line from John Agard[5]—is but one part of the story about taxidermy and blackness.

If this seldom acknowledged black taxidermist, John Edmonstone, was the master behind the apprentice, Darwin, later in the century the tables and tools are turned in H. G. Wells's Gothic tale "The Triumphs of a Taxidermist," which disturbingly features a black man as one specimen among many others being stuffed. This story, as we have already discussed in Chapter 1, frames taxidermy as an outdated practice predicated on illusions, forgeries, and various aesthetic and moral violations, a thinly veiled art of

3 Darwin lived at 11 Lothian Street while studying at the University of Edinburgh (1825–1827).

4 For more on Edmonstone, see R.B. Freeman's "Darwin's Negro Bird-Stuffer." *Notes and Records of the Royal Society of London*, 33.1 (1978): 83–86.

5 See Agard's poem "The Ascent of John Edmonstone" in *Alternative Anthem: Selected Poems*. Tarset: Bloodaxe Books, 2009.

104 TAXIDERMY AND THE GOTHIC

the counterfeit not unlike its Gothic cousin. The story's unnamed black man stands out among the taxidermy specimens we are introduced to, described in a half-drunken account of the various fantastical and counterfeit creatures stuffed by the unnamed taxidermist. As the taxidermist boasts to the narrator, "I have stuffed elephants and I have stuffed moths, and the things have looked all the livelier and better for it. And I have stuffed human beings— chiefly amateur ornithologists" (48). He immediately follows this by declaring he stuffed a black man once, staging him "with all his fingers out and used him as a hat-rack, but that fool Homersby got up a quarrel with him late one night and spoilt him. That was before your time" (48).

This claim makes Wells's taxidermist exceptional in the worst way, having performed multiple human taxidermies. In actuality, real human specimens were rarely done and never done well enough so as to be mistaken for a real, live human (which is implied in the story with Homersby getting into a fight with the specimen). Some rare examples, likely inspiring Wells's story, include the well-known and horrifying specimen of Jeremy Bentham's (1748–1832) Auto-Icon, his own dissected and preserved skeleton, created after his death and publicly displayed at the University College of London in 1850 as part of his bequest.[6] Yet it is likelier that Wells's stuffed black body was inspired by other nineteenth-century scandals involving the preservation of black bodies, such as the "Hottentot Venus" and "El Negro," that were part of the period's interest in human zoos, ethnographic exhibitions that emerged as ways of showcasing various "savages" from exotic locales.[7]

Saartje (Sara) Baartman (c.1789–1815), the so-called Hottentot Venus, was a Khoikhoi woman from Cape Town, South Africa, who had been brought to Britain in 1810 by British military doctor Alexander Dunlop and Hendrik Cesars (Dunlop's manservant) and was exhibited for financial gain in freak shows, salons, museums, and universities throughout Britain and France as an exotic and erotic object of curiosity for her voluptuous physique and scantily clad dancing. She was a sensational object in print culture and seemed to embody different political anxieties for Britain and France. As William

6 While the surviving Auto-Icon now contains a wax head atop of Bentham's preserved skeleton, initially his head was meant to be preserved too. However, the process of desiccation "went disastrously wrong, robbing the head of most of its facial expression, and leaving it decidedly unattractive. The wax head was therefore substituted, and for some years the real head, with its glass eyes, reposed on the floor of the Auto-Icon, between Bentham's legs" (UCL "Auto-Icon").

7 On the history of this, see *Human Zoos: Science and Spectacle in the Age of Colonial Empires.* Ed. Blanchard, Pascal et al. Trans. Teresa Bridgeman. Liverpool University Press, 2008; Andreassen, Rikke. *Human Exhibitions: Race, Gender and Sexuality in Ethnic Displays.* Ashgate, 2015.

TAXIDERMY, FUNGIBILITY, AND GOTHIC HORRORS 105

Heath's satirical print titled "A Pair of Broad Bottoms" (1810) makes clear, Baartman comes into focus at a time when the British political imaginary is obsessed with bottoms via the "broad bottom" government of Lord William Grenville (prime minister 1806–1807), who himself had large buttocks.[8] And for the recently defeated France, in the wake of the Haitian Revolution, Baartman symbolized another attempt at imperial domination. Not only were Black women during this time "seen as Other," as Robin Mitchell argues, but "the use and production of their bodies reinforced strategies of Whiteness, Blackness, and Frenchness" (11). In short, certain identities were shored up against the spectacle of blackness with which Baartman was synonymous, just as animals were used to shore up the identity of, to use Sylvia Wynter's phrase, a certain "genre of the human"—that is, white, bourgeois European Man.

The novelty here was not that Baartman was black, for as Rachel Holmes notes, "Africans in England were no longer of themselves a remarkable curiosity. The permanent black population of Britain at the beginning of the nineteenth century was about twenty thousand, with numbers steadily rising following abolition in 1807. London was already multiethnic" (42). Rather, it was that she was a "Hottentot"—an offensive colonial appellation used throughout the seventeenth and eighteenth centuries to associate the Khoikhoi with what many Europeans then considered to be bestial bodies and behaviors: large genitals, a primitive-sounding language of click sounds, to barbarism and even cannibalism (Qureshi 234).

For some of her performances, Baartman appeared chained and taking commands in a cage alongside exotic animals—a clear alignment of blackness with animality, an association that would persist even in her death.[9] In 1816, French anatomist and zoologist Georges Cuvier made a full body plaster cast of and dissected and preserved her skeleton, brain, and genitals and put them on public display as part of a comparative anatomy exhibit at the Muséum d'Histoire Naturelle until 1937, when they were moved to the Musée de l'Homme in Paris.[10] Cuvier used Baartman as part

8 For more on Baartman's emergence in England and its obsession with bottoms at the time, see Rachel Holmes's *African Queen* (pp. 43–45).

9 While in France, in 1815, Baartman was managed by an animal showman named S. Reaux (Crais and Scully 127).

10 Cuvier had met Baartman while she was alive and had invited her to the Muséum to be studied. She refused to allow Cuvier and fellow scientists to study her genitals, although had no luck in preventing this from happening after her death. Cuvier's plaster cast was displayed longer until 1970 and in 2002 all of Baartman's remains and the cast were expatriated and buried in South Africa. By some reports, Cuvier kept her brain and genitals preserved in jars in his private residence.

106 TAXIDERMY AND THE GOTHIC

of his racist alignment of black bodies with animal bodies, which was part
of his project of classifying different ethnic groups into a hierarchy of
"species," work that influenced nineteenth-century evolutionary theories and
racist sciences.[11] Indeed, as a "Hottentot," Baartman became representative
of the "missing link" between human and animal species, occupying an
ontological liminality not unlike taxidermy.[12] Just as nineteenth-century
taxidermy in North America aligned animal and Indigenous bodies, working,
as Pauline Wakeham argues, to reinforce racist discourses and fantasies
of colonial domination over various "wild" bodies, we find a precursor to
this in Europe over black bodies.

If in life Baartman was already "a compound of science, phantasmagoria,
fantasy, and curiosity" (Holmes 77), in death she becomes gothically
preserved. Her relationship with Cuvier, who became obsessed with having
her as part of his collection, and Parisian science at the time resembles
a tortured scene from a gothic narrative. Indeed, from the time she models
for the leading scientific men of the day—Étienne Geoffroy Saint-Hilaire,
Cuvier, and Henri de Blainville—at the Jardin du Roi, but frustrates them
by refusing to reveal her genitals, Baartman becomes in this prohibition all
the more desired by Cuvier. Baartman is like the real-life dramatization of
a Gothic heroine, doggedly pursued by a powerful man with dark designs,
a black Isabella fleeing from the Manfred-like Cuvier.[13] Yet unlike Walpole's
Isabella, Baartman ultimately does not escape. In death, Baartman's
preserved and displayed body served as more than just the tangible "missing
link" between human and animal kingdoms, a lost piece found and fit into

11 Henri Marie Ducrotay de Blainville aligned Baartman with the orangutan, a point
 echoed by Georges Cuvier in his report, following his dissection of Baartman,
 that the Hottentot was closer in relation to the great ape than to the human (Crais and
 Scully 140). Clifton Crais and Pamela Scully. 2009. *Sara Baartman and the Hottentot
 Venus: A Ghost Story and a Biography.* Princeton: Princeton University Press.

12 Hottentots and Australian aborigines were considered even more primitive than
 Africans. Gould, Stephen Jay. 1981. *The Mismeasure of Man.* New York: W.W. Norton &
 Co., pp. 118–19. Jones, Steve. 1996. *In the Blood: God, Genes and Destiny.* New York:
 HarperCollins, p. 170. The racist French anthropologist Paul Topinard discussed
 Baartman's ape-like expressions and movement in his book. Topinard, Paul. 1894.
 Anthropology. London: Chapman and Hall, pp. 493–94. Wells never explicitly refers to
 the Hottentot Venus, but does have a character mention the Hottentot in *The Research
 Magnificent.*

13 Rachel Holmes describes Cuvier as being "a plodding, assiduous creep [...] who owed
 his ascendance to the fact that he never undertook the adventurous risks of fieldwork.
 [...] he was paranoid, lonely, self-pitying, and constantly besieged by imaginary
 monsters threatening to assail his intellectual preeminence" (76).

an order of things. Rather, her body-turned-public specimen also served to locate blackness within a particular spacetime, a performance that renders the non-white, non-European preserved body like taxidermy, as "atavistic, frozen specimens of the past who are ostensibly dead to the present" (Wakeham 203). She was a perpetually "living fossil," as Crais and Scully put it (128).

While the Hottentot Venus stands as a close cognate of taxidermy, "El Negro" is a real and gruesome human mount.[14] "El Negro" was an African warrior who died in 1830, and whose body was stolen, shipped back to Europe, and stuffed by the celebrated French taxidermists the Verreaux brothers before being displayed in Paris (and shockingly remaining on display until 1997).

Jules Verreaux (1807–1873) and Edouard Verreaux (1810–1868) helped make Maison Verreaux, established in 1803, the "premier provider of taxidermy collections for museums of natural history" (Molina 30). Maison Verreaux played a significant role in the economy of knowledge production; it was a commercial business, with an extensive catalog of natural history objects available, a hub for leading intellects of the day to gather, and a financial backer for global expeditions (Daszkiewicz 130). Some of the age's best-known scientists, including Cuvier, made discoveries in classification after seeing the specimens collected and displayed by the Verreaux brothers.[15] Already, by the mid-nineteenth century, Maison Verreaux was a veritable taxidermy emporium, warehousing over 3000 mammals and 40,000 birds (Mearns and Mearns 405).

Recently it was discovered that "El Negro" was not the only instance of the Verreaux brothers using humans or at least human remains as part of their taxidermy. Their masterpiece diorama *Lion Attacking a Dromedary*, created in 1867 for the Paris Exhibition, sensationally and inaccurately depicts what the brothers thought was an "Arab" atop a dromedary fighting off a lion attack. While criticism of this human figure has long rested on the grounds that the Verreaux brothers assembled this figure without any cultural accuracy, in 2016, testing, including X-rays and DNA samples done as part of a restoration process, made the disturbing discovery of human remains within it—a human skull, leg, and arm bones. Little is known about

14 This specimen went by other names as it was trafficked to other countries following Verreaux's sale of it, such as the name "EI Betjouanas" (Parsons "One Body" 21).

15 The whale shark captured in the Cape of Good Hope proved to be among some of the original specimens used to define species. Jules Verreaux would even study under Cuvier for five years as a young man (Mearns and Mearns 405).

these mystery remains.[16] At Pittsburgh's Carnegie Museum of Natural History, where the taxidermy diorama has long been on display since 1899, the interim director of the museum, Stephen Tonsor, finally hid it from view from 2019 to 2020 by veiling it with a curtain for ethical concerns—a decision explained as coming on the heels of increased racialized violence in America and the protests against systemic racism and police brutality.[17] If, in the nineteenth century, this taxidermy diorama spoke to the imperialist violence of France against citizens of Algeria, Morocco, and Tunisia, in our present moment, it now speaks to the ongoing violence against Black, Indigenous, and People of Colour communities in America.

Thus, as these examples show—from John Edmonstone, Darwin's nearly erased black taxidermist teacher, to the well-known preserved black bodies of Baartman and El Negro, likely inspirations for the figure of the black taxidermied body-object-thing in Wells's story—taxidermy plays a role in the biopolitical enmeshment of blackness and animality. We can also add taxidermy to the list of discourses that contributed to what Zakiyyah Iman Jackson in *Becoming Human* calls the "history of blackness's bestialization and thingification: the process of imagining black people as an empty vessel, a nonbeing, a nothing, an ontological zero, coupled with the violent imposition of colonial myths and racial hierarchy" (1).

And yet, taxidermy also shares with blackness what Jackson theorizes as black(ened) being's ontological plasticity. For Jackson, it is not simply that black people are dehumanized or abjected for being animal-like, but that subtending such common thinking is the more radical plasticization of what blackness can be; it is a view of blackness as simultaneously "everything and nothing," as the "privation and exorbitance of form" where black(ened) being is a "statelessness that collapses a distinction between the virtual and the actual" (35). The profound instability or plasticity of blackness, of black flesh or materiality, is both a site of critique and creative possibility for Jackson and the authors she considers. Taxidermy, I offer, in Claudia Rankine's poem *Citizen* and Jordan Peele's horror film *Get Out* performs a similar maneuver— forging an identification with black life and its attendant horrors. Taxidermy, like Jackson's "black(ened) being," is a figure that is ontologically plastic, or what I describe as having a "nocturnal ontology" (in Chapter 2). And

16 According to one source, "It was the body, they concluded, of a man aged about 27, who had possibly died of a pulmonary infection. The anthropologist among them, a lawyer by profession, pronounced on the body as being of 'Bushman' race" (qtd in Parsons 21).

17 In 2021, the controversial diorama returned to public view but with new signage, as the museum continues to solicit public feedback for a permanent solution.

TAXIDERMY, FUNGIBILITY, AND GOTHIC HORRORS 109

yet, despite its plasticity or fuzziness, taxidermy is simultaneously and paradoxically also a horrifying figure for stuckness. As we will see next, where Rankine's text lays this relation bare in a more elegiac vein, Peele's text explores the possibility of what it might look like when taxidermy and black life get unstuck—that is, get a second shot at life, get out, and get revenge.

Rankine's Use of Taxidermy: Kate Clark's *Little Girl*

Black American poet Claudia Rankine's award-winning collection *Citizen: An American Lyric* (2014), a genre-bending prose poem, interrogates the ubiquitous violence of racist microaggressions and anti-black racism in America. Interspersed within the text are several color images, one of which is a taxidermy piece that Rankine specially commissioned by Kate Clark, a Brooklyn-based taxidermist sculptor known for her uncanny "humanimal" (human–animal) hybrid creations, and who, since working with Rankine, has gone on to have other high-profile cultural collaborations with black artists.[18]

Some of the most captivating contemporary taxidermy artwork today comes from Clark, whose creations use real animal skins, many of which are often damaged and unwanted skins that are then "up-cycled" into her art. Her approach is motivated by the entwined human tendencies to love and revere animals as well as to dominate them. If her work balances violence and intimacy, it also balances traditional techniques of taxidermy—the cutting, gluing, and stitching of hides—with imaginative additions of human-like faces. In her practice, a white polymer clay face, which is modeled on a live human model, is then covered by the animal's facial skin, cut, shaved, and stitched back together with the stitches visibly showing. Clark frequently uses racialized faces, inviting us to see a variety of bodies, family structures, and skins in close relation to the animal.

For *Citizen*, Rankine selected Clark's taxidermy sculpture *Little Girl*, which appears to feature a black woman's face affixed to a taxidermied young deer's slight body, curled up in the position of resting. However, as the figure's anthropomorphized facial expression makes clear, we would be remiss to think that this resting is peaceful; instead, with a facial expression that seems a mixture of fear and apprehension, the figure's guard is far from down.

18 Clark was commissioned by Kanye West's team to create a taxidermy sculpture mask—made out of black bear and antelope hides—for the music video for Desiigner's single, "Panda," in which Desiigner transforms into a "half man/half panda" in the video's final scene.

Like Clark's hybrid taxidermy sculpture, Rankine's *Citizen* subverts expectations of genre. *Citizen* resists the parameters of being called poetry and has been critically hailed as a hybrid mixture of poetic fragments, prose poems, and lyrical essays. Indeed, it shares the difficulty in containment and hybrid sensibility that we find in the long tradition of Gothic and taxidermy texts (as discussed in the first chapter of this book). *Citizen* also shares something with the Southern Gothic, the long tradition in American literature of turning to Gothic tropes to address the nation's violent history of slavery and racism and its attempted repression of these events. But these ghosts have never gone away, and as Sheri-Marie Harrison writes, "Gothic violence remains a part of everyday black life" ("New Black Gothic," n.pag.).

Rankine's *Citizen* speaks in visual and textual ways to the insidious Gothic violence of racism in North American life. It is a text, like the lives it describes, that is marked by hauntings, beginning with the book's cover image: a photograph of David Hammons's sculpture titled *In the Hood*, which depicts a black hood that looks violently torn off a hoodie, set against a stark white cover. While Hammons's sculpture precedes Trayvon Martin's murder by George Zimmerman in 2012 and the Black Lives Matter movement, formed in response in 2013 after Zimmerman's acquittal, it nevertheless stands as a powerful overdetermined image for Martin, who was shot while unarmed and wearing a hoodie, and the myriad ways that black lives are shrouded in systemic racism.

For multiple reasons, it is especially poignant that Rankine selects the taxidermy sculpture *Little Girl* by Clark for inclusion in her collection: first, on the grounds that it has a young black girl's face; second, for the particular species and age of the specimen (not just a deer but more specifically a fawn); and third, for its medium, namely the fact that it is taxidermy, an art of the breathless (Figure 4.2). And indeed, it is the horrors of anti-black racism and the toxic, suffocating effect of this racism on black bodies that renders taxidermy's breathlessness a metaphor for blackness.

In a 2014 interview with Lauren Berlant in *BOMB* Magazine, Rankine explains her choice to include Clark's taxidermy, in a passage worth quoting at length:

> Kate Clark's *Little Girl* and Wangechi Mutu's *Sleeping Heads* were both important for me to get the rights to use in *Citizen* because they performed, enacted, and depicted something ancient that I couldn't or didn't want to do in language. In African-American literature **it's the moment the ancestor shows up in a corner somewhere**, a direct descendant of slavery. They are both, in a sense, collaged pieces insisting the viewer bring together that which does not live together.

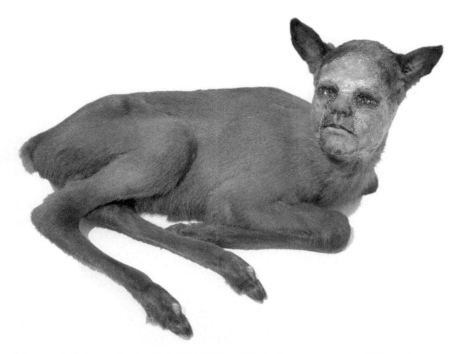

Figure 4.2 Kate Clark. *Little Girl*. © Kate Clark. Image courtesy of the artist.

They are disturbing because they are "wrong" and yet familiar on a certain level. [...] The incongruity, the dissonance, revolts and attracts. *Unheimlich* comes to mind—you want to look away and can't look away because it's your doppelganger that's been shadowing you. Clark uses taxidermy to create her sculptures. In the particular piece I used in *Citizen*, she attached the black girl's face on this deer-like body—it says it's an infant caribou in the caption—and I was transfixed by the memory that **my historical body on this continent began as property no different from an animal. It was a thing hunted and the hunting continues on a certain level**. (Rankine "Interview," emphasis in bold added)

For Rankine, this image of the taxidermied black girl/deer accomplishes something that language cannot, invoking a certain affect without clarifying or providing an easy answer. Taxidermy here serves to conjure a certain atmospheric experience: of being unsettled or haunted by the past that refuses to stay hidden. This idea that Rankine articulates of "the ancestor show[ing] up in a corner somewhere" dovetails with how taxidermy functions

more broadly, that is, in an anamorphic manner throughout Gothic horror. Taxidermy requires a certain perspective, a particular vantage point or looking at it awry, in order to make the image come into focus. This peripheral quality of the ancestor showing up, talisman-like, as a vestige of the deep, archaic past, invoking the event of slavery and the "history of blackness's bestialization and thingification" (Jackson 1), stands taxidermy-like in the room, still haunting the spacetimemattering of our own moment.

However, if we look even closer and linger on this particular choice to use taxidermy as the evocative figure that produces this sense of haunting and uncanniness, another insight irrupts here over the phenomenon of interrupted breath. Rankine's *Citizen* offers a view of the condition that Shermaine M. Jones calls "affective asphyxia" which "results from the expectation that black people must choke down the rage, fear, grief, and other emotions that arise when confronted with racism and racial microaggressions" (38). As Jones finds in *Citizen*, "In these awkward moments of everyday racist encounters, the body aches as it negotiates whether to respond, whether to teach, or whether to be silence" ("I Can't Breathe!" 39). Indeed, as Rankine writes, "confrontation is headache producing" (*Citizen* 10).

Taxidermy, paradoxically, helps speak to this affective asphyxia, as does Rankine's particular choice of taxidermy. That Rankine selects a "deer-like body" for this project is telling for the same reason that it is critical that in the film *Get Out* it is also a deer and deer-like bodies that constellate the anxieties and horrors of black existence. While this will be more fully explored later in this chapter's discussion of *Get Out*, briefly put the answer has to do with what the deer, as an animal of prey, represents on the surface as a psychic defense mechanism in response to trauma.

Another way to read this image is as commentary on the "fawning" response, an attempt to "people please" that develops in response to trauma and toxic relationships. Fawning, a term developed by psychotherapist Pete Walker in *Complex PTSD: From Surviving to Thriving* (2013), is the fourth trauma response after fight, flight, and freeze. It names the trauma response in which an individual resorts to people-pleasing behavior to deescalate threatening situations and reestablish a sense of safety. As Walker states, "Fawn types seek safety by merging with the wishes, needs and demands of others. They act as if they unconsciously believe that the price of admission to any relationship is the forfeiture of all their needs, rights, preferences and boundaries" (122). The feeling of walking on eggshells, of having to conceal true feelings out of fear, of having to shove aside one's own feelings for the comfort of others—these are all examples of fawning.

This defense structure, which sees an individual bypass their own needs and even identity for the sake of pleasing another, resembles the emotional toll

TAXIDERMY, FUNGIBILITY, AND GOTHIC HORRORS 113

and negative health effects that racism has on black bodies—the exhaustion, fatigue, and chronic stress that systemic racism inflicts on the body's physiology—one of the central ideas that *Citizen* explores. For Rankine, racism acutely accumulates in the respiratory system: "Certain moments send adrenaline to the heart, dry out the tongue, and clog the lungs. Like thunder they drown you in sound, no, like lightning they strike you across the larynx. Cough" (*Citizen* 7).

Like affective asphyxia that comes with the stifling of black emotions, fawning is also found in response to racial trauma. As psychotherapist Sharon Kwon confesses in a moving column for *The Huffington Post*, "I fawned by aiming to please white people and viewing myself the way they saw me. I fawned by laughing off racist jokes, microaggressions, fetishizations, and the repeated belittling of my cultural background and how I look." What is key here is how the effects of fawning and ubiquitous racism live in the body and language. "Black expressive culture is replete," as Jones notes, "with ruminations, musings, and lamentations on how it feels to be black in America, and these expressions [...] often incorporate the imagery and language of smothering and choking that signifies asphyxiation" (38).

In addition to the language of smothering and difficult breathing, *Citizen* explicitly invites us to think about the collusion between the deer-like body and the suffering black body:

To live through the days sometimes you moan like deer. Sometimes you sigh. The world says stop that. Another sigh. Another stop that. Moaning elicits laughter, sighing upsets. Perhaps each sigh is drawn into existence to pull in, pull under, who knows; truth be told, you could no more control those sighs than that which brings the sighs about. (*Citizen* 59)

The black body is aligned here with the suffering animal body and is an echo of what Cornel West identifies as the condition produced by "America's unrelenting assault on black humanity," namely "the guttural cry and wrenching moan as both a cry for recognition and [an] ur-text of black culture" (101). And as Tiffany Lethabo King writes in *The Black Shoals*, "Black life and expression is an utterance or moan that emerges from the hold of the ship and continues on the plantation, like Aunt Hester's scream" (22)— the scream from Frederick Douglass's enslaved aunt (named Aunt Hester) who is sadistically whipped by the slaveholder Captain Anthony, as Douglass recounts in his *Narrative of the Life of Frederick Douglass* (1845). Moans and sighs are an acoustic, affective connective tissue showing the long history and horror of black existence across diverse spacetime.

It is not only the sound of suffering that Rankine explores in *Citizen* but also its interruption, such as the various kinds of breathwork or voices that get interrupted: a moan that is stuck in the throat, the sigh or breath, all suggested in the art of taxidermy. As Rankine writes in *Citizen,*

> The world is wrong. You can't put the past behind you. It's buried in you; it's turned your flesh into its own cupboard. Not everything remembered is useful but it all comes from the world to be stored in you. Who did what to whom on which day? Who said that? She said what? What did he just do? Did she really just say that? He said what? What she did do? Did I hear what I think I heard? Did that just come out of my mouth, his mouth, your mouth? Do you remember when you sighed? (63)

What is taxidermy if not flesh turned cupboard, a corporeal archive, a past preserved to look as if it were present? The storing of these questions and the incredulity of what may have just come out of the mouth—a moan, a sigh, a speech act—makes us think about traditional taxidermy trophy mounts where the face of the animal is privileged, where we stare and imagine that, perhaps with enough concentration, we just might see the nostrils flare or lips part and voice erupt out of its frozen mouth. Taxidermy becomes a provocative figure for thinking about all the ways we become mute and are rendered breathless, often in shock or disbelief as a result of microaggressions and ubiquitous violence.

Moreover, if we look away from this arresting face that appears as if it is holding its breath in fear or shock to the rest of *Little Girl*'s body, we encounter a body at rest or even injured. Indeed, I read it as a maimed figure. Not only does the figure's breathlessness speak to the difficulty of living amidst systemic anti-black violence, but its maimed body calls attention to the difficulty of escape. As Jasbir Puar shows in *The Right to Maim* (2017), maiming, unlike killing, debilitates an individual and keeps them available as an ongoing "source of value extraction" (xviii). Maiming, in other words, keeps bodies stuck in the violence of life.

The breathlessness and stuckness of taxidermy, then, as a metaphor for the shock or paralysis that comes from our difficult encounters with one another and with systemic violence—as invoked by the image of Clark's *Little Girl*—has an interesting relationship to the text in *Citizen*. In their interview with Rankine, Lauren Berlant explains that both their work share an interest in how writing can interrupt "the sense of a fated stuckness" (Interview, n.pag.). Writing serves as a counterpoint or an anamnesis (painful

TAXIDERMY, FUNGIBILITY, AND GOTHIC HORRORS 115

working-through), soothing like a "balm upon the world" as Keats famously puts it (*The Fall of Hyperion* line 199). And yet, while writing serves as a salve against stuckness, Rankine's account of the work of the visual shows how her images, in this case the image of taxidermy, more complicatedly swerve both toward and away from forms of stuckness.

The image of *Little Girl* helps create the affective landscape of breathlessness, working to catch the reader's breath. As Rankine writes,

> I was attracted to images engaged in conversation with an incoherence [...] in the world. They were placed in the text where I thought silence was needed, but I wasn't interested in making the silence feel empty or effortless the way a blank page would. (Interview, n.pag.)

To hold and feel the weight of silence, to create a hypostasis of discomfort is the aim of Rankine's images. *Little Girl* attempts to create a blockage, to render us silent and momentarily frozen in our reading experience and forces us to register the incoherence. Redoubling the neighboring poetic prose, this disorienting encounter with the image of this strange uncanny animal-object-thing disrupts the process of reading. In multiple registers that come crashing together with the arrival of this image of Clark's taxidermy, we feel the stuckness, and feel something like the Levinasian night that haunts and maims us—the horror of existence, the horror of being-there. What Clark's *Little Girl* offers is an overdetermined silence that speaks of multiple knowledge, histories, traditions, and genres uneasily crashing together. Just as anamorphosis works by generating an excess of meaning, Rankine's use of taxidermy intensifies an affective encounter, an experience that the reader has in relation to the text's words—an oscillation between stuckness and an interruption of this.

Rankine's integration of images changes the physiological processes of the reading experience, one that, as Berlant describes it, creates a shift in our breathing:

> There's something consoling the interruption by the image in your text, even when the image itself is a sudden punch. The image forces things to stop for a moment. It forces the reader to reinvent breathing so that the eyes can again focus. [...] We are left there with the atmosphere of encounter pressuring a disturbance in us. (Interview, n.pag.)

To rephrase Berlant's observations here of Rankine's punchy use of the visual to interrupt, to momentarily arrest and "reinvent breathing," we could put

116 TAXIDERMY AND THE GOTHIC

it in Deleuzian terms as a "shock to thought."[19] However, as Rankine notes, "the images don't exactly recoup or repair — they are a form of recess, which is its own kind of movement, including both the break from and passage back to the unbearable" (Interview, n.pag.). The receding or withdrawal inspired by the image generates an excess of meaning. The refusal of *Citizen*'s taxidermy to recoup or repair echoes taxidermy's appearance in other texts where it too frustrates and refuses narrative closure.[20]

Speaking at The International Festival of Arts & Ideas in 2015, Rankine explains that in *Citizen* she wanted to create a form where the text was "trembling." She suggests that her incorporation of these images, such as Clark's taxidermy, and their ability to make the text tremble are akin to how the black body functions in the American imaginary. The sudden, unexpected entrance of the image in the collection, like the black body in the room, "derails expectations," she says. Our reading experience of the collection, of what we expect to encounter within poetry, is disrupted by the shock of taxidermy. To derail and disrupt, to reinvent breathing, to make tremble, to call attention to the ancestor haunting us from the corner of the room—these all hang together to form the function and force of taxidermy in *Citizen*. This figure constellating the horrors of black life continues to line the walls in subsequent black horror texts, including *Get Out*, a text that extends this figure, giving it a second life, as it were by imagining what other movements, namely becoming unstuck, might look like.

Taxidermy in *Get Out*

No text more strongly captures this constellation of taxidermy as breathlessly speaking to the horrors of black life than the horror film *Get Out* (2017), directed by Jordan Peele. It is a film that, as one critic puts it, performs a "cultural vivisection" of our current race relations (Powell 419). Although it is the boldest cinematic alignment of taxidermy with the black body, the film's heavy-handed reliance on taxidermy has gone largely unnoticed by scholars.[21]

19 See Deleuze, *Cinema 2*, especially Chapter 7. For Deleuze, film has the power to directly affect our sensory system and shock thinking into action.

20 In Chapter 3, I discuss how taxidermy functions to disrupt plot in the Southern Gothic tele-series *Tell Me Your Secrets*.

21 Two exceptions are Sarah Choi (2021) and Sarah O'Brien (2023). However, Choi focuses less on the film's actual representations of taxidermy and more on the taxidermic function of photography. I attend to the overlooked but uncanny surface of things, to what we visibly recognize as taxidermy.

TAXIDERMY, FUNGIBILITY, AND GOTHIC HORRORS 117

Like both the animal-object-thing of taxidermy and the genre of Rankine's *Citizen*, Peele's *Get Out* finds itself difficult to categorize. The film was submitted as a nominee for the Golden Globes's Best Motion Picture, Musical or Comedy, while Peele himself jokingly associated it with the documentary genre, critics have clearly recognized it as belonging within the horror genre.[22] Within this last category, critics have further subcategorized it: comedic horror, black horror, truthful horror, and political horror. To add to this effort, I read the film as an example of the everyday horror of black(ened) life. As numerous critics have observed, horror film is well suited for depicting the horrors of everyday life, for making visible the otherwise unseen terrors that grip us.[23] For Isabel Cristina Pinedo, the genre of the horror film is "an exquisite exercise in coping with the terrors of everyday life" (*Recreational Terror* 39). Alison Landsberg, in her reading of *Get Out*, is correct when she writes that "certain cinematic conventions of the horror film," such as jump scares, shocking plots, and intense visual and aural surprises, are "uniquely suited" to call attention to the kinds of "everyday, endemic and chronic horror" (630) that are otherwise difficult for some to see within our routinized daily lives.

But it isn't just that the everyday horrors of anti-black racism, microaggressions to which Rankine refers in *Citizen* are difficult for some to see; it is also that they are rarely represented in horror films. This "lack of representation," as Tananarive Due notes, "is a hostile act of erasure" (9). Indeed, race was a long-standing and noteworthy absence in horror films, as scholars like Jack Halberstam, Carol Clover, and Pinedo have noted. Halberstam in *Skin Shows* (1995) suggests that this absence of racialized bodies in horror films reflects the overbearing presence these same bodies already have in the American cultural imagination as monsters. To be black(ened) in American culture, then, is to already be "gothicized" (4), that is, "transformed into a figure of almost universal loathing who haunts the community and represents its worst fears" (18).[24] *Get Out* inverts this cultural association of black(ened) being as the monster, and in a Gothic move, where the threat comes not from outside but from within, it is the film's liberal,

22 Dawn Keetley (2020) sees it as political horror; Dionne Powell calls it "comedic horror" ("From the Sunken Place" 417); Alison Landsberg calls it "horror vérité" or truthful horror (630). However, to classify this film as comedy or comedic shows, as Peele remarks in an interview, "that we are still living in a time in which African-American cries for justice aren't being taken seriously" (Peele, interview).

23 A variation on this that focuses on the horror inspired by everyday objects is what Marc Olivier calls "household horror."

24 Elizabeth Young also explores this in *Black Frankenstein*.

affluent, educated, white people (the Armitages and their friends) who inspire universal loathing and who are revealed to be the most dangerous monsters.

The film isn't without its influences. We can look to George A. Romero's classic *Night of the Living Dead* (1968), which features the first black lead (Duane Jones as "Ben") in a horror film, to a range of blaxploitation films, *Blacula* (1972), *Candyman* (1992), and to Rusty Cundieff's black horror film anthology *Tales From the Hood* (1995), which has only recently, following *Get Out*'s enormous financial success, produced two sequels: *Tales From the Hood 2* (2018) and *Tales From the Hood 3* (2020). Consider also black horror films *Leprechaun in the Hood* (2000), *Hood of Horror* (2006), and the television series *American Horror Story: Coven* (2013). *Get Out* intensifies the growing appetite for (and for some near exhaustion with) black horror and has, in turn, inspired other horror series like HBO's *Lovecraft Country* (2020) and Amazon's *Them* (2021).[25] While much has been and could still be said about *Get Out*'s role in the black horror tradition and the growing field of black Gothic studies more broadly, I am more acutely focused on how the film dramatically mobilizes taxidermy.[26] In its taxidermic turn, *Get Out* not only draws on the long-standing Gothic horror trope of taxidermy to signal the horrors of existence, the horror of being stuck, but it also enters into conversation with Rankine's *Citizen* where the figure speaks, breathlessly, with the suffering and stuckness of blackness. *Get Out*'s taxidermy uncannily protrudes from the background into the filmic foreground to breathlessly constellate the everyday horrors of black(ened) existence.

Get Out begins with an opening scene of a black man, seemingly lost walking through a tree-lined subdivision at night, who suddenly gets attacked by a white man and stuffed in the trunk of a sportscar—a scene that will foreshadow the anti-black violence of the film to come, and a character we will eventually meet again albeit drastically transformed later in the film. The film tells the story of Chris Washington (Daniel Kaluuya), a black photographer, who is going on a weekend trip with his white girlfriend, Rose Armitage (Allison Williams), to meet her parents for the first time. Rose has supposedly not yet told her parents that Chris is black, though she tries to reassure him that it won't be a problem as her parents, Missy (a psychiatrist) and Dean Armitage (a neurosurgeon), are affluent white liberals who voted

25 On being tired of black horror, see Hannah Giorgis. "Who Wants to Watch Black Pain?" *The Atlantic* April 17, 2021. https://www.theatlantic.com/culture/archive/2021/04/black-horror-racism-them/618632/.

26 Key figures in the growing field of black Gothic studies include Maisha Wester, Diana Mafe, Sheri-Marie Harrison, Leila Taylor, Jamil Mustafa, Kobena Mercer, Tashima Thomas, and Sybil Newton Cooksey.

for Obama. En route to the Armitage country estate in upstate New York,[27] Rose and Chris hit a deer with their car, an event that deeply unsettles Chris, the first of many encounters that affect Chris in increasing intensity. I will return to this encounter with the deer shortly. Once at the Armitages, Chris increasingly notices strange behavior from the black staff (a phenomenon that is at odds with the Armitage's otherwise liberal rhetoric) and from the Armitages themselves. Missy briefly hypnotizes Chris, disturbingly without his consent, under the ruse of helping him to quit smoking. During this traumatic "therapeutic" hypnosis, she forces him to sink into "The Sunken Place," a psychic place depicted as black subconscious floating space where Chris is utterly paralyzed, rendered mute, and immobile—not unlike the taxidermy that adorns the Armitage home. Missy's ability to hypnotize black victims into the Sunken Place turns out to be key to how the Armitages procure their otherwise healthy, young, strong black victims for the "Coagula Process," a neurosurgical procedure whereby aging white consciousness is implanted into a healthy, virile black body and lives, parasite-like, alongside the original black consciousness that remains mostly suppressed through hypnosis in the Sunken Place. Once confronted with the shock of a camera's flash, the original black consciousness awakes from the Sunken Place. Chris realizes this when, during a garden party at the Armitages, he takes a picture of the one other black man in attendance (the kidnapped man from the opening sequence) who then screams the warning of "get out!" to Chris. Later, during the same party, which is a cover for a secret meeting of the Order of the Coagula, the white guests bid on Chris's body, which in the end is auctioned off to a blind art dealer. Chris is prevented from escaping by the Armitages and held captive in the basement while he awaits the neurosurgical procedure. In an incredible escape scene, Chris eventually manages to save himself, killing many members of the Armitage family during the process, and is reunited with his best friend, Rod, who arrives at the last minute to help him.

While *Get Out* has rightly attracted critical attention, including an entire edited collection (Keetley 2020), the film's abundance of taxidermy largely remains understudied.[28] And yet, I argue, this is a key figure through which the film's horror is constellated. Let us return now to key scenes in the film that stage this horror.

27 Peele explains that while the Armitage estate was meant to signify upstate New York, it was actually filmed in Alabama and has elements of both the South and the North (Peele, *Get Out*, Inventory Press, 170, fn 15).

28 None of the essays in Keetley's volume address the film's taxidermy at length.

Figure 4.3 Screenshots from *Get Out* (dir. Peele).

The film's collision between blackness and taxidermy begins with an actual motor vehicle accident. While it isn't an instance of taxidermy, the injured and dying deer that is struck by Rose and Chris's car—a hit that comes as a jump scare—and the way this scene slows down and thickens the film's affect foreshadows the reactions and affect that future iterations of the deer as taxidermy will come to invoke.

Chris gets out of the car to inspect the damage to the vehicle and then heads into the woods to see if the deer is okay (Figure 4.3). Directions in the screenplay read as follows:

> A guttural, almost human, MOAN OF PAIN comes from in the trees behind them. They watch the woods in horror. Chris walks back towards the haunting wail. It stops.[…] Something breathes deep in the bushes.

TAXIDERMY, FUNGIBILITY, AND GOTHIC HORRORS 121

[...] Chris gathers his courage and steps off the road into the dark thicket. He peers through the bushes. The deer lies there gasping for air and watching him with a black, wet eye. Chris is transfixed. (41)

This injured deer straddles not only species lines—a haunting, guttural voice that is meant to sound "almost human" as the screenplay tells us—but also the line between life and death (is it already dead? Almost dead? we find ourselves wondering) and thus incites the same questions that realistic taxidermy itself does. But beyond this question, this scene appears to unsettle Chris in more profound ways. His empathy and fascination with the dying deer register on his face as he slides into a trance-like state. Much later in the film, we retroactively make sense of his reaction by locating in it an echo of a childhood trauma: Chris's mother was also killed by a hit-and-run. Yet before this knowledge is revealed (during his hypnosis session with Missy), we still recognize a thick moment, some kind of emotionally charged identification between the struck and dying deer and Chris himself. The deer's "black, wet eye" (41) that watches Chris is haunting, and finds an uncanny echo, not long later, in Chris's own wet, unblinking eyes as he becomes traumatically hypnotized into the Sunken Place. As the camera shot makes clear, both the deer and Chris have glassy eyes—a detail that foreshadows not only the taxidermy that adorns the walls of his girlfriend's family home but also the unblinking, transfixed and horrified state that Chris himself will come to be in as he is sent through hypnosis to the Sunken Place.

The glassy-eyed gaze shared by the injured deer and Chris in their encounter along the side of the road is intensified, reflected, and refracted by the scene that immediately follows, when a shaken Chris gets back into the vehicle. The vehicle's windows and windshield become the lens through which we see a glassy-eyed Chris, now ensconced in an uncanny likeness of the glass enclosures of cabinets of curiosity behind which taxidermied specimens are traditionally found. But the glass also functions as a mirror; witnessing the injured deer through the glass, Chris is also seeing his own condition, in effect seeing a version or symbolic embodiment of himself and a much deeper, archaic past—a similar irruptive move that the image of taxidermy makes in Rankine's *Citizen*, figured as the ancestor appearing in the corner. While never articulated in this moment, we later learn in the film that this roadside scene does bear an uncanny resemblance to the way Chris's own mother was hit by a car and died on the side of the road—a trauma recalled from that other archaic past: childhood.

We are invited to see this violent collision with the deer and its aftermath as a blurry space—the vehicle's glass functioning as a display case for a taxidermied specimen, a mirror, and a looking glass through which we

find a palimpsest of multiple traumatic pasts still haunting the present. Furthermore, the foregrounding of glass in this scene (and the accompanying glassy eyes of the deer and Chris) also invokes the lens of the camera, leading us to question our own role in this scene. Are we looking at Chris through the vehicle windows as a specimen, or are we (also) sharing the gaze with Chris and seeing ourselves reflected here?[29]

What is uncanny, too, about this scene is the way Chris's glazed-over face not only anticipates that of the taxidermy deer, frozen in place, in the basement room where Chris is later held captive awaiting the Coagula procedure, but even before that this glassy look anticipates his physiological response to the Sunken Place when under hypnosis. When Chris is stuck in the Sunken Place, his eyes are wide open and unblinking. The film's motif of the unblinking open eye not only invites association with death but a kind of stuckness, immobility, or even slumber.

Other organs of sensation and the phenomenological horror of their openness—ears—also play an important role here. The sound of the teacup, the rhythmic, hypnotic clinking of the spoon against the wall of the teacup as Missy stirs it, as the sound that disables Chris and sends him into the Sunken Place, resonates with how Lauren Berlant describes the sound of how cruel optimism operates, of those attachments that we may well know aren't good for us, indeed are inimitable to life, but to which we nevertheless remain attached. In Berlant's 2006 essay "Cruel Optimism" (which becomes the basis of their 2011 book by the same title), they describe these objects of desire, these "clusters of promises," as sounds ticking away in the background of our lives like a "white noise machine" rather than the ticking of a bomb that they really might be. Certain objects of desire, certain fantasies of "the good life," can be unhealthy for us; relentlessly clinging to them can become toxic for us actually impeding our flourishing. These fantasies hum away in the background, and it is this hum or ambient sound that Berlant says that we fundamentally mishear or misrecognize. Instead of hearing it as a scary sound, a sound that is threatening to our lives—which, if we did might make us leap into action, and run away for our lives—this rhythmic sound instead is strangely comforting in its repetition and familiarity, and thus lulls us in a kind of dogmatic slumber.

In *Get Out*, the sound of the stirring spoon gently tinkling against the teacup is one such sound that lulls its listeners into this kind of sleep that Berlant speaks of. Indeed, if read it as a metaphor, Missy's tinkling teacup done

29 This series of surfaces here and the slippery processes of identification at work recall what Sedgwick says of the Gothic.

in a therapeutic setting, speaks to the fantasy, the object of desire or cluster of promises we have of neoliberalism. The promise here is of allyship, of an ethical, therapeutic relation, an ethics of care, a new relational encounter that transcends racial divisions, particularly in a post-Obama era. And yet, as we quickly see, this sound, operating in the background, most forcefully lulls the listening subject to sleep into a state of paralysis, or what Berlant (in the same essay) also describes as "political depression." Chris ought to hear this sound as the ticking of bomb—and indeed, he does eventually figure it out and comes to be terrified of the sound, again dramatizing how the objects of desire, those certain markers of a particular (white, neoliberal) vision of "the good life," secretly house insidious violence. But Chris does not appear to be the only one affected. Missy herself is always strangely hazy. While we might be tempted to read her as an old white hippy, we might also read this haziness as fatigue, symptomatic of her involvement with making that hypnosis happen, suggesting that she herself isn't immune to the "white noise." Missy, too, suffers at a lower intensity than Chris's suffering, from her own cruel attachment to the Coagula Order and its desire for procuring powerful black bodies. The film invites us to see that the attachments these characters nourish are also keeping them lulled and locked into a slumber from which they struggle to fully awake.

The collusion between these responsive looks—Chris's glassy-eyes with the dying deer, and his eyes while in the Sunken Place—invites us to read these traumas as connected, as threaded together by the systemic violence that inflicts and enforces silent and sometimes barely perceptible suffering. As Peele himself tweeted about the film: "The Sunken Place means we're marginalized. No matter how hard we scream, the system silences us."

This affective collusion between Chris and the dying deer is visually echoed in numerous verbal and visual references to deer within the Armitage country home. This ranges from the desultory comments by Rose's father, Dean Armitage, over the pest-like nature of deer, to the totemic images— paintings, statues and busts, skulls, and of course, an actual taxidermy mount—of deer around the Armitage household. However, there is another animal that also occupies some of the symbolic space: the lion. Indeed, in Missy's home office, the chair in which she sits and performs the hypnosis on Chris has ornate lion heads carved into its armrests. And, in Rose's childhood room where Chris and Rose stay during their visit, there is a (creepy) cute stuffed animal lion, presumably an object from her childhood. Chris is unsettled by it and moves it in the middle of the night, a gesture perhaps of his feeling already hunted.

The tension bubbling up between the film's animal figures of deer/stag and lion plays out like a scene from George Stubbs's (1724–1806) painting,

124 TAXIDERMY AND THE GOTHIC

A Lion Attacking a Stag (c.1765), wherein a lion, in a pose reminiscent of heraldic lions with a bulging-eyed stag in its clutches, rests before a dramatic chiaroscuro, an ominously pitch-black painted backdrop.[30] The film, as with the painting, generates tension between the two beasts as an allegorical drama over naturalized authority and sovereign power. Indeed, the core belief of the Order of the Coagula is the natural physical superiority of black bodies (to be perfected with augmentation by white consciousness).

While more could be said about the lion and deer imagery, I want instead to close in on the relational lines drawn between the deer and black(ened) being as exposed in the film's most enigmatic scene: the scene when Chris wakes up in the Armitage basement, strapped to the chair in the middle of the room, forced to watch a video that explains the Coagula process. It is this scene (which marks the beginning of the escape sequence) that best constellates the tensions between blackness, taxidermy, and the horror of being-there.

To begin, let us consider the layout and staging of this scene. Chris sits strapped to a padded chair in the middle of the basement room. On the wall which Chris is facing is a clunky, outdated television and a traditional taxidermy deer mount. As the only other objects in Chris's direct field of vision, his gaze is triangulated between the television and the taxidermy. Behind Chris, flanking him on either side, are two lamps atop tall wooden pillars, classical or colonial in design. The symmetrical balance and restraint of the scene are both at odds with the present use of the room as a torture waiting room and simultaneously reveal the violence and imposing aesthetics that are an extension of what the Armitages and the Order of the Coagula believe in. Behind these lamps, and also perfectly centered behind Chris, is a ping-pong table, and hanging behind it on the wall is a dartboard. This dartboard, appearing directly behind Chris's head in numerous camera shots, suggests Chris is in the cross-hairs between the two targets (taxidermy and dartboard), his body another hunted prize about to be preserved (Figure 4.4).

The ping-pong table, dartboard, and television here are more than outdated markers of white suburban leisure, these tokens of the American upper-middle-class domestic "rec room." In its hodgepodge of styles (not unlike the taxidermist's apartment in H. G. Wells's "The Triumphs of the Taxidermist"), this basement space underpinned by an ugly thick yellow carpet is starkly out of place with the rest of the stylish and modern Armitage manor; it is a repository of an earlier generation's style, invoking the Armitage grandparents—yet another nod to ancestral trauma. Indeed,

30 Stubbs's painting also features a stark black background, another association with the floating black background of *Get Out*'s Sunken Place.

TAXIDERMY, FUNGIBILITY, AND GOTHIC HORRORS

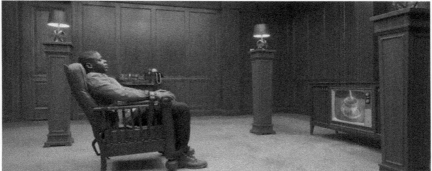

Figure 4.4 Screenshots from *Get Out* (dir. Peele).

reinforcing this message is the fact that the Armitage grandfather welcomes us to this space as he stars in the infomercial that plays on the television. Yet this space also smuggles in another line of relation, for we are also clearly meant to feel the kinship between the black body and taxidermy.

If time is out of joint here, the seemingly antiquated leisure objects themselves also contribute to the uncanniness. Even though the television looks old and outdated, the screen appears to be a two-way transmission, as Chris can communicate with those on the outside of the room through it (namely the wealthy white blind man and art dealer who will be uploading himself into Chris's body). In fact, as Sarah O'Brien argues, television and taxidermy are operating in similar ways, transmitting similar messaging. O'Brien, who reads Black horror films and television series (including *Get Out*) that use taxidermy to explore the trope of the "Black buck" (the stereotypical image of the hypersexualized Black male), insightfully suggests that television and taxidermy are entangled media imbued with colonialist values and are "overlooked sources and structures of meaning that work in service of white supremacy, racial violence, and the commodification of hypervisible

Blackness" (O'Brien 11). This collusion, then, between the taxidermy and the clunky television—what many would see as unfashionable relics of a bygone era—in this scene dovetails with that gnawing feeling we have around the other objects in the room that also take on an uncanny quality.

We come to wonder about the room's other objects; we are primed to view suspiciously the taxidermy mount, especially following how Chris looks at the taxidermy. We might wonder whether the taxidermy is, like the television, part of a surveillance apparatus, and if it has been watching Chris (a concern that, as we saw in Chapters 2 and 3, plays out in other Gothic horror films and series, such as *The Cabin in the Woods, A Classic Horror Story,* and *Tell Me Your Secrets*). With our expectations of this antiquated television now violated, we distrust this traditional taxidermy mount and suspect it as having powers beyond being stuffed and dead on a wall. In short, the associative linkage between the television and the taxidermy mount charges the taxidermy with greater potentiality to surprise, perhaps even to communicate in some capacity (not unlike the antiquated television). And indeed, as we soon see (or, rather, hear), our suspicions are not misguided.

While Chris is held captive in the basement, he is continually pulled in and out of consciousness, in and out of the Sunken Place, by the sound of the spoon tinkling against the teacup—a process that is violent and causes Chris to claw intensely at the padded armrests of the chair to which he is tied, eventually exposing its upholstered stuffing. Chris continues to fall victim to the debilitating effects of hypnosis, repeatedly slipping into the Sunken Place, until he decides to plug his ears with some of the white stuffing from the padded chair. From the violence of his suffering, Chris acquires the very tool he will use to free himself. After Chris frees himself and bludgeons Rose's brother, Jeremy Armitage, with a bocce ball (another emblem of leisure society), he removes the stuffing from his ears and looks up at the taxidermy deer mount on the wall. The camera shot lingers on this gaze, a scene we too will linger on shortly (Figure 4.5).

What the film makes clear through its palimpsestic overlaying of scenes of black bodies and taxidermy is this close proximity or interchangeability between the two. Indeed, in this extended interchangeability throughout the film of taxidermy and black bodies, taxidermy works to capture the horror of black(end) being-there, which we can understand through the concept of fungibility—which, in short, means to be exchangeable.

For scholars working with the notion of fungibility and its cognates, such as Hortense Spillers, Saidiya Hartman, and Tiffany Lethabo King, the transatlantic slave trade is the hotbed for the equating of black bodies with commodities and capital. As Hartman in *Lose Your Mother* (2007) writes, "the Atlantic trade created millions of corpses, but as a corollary to the making

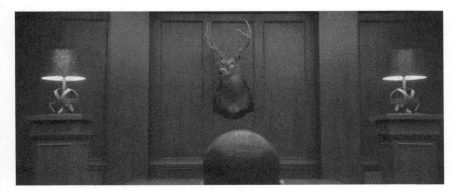

Figure 4.5 Screenshot from *Get Out* (dir. Peele).

of commodities" (31). Moreover, as Shannon Winnubst notes, "It is this precise abstraction of living, human bodies into quantities of commerce that enacts an ontological transformation—namely, the transformation of human bodies into black cargo. Through this shift in the mode of being, fungibility defines blackness at its very birth" (105).

Hartman, in her book *Scenes of Subjection: Terror, Slavery, and Self-Making in Nineteenth Century America*, considers the ways that enslaved black bodies could solicit pleasure not only from slave masters but also from abolitionists. She suggests that this was ultimately possible because of the interchangeability or "fungibility" of the commodity-like black body that could be bought, sold, and traded. As Hartman writes:

> The relation between pleasure and the possession of slave property, in both the figurative and literal senses, can be explained in part by the fungibility of the slave—that is, the joy made possible by virtue of the replaceability and interchangeability endemic to the commodity—and by the extensive capacities of property—that is, the augmentation of the master subject through his embodiment in external objects and persons. (21)

As Hartman further explains, applying the logic of the commodity to the black enslaved and traded body,

> the fungibility of the commodity makes the captive body an abstract and empty vessel vulnerable to the projection of others' feelings, ideas, desires, and values; and, as property, the dispossessed body of the enslaved is the surrogate for the master's body since it guarantees his disembodied universality and acts as the sign of his power and dominion. (21)

Stripped of its subjectivity, the black enslaved body becomes object-like, something akin to a black tabula rasa. The system of exchange empties out the black body by leveling it, transforming it into a substitute for another body, thing, object, or idea, through which the master stands to extend himself, financially and symbolically. Just as within the Hegelian master–slave dialectic, wherein each term depends upon the other for its own identity, the states of dispossession and disembodied universality for the slave and master, respectively, depend upon one another. Put differently, the black body/psyche must be hollowed out in order to become stuffed by the white body/psyche—which is taken literally in *Get Out* in the creepy "Coagula" process when black bodies are hunted and hijacked for their genetic superiority and then neurosurgically implanted with (rich, aged) white consciousness.

However, black fungibility might also be a site of potentiality. It is, according to Tiffany Lethabo King in *The Black Shoals*, "to be rendered porous, undulating, fluttering, sensuous, and in a space and state between normative configurations of sex, gender, sexuality, space, and time to stabilize and fix the human category" (223, footnote 110)—a concept that King suggests can also be "a space of alterity and possibility" (223, footnote 110). King's reclamation of black fungibility and the ways black flesh can connote malleability and potentiality that reveal "unexpected and ever emerging modes of freedom" (223, footnote 110) play out in the film *Get Out* in the ways that taxidermy, like the black body, ultimately gets its revenge, successfully moving from passive, victimized object to aggressive subject—from stuffed to stuffer. Not just black bodies but also their cognates, their fungibles, get revenge. Put another way: this silenced, stilled life (taxidermy) gets a second life, coming back to hunt the hunter, shifting its state from one of stasis, death, and objecthood to one of unexpected movement and mobilization in a reversal of the violence of the hunt. It is significant that when Chris frees himself from the restraints, he pulls the deer mount off the wall and lugs it down the hall, ultimately to use it as an unlikely and unwieldy weapon to bludgeon Rose's father. (This is also poetic justice, of course, as Rose's father made derisive comments about deer earlier in the film). Chris, like the taxidermy mount, gets a second shot at life. When Chris pulls the cotton-like stuffing from the armrests out of his ears, which Sarah Juliet Lauro reads as a "reference to the most profitable slave crop in the US" (155), Chris literally unstuffs himself and pulls the deer mount off the wall. In this exchange, we are invited to see these bodies as occupying a doubled movement, a fugue-like or fugitive movement together, one symbolically standing in for the other in a shifting configuration of skins and spaces. Of course, this fugue-like moment is also contrapuntal, and we might read this scene as both avowing and disavowing fungibility altogether.

TAXIDERMY, FUNGIBILITY, AND GOTHIC HORRORS 129

The mount comes to life, or is given renewed life as a weapon, in the same movement as Chris unstuffs himself and frees himself from constraints. As Chris and the deer mount charge down the hall together, it is a scene that accumulates symbolic freight; after all, the hall is lined with more animal representations—another deer or ram skull and a painting of what appears to be a violent hunt. Like musical motifs, these fugue-like lines converge as the film thunders toward this ultimate scene of confrontation where Chris and the taxidermy attack Dean Armitage, the patriarch of the family and head of the secret Coagula Order, the fatherly face of neoliberal systemic anti-black racism and violence.

Moreover, it is fitting that this attack on Dean, who represents the violence of the system (his name even etymologically signaling structural authority), occurs from within the space of the basement.[31] More than just a classic horror trope, the basement of the house of horrors, as the space of the repressed or abjected, is drawing its poisonous waters here from another well. For it is in this trek down that hallway, decked out with rich wood paneling and dim lighting, the dark and violent escape from the basement, that bears historical traces of other difficult passages for black lives. This scene invokes the hull of the slave ship, that primal site of fungibility for the transformation of black bodies into commodities, a site itself that reappears in myriad forms today. As Christina Sharpe writes, there are "reappearances of the slave ship in everyday life in the form of the prison, the camp, and the school" (*In the Wake* 21). And yet, in this space, there is also the crux of the rebellion; it is here where Chris reverses black transmogrification into a commodity and enacts his revenge (Figure 4.6).

Let us rewind and return again to more closely read that uncanny encounter between Chris and the taxidermy mount. As Chris stands back after killing Jeremy, he slowly removes the stuffing from his ears and looks at it (for two beats) in a medium close-up shot that comes from above. Slowly Chris turns and looks up, his eyes next landing on something that lies just beyond the frame of the scene. For three beats, we are made to watch Chris as his eyes focus on this image, but his numbed expression registers little more than some kind of minimal recognition. At this moment, the camera cuts from Chris's face to the object of his gaze: the taxidermy mount. The next shot, also held for three beats, is a close-up of the taxidermy mount, which we see from the front, slightly from below, in a shot that is clearly meant to be from Chris's perspective. The mount itself is a beautiful, lifelike specimen, with chestnut

31 In Lacanian terms, Dean is the Name-of-the-Father. See Lacan, *On the Names-of-the-Father* (2013).

130　TAXIDERMY AND THE GOTHIC

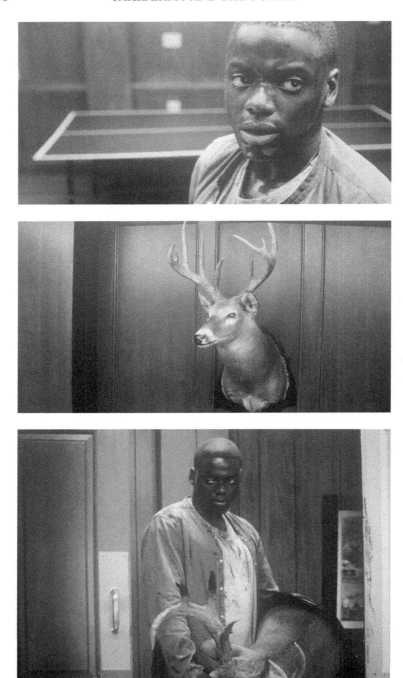

Figure 4.6 Screenshots from *Get Out* (dir. Peele).

TAXIDERMY, FUNGIBILITY, AND GOTHIC HORRORS 131

brown fur and thick antlers, closed mouth, eyes and head looking askew. Two noteworthy features here are its dark eyes, with their bottomless gaze, and the tilt of its head. This taxidermied deer looks at Chris from an oblique angle, a sideways askew gaze. This, I insist, redoubles the anamorphic function of taxidermy here, as if performing the very reading we must make of taxidermy in Gothic horror. In this gesture that calls attention to the act of reading taxidermy (a looking awry), the taxidermy simultaneously calls attention to itself as a gazing animal-object-thing that looks back. This taxidermy mount redoubles the fate of the black body in the film as a site of preservation and violence. Its eyes are trained not back at Chris but also as if on an image beyond the frame of the scene. Visually, then, the taxidermy echoes the frozen gaze we just encountered in the previous shot with Chris.

My reading of this scene and the impossibility of the gaze—that is, the way taxidermy looks awry with a bottomless gaze that is not returned to Chris—is in opposition to other readings of the scene. For Cayla McNally, "Chris shares an experience and gaze with something. He sees and is seen in return" by the deer that "impassively stares back. Chris is reflected in its eyes" (219). But this, I offer, too easily closes the loop and greatly overstates the reciprocity of the gaze. Instead, there is a tension between the structure of the scene and the content of the scene: the camera shot gives us the perspective from an angle as if from the eyes of the taxidermy, and the taxidermy's eyes are glassy and the direction of its gaze is awry and out of alignment with Chris. The crucial effect, I argue, is not that Chris is reflected here, but that reflection (read: identification) is both courted and thwarted, avowed and disavowed. We are both reminded of the common associations between blackness and animality and required to read otherwise. Reciprocal capture denied.

Tellingly, at the very moment that we cut from Chris's face to the close-up of the taxidermy mount, the ominous string orchestral music suddenly introduces quiet repetitive chanting layered over it. This chanting is the same Swahili word "Sikiliza," meaning "Listen," heard earlier in the film from the song "Sikiliza Kwa Wahenga" played during the opening title credits. As the song's composer Michael Abels explains, these chanting voices in Swahili are meant to invoke the ghostly voices of dead slaves and lynching victims and serve as a warning to Chris to get out.[32] The timing of this chanting at the very moment that we cut to the taxidermy mount has the effect of imbuing the taxidermy with precisely the vitality or powers that we earlier suspected it might have: that it could communicate or come to life in a way not unlike the uncanny television. Here, the taxidermy mount

32 In an interview, Abels explains his choice of Swahili was for the language's musicality.

may not see but it does seemingly "speak," as it suddenly appears to manifest voice, or rather the voices of a ghostly multitude. It comes to function, I offer, in the same way that the taxidermy image in Rankine's *Citizen* does, performing and depicting "something ancient" that couldn't be done in language, that "moment the ancestor shows up in a corner somewhere, a direct descendant of slavery" (Interview, n.pag.). It is a kind of conjuring of a spectral, haunted enslaved past that is never actually past.

Of course, for those of us viewers who do not know Swahili, we do not in that moment of initial encounter recognize or understand the message. This, I argue, is precisely part of the message that the film is exploring: namely the failure of communication, of understanding the suffering of another. Even Chris—one of the intended interlocutors of the message to "listen" and "run" and "get out"—arguably fails to understand the words, the messages and warnings that have been given to him throughout much of the film, at least up until this very moment.[33] One of the questions the timing of this chanting raises, then, is in what ways do the voices, warnings, and stories of others go unheard? What does it mean that these voices and warnings are (mis)heard only as rhythm in the background rather than as legible scripts in the foreground? It is akin to what Berlant warns of in "Cruel Optimism" in how we fail to recognize the sound for what it is—the ticking of a bomb—and mistakenly hear it as a comforting sound—white noise—with its reassuring repetition.

The next time we encounter the taxidermy mount and Chris is when they suddenly appear together, as Chris drives the mount's antlers into Dean's torso. Chris's body and the taxidermied deer head work together like one of Clark's taxidermy sculptures come to life. Chris's weaponization of taxidermy is a symbolic move since, as Laura Thorp notes, to use "the buck's head to impale Dean, thus taking a term [buck] that denigrates young black men and using it to destroy the person who initially wielded it to suppress Chris's agency" (207–8). After Dean slumps to the ground, Chris throws the taxidermy mount down and proceeds to escape. Here, the film's use of taxidermy suddenly and abruptly comes crashing down (literally with a thud on the floor), and the film hereafter discards the figure that has up to this point been constellating a fuzzy and uncanny relationality with Chris. The disappearance of this figure reinforces how the film both creates a constellation between black life and taxidermy and creates narrative swerves

33 Given the highly altered hypnosis-induced states in which Chris finds himself, it is possible to imagine Chris also hearing this chanting. In this sense, then, we can imagine the message as operating outside of the extradiegetic sense in which soundtracks are typically read.

TAXIDERMY, FUNGIBILITY, AND GOTHIC HORRORS 133

away from a straightforward identification between these two, ultimately suggesting the impossibility and horror of truly understanding another.[34]

In this sense, then, taxidermy in *Get Out* is stuffed with the lessons of Afro-pessimism, a political philosophy that understands slavery as the event that created the ontological category of blackness and as the foundational paradigm that continues to organize black existence and anti-black violence today.[35] At the heart of Afro-pessimism is the view that emancipation is a liberal fantasy, and upon frank acknowledgments of how black lives continue to be enslaved within the neoliberal present. Taxidermy, in its stubborn stasis and silence, stages the difficulty in knowing another's suffering. It embodies what Frank B. Wilderson III calls the failure of a common "grammar of suffering" found when we homogenize the suffering of other oppressed groups (e.g., feminist, Marxist, queer) as akin to the violence experienced by black bodies (*Red, White, and Black* 6). Taxidermy, then, operates in the vexatious spirit of what Ryan Poll calls *Get Out*'s "intentionally failed aesthetics" (78), those scenes featuring abruptly interrupted camera movements that ultimately work to reinforce the message of the "profound and perhaps impossible challenges of aesthetically representing the systemic horror of anti-Black violence" (78).[36] While Poll never addresses the film's representations of taxidermy, I offer that these scenes with taxidermy are similarly working as important figures of disruption. Taxidermy in this film serves to triangulate the horror of being-there, the horror of blackened existence within a neoliberal America where beneath the surface of being socially aware and politically progressive lies a deeper, sunken place of insidious anti-black racism. What we encounter in these protracted, tenuous scenes between Chris and the deer—first injured and then taxidermied—is what we could also recognize as another kind of failure, namely the failure of looking and of hermeneutics. If, as the ancient adage goes, eyes are the windows to the soul, *Get Out* frustrates and obscures such direct access.

34 This, however, is unsurprising that taxidermy would produce such a swerve or interruption in the process of identification, for it has already served in its earlier form (in the figure of the struck deer) to abruptly interrupt the film's action. As Sarah Juliet Lauro notes, "The film's structure [...] begins with movement but then stalls in a state of paralysis (foreshadowed in the struck deer)" ("Specters of Slave Revolt" 151).

35 On *Get Out*'s association with Afro-pessimism, see Ryan Poll (2018). Some of the most notable Afro-pessimist scholars include Saidiya Hartman, Jared Sexton, Christina Sharpe, and Frank B. Wilderson III.

36 The film's alternative ending in which Chris ends up incarcerated is another example of the film's commitment to Afro-pessimism (Poll 92).

TAXIDERMY AND THE GOTHIC

Taken together—the stubborn silences around taxidermy, the furtive glances, the multiple protracted shots of Chris looking at the injured and dying deer, the extended scene of looking at the taxidermied deer mount in the Armitage basement, the mismatched gaze between Chris and this mount, and the easily missed or misunderstood song with the warning to "listen" in Swahili chant overlaid upon the close up of the taxidermy— all these elements enforce Wilderson's observation of the difficulty in finding the words to account for another's suffering. For these scenes of thick or hazy vision—a looking without any narration provided to help contextualize what is going on, or to tell the audience what Chris is thinking in these moments—only muddy rather than clarify the relation. Despite there being no understandable "grammar of suffering," no clear language to describe this relation, there is an affective resonance. Even if access to Chris's thoughts in these material encounters is unavailable to us, as viewers, we recognize in Chris's frozen gaze the way the deer (first injured and then taxidermied) serves as an attractor, pulling his gaze in. Still, from the earliest encounter of Chris staring at the dying deer to his observation of the taxidermy deer mount in the final escape sequence, Chris maintains a hard-to-read numbed expression, one reflected in the taxidermy's own glassy, empty expression, a look that I earlier described, following Derrida, as its bottomless gaze (see Chapter 2).

It is significant that Peele cut a scene from *Get Out* which would have otherwise sharpened and defined the relation between Chris and the taxidermy. In the screenplay, this scene comes after Chris is finally captured and dragged down to the basement. As Chris is subdued by the Armitage family, once again through hypnosis, he falls into the Sunken Place until he appears to land or become momentarily suspended. It is a scene that has Chris utter only one word throughout it ("Shit") as he shivers and struggles to light his cigarette lighter, looking around frantically as a large, dark, mysterious shape moves beneath and around him. As the directions in the screenplay indicate:

Each flash [of Chris's lighter] illuminates a large face beside his. He doesn't see it. The amorphous antlered thing emerges from the shadow. Its eyes glow and flicker faint blue in its sockets. He finally lights the flame and feels the beast's presence he turns, but the creature is gone. He turns back and there it is. Very close. Its head is the skull of a deer and its has dim blue glowing eyes. It MOANS A WRONG SOUNDING MOAN OF HATEFUL ANGUISH. (Peele, screenplay, 201, original emphasis).

TAXIDERMY, FUNGIBILITY, AND GOTHIC HORRORS 135

Curiously, it is only in this deleted scene that the film offers a direct face-to-face confrontation between Chris and taxidermy, where the taxidermy-skeleton creature directly returns the gaze mere inches away from Chris's face. The deer not only looks at Chris but also appears to directly address him, moaning angrily into his face, as if it were darkly dramatizing the very question that Derrida asks: "And Say the Animal Responded?"[37] That this confrontation takes place once Chris stops falling and appears suspended in the Sunken Place is noteworthy, as if finally reaching the bottom. However, by deleting this scene with the ghostly beast-skeleton's reciprocal gaze, the final version of the film preserves the auspicious encounters of glazed, missed vision, maintaining the horror of the bottomlessness of taxidermy's gaze and the Sunken Place.

In the final film version, the repeated encounters between Chris and the deer scratch at a grammar of suffering that positions a fuzzy relation between Chris and the deer, between the black body and the animal-object-thing that is taxidermy. And yet, this grammar of suffering also remains inaccessible, illegible, incomplete, a refusal signaled by the frequently empty, expressionless face of Chris. Thus, for the ways that it both attracts and repels, implies a relation and obfuscates it at the same time, taxidermy is a disruptive figure within *Get Out*. This figure of breathless, still(ed) life acquires a turbulent force throughout the film, seemingly acquiring a second shot at life by playing out a revenge fantasy of coming off the wall to violently hunt the hunter.

Whether it appears in pop culture, poetry collections, or horror films—from Claudia Rankine's *Citizen* to Jordan Peele's *Get Out*, two texts that we have examined at length here—taxidermy plays a key role in speaking to the all too often unspoken horrors of blackened existence. As I have shown in this chapter, black artists and auteurs are leveraging taxidermy and its fungibility as a response to the everyday horrors of living a racialized life in twenty-first century America—a time that Sheri-Marie Harrison calls a "black Gothic revival." Taxidermy, embodying the horrors of still life, of being stuck in existence, becomes a powerful metaphor for black life. In addition to invoking the historic animalization of blackness, taxidermy

37 In response to his cat's gaze, the key question for Derrida isn't about whether the animal is capable only of a reaction or if it can respond (Lacan believed the animal could only react), but if we even know what it means to respond. Donna Haraway sees this as a failed moment for Derrida to see and imagine his cat as a companion (*When Species Meet* 20).

also speaks to the frustrations, paralysis, and stagnation—of the *stillness* of a life that is *still* filled with violence and microaggressions—of a life that might claim to be post-race. Black bodies, as this chapter has tracked, have haunted the practice of taxidermy, from the nearly forgotten black taxidermist John Edmonstone who trained Charles Darwin, to the black bodies preserved and stuffed (such as the Hottentot Venus and El Negro) and even appearing in fictionalized form in H. G. Wells's Gothic tale. But now taxidermy looms large in these contemporary texts, hauntingly returning, like the uncanny reminder, or the ancestor in the corner (to borrow Rankine's phrase one last time), as a way to expose, critique, but also remake and reimagine the spaces and conditions of anti-black violence. Horror is endemic to black life, past and present, from slavery and Jim Crow-era lynchings to our own moment of Trayvon Martin and others in a list of names that continues to grow. Black horror sluices everywhere, just as "Gothic violence remains a part of everyday black life" (Harrison). In texts such as Rankine's *Citizen* and Peele's *Get Out* that explore the idea that to be black is to be inescapably stuffed by horror, taxidermy becomes a powerful transhistorical constellation that both lays bare the preservation and ongoingness of racial violence, embodying those terrifying parts of life that continue to live on, and contains the potentiality to shock thought, affect the breath, and perhaps even find a way to get unstuck and get out of this place.

AFTERWORD: ALL STITCHED UP

Portions of this book were written in and inspired by the company of taxidermy in museums, galleries, and archives across America and England: from the large institutional collections at the Nature Lab at Rhode Island School of Design, the Smithsonian, the Manchester Museum, London's Natural History Museum, and Oxford's Natural History Museum to the quirky Viktor Wynd Museum of Curiosities, a taxidermy-crammed basement collection in Hackney buried beneath an absinthe bar.

Recently, I returned to Oxford's Natural History Museum—that treasure trove of taxidermy. I was delighted to find that the Museum encourages its visitors to touch some of its taxidermy specimens: a cute and very soft fox perched on the Welcome Desk, and two big brown bears flanked either side of the entrance to the main exhibition hall. My pleasure in touching taxidermy here was only surpassed by something I overheard while wandering through the upper galleries: a little boy loudly and passionately announced, "That's DISGUSTING!" in response to seeing a case of stuffed birds. I continued to wander through the museum, still savoring his response out of admiration for the beastly freedom of it in breaking the otherwise quiet, breathless space of the museum. After all, the wild child, as Kalpana Rahita Seshadri puts it, is the one who "surprises the law" (165).

My delight was sustained by a second encounter, also between a child and taxidermy. Just before exiting the museum, as I stood petting the taxidermied fox, a little girl and her mother came up to join. Despite the mother's cooings that "it won't bite," the girl stubbornly refused to listen to her. The girl seemed paralyzed by the taxidermy, surely caught in what Kristeva calls fear's "fluid haze" (6), and refused to touch the fox, as if it might spring to life under her fingers and bite. These fleeting encounters remind us that something of the negative sticks to our experiences with taxidermy; sometimes, even realistic, neutrally staged mounts in institutional settings, such as a natural history museum, can still conjure up those "ugly feelings" of disgust, fear, and anxiety. Moreover, in both these encounters I describe, there is a delightful resonance between the figure of the child, who we see as wild and monstrous

as Kathryn Bond Stockton and Jack Halberstam remind us, and the strange animal-object-thing of taxidermy with the fascinating and horrifying stuckness of life that clings to it.[1]

Bemused, I can't help but wonder what the children's anxious responses might have been had they turned the corner along the upper galleries' corridor to find the towering 7 ft wood-and-glass case containing 30+ pheasants. In this tightly packed diorama, filling all corners of the narrow case from top to bottom, pheasants of various colors, sizes, and positions appear almost to be standing one on top of another with snatches of greenery spotted throughout. Strangely, despite their proximity, none of the birds are engaged with each other; most appear glassily looking off into the distance; some stare directly and unnervingly at us. They are so close to the case's glass that one could almost think they had flown fatally into it. Crammed together in the teeming case, it is as if there is no air to breathe, no imaginable space for the pheasants to burst up in a "flush" (as they do) and fly away—an arrangement that reifies their breathlessness and the horror of their stuckness. Moreover, the excess of this scene in its multitude of objects overwhelms our gaze and makes it momentarily fuzzy. Indeed, horror, as Marc Olivier writes, "recovers the wonder and fear of objects in a way that approaches the sincerity of a child frightened by the shapes of objects in the dark" (1–2). The bodies of these colorful, wildly diverse pheasants blur together in this stuffed spectacle, and in our straining to unblur the boundaries, we become aware of how, as Olivier notes, "objects take on an otherworldly aura, a buzzing, a strangely diffuse density" (4). With this dizzying case perched atop a flight of stairs connecting the upper galleries to the main floor, I made sure to hold the handrails to descend. (After all, stairwells, as Gothic horror teaches us, are occupational hazards).

How, I wonder, might these children have responded to taxidermy that consciously revels in the dark side? What if those stuffed birds in the case had been arranged, for instance, to be feasting on a bloodied human heart, as they are in British taxidermist Polly Morgan's piece *Myocardial Infarction* (2013), or if that fox had actually looked, well, dead—as it does in another of Morgan's pieces? In *Harbour* (see Figure A1.1), part of Morgan's 2012 London installation that scratches at the violent cycles of life, a taxidermied fox lies prone with octopus tentacles monstrously protruding from its body while taxidermied birds, in flight, peck at the tentacles.

It is not a stretch to imagine this happening since, in 2015, the Horniman Museum included an exhibition of Morgan's taxidermy. Described by one

1 See Stockton's *The Queer Child* (2009) and Halberstam's *Wild Things* (2020).

Figure A1.1 Polly Morgan. *Harbour.* 2012. © Polly Morgan. All Rights Reserved, DACS/Artimage/CARCC Ottawa 2024.

critic as pop art meets "macabre Edgar Allen Poe-Gothic theatricality" (Lala), Morgan's taxidermy gestures to Gothic fiction, given that Morgan is self-taught and turned to taxidermy after studying English Literature at university.

I imagine what might happen if the taxidermied painted turtle in Oxford's Natural History Museum were to be swapped with a different taxidermied turtle: *Snapping Turtle Eating Human Eyeball* (see Figure A1.2), a piece by the American rogue taxidermist Scott Bibus that mingles traditional nineteenth-century museum taxidermy (a realistic presentation of a snapping turtle) with the glaring difference of a severed green human eyeball in its open mouth. Another of Bibus's dioramas features a beaver, with a bloodstained muzzle, gnawing on a bloodied human thumb. Bibus's work thoroughly embraces Gothic horror, bringing what fellow taxidermist Robert Marbury calls, a "campy, horror-film aesthetic to taxidermy by showing gruesome scenes of animals eating human parts, mutations, and zombie animals in midscream" (Marbury 37). *Snapping Turtle Eating Human Eyeball* perversely (and pleasurably) stages the fantasy of what happens when the animal bites back.

I want to linger on this image of *Snapping Turtle Eating Human Eyeball* for the ways it stitches up several of the concerns this book has threaded throughout.

Figure A1.2 Scott Bibus. *Snapping Turtle Eating Human Eyeball*. © Scott Bibus. Image courtesy of the artist.

Snapping Turtle shares many of the same morbid obsessions with Gothic horror as many of the works considered here in this book, such as the violated body. For Rachel Youdelman, there is something inherently Gothic about all taxidermy: "[t]axidermied animals share Gothicism's morbid obsessions: they serve as specters of a dissociated past and as evidence of fractured relationships with nature, spirituality, and labor" (39). And yet, *Snapping Turtle* goes beyond this and complicates recent theorizations of taxidermy that read it in its various forms as a technology or art of mourning (cf. Poliquin, McHugh), that see it, as essayist and poet Anna Journey does, as "acutely linked to loss," a frozen "lyric moment [...] that testifies to the beauty, bittersweetness, and gravity of impermanence" (179–80). When looking at *Snapping Turtle*, we find another mode of encountering taxidermy: through the affective work of horror, such as anxiety, hesitation, and uncertainty. Indeed, taxidermy and Gothic horror with their emphasis on the violated body share in what Xavier Aldana Reyes in *Horror Film and Affect* identifies as the principal affect of horror, that is to

AFTERWORD

feel "under corporeal threat" (3). Taxidermy and Gothic horror share an overlapping interest in the body; in both, the natural corporeal and temporal boundaries of a fleshy finite subject get violated.

Snapping Turtle deliberately disrupts the story of nature's unity and calls attention to a different story: that of the conspicuous violence that shrouds the taxidermic specimen. Unlike Angela Singer's *sore I* (see Figure 0.1 in the Introduction), where a blood-drenched deer mount wears the violence of the hunt, Bibus's *Snapping Turtle* incorporates a violated human body, perhaps even that of the taxidermist. If taxidermy traditionally affords viewers the fantasy of mastery over frozen animals, as Laura White suggests (145), *Snapping Turtle* darkly stages what happens when taxidermy returns and quite literally consumes the human gaze. The frozenness of the taxidermied turtle and its gaze is eerily matched by the single unblinking severed human eye. This snapping turtle uncannily appears to offer up the dismembered human subject (metonymically represented by the single green eye) for the viewer's consumption in a quasi-reversal of agency. The human is unusually invoked and interpellated into this scene, subject to violent dismemberment at the hands of the taxidermied object that snaps back. With the human eye swallowed into the diorama as a frozen partial-object to be gazed at, this artistic mount challenges human exceptionalism and the dominant politics of the gaze, snapping at "the brutal power relations that shape the dioramic field of vision" (Wakeham 4).

The severed eyeball, this unquiet thing in Bibus's diorama, transforms what would otherwise be a traditional realistic taxidermy mount into a Gothic spectacle. The fragmented, dismembered body is a familiar Gothic image, deployed in the Gothic tradition ranging from Walpole and Radcliffe to Stephen King, what Ian Conrich and Laura Sedgwick call in *Gothic Dissections*, a "carnographic parade of the opened and damaged body" (11). Bibus's disturbing rogue taxidermy imagines a new kind of narrative, a diorama of body horror, where the calm seemingly naturalistic demeanor of the preserved specimen takes on an even darker register with the violently dismembered human body parts strewn about the scene. Just as Jack Halberstam argues that the Gothic "marks a peculiarly modern preoccupation with boundaries, and their collapse," and "the monsters of modernity are characterized by their proximity to humans" (*Skin Shows* 23), taxidermy, and particularly rogue taxidermy that violently integrates the fragmented human body into the scene, provocatively collapses boundaries.

Typically, as Zoe Hughes notes, taxidermy "has the eerie ability to obscure both its individual life and its death. It is encountered as animal material, harkens back to the animal, but erases the violence in between—the death, skinning, stretching, and sewing. In more than one way, then, the taxidermic

object obscures its human construction" (172). It is not unlike how information in Gothic narratives comes in the form of bits and pieces, such as "confused fragments—replete with variants, changed names, concealed relationships, blurry boundaries, teasing lacunae, and stunning coincidences which may or may not be significant" (Johnson 110). Both taxidermy and the Gothic, as I've argued throughout this book, are stuffed by the counterfeit.

While the collusion of taxidermy and Gothic horror is most visible in these material encounters, the connections between these two discursive bodies are more than just skin deep. As I have worked to show over the course of this book, taxidermy as a practice shares an entwined origin story and history with the Gothic, an imbrication that carries on well into the contemporary moment. *Taxidermy and the Gothic* draws on insights from original archival work and offers a new theory of taxidermy's curious and enduring place in Gothic horror.

Indeed, all the Gothic texts in this book are threaded together by their association of taxidermy with the work of horror, that "vortex of summons and repulsion" as Kristeva puts it (1). In its constellation with Gothic horror, taxidermy becomes inextricably linked to the dark side of life: it becomes, as I've argued throughout the book, a potent, catachrestic figure for the persistence, stubbornness, or "stuckness" of life's horrors. These horrors, as I've argued, include the horror of existence itself and its impossibility of escape, as explored in Chapter 2—that haunting, impersonal, anonymous existence that Levinas describes as the *il y a*, or what Dylan Trigg describes as a "nocturnal ontology" that "threatens the singularity of the subject"(50); the horror in the ineradicability of perversions, those dark desires that ought not to exist but that do, as taken up in Chapter 3; and the ubiquitous everyday horror of racism and microaggressions, as treated in Chapter 4. Guided by the Gothic spirit of impurity that I described in the introduction, I have located texts from the Gothic's origins into the contemporary moment and from a range of genres—nineteenth-century taxidermy manuals, political philosophy, natural history, periodicals, paintings, satirical prints, essays, short stories, poetry, novels, horror film, and material mounts of taxidermy (traditional museum specimens and artistic specimens)—to establish a genealogy for these entwined discourses. You might imagine the rich collection of texts gathered here displayed like Leatherface's wall of taxidermy in *The Texas Chainsaw Massacre*. Moreover, inspired by the art of taxidermy, I have operated in a mode of reading that toggles between surface and depths. In each chapter, I read by paying attention to the skin, stitching bits and pieces together, noticing surface elements like the taxidermy that silently, breathlessly lines the walls and pages of so many Gothic texts; I also read by peeling flesh from bone, or "fleshing" as taxidermists call it. Put otherwise,

AFTERWORD 143

I mix surface reading and close reading. In this, I hope readers will find my technique more scalpel than chainsaw.

Taxidermy and the Gothic has sought to pull the strange figure of taxidermy out of the shadows and expose the secret stitching and stuffing to show the "reciprocal capture" between Gothic horror and taxidermy—to use Isabelle Stengers's phrase for a symbiotic agreement between enmeshed bodies (36)—that occurs between these fields at their mutual emergence and continued evolution, a hold that promises to continue. Both Gothic scholarship and what I am calling critical taxidermy studies, the latter of which is the stuffed progeny of critical animal studies, would do well to embrace this omnipresent but seldom acknowledged Gothic underbelly rather than attempt to thrust it aside. For there is a wealth of material that remains overwhelmingly untouched by scholarship on both sides, and it is my hope that this book will serve as a point of departure and spark more interest in perversely and pleasurably getting stuffed on taxidermy's collusion with Gothic horror.

BIBLIOGRAPHY

"About Taxidermy.—1. The Principles Laid Down" 36.914 (15 Nov. 1882, p. 206) *Nineteenth Century UK Periodicals*. Gale. Accessed 13 Oct 2022.

"About Taxidermy.—2. On Unreason in Clients" *Fun* 36.915 (22 Nov. 1882, p. 216) *Nineteenth Century UK Periodicals*. Gale. Accessed 13 Oct 2022.

"About Taxidermy.—3. The Misinformed Naturalist" *Fun* 36.916 (29 Nov. 1882, p. 233) *Nineteenth Century UK Periodicals*. Gale. Accessed 13 Oct 2022.

"About Taxidermy.—4. An Unappreciated Triumph" *Fun* 36.917 (6 Dec. 1882, p.238) *Nineteenth Century UK Periodicals*. Gale. Accessed 13 Oct 2022.

"About Taxidermy.—5. The Lifelike Pet" *Fun* 36.918 (13 Dec. 1882, p. 248) *Nineteenth Century UK Periodicals*. Gale. Accessed 13 Oct 2022.

"Russian Taxidermist who makes models of dead animals having sex is accused of being a pervert by activists." Darren Boyle. 29 Feb 2016. *The Guardian*, https://www.dailymail.co.uk/news/article-3469387/Russian-taxidermist-makes-models-dead-animals-having-sex-accused-pervert-activists.html.

"Taxidermy in Rome." *Blackwood's Edinburgh Magazine* 62.383 (1847): 292–300. *ProQuest*, https://www.proquest.com/historical-periodicals/taxidermy-rome/docview/6540658/se-2.

A Classic Horror Story. Dir. De Feo, Roberto and Paolo Strippoli. Colorado Film, 2021.

Abels, Michael. Interview. *Score: The Podcast*. Season 2, Episode 12. 4 July 2019. https://www.youtube.com/watch?v=tL2CI98wlJI.

Acheson, Katherine. *Visual Rhetoric and Early Modern English Literature*. Burlington, VT: Ashgate, 2013.

Adorno, Theodor and Max Horkheimer, *Dialectic of Enlightenment*. Trans. John Cumming. London: Verso, 1997.

Agard, John. *Alternative Anthem: Selected Poems*. Tarset: Bloodaxe Books, 2009.

Aikin, John and Anna Laetitia Aikin (later Barbauld). "On the Pleasure Derived from Objects of Terror; with Sir Bertrand, A Fragment" in *Miscellaneous Pieces in Prose*, Aikin and Aikin. London: Joseph Johnson, 1773. 119–137.

Alaimo, Stacey. *Bodily Natures: Science, Environment, and the Material Self*. Bloomington: Indiana University Press, 2010.

Alaimo, Stacey. *Exposed: Environmental Politics and Pleasures in Posthuman Times*. Minneapolis: University of Minnesota Press, 2016.

Aldana Reyes, Xavier. *Body Gothic: Corporeal Transgression in Contemporary Literature and Horror Film*. Cardiff: University of Wales Press, 2014.

Aldana Reyes, Xavier. *Horror Film and Affect*. New York: Routledge, 2016.

Aldington, Richard. *The Strange Life of Charles Waterton, 1782–1865*. London: Evans Brothers, 1949.

Aloi, Giovanni. *Speculative Taxidermy: Natural History, Animal Surfaces, and Art in the Anthropocene*. New York: Columbia University Press, 2018.

Amato, Sarah. *Beastly Possessions: Animals in Victorian Consumer Culture*. Toronto: University of Toronto Press, 2015.

Amirpour, Ana Lily. *The Outside*. In *Guillermo del Toro's Cabinet of Curiosities*. Exile Entertainment, 2022.

Andreassen, Rikke. *Human Exhibitions: Race, Gender and Sexuality in Ethnic Displays*. Surrey: Ashgate, 2015.

Arnett, Kristen. "The Year in Taxidermy," 4 Dec 2018. https://hazlitt.net/feature/year-taxidermy.

Arnett, Kristen. *Mostly Dead Things*. Portland: Tin House Books, 2019.

Asma, Stephen T. *Stuffed Animals and Pickled Heads: The Culture and Evolution of Natural History Museums*. New York: Oxford University Press, 2001.

Bailly, Jean-Christophe. *The Animal Side*. New York: Fordham University Press, 2011.

Baldick, Chris, ed. *The Oxford Book of Gothic Tales*. New York: Oxford University Press, 1992.

Bann, Stephen, ed. *Frankenstein, Creation, and Monstrosity*. London: Reaktion, 1994.

Barthes, Roland. *Camera Lucida: Reflections on Photography*. Trans. Richard Howard. New York: Hill and Wang, 2010.

Beckford, William. *Vathek; with the episodes of Vathek*. [1786]. Ed. Kenneth Graham. Peterborough, ON: Broadview, 2001.

Bennett, Jane. *Vibrant Matter: A Political Ecology of Things*. Durham: Duke University Press, 2010.

Bentley, Gerald Eades, ed. *William Blake: The Critical Heritage*. New York: Routledge, 1996.

Berlant, Lauren. "Cruel Optimism" *differences* 17.3 (2006): 20–36. doi: https://doi.org/10.1215/10407391-2006-009.

Berleant, Arnold. *Sensibility and Sense: The Aesthetic Transformation of the Human World*. Exeter: Imprint Academic, 2010.

Best, Stephen and Sharon Marcus. "Surface Reading: An Introduction" *Representations* 108.1 (2009): 1–21.

Beyond the Darkness. Dir. Joe D'Amato. Severin Films, 2017.

Bezan, Sarah and Susan McHugh. "Introduction: Taxidermic Forms and Fictions" *Configurations* 27.2 (2019): 131–138.

Blackburn, Julia. *Charles Waterton: Traveller and Conservationist*. London: Century, 1991. 194–195.

Blake, William. *Illustrations to Edward Young's "Night Thoughts" c. 1795-97: electronic edition*. The William Blake Archive, 2017. https://blakearchive.org/copy/but330.1.

Blanchard, Pascal et al., eds. *Human Zoos: Science and Spectacle in the Age of Colonial Empires*. Trans. Teresa Bridgeman. Liverpool: Liverpool University Press, 2008.

Botting, Fred. *Gothic*. London: Routledge, 1996.

Bourke, Joanna. *Loving Animals: On Bestiality, Zoophilia and Post-human Love*. London: Reaktion Books, 2020.

Bowdich, Sarah (Mrs. R. Lee). *Taxidermy: Or the Art of Collecting, Preparing and Mounting Objects of Natural History. For the Use of Museums and Travellers*, [1820], 1843.

Bowdich, Sarah. *Stories of Strange Lands; and Fragments from the Notes of a Traveller. By Mrs. R. Lee, (Formerly Mrs. T. Edward Bowdich)*. London: Edward Moxon, 1835.

BIBLIOGRAPHY 147

British Academy of Taxidermy. "Pornographic Mouse Taxidermy." http://www. thebritishacademyoftaxidermy.org/taxidermy-classes-london/event/pornographic-mouse-taxidermy/#.YOhGXy0ZO00.

Broglio, Ron. *Surface Encounters: Thinking with Animals and Art.* Minneapolis: University of Minnesota Press, 2011.

Brontë, Emily. *Wuthering Heights.* [1847]. Ed. Beth Newman. Peterborough, ON: Broadview, 2007.

Brooks, Peter. *Reading for the Plot: Design and Intention in Narrative.* New York: A.A. Knopf, 1984.

Brown, Bill. "Thing Theory" *Critical Inquiry* 28.1 (2001): 1–22.

Brown, Thomas. *The Taxidermist's Manual; or the Art of Collecting, Preparing and Preserving Objects of Natural History.* Glasgow: Archibald Fullarton, 1833.

Bruhm, Steven. *Gothic Bodies: The Politics of Pain in Romantic Fiction.* Philadelphia: University of Pennsylvania Press, 1994.

Bruhm, Steven. "Contemporary Gothic: Why We Need It" in *The Cambridge Companion to Gothic Fiction.* Ed. Jerrold Hogle. Cambridge: Cambridge University Press, 2002. 259–276.

Buckingham, Will. *Levinas, Storytelling, and Anti-Storytelling.* London: Bloomsbury, 2013.

Bulwer-Lytton, Edward. *A Strange Story.* [1862]. London: Routledge, 1887.

Burke, Edmund. Ed. Adam Phillips. *A Philosophical Enquiry into the Origin of Our Ideas of the Sublime and Beautiful.* New York: Oxford University Press, 1990.

Calarco, Matthew. *Zoographies: The Question of the Animal from Heidegger to Derrida.* New York: Columbia University Press, 2008.

Calarco, Matthew. *Thinking through Animals: Identity, Difference, Indistinction.* Stanford: Stanford University Press, 2015.

Caravaggio, Michelangelo Merisi Detto. *Rest on the Flight into Egypt.* 1597, Doria Pamphili Gallery.

Carroll, Noël. *The Philosophy of Horror; or, Paradoxes of the Heart.* New York: Routledge, 1990.

Carroll, Victoria. *Science and Eccentricity: Collecting, Writing and Performing Science for Early Nineteenth-Century Audiences.* London: Pickering & Chatto, 2008.

Castle, Terry. "The Gothic Novel" in *The Cambridge History of English Literature, 1660–1780.* Ed. John Richetti. Cambridge: Cambridge University Press, 2005. 673–706.

Castricano, Jodey. *Gothic Metaphysics: From Alchemy to the Anthropocene.* Cardiff: University of Wales Press, 2021.

Chion, Michel. *The Voice in Cinema.* Trans. Claudia Gorbman. New York: Columbia University Press, 2008.

Choi, Sarah. "Life, Death, or Something in between: Photographic Taxidermy in 'Get out'" (2017), *Quarterly Review of Film and Video* 39.4 (2021): 867–889. doi: 10.1080/10509208.2021.1888606

Clark, David L. "On Being 'the Last Kantian in Nazi Germany': Dwelling with Animals after Levinas" in *Postmodernism and the Ethical Subject.* Eds. B. Gabriel and S. Ilcan. Montreal: McGill-Queen's University Press, 2004. 41–75.

Cohen, William and Ryan Johnson, eds. *Filth: Dirt, Disgust, and Modern Life.* Minneapolis: University of Minnesota Press, 2005.

Colebrook, Claire. *Death of the PostHuman: Essays on Extinction, Vol.1.* Open Humanities Press, 2014.

Coleridge, Samuel Taylor. *Selected Poetry.* Ed. William Empson and David Pirie. Manchester: Carcanet, 1989.

Colley, Ann. *Wild Animal Skins in Victorian Britain: Zoos, Collections, Portraits, and Maps.* Surrey: Ashgate, 2014.

Colvin, Christina M. "Freeze-Drying Fido: The Uncanny Aesthetics of Modern Taxidermy" in *Mourning Animals: Rituals and Practices Surrounding Animal Death.* Ed. Margo DeMello. East Lansing, MI: Michigan State University Press, 2016. 65–72.

Conrich, Ian and Laura Sedgwick. *Gothic Dissections in Film and Literature: The Body in Parts.* London: Palgrave Macmillan, 2017.

Crais, Clifton and Pamela Scully. *Sara Baartman and the Hottentot Venus: A Ghost Story and a Biography.* Princeton: Princeton University Press, 2009.

Critchley, Simon. *Very Little—Almost Nothing: Death, Philosophy, Literature.* 2nd ed., New York: Routledge, 2004.

Dandridge, Eliza Bourque. "William Beckford's Comic Book, or Visualizing Orientalism with *Vathek*" *Eighteenth-Century Fiction* 29.3 (2017): 427–454.

Darke, Verity. "Nineteenth-Century Taxidermy Manuals and *Our Mutual Friend*" *19: Interdisciplinary Studies in the Long Nineteenth Century* 24 (2017). npag.

Dartt, Mary. *On the Plains, and among the Peaks: Or, How Mrs. Maxwell Made Her Natural History Collection.* Ed. Julie McCown. Chicago: University Press of Colorado, 2021.

Darwin, Charles and Francis Darwin. *The Autobiography of Charles Darwin: From The Life and Letters of Charles Darwin.* Auckland, NZ: The Floating Press, 2009.

Darwin, Charles. *Journal of Researches into the Natural History and Geology of the Countries Visited during the Voyage of H.M.S. Beagle.* [1845]. Cambridge: Cambridge University Press, 2011.

Darwin, Charles. "Letter no. 22" *Darwin Correspondence Project*, Accessed 5 May 2021, https://www.darwinproject.ac.uk/letter/DCP-LETT-22.xml.

Daszkiewicz, Piotr. "The Decline and Closure of Maison Verreaux as Indicated by Władysław Taczanowski's Letters" *Archives of Natural History* 44.1 (2017): 130–133.

Davis, Lennard. *Obsession: A History.* Chicago: University of Chicago Press, 2008.

Dean, Tim. "The Frozen Countenance of the Perversions" *Parallax* 14.2 (2008): 93–114.

Deleuze, Gilles and Félix Guattari. *A Thousand Plateaus: Capitalism and Schizophrenia.* Trans. Brian Massumi. Minneapolis: University of Minnesota Press, 1987.

Derrida, Jacques. *The Animal That Therefore I Am.* Ed. M-L Mallet. (D. Wills, Trans). New York: Fordham University Press, 2008.

Desmond, Jane. "Vivacious Remains: An Afterword on Taxidermy's Forms, Fictions, Facticity, and Futures" *Configurations* 27.2 (2019): 257–266.

Dolar, Mladen. *A Voice and Nothing More.* Cambridge, MA: MIT Press, 2006.

Dolar, Mladen. "Hitchcock's Objects" in *Everything You Always Wanted to Know about Lacan but Were Afraid to Ask Hitchcock.* Ed. Slavoj Žižek. London: Verso, 2010. 31–46.

Doty, Alexander. *Flaming Classics: Queering the Film Canon.* New York: Routledge, 2000.

Douglas, Mary. *Purity and Danger: An Analysis of Concepts of Pollution and Taboo.* New York: Routledge, 1966.

Douglass, Frederick. *Narrative of the Life of Frederick Douglass.* [1845]. Mineola, NY: Dover Press, 1995.

Drake, Nathan. "On Objects of Terror" in *Literary Hours: Or Sketches, Critical, Narrative, and Poetical, 1798*, 4th ed., 3 vol. London: Longman, Hurst, Rees, Orme, and Brown, 1820. 1: 362.

Due, Tananarive. "Get Out and the Black Horror Aesthetic" in *Get Out*, Jordan Peele and Tananarive Due. Los Angeles: Inventory Press, 2019. 6–15.

BIBLIOGRAPHY 149

Edwards, Justin, Rune Graulund and Johan Höglund, eds. *Dark Scenes from Damaged Earth: The Gothic Anthropocene*. Minneapolis: University of Minnesota Press, 2022.

Elfenbein, Andrew. *Romantic Genius: The Prehistory of a Homosexual Role*. New York: Columbia University Press, 1999.

Elliott, Julia. *The New and Improved Romie Futch*. Portland: Tin House Books, 2015.

Elliott, Kamilla. *Portraiture and British Gothic Fiction: The Rise of Picture Identification, 1764–1835*. Baltimore: Johns Hopkins University Press, 2012.

Felski, Rita. "Critique and the Hermeneutics of Suspicion" *M/C Journal* 15.1 (2012): http://journal.media-culture.org.au/index.php/mcjournal/article/view/431.

Foucault, Michel. *History of Sexuality*. New York: Vintage, 1978.

Foucault, Michel. *Discipline and Punish: The Birth of the Prison*. New York: Vintage, 1979.

Freeman, Richard Broke. "Darwin's Negro Bird-Stuffer" *Notes and Records of the Royal Society of London* 33.1 (1978): 83–86.

Freud, Sigmund. *Totem and Taboo: Some Points of Agreement between the Mental Lives of Savages and Neurotics*. Trans. James Strachey. New York: Routledge, 1950.

Freud, Sigmund. "The 'Uncanny'" in *The Standard Edition of the Complete Psychological Works of Sigmund Freud*. Ed. and Trans. James Strachey, 17: 217–252. London: Hogarth Press, 1953–1974.

Freud, Sigmund. "Three Essays on Sexuality" in *The Standard Edition of the Complete Psychological Works of Sigmund Freud*. Trans. James Stracey et al. 7:125–245. London: Hogarth, 1953–1974.

Friedmann, Jonathan L. *Musical Aesthetics: An Introduction to Concepts, Theories, and Functions*. Newcastle upon Tyne: Cambridge Scholars, 2018.

Fyfe, Aileen and Bernard Lightman, eds. *Science in the Marketplace: Nineteenth-Century Sites and Experiences*. Chicago: University of Chicago Press, 2007.

Gardner, James. *Bird, Quadruped, and Fish Preserving: A Manual of Taxidermy for Amateurs*. London: Henry Lea, 1865.

Genter, Robert. "'We All Go a Little Mad Sometimes': Alfred Hitchcock, American Psychoanalysis, and the Construction of the Cold War Psychopath" *Canadian Review of American Studies* 40.2 (2010): 133–162.

Get Out. Dir. Jordan Peele. USA: Universal Pictures, 2017.

Gill, Flora. "Pornographic mouse taxidermy for couples is a thing. So I went" *GQ Hype*. 22 June 2019. https://www.gq-magazine.co.uk/article/taxidermy-london-class.

Giorgis, Hannah. "Who Wants to Watch Black Pain?" *The Atlantic* April 17, 2021. https://www.theatlantic.com/culture/archive/2021/04/black-horror-racism-them/618632/.

Godwin, William. *Enquiry Concerning Political Justice*. [1793]. Batoche Books, 2000.

Godwin, William. *Fleetwood*. [1805]. Ed. Gary Handwerk and A.A. Markley. Peterborough, ON: Broadview, 2001.

Godwin, William. *St Leon*. [1799]. Ed. William Brewer. Peterborough, ON: Broadview, 2006.

Gregory, Helen and Anthony Purdy. "Present Signs, Dead Things: Indexical Authenticity and Taxidermy's Nonabsent Animal" *Configurations* 23.1 (2015): 61–92.

Greven, David. *Psycho-Sexual: Male Desire in Hitchcock, De Palma, Scorsese, and Friedkin*. Austin: University of Texas Press, 2013.

Haggarty, George. "Gothic Success and Gothic Failure: Formal Innovation in a Much-Maligned Genre" in *The Cambridge History of the English Novel*. Eds. Robert L. Caserio and Clement Hawes. Cambridge: Cambridge University Press, 2011. 262–276.

Halberstam, Jack. *Skin Shows: Gothic Horror and the Technology of Monsters.* Durham: Duke University Press, 1995.

Halberstam, Jack. *Wild Things. The Disorder of Desire.* Durham: Duke University Press, 2020.

Hall, Polly. *The Taxidermist's Lover.* Brentwood: CamCat, 2020.

Hansman, Heather. "The New Movies from SXSW We're Excited About" *Outside* magazine. 11 Mar 2019. https://www.outsideonline.com/culture/books-media/sxsw-2019-new-movies/.

Haraway, Donna. "Teddy Bear Patriarchy: Taxidermy in the Garden of Eden, New York City, 1908–1936" *Social Text* 11 (1984–85): 20–64.

Haraway, Donna. *When Species Meet.* Minneapolis: University of Minnesota Press, 2008.

Hardy, Zoé. "Stuffing the Short Story with Context: Artistic Creation and Gender in H.G. Wells's 'The Triumphs of a Taxidermist'" *Journal of the Short Story in English* 71 (2018): 43–56.

Harris, Wendell. *British Short Fiction in the Nineteenth Century: A Literary and Bibliographic Guide.* Detroit: Wayne State University Press, 1979.

Harrison, Sheri-Marie. "New Black Gothic" *Los Angeles Review of Books* 23 June 2018. https://lareviewofbooks.org/article/new-black-gothic/.

Hartman, Saidiya. *Scenes of Subjection: Terror, Slavery, and Self-Making in Nineteenth-Century America.* New York: Oxford University Press, 1997.

Hartman, Saidiya. *Lose Your Mother: A Journey Along the Atlantic Slave Route.* New York, NY: Farrar, Straus and Giroux, 2007.

Haslam, Fiona. *From Hogarth to Rowlandson: Medicine in Art in Eighteenth-Century Britain.* Liverpool: Liverpool University Press, 1996.

Healey, Jane. *The Animals at Lockwood Manor.* New York: Houghton Mifflin Harcourt, 2020.

Heath, William. "A Pair of Broad Bottoms" [graphic].. [November 1810?]. https://collections.library.yale.edu/catalog/15810258.

Heholt, Ruth and Melissa Edmundson, eds. *Gothic Animals: Uncanny Otherness and the Animal With-Out.* Cham: Palgrave, 2020.

Hendershot, Cyndy. *The Animal within: Masculinity and the Gothic.* Ann Arbor: University of Michigan Press, 1998.

Henning, Michelle. "Anthropomorphic Taxidermy and the Death of Nature: The Curious Art of Hermann Ploucquet, Walter Potter, and Charles Waterton" *Victorian Literature and Culture* 35.2 (2007): 663–678.

Hitchcock, Alfred. *Psycho.* Paramount Pictures, 1960.

Hobson, Richard. *Charles Waterton: His Home, Habits, and Handiwork.* Whittaker, 1866.

Hoeveler, Diane Long. "Introduction: A Gothic Cabinet of Curiosities" *European Romantic Review* 24.1 (2013): 1–2.

Hogarth, William. *Marriage-à-la-Mode.* 1743, National Gallery, London.

Hogle, Jerrold. "Introduction: The Gothic in Western Culture" in *The Cambridge Companion to Gothic Fiction.* Ed. Jerrold E. Hogle. Cambridge: Cambridge University Press, 2002. 1–20.

Holmes, Rachel. *African Queen: The Real Life of the Hottentot Venus.* New York: Random House, 2007.

Hooper, Tobe. *The Texas Chainsaw Massacre.* Hollywood Scripts, 1974. https://assets.scriptslug.com/live/pdf/scripts/the-texas-chain-saw-massacre-1974.pdf.

Hooper, Tobe. Dir. *The Texas Chainsaw Massacre.* Vortex, 1974.

BIBLIOGRAPHY 151

Hornaday, William Temple. *Taxidermy and Zoological Collecting ... with Chapters on Collecting and Preserving Insects by W. J. Holland. Illustrated by C. B. Hudson and Other Artists, Etc.* [1891]. 4th ed. New York: Charles Schribner, 1894.

Hsu, Hsuan L. *The Smell of Risk: Environmental Disparities and Olfactory Aesthetics.* New York: New York University Press, 2020. https://www.erudit.org/en/journals/memoires/2016-v7-n2-memoires02575/1036861ar.pdf.

Huckvale, David. *A Dark and Stormy Oeuvre: Crime, Magic and Power in the Novels of Edward Bulwer-Lytton.* Jefferson, NC: McFarland, 2015.

Hughes, Zoe. "Performing Taxidermy or the De- and Reconstruction of Animal Faces in Service of Animal Futures" *Configurations* 27.2 (2019): 163–186.

Hunter, William. *The Anatomy of the Human Gravid Uterus Exhibited in Figures.* Birmingham, 1774.

Hutchings, Peter. *Historical Dictionary of Horror Cinema.* Lanham: Scarecrow, 2008.

Jackson, Zakiyyah Iman. *Becoming Human: Matter and Meaning in an Antiblack World.* New York: New York University Press, 2020.

James, Henry. *The Turn of the Screw and Other Tales.* Ed. Kimberly C. Reed. Peterborough, ON: Broadview, 2010.

Johnson, Claudia L. *Equivocal Beings: Politics, Gender, and Sentimentality in the 1790s.* Chicago: University of Chicago Press, 1995.

Jones, Darryl. *Sleeping with the Lights On: The Unsettling Story of Horror.* New York: Oxford University Press, 2018.

Jones, David Annwn. *Gothic Effigy: A Guide to Dark Visibilities.* Manchester: Manchester University Press, 2018.

Jones, Shermaine. "'I Can't Breathe!': Affective Asphyxia in Claudia Rankine's *Citizen: An American Lyric*" *South: A Scholarly Journal* 50.1 (2017): 37–46.

Jordanova, Ludmilla. "Gender, Generation and Science: William Hunter's Obstetrical Atlas" in *William Hunter and the Eighteenth-Century Medical World.* Eds. W. Bynum and R. Porter. Cambridge: Cambridge University Press, 1985. 385–412.

Journey, Anna. *An Arrangement of Skin.* Berkeley: Counterpoint, 2017.

Kant, Immanuel. *Critique of Judgement.* Ed. Nicholas Walker. New York: Oxford University Press, 2007.

Keats, John. *Complete Poems.* Ed. Jack Stillinger. Cambridge, MA: Harvard University Press, 1978.

Keetley, Dawn and Matthew Wynn. "Introduction: Approaches to the Ecogothic" in *Ecogothic in Nineteenth-Century American Literature.* Eds. Dawn Keetley and Matthew Wynn Sivils. New York: Routledge, 2018.

Keetley, Dawn, ed. *Jordan Peele's Get Out: Political Horror.* Columbus: Ohio State University Press, 2020.

Khalip, Jacques. "The Last Animal at the End of the World" *European Romantic Review* 29.3 (2018): 321–332.

Kilcoyne, Elizabeth. *Wake the Bones.* New York: Wednesday Books, 2022.

King, Stephen. *Danse Macabre.* New York: Berkley Books, 1983.

King, Tiffany Lethabo. *The Black Shoals: Offshore Formations of Black and Native Studies.* Durham: Duke University Press, 2019.

Kingfisher, T. *The Hollow Places.* New York: Gallery/Saga, 2020.

Kopley, Emily. "Anon Is Not Dead: Towards a History of Anonymous Authorship in Early-Twentieth-Century Britain" *Mémoires du livre / Studies in Book Culture* 7.2 (2016): np.

Korsmeyer, Carolyn and Barry Smith. "Visceral Values: Aurel Kolnai on Disgust" in *Aurel Kolnai, On Disgust*. Eds. Barry Smith and Carolyn Korsmeyer. Chicago: Open Court, 2004, 1–25.

Krafft-Ebing, Richard von. *Psychopathia Sexualis: A Medico-Forensic Study*. Trans. Harry E. Wedeck. New York, 1965.

Kristeva, Julia. *Powers of Horror: An Essay on Abjection*. Trans. Leon Roudiez. New York: Columbia University Press, 1982.

Kristeva, Julia. *The Severed Head: Capital Visions*. New York: Columbia University Press , 2012.

Kwon, Sharon. "I Hated Myself for Not Being White for Most of My Life. Here's How I Stopped" *Huffpost Personal*. 7 April 2021 https://www.huffpost.com/entry/ internalized-racism-asian-american_n_606c93bdc5b6832c793c64e9.

Lacan, Jacques. Trans. Silvia Rodríguez, "Spring awakening" *Analysis* 6.6 (1995): 32–34.

Lacan, Jacques. "Kant with Sade" in *Écrits: The First Complete Edition in English*. Trans. Bruce Fink. New York: W.W. Norton, 2006. 645-668.

Lacan, Jacques. *The Seminar of Jacques Lacan Book XVII: The Other Side of Pscyhoanalysis, 1959–1960*. Ed. Jacques-Allain Miller. Trans. Russell Grigg. New York: W.W. Norton, 2007.

Lacan, Jacques. *On the Names-of-the-Father*. Trans. Bruce Fink. Cambridge: Polity Press, 2013.

Lacan, Jacques. *The Seminar of Jacques Lacan Book XXIII: The Sinthome*. Ed. Jacques-Allain Miller. Trans. Adrian Price. Cambridge: Polity Press, 2016.

Lala, Kisa. "Sculpting Corpses: A Conversation with Taxidermy Artist Polly Morgan." *HuffPost*. 10 May 2011, updated 6 Dec 2017. https://www.huffpost.com/entry/ sculpting-corpses-a-conve_b_852712.

Lander, James. *Lincoln and Darwin: Shared Visions of Race, Science, and Religion*. Carbondale: Southern Illinois University Press, 2010.

Landsberg, Alison. "Horror Vérité: Politics and History in Jordan Peele's *Get Out* (2017)" *Continuum* 32.5 (2018): 629–642.

Lauro, Sarah Juliet. "Specters of Slave Revolt" in *Jordan Peele's Get Out: Political Horror*. Ed. Dawn Keetley. Columbus: Ohio State University Press, 2020.147–159.

Lazo, Norma. "The Taxidermist (The Father)" *Callaloo* 26.4 (2003): 969–971.

Lee, Meera. "Perversion after Freud: From the Cruel Father to the Joycean Clinic" in *Lacan's Cruelty: Perversion beyond Philosophy, Culture and Clinic*. Ed. Meera Lee. Cham: Palgrave, 2022. 109–132.

Levinas, Emmanuel. *Ethics and Infinity*. Trans. Richard A. Cohen. Pittsburgh: Duquesne University Press, 1985.

Levinas, Emmanuel. *Time and the Other*. Pittsburgh: Duquesne University Press, 1987.

Levinas, Emmanuel. *Existence and Existents*. [1947]. 3rd ed. Pittsburgh: Duquesne University Press, 2008.

Lewis, Matthew. *The Monk*. [1796]. Ed. D.L. Macdonald and Kathleen Scherf. Peterborough, ON: Broadview, 2004.

Lightman, Bernard. *Victorian Popularizers of Science: Designing Nature for New Audiences*. Chicago: University of Chicago Press, 2009.

Literary Gazette no. 538 (12 May 1827): 300.

Llewelyn, John. *The Middle Voice of Ecological Conscience: A Chiasmic Reading of Responsibility in the Neighbourhood of Levinas, Heidegger and Others*. London: Macmillan, 1991.

Lloyd-Smith, Allan. *American Gothic Fiction: An Introduction*. New York: Continuum, 2004.

BIBLIOGRAPHY

Love, Heather. "Truth and Consequences: On Paranoid Reading and Reparative Reading." *Criticism* 52.2 (2010): 235–241.

Lovecraft, H. P (Howard Phillips). *The Lurking Fear and Other Stories.* St Albans: Panther, 1964.

Ludlow, Fitz Hugh. "The Taxidermist's Story." *The Ladies' Treasury: An Illustrated Magazine of Entertaining Literature,* 1 July 1872, pp. 12+. *Nineteenth Century UK Periodicals,* Accessed 5 Oct. 2022.

MacCormack, Patricia. "Necrosexuality" in *Queering the Non/human.* Eds. Noreen Giffney and Myra J. Hird. New York: Routledge, 2008. 339–362.

MacCormack, Patricia. "Perversion" http://www.sensesofcinema.com/2004/perversion/perversion_intro/.

Macneal, Elizabeth. *The Doll Factory.* Toronto: Simon & Schuster, 2019.

Madden, Dave. *The Authentic Animal: Inside the Odd and Obsessive World of Taxidermy.* New York: St. Martin's Press, 2011.

Manton, Walter Porter. *Taxidermy without a Teacher, Comprising a Complete Manual of Instruction for Preparing and Preserving Birds, Animals and Fishes ...* 1882.

Marbury, Robert. *Taxidermy Art: A Rogue's Guide to the Work, the Culture, and How to Do It Yourself.* New York: Artisan, 2014.

Marsh, Richard. *The Beetle.* [1897]. Ed. Julian Wolfreys. Peterborough, ON: Broadview, 2004.

Maturin, Charles. *Melmoth the Wanderer.* [1820]. Ed. Douglas Grant. Intro. Chris Baldick. Oxford: Oxford World's Classics, 1989.

McGrath, Patrick. "Transgression and Decay" in *Gothic: Transmutations of Horror in Late Twentieth-Century Art.* Ed. Christoph Grunenberg. Boston and Cambridge, MA: Institute of Contemporary Art and MIT P, 1997. 158–153 [sic].

McHugh, Susan. "Taxidermy's Literary Biographies" in *Animal Biography: Re-framing Animal Lives.* Eds. André Keruber and Mieke Roscher. Basingstoke: Palgrave, 2018. 141–160.

McHugh, Susan. *Love in a Time of Slaughters: Human-Animal Stories against Genocide and Extinction.* University Park, PA: Pennsylvania State University Press, 2019.

McHugh, Susan. "Mourning Humans and Other Animals through Fictional Taxidermy Collections" *Configurations* 27.2 (2019): 239–256.

McNally, Cayla. "Scientific Racism and the Politics of Looking" in *Jordan Peele's Get Out: Political Horror.* Ed. Dawn Keetley. Columbus: Ohio State University Press, 2020.212–222.

McNees, Eleanor. "Accounts for the Arm-Chair Traveller: The Italy of Badham and Dickens" in *The Victorians and Italy: Literature, Travel, Politics and Art.* Eds. Alessandro Vescovi, Luisa Villa and Paul Vita. Milano: Polimetrica, 2009. 45–60.

Mearns, Barbara and Richard Mearns. *Biographies for Birdwatchers: The Lives of Those Commemorated in Western Palearctic Bird Names.* Illus. Darren Rees. New York: Academic Press, 1988.

Merchant, Rex. *A Guide to the Restoration of Antique Taxidermy Specimens.* Oakham:Norman Cottage, 2005.

Merleau-Ponty, Maurice. *The Phenomenology of Perception.* Trans. Colin Smith. London: Routledge, 1962.

Mighall, Robert. *A Geography of Victorian Gothic Fiction: Mapping History's Nightmares.* Oxford: Oxford University Press, 1999.

Milgrom, Melissa. *Still Life: Adventures in Taxidermy.* Boston: Mariner Books, 2011.

Mitchell, Robin. *Vénus Noire: Black Women and Colonial Fantasies in Nineteenth-Century France.* Athens: University of Georgia Press, 2020.

Moers, Ellen. *Literary Women: The Great Writers.* New York: Doubleday, 1976.

Molina, Miquel. "More Notes on the Verreaux Brothers" *Pula: Botswana Journal of African Studies* 16.1 (2002): 30–36.

Mondal, Subarna. "'Did He Smile His Work to See?'—Gothicism, Alfred Hitchcock's *Psycho* and the Art of Taxidermy." *Palgrave Communications* 3:17044. doi: 10.1057/palcomms.2017.44

Moody, Elizabeth. *Poetic Trifles.* London: Baldwin, 1798.

Morgan, Polly. *Harbour,* 2012. [taxidermy].

Morgan, Polly. *Myocardial Infarction,* 2013. [taxidermy].

Morris, Pat. *A History of Taxidermy: Art, Science and Bad Taste.* Ascot, UK: MPM Pub., 2010.

Morris, Pat. *Charles Waterton (1782–1865) and his Eccentric Taxidermy.* Berkshire: MPM, 2014.

Mosse, Kate. "Novelist Kate Mosse tries taxidermy: 'I found the smell overwhelming'" *The Guardian.* 17 October 2014. https://www.theguardian.com/lifeandstyle/2014/oct/17/novelist-kate-mosse-taxidermy-smell-overwhelming.

Mosse, Kate. *The Taxidermist's Daughter.* London: Orion, 2014.

Munro, Alice. *Open Secrets: Stories.* Toronto: McClelland & Stewart, 1994.

Myers, Tony. *Slavoj Žižek.* New York: Routledge, 2003.

Napier, Elizabeth. *The Failure of Gothic: Problems of Disjunction in an Eighteenth-Century Literary Form.* Oxford: Oxford University Press, 1987.

Nevill, Adam. *The House of Small Shadows.* New York: St. Martin's, 2013.

Niesel, Jeffrey, "The Horror of Everyday Life: Taxidermy, Aesthetics and Consumption in Horror Films." [originally published in *Journal of Criminal Justice and Popular Culture* 2.4 (1994): 61–80]. Reprinted in *Interrogating Popular Culture: Deviance, Justice, and Social Order,* ed. Harrow and Heston, 1998.

Night of the Living Dead. Dir. George Romero. Image Ten/Laurel Group/Market Square Productions, 1968.

O'Brien, Sarah. *Bits and Pieces: Screening Animal Life and Death.* Ann Arbor: University of Michigan Press, 2023.

Olivier, Marc. *Household Horror: Cinematic Fear and the Secret Life of Everyday Objects.* Bloomington: Indiana University Press, 2020.

Orr, Mary. "The Stuff of Translation and Independent Female Scientific Authorship: The Case of *Taxidermy…..*, anon. (1820)" *Journal of Literature and Science* 8.1 (2015): 27–47.

Parsons, Neil. "One Body Playing Many Parts—le Betjouana, el Negro, and il Bosquimano" *Pula: Botswana Journal of African Studies* 16.1 (2002): 19–29.

Patchett, Merle. *Putting animals on display: Geographies of taxidermy practice.* PhD thesis, 2010.

Patchett, Merle. "The Taxidermist's Apprentice: Stitching Together the Past and Present of a Craft Practice" *Cultural Geographies* 23.3 (2016): 401–419.

Peele, Jordan and Tananarive Due. Screenplay for *Get Out.* Los Angeles: Inventory Press 2019.

Peele, Jordan. @JordanPeele. Tweet. "The Sunken Place means we're marginalized..." 17 March 2017 https://twitter.com/JordanPeele/status/842589407521595393?s=20.

Peele, Jordan. Interview. "Jordan Peele's X-Ray Vision" *The New York Times Magazine.* December 20, 2017.

Pinedo, Isabel Cristina. *Recreational Terror: Women and the Pleasures of Horror Film Viewing.* Albany, NY: SUNY Press, 1997.

BIBLIOGRAPHY

Poliquin, Rachel. *The Breathless Zoo: Taxidermy and the Cultures of Longing*. University Park: Pennsylvania State University Press, 2012.

Poll, Ryan. "Can One 'Get Out?' The Aesthetics of Afro-Pessimism" *Journal of the Midwest Modern Language Association* 51.2 (2018): 69–102.

Powell, Dionne. "From the Sunken Place to the Shitty Place: The Film *Get Out*, Psychic Emancipation and Modern Race Relations from a Psychodynamic Clinical Perspective" *The Psychoanalytic Quarterly* 89.3 (2020): 415–445.

Pratt, Marie Louise. "Arts of the Contact Zone" *Profession* 1 (1991): 33–40.

Psycho. Dir. Alfred Hitchcock. Paramount, 1960.

Puar, Jasbir. *The Right to Maim: Debility, Capacity, Disability*. Durham: Duke University Press, 2017.

Punter, David. *Gothic Pathologies: The Text, the Body and the Law*. New York: St. Martin's Press, 1998.

Qureshi, Sadiah. "Displaying Sara Baartman, the 'Hottentot Venus'" *History of Science* 42.2 (2004): 233–257.

Radcliffe, Ann. *The Italian*. [1797]. Ed. Frederick Garber. Oxford: Oxford World's Classics, 2008.

Radcliffe, Ann. "On the Supernatural in Poetry" *New Monthly Magazine* 16.1 (1826): 145–152.

Raimi, Sam. *Evil Dead II*. Renaissance Pictures, 1987.

Rankine, Claudia. *Citizen: An American Lyric*. Minneapolis: Graywolf Press, 2014.

Rankine, Claudia. Interview with Lauren Berlant. *BOMB Magazine*, 1 October 2014 https://bombmagazine.org/articles/claudia-Rankine/.

Rankine, Claudia. "How Art Teaches a Poet to See." Keynote. International Festival of Arts and Ideas, 2015. Keynote. https://www.youtube.com/watch?v=2sbPwNN09n8.

Reeve, Clara. *The Old English Baron*. [1778]. Ed. James Trainer. Intro. James Watt. Oxford: Oxford World's Classics, 2008.

Ritvo, Harriet. *The Platypus and the Mermaid and Other Figments of the Classifying Imagination*. Cambridge, MA: Harvard University Press, 1997.

Rose, Deborah Bird, Thom Van Dooren and Matthew Chrulew, "Introduction: Telling Extinction Stories" in *Extinction Studies: Stories of Time, Death, and Generations*. Eds. Rose, Deborah Bird, Thom Van Dooren and Matthew Chrulew. New York: Columbia University Press, 2017. 1–17.

Ross, Alan S. "Introduction: Preserving the Animal Body—Cultures of Scholarship and Display, 1660–1914" *Journal of Social History* 52.4 (2019): 1027–1032.

Rothman, William. *Hitchcock: The Murderous Gaze*. 2nd ed. Albany: SUNY Press, 2012.

Roudinesco, Élisabeth. *Our Dark Side: A History of Perversion*. Cambridge, UK: Polity, 2009.

Saler, Michael. *As If: Modern Enchantment and the Literary Prehistory of Virtual Reality*. New York: Oxford University Press, 2012.

Sauer, Gordon, ed. *John Gould the Bird Man: Correspondence with a Chronology of his Life and Works*. Vol. 1. London: The Natural History Museum, 1998.

Sconce, Jeffrey. *Haunted Media: Electronic Presence from Telegraphy to Television*. Durham: Duke University Press 2000.

Scott, Walter. *The Lady of the Lake*. [1810]. Clarendon, 1916.

Secord, James. *Visions of Science: Books and Readers at the Dawn of the Victorian Age*. Chicago: University of Chicago Press, 2014.

Sedgwick, Eve Kosofsky. *The Coherence of Gothic Conventions*. New York: Methuen, 1986.

Seshadri, Kalpana. *HumAnimal: Race, Law, Language*. Minneapolis: University of Minnesota Press, 2012.

Sha, Richard C. *Perverse Romanticism: Aesthetics and Sexuality in Britain 1750–1832*. Baltimore: Johns Hopkins University Press, 2009.

Shelley, Mary Wollstonecraft. *Frankenstein: Or, The Modern Prometheus*. [1818]. 3rd ed., edited by D.L. Macdonald and Kathleen Scherf. Peterborough, ON: Broadview P, 2012.

Shotwell, Alexis. *Against Purity: Living Ethically in Compromised Times*. Minneapolis: University of Minnesota Press, 2016.

Simpson, Hannah. "'Strange Laughter': Post-Gothic Questions of Laughter and the Human in Samuel Beckett's Work" *Journal of Modern Literature* 40.4 (2017): 1–19.

Spary, Emma C. "On the Ironic Specimen of the Unicorn Horn in Enlightened Cabinets" *Journal of Social History* 52.4 (2019): 1033–1060.

Spooner, Catherine. *Contemporary Gothic*. London: Reaktion Books, 2007.

Stedman, John Gabriel. *Narrative, of a Five Years' Expedition, against the Revolted Negroes of Surinam*. London: J. Johnson and J. Edwards, 1796.

Stengers, Isabelle. *Cosmopolitics I*. Minneapolis: University of Minnesota Press, 2018. 35–36.

Stockton, Kathryn Bond. *The Queer Child, or Growing Sideways in the Twentieth Century*. Durham: Duke University Press, 2009.

Stuffed. Dir. Theo Rhys. Agile Films, 2021.

Swainson, William. *Taxidermy: Bibliography and Biography* (1840)

Taxidermia. Dir. György Pálfi. Fortissimo Films, 2006.

Tell Me Your Secrets. Dir. John Polson. Amazon Prime, 2021.

The Cabin in the Woods. Dir. Drew Goddard. Lionsgate, 2011.

The Washington Post, "Nurse accused of amputating man's foot for her family's taxidermy shop" by Jonathan Edwards. 8 Nov 2022. https://www.washingtonpost.com/nation/2022/11/08/nurse-arrested-foot-amputation-taxidermy/.

Thorp, Laura. "The Fantasy of White Immortality and Black Male Corporeality in James Baldwin's 'Going to Meet the Man' and *Get Out*" in *Jordan Peele's Get Out: Political Horror*. Ed. Dawn Keetley. Columbus: Ohio State University Press, 2020.200–211.

Tidwell, Christy and Carter Soles. "Introduction: Ecohorror in the Anthropocene" in *Fear and Nature: Ecohorror Studies in the Anthropocene*. Eds. Christy Tidwell and Carter Soles. University Park: Pennsylvania State University Press, 2021.11-31.

Tidwell, Christy. "Ecohorror" in *Posthuman Glossary*. Eds. Rosi Braidotti and Maria Hlavajova. London: Bloomsbury, 2017. 115–117.

Tompkin, Joyce Marjorie Sanxter. *The Popular Novel in England: 1770–1800*. New York: Methuen, 1969.

Townshend, Dale. "'Love in a convent': Or, Gothic and the Perverse Father of Queer Enjoyment" in *Queering the Gothic*. Eds. William Hughes and Andrew Smith. Manchester: Manchester University Press, 2017. 11–35.

Trigg, Dylan. *The Thing: A Phenomenology of Horror*. Winchester, UK: Zero Books, 2014.

Truffaut, Francois. *Hitchcock*. New York: Simon, 1984.

Tsing, Anna. "Arts of Inclusion, or, How to Love a Mushroom" *Mānoa* 22.2 (2010): 191–203.

UCL "Auto-Icon." Bentham Project. https://www.ucl.ac.uk/bentham-project/who-was-jeremy-bentham/auto-icon.

van Dooren, Thom, Eben Kirksey and Ursula Münster "Multispecies Studies: Cultivating Arts of Attentiveness" *Environmental Humanities* 8.1 (2016): 1–23.

BIBLIOGRAPHY

Vuong, Ocean. *On Earth We're Briefly Gorgeous.* New York: Penguin, 2019.

Wakeham, Pauline. *Taxidermic Signs: Reconstructing Aboriginality.* Minneapolis: University of Minnesota Press, 2008.

Walker, Pete. *Complex PTSD: From Surviving to Thriving.* Lafayette, CA: Azure Coyote, 2013.

Wallace, Alfred. "Museums for the People" *Macmillan's Magazine* 19 (1869): 244–250.

Walpole, Horace. Letter to Horace Mann, 14 Feb 1753. *Horace Walpole's Correspondence,* Yale edition, 358–9. https://libsvcs-1.its.yale.edu/hwcorrespondence/page.asp?vol=20&seq=382&type=b.

Walpole, Horace. *Fugitive Pieces in Verse and Prose.* Twickenham: Strawberry-Hill Press, 1758.

Walpole, Horace. *A Catalogue of the Classic Contents of Strawberry Hill Collected by Horace Walpole,* 1842.

Walpole, Horace. *The Castle of Otranto and The Mysterious Mother.* [1764] Ed. Frederick S. Frank. Peterborough, ON: Broadview. Reprint 2011.

Warren, Calvin L. *Ontological Terror: Blackness, Nihilism, and Emancipation.* Durham: Duke University Press, 2018.

Waterton, Charles. *Wanderings in South America, the North-West of the United States and the Antilles, in the Years 1812, 1816, 1820, and 1824 / Charles Waterton.* London: J. Mawman, 1825.

Waterton, Charles. *Essays on Natural History: Chiefly Ornithology.* Longman, 1838.

Waterton, Charles. "Taxidermy ('To the Editor of the Illustrated London News')" *Illustrated London News.* 11 October 1851. 471.

Wells, H. G. *The Complete Short Stories of H.G. Wells.* London: Benn, 1966.

Wells, H.G. *The Island of Doctor Moreau.* [1896]. Ed. Mason Harris. Peterborough, ON: Broadview, 2009.

Wells, H. G. "The Triumphs of a Taxidermist" [1894] in *The Stolen Bacillus and Other Incidents.* Auckland, NZ: The Floating Press, 2009.

West, Cornel. *The Cornel West Reader.* New York, Basic Civitas Books, 1999.

White, Laura. "Recomposing the Slut: Feminist Taxidermic Practice in Charlotte Wood's *The Natural Way of Things*" *Configurations* 27.2 (2019): 139–161.

Whitehead, Angus. "'a bite': The First Published Reference to Blake's Ghost of a Flea?" *Blake/An Illustrated Quarterly* 49.3 (2015–16): 7 paragraphs.

Wilderson, Frank B, III. *Red, White & Black: Cinema and the Structure of U.S. Antagonisms.* Durham: Duke University Press, 2010.

Williams, Evan Calder. "Sunset with Chainsaw" *Film Quarterly* 64.4 (2011): 28–33.

Willis, Martin. *Vision, Science and Literature, 1870–1920: Ocular Horizons.* London: University of Pittsburgh Press, 2011.

Winnicott, Donald W. "Transitional Objects and Transitional Phenomena; A Study of the First Not-Me Possession" *The International Journal of Psycho-Analysis* 34.2 (1953): 89–97.

Winnubst, Shannon. "The Many Lives of Fungibility: Anti-blackness in Neoliberal Times" *Journal of Gender Studies* 29.1 (2020): 102–112. doi: 10.1080/09589236.2019.1692193

Wirtén, Eva Hemmungs. *Terms of Use: Negotiating the Jungle of the Intellectual Commons.* Toronto: University of Toronto Press, 2008.

Wolfe, Cary. *Animal Rites: American Culture, the Discourse of Species, and Posthumanist Theory.* Chicago: University of Chicago Press, 2003.

Wonders, Karen. *Habitat Dioramas: Illusions of Wilderness in Museums of Natural History.* Uppsala, Sweden, 1993.

Yanni, Carla. *Nature's Museums: Victorian Science and the Architecture of Display*. Baltimore: Johns Hopkins University Press, 1999.

Youdelman, Rachel. "Iconic Eccentricity: The Meaning of Victorian Novelty Taxidermy" *PsyArt* 21 (2017): 38–68.

Young, Elizabeth. *Black Frankenstein*. New York: New York University Press, 2008.

Young, Elizabeth. *Pet Projects: Animal Fiction and Taxidermy in the Nineteenth-Century Archive*. University Park: Pennsylvania State University Press, 2019.

Žižek, Slavoj. *Looking Awry: An Introduction to Jacques Lacan through Popular Culture*. Cambridge, MA: MIT Press, 1991.

Žižek, Slavoj. *Enjoy Your Symptom!: Jacques Lacan in Hollywood and Out*. New York: Routledge, 1992.

Žižek, Slavoj. "'I Hear You with My Eyes': Or, The Invisible Master" in *Gaze and Voice as Love Objects*. Eds. Slavoj Žižek and Renata Salecl. Durham: Duke University Press, 1996. 90–126.

Žižek, Slavoj. *Less Than Nothing: Hegel and the Shadow of Dialectical Materialism*. London: Verso, 2012.

INDEX

abjection xxi–xxiii, xxiv, 24n22, 78, 87, 129 (*see also* repulsion)
acousmatic sound 61, 82n10
Adorno, Theodor 34
aesthetics (*see* failed aesthetics; negative aesthetics)
Afro-pessimism 133
Alaimo, Stacey 34, 71
Aldana Reyes, Xavier xvi, 11, 140
alligators, taxidermied 3, 25–27
Aloi, Giovanni xiii, xviii, xxxix
alterity xxv, 34, 42, 53, 59–61, 128
amateur taxidermy (*see also* ornithologists)
 in films xii, 63
 as practice xxix, 7, 74, 75
 quality of 1
analysis of the Gothic
 close reading xxxiv
 depth readings xxxv
 distance reading xxxiv
 reparative reading xxxvn15
 surface reading xxxiv, xxxv
anamorphosis xxxv, 96, 112, 115, 131
animality xxxi, 105–6, 108, 131
 the animal within (Gothic double) xxxvi
 creature-terror xxxvi–xxxvii, 7
 gaze of the animal xxxvi
 plurality of 45n4
animal-object-thing (*see also* nocturnal ontology)
 becoming the xliii
 and being stuck xxvii
 and being-there xxvii
 Benjaminian aura of xxxviii, 70
 forced identification with xli
 imagining the feeling of body horror xl

and inhuman materiality 45
ontological instability of xxi, xxxvii
taxidermy as xv
Annwn Jones, David xxv
anonymous authorship 9, 20, 32
anonymous being xlii, 45
anonymous existence 43–45, 47, 52, 61, 67, 70, 142 (*see also* Levinas, Emmanuel)
the Anthropocene xviii, xxi, xxvii, xlii
anthropomorphic taxidermy xxxii, 1, 38, 38n28, 74, 75 (*see also* contemporary artistic taxidermy)
anti-black racism (*see* racism, anti-black; racism, systemic)
anti-black violence 133
Appiah, Kwame Anthony 11
Arnett, Kristen 71
Asma, Stephen xix
asphyxia, affective 113
attraction and repulsion xliii, 70
 (*see also* repulsion)
authenticity (*see also* the counterfeit)
 Benjaminian aura xxxviii–xxxix, 70
 the conceptual power of taxidermy xxxviii, 69
 the counterfeit 34
 "The Nondescript" (Waterton) 24
 not admired in taxidermy xxxix, 70
 and the *punctum* xxxix, 70
 of "The Triumphs of the Taxidermist" (Wells) 21n18

Baartman, Saartje (Sara) 104–8
bad taxidermy (*see* failed taxidermy)
Badham, Charles David 2, 18, 20

Bailly, Jean-Christophe 51
Baldick, Chris 20, 68
Bann, Stephen 25
barbarism xix, 105
Barthes, Roland 48
basement of the house of horrors 32,
 63–65, 119, 122, 124–25, 129,
 134, 137
The Beetle (Marsh) 39
being stuck (*see* stuckness)
being-there (*see also* stuckness)
 animal-object-thing xxvii
 the material encounter with
 taxidermy 43
 and power/knowledge 98–99
 racialized bodies and black
 horror xxxi
 The Turn of the Screw (James) 69
Bennett, Jane 43
Bentham, Jeremy xv, 104
Berlant, Lauren 110, 114–16,
 122–23, 132
Best, Stephen xxxv
Bezan, Sarah xiii, xviii, xx, xli, 2
Bibus, Scott xxii, 139, 141
Bird Rose, Deborah xix
the black body (*see also* slavery)
 the "Black buck" trope 125, 132
 and the deer-like body 112, 113
 Edmonstone 103
 El Negro (unnamed African warrior)
 104, 107–8
 and fungibility 126–29, 135
 the Hottentot Venus xxxi, 101, 107
 human taxidermy of xxxi, 33, 35,
 103–4, 136
 as the hunted and the hunting 111
 Lion Attacking a Dromedary (Maison
 Verreaux) 107–8
 Narrative of the Life of Frederick Douglass
 (Douglass) 113
 physical superiority (in *Get Out*) 124
 response to racism 112
 and slavery 126–28
 the suffering animal body 113
 and taxidermy 102, 126
black existence, the horror of 136 (*see also*
 Citizen: An American Lyric (Rankine))

The Black Shoals (King) 113
Complex PTSD: From Surviving to Thriving
 (Walker) 112
 The Right to Maim (Puar) 114
 and taxidermy xiv
black Gothic studies 118
black horror film xxvi, 118, 125
 (*see also Get Out* (Peele))
blackness
 aligned with animality xxxi, 105–6
 animality 108, 131
 and Baartman 105
 bestialization and thingification xxxi,
 108, 112
 black(ened) being's ontological plasticity
 108–9
 commodification of 126
 plasticity of xxxi
 relationship to slavery 133
Blake, William xxiv, xxxvi, 6, 27
blockages xxvii, xlii–xliii, 67, 73, 82,
 90, 115
body horror xxix, xl, 46, 72, 141
botched taxidermy (*see* failed taxidermy)
Botting, Fred xxii
the bottomless animal gaze 49,
 50, 52
the bottomless gaze 48, 66 (*see also*
 Derrida, Jacques)
 The Artist in His Museum (painting)
 (Peale) 14–16, 55
 Get Out (Peele) 49
 and the limits of the human 49
 phenomenology of taxidermy xxix
 in *Psycho* (Hitchcock) 53, 54
 Rest on the Flight into Egypt (painting)
 (Caravaggio) 50–51
 as signifier for nocturnal ontology 42
 The Texas Chainsaw Massacre
 (Hooper) xxx
 violence of hunting bows 51
the bottomless gaze of taxidermy in
 Gothic horror 52–57
 close-up details of taxidermy 52
 the emphasis on looking 57–59
 the eye 52–53
 in *Get Out* (Peele) 129–31
 looking at taxidermy leads to death 56

INDEX

the object gaze 60–61
and reflection 57–62, 131
sublime astonishment 59
boundaries
and awareness 138
being breached 66
and Derrida 49
dissolution of 53
in Gothic horror 141
in Levinas's account of existence 46
with living animals 22n19
preoccupation with boundaries 142
and the speculative "as if" 10–11
in "The Triumphs of a Taxidermist"
33, 34
and transgressions 65, 90
Waterton's violations of 22–23
where horror operates 67
Bourke, Joanna 86
Bowdich, Sarah 9
Bowdich, Thomas E. 24n22
breathlessness (see also asphyxia,
affective)
in Get Out (Peele) 116–35
Little Girl (sculpture) (Clark) 114, 115
as metaphor for blackness 69
as metaphor for systemic
violence 114
of taxidermy xxxi, xl–xli, 84, 138
when reading Gothic fiction 69
Brewer, Sarina xxii
British Academy of Taxidermy 74, 75
British Museum xviii, 9, 31–32
Broglio, Ron 68
Brown, Thomas xxix, 37
Browne, Montagu 10
Bruhm, Steven xvin4, xli, xlii, 11, 83
Buckingham, Will 47
Bulwer-Lytton, Edward xxvi, 2, 4–7, 53
Burke, Edmund 6, 58

The Cabin in the Woods (Goddard) xii,
xli, 57
cabinets of curiosities
car windshield likened to 121
in Guillermo del Toro's Cabinet of
Curiosities 62
lietmotif in book xiii, xxviii

recalled in presentation of Leatherface's
taxidery 55
cadavers xxiv, 74
cannibalism 53, 105
Carroll, Noël 25
The Castle of Otranto (Walpole) 7, 8, 89
as the counterfeit 11
the invisible hand 14
Castricano, Jodey xxxviii
Chen, Mel Y. xxvi
Christabel (poem) (Coleridge) 18, 89
Chrulew, Matthew xix
Citizen: An American Lyric (Rankine)
(see also Clark, Kate)
affective asphyxia 112
ancestors showing up in a corner 110,
121, 132
and genre 110, 117
In the Hood (sculpture)
(Hammons), 110
the horror of black existence
135, 136
Little Girl (sculpture) (Clark) xxxi, 101,
110–11
Sleeping Heads (Mutu) 110
sound of suffering 113–14
stuckness and breathlessness xxxi
stuckness of blackness 118
Clark, Kate xxxi, 101, 102, 109–10
A Classic Horror Story (De Feo and
Strippoli) xii, xxx, xliii, 57–62
Clemens, Valdine xxxvi
close-ups of taxidermy
in The Cabin in the Woods
(Goddard) 87
in A Classic Horror Story (De Feo and
Strippoli) 57
in Get Out (Peele) 129, 131, 134
glassy eyes 52
opening shots 57
reflective eyes 58
in The Texas Chainsaw Massacre
(Hooper) 55
Cohen, William xxiv
Colebrook, Claire xxi
colonial domination 106 (see also
imperialism)
colonial gaze 12

colonial logic xv
colonial myth xxxi
colonial violence xxiii
colonialism 105, 106
colonialist values 125
Colvin, Christina M. 1
Conrich, Ian 141
consumerism xxiv, 66
contemporary artistic taxidermy
 Bibus xxii
 "Fox in a Box" (Field and Young) xviii
 "Goth Griffin" (Brewer) xxii
 Harbour (taxidermy) (Morgan)
 138, 139
 Little Girl (sculpture) (Clark)
 109–10, 115
 Mothmeister xxii
 Myocardial Infarction (taxidermy)
 (Morgan) 138
 Snapping Turtle Eating Human Eyeball
 (taxidermy) (Bibus) 139–41
 Sore I (Singer) xxii, xxiii, 141
 speculative taxidermy xxxix, 38n28
 Young on xiii, xxiii, 21
contemporary Gothic, hallmarks of
 xlii–xliii
corporeality xvi, xxv, 11, 34, 68, 95
the counterfeit (*see also* authenticity)
 and authenticity 34
 authorship 8–9, 11
 and identity 91
 origins of 10
 in prefaces 7
 and taxidermy 67, 97, 104, 142
 and the taxidermist 36, 64
 trope of the great secret 32–33
Crais, Clifton 107
crap taxidermy (*see* failed taxidermy)
creature-terror xvin4, xxxvi–xxxvii, 7, 42
 (*see also* terror)
Critchley, Simon 45
critical animal studies xviii–xix (*see also*
 extinction studies)
critical taxidermy studies xviii–xix, xxviii
 (*see also* scholarship on taxidermy)
Cuvier, Georges 105–7

D'Amato, Joe xliii, 72
the dark background (*see also* noticing the
 background)
 chiaroscuro 51, 61, 124
 the horror of existence (the *il y a*)
 45, 52
 an impersonal vigilance 52
 violence in 51–52
dark ecology xxxix
Darke, Verity 10, 13
Darwin, Charles xxxi, 22, 101–4,
 108, 136
Darwinian science 28
del Toro, Guillermo xii, 62
Deleuze, Gilles xxviii, 116
Derrida, Jacques
 "The Animal That Therefore I Am
 (More to Follow)" 48
 animot 45, 45n4
 and the bottomless gaze xxix, 48, 49,
 52, 134
 gaze of the animal xxxvi, 135
 and his cat's gaze 42, 48, 50,
 53, 135
 on Levinas 44
 Žižek's animal gaze response 60
Desmond, Jane xviii, xxxix–xli,
 13, 69
dioramas, taxidermic xxxiii, 12, 13, 38,
 138, 139, 141
dirtiness
 of individuals 34–35, 87
 of spaces xxiv, xxxiv
 of taxidermy xxii, xxiii
disappointment xii, 41–43, 64
the disciplinary society
 Discipline and Punish (Foucault) 97
 the medical system 97–99, 118
 the penal system 91, 97–98
 surveillance 126
disgust
 and libidinal energies 35, 75, 88
 response to taxidermy 137
 smell of death 34
 the taxidermist's body 34
 ugly feelings xiii

INDEX

Dolar, Mladen 61, 81–82
domestic space
 curtains xxxvii, 14, 33, 55
 painting of Diana and Endymion 18
 painting of naked nymph 18
 of the taxidermist 18–19, 22, 33–34,
 63–65, 82, 85–86, 93, 124
Douglas, Mary xxiii
Douglass, Frederick 113
Due, Tananarive 117

ecoGothic horror xxvii
ecohorror xxvi, xxvii, xlii
Edmonstone, John xxxi, 102–4,
 108, 136
Edmundson, Melissa xxxvi–xxxvii
El Negro (unnamed African warrior) 104,
 107–8
Elliot, Kamilla 19
empiricism 35
the Enlightenment 10, 35
Evil Dead II: Dead by Dawn (Raimi)
 39, 64
existential crisis 42, 53
extinction studies xviii (*see also* critical
 animal studies)

failed aesthetics 133
failed taxidermy (*see also* rogue taxidermy)
 bad taxidermy at the British
 Museum 31
 botched taxidermy xviii, xxix
 crap taxidermy xxii, 19n14, 24
 does not preserve xxv
 Lion of Gripsholm Castle (Sweden) 19
 the two-headed kitten (Potter) 1–2
 Waterton on 23
failure
 of a common "grammar of
 suffering" 133
 of communication 132
 the Horniman walrus 29–31
 of human effort 49
 of looking and of hermeneutics 133
 taxidermied pets 42
 The Taxidermist's Manual (Browne) 17
 and Waterton 23

fathers (*see* Freud, Sigmund; Gothic
 horror, paternal figures)
Felski, Rita xxxv
filth xxiii–xxiv, 22n19, 32 (*see also*
 abjection; dirtiness; disgust;
 purity)
Fleetwood (Godwin) 2, 3
Foucault, Michel xxxiii, 78–80, 97
Frankenstein (Shelley)
 affective power of taxidermy 7
 epistolary style of xxxiii
 failed fathers in 89
 published anonymously 9
 Victor Frankenstein xxix, 2, 21, 22
Freud, Sigmund xiv, xxx, 71, 73, 76, 77,
 88, 96
Friday the 13th xii, xliii
fuzzy, defined xiv

Gardner, James 31, 37
gaze of taxidermy xxviii, xliii, 94–95, 99
Genter, Robert 82
Get Out (Peele) xxxi, 102, 125, 130
 anti-black violence in 118
 black male bodies xxvi
 bottomless gaze 49
 compared to *Citizen: An American Lyric*
 (Rankine) 135
 "Cruel Optimism" (Berlant)
 122–23, 132
 the cut scene 134
 the escape sequence 124–25
 face-to-face confrontation between
 Chris and taxidermy 134–35
 failed aesthetics of 133
 genre of 117
 grammar of suffering 133–135
 influences of 118
 A Lion Attacking a Stag (painting)
 (Stubbs) 123
 second chance (second life) 109
 "Sikiliza Kwa Wahenga" (song) (Abels)
 131–32
 stuckness of blackness 118
 taxidermy in 101
 transspecies speculation in xli
 white consciousness xli

Gill, Flora 74
Gillray, James 24
Goddard, Drew 86
Godwin, William 2, 4
the Gothic
 affective response xl–xli, 11
 and the body xvi–xvii, 83, 87
 defining xiv
 as form of taxidermy xxv
 Gothic preoccupation with 142
 and preservation xxv
 representational strategies of 13
 the sensational 7
the Gothic body xvi, 11–12
Gothic criticism xiii (*see also* analysis of the
 Gothic; black Gothic studies)
Gothic Effigy: A Guide to Dark Visibilities
 (Annwn Jones) xxv
Gothic fiction
 The Animals at Lockwood Manor (Healey)
 xxxiii
 defined xvi
 "Eliza Carthago" (Bowdich) 9
 and the Gothic body 11
 literary picture identification 19
 Madonna/whore paradigm 18
 The Monk (painting) (Lewis) 18, 89
 narrative techniques xxix, 2, 7,
 14, 142
 Southern Ontario Gothic 72
 Wordsworth on xxiii
Gothic horror (*see also* Southern Gothic)
 Dracula (Stoker) 39
 furnishings of xxxvii
 narrative desire 96
 new materialism xxxviii
 object awareness 94
 object-oriented xxxviii
 paternal figures xxxii, xxxiv, 20, 72,
 89, 129
 posthumanism xxxviii
 scenarios of horror of interminable
 existence 47
Gothic horror and taxidermy
 American history of racism and slavery
 addressed in 110
 craft of taxidermy xxx, 77
 creature-terror xxxvii

The Doll Factory (Macneal) xxxiii
and empirical knowledge 35
function of taxidermy xxxix–xli, 118
genealogy of xxix
grotesque preservation xxv
The Hollow Place (Kingfisher) xxxiv
"The Hound" (Lovecraft) 4
Melmoth the Wanderer (Maturin) 2
Mostly Dead Things (Arnett) xxxiii
The New and Improved Romie Futch
 (Elliott) xxxii
Night Thoughts (Edward Young) 6
polymorphously perverse xxx
reciprocal capture xix
repetition compulsions xliii, 62, 70
secret chambers in 3–4
shared features xxv, xxix, xxx
A Strange Story (Bulwer-Lytton) 2,
 4–7
The Taxidermist's Daughter (Mosse) xxvi,
 xxxii, 72
The Taxidermist's Lover (Hall) xxxiii
"Taxidermy in Rome" (Badham)
 2, 18
and terror 2
transspecies speculation xxxix–xli
Vandals (Munro) xx, 71
Vathek (Beckford) 20
vital materialism xxxviii
Wake the Bones (Kilcoyne) xxxiv
the Gothic (*see* contemporary Gothic,
 hallmarks of)
Gothic spectacle 4, 6, 141
Gregory, Helen xxxviii, 69
Guattari, Félix xxviii
Guillermo del Toro's Cabinet of Curiosities xii,
 62–63

Halberstam, Jack 117, 138, 141
Hammons, David 110
Haraway, Donna xix, xxiv, 13, 57,
 135n37
Hardy, Zoé 34
Harley, George 22, 23
Harrison, Sheri-Marie 110, 135
Hartman, Saidiya 126–27
Haslam, Fiona 25
the haunted house 92

INDEX

165

the haunted portrait 93–94
Healey, Jane xxxiii
Heholt, Ruth xxxvi–xxxvii
Heidegger, Martin 47
heimlich and *unheimlich* xxxvi, 71
Hendershot, Cyndy 13
Henning, Michelle 24
Hitchcock, Alfred 62, 84–85
Hobson, Richard 22, 22n19, 23, 25
Hogarth, William 25, 27
Hogle, Jerrold xxv, 10
Holmes, Rachel 105, 106n13
Hornaday, William 16, 67
Horniman Museum 138
the Horniman walrus xviii
horror film
 absence of race in 117–18
 cultural value of xx
 human taxidermy in xv, 38n28
 reflects the terror of everyday
 life 117
 taxidermists in 38n28, 63
 taxidermy in xii, xx–xxi, xxiv, xxvi,
 52–53, 125
the horror of existence (the *il y a*)
 anonymous existence 43
 as a dark background 45, 52
 and death 47
 human exceptionalism 50
 and materiality 46
 nocturnal ontology 44, 77, 142
 and stuckness xxix
 and taxidermy xxvii, xxix, 42
 taxidermy as catachresis for xxxv, 43,
 48, 142
The House of Small Shadows (Nevill) xxxii
the Hottentot Venus (*see* Baartman,
 Saartje (Sara); the black body;
 colonialism)
Hsu, Hsuan 33
Hughes, Zoe 141
human exceptionalism 50, 78,
 86, 141
the human gaze 141
human remains 107
human taxidermy
 Bentham's Auto-Icon xv, 104
 of black bodies 33, 36, 103–4

Buio Omega (D'Amato) 72
 in contemporary horror film xv,
 38n28
 material examples of xv, 24n22
Taxidermia (Pálfi) 72
 in *The Texas Chainsaw Massacre* (Hooper)
 xxiv, 55
hunting
 bows for 51
 and haunting 93
 and the hunted 111, 123, 124, 128
 the hunted and the hunter 83
 the hunter 128, 135
Hutchings, Peter 52

the *il y a* (*see* the horror of existence
 (the *il y a*); Levinas, Emmanuel)
imperialism xxvi (*see also* colonial
 domination)
impurity xxiii (*see also* filth; purity)
inanimate objects imbued with life 38,
 43, 61
insomnia 45–47
interiority 11, 12, 65, 68
 psychic 85
the invitation to follow 9–10, 55

Jackson, Zakiyyah Iman
 xxxi, 108
Johnson, Ryan xxiv
Jones, Darryl xxxvii
Jones, Edwin 25–27
Jones, Shermaine M. 112, 113
Journey, Anna 140

Kant, Immanuel 66
Keetley, Dawn xxvii, 117n22
Khalip, Jacques 49
King, Stephen 81n9, 83n12, 91, 141
King, Tiffany Lethabo 113, 126, 128
Kopley, Emily 9
Korsmeyer, Carolyn 35
Kristeva, Julia xxi, 87, 88, 137, 142 (*see also*
 abjection)
Kwon, Sharon 113

Lacan, Jacques 60, 60n8, 73, 76, 77, 82,
 83, 89
Landsberg, Alison 117, 117n22
Lauro, Sarah Juliet 128, 133n34

166 TAXIDERMY AND THE GOTHIC

Levinas, Emmanuel (*see also* anonymous
 existence)
 anonymous existence xlii, 47, 70
 on childhood fear of the darkness
 45–46
 Existence and Existents 44–46
 the faceless animal 48
 on horror as not anxiety about
 death 47
 the *il y a* (the horror of existence) xxvii,
 xxix, 42, 45, 52, 77, 142
 inescapability of night 67
 the night of 45, 47–48, 115
 relationship to animals 44–45
 taxidermy as metaphor 42
 weird realism of 46
literary taxidermy xviii
Lloyd-Smith, Alan xiv
Lovecraft, H. P. 4

MacCormack, Patricia 80–81
Madden, Dave xviii, xix
Mann, Horace xi
Manton, Walter xxix, 9–10
manuals, taxidermy
 alerts of potential problems 14
 The Anatomy of the Human Gravid Uterus
 exhibited in Figures (Hunter) 12
 Bird, Quadruped, and Fish Preserving: A
 Manual of Taxidermy for Amateurs
 (Gardner) 31
 decay 36–37
 illustrations in 12
 narrative techniques in xxix, 2
 negation of the body in 12–13
 presentational strategies of 13
 storytelling techniques 10
 Taxidermy and Zoological Collecting
 (Hornaday) 16
 Taxidermy Without a Teacher (Manton)
 xxix, 2, 9–10, 14, 36
 Taxidermy: or the Art of Collecting, Preparing
 and Mounting Objects of Natural History
 xxxii, 9
 Taxidermy: With the Biography of Zoologists
 (Swainson) 13n8
 The Taxidermist's Manual (Brown) xxix,
 2, 6, 16, 37

treatment of the body of the
 specimen 12
Marbury, Robert 13, 139
Marcus, Sharon xxxv
Marey, Etienne-Jules 94
Martin, Trayvon 110, 136
the material encounter with
 taxidermy 43
materialism 4, 46 (*see also* new
 materialism; vital materialism)
materiality
 of the animal's gaze 49, 53
 of the bottomless gaze 53
 and the disgusting 35
 and forms of the night 47
 of Hitchcockian objects 82
 of the human body xxvn9
 and the *il y a* 46
 instability of 108
 of the subject 46
 of taxidermy xlii, xliii, 43, 45, 53, 70
Maturin, Charles 2
McGrath, Pat 21
McHugh, Susan xiii, xviii, xx, xli,
 2, 42
McNall, Cayla 131
memory
 of the historical body 111
 loss of xxxii, 90, 97, 99
 and the poetic 43
Merleau-Ponty, Maurice 94
Milgrom, Melissa xviii
modernity 141
Moers, Ellen 11, 13
Mondal, Subarna xxv
monsters
 animacy hierarchy xxvi
 cinematic close-ups 52
 the feudal system as 3
 in *Get Out* (Peele) 117
 and the Gothic xlii, 1
 of modernity 141
 and supernatural powers xxxiv
 in *Tell Me Your Secrets* 91
the monstrous xxvi, 25, 52, 57,
 74, 78
 animal encounters xxxvi
 the Anthropocene as xxvii

INDEX

167

a house's agency as 19
and perversion 78
signalled through humor 38n29, 74
the taxidermist as xxix, 2
taxidermy as xxvii, 25, 52, 57, 138
Moody, Elizabeth 41, 49
Morgan, Polly xxii, 138–39
Morris, Pat xv, xx, 23
Morrison, Robert 20
Morton, Timothy xxxix
mother–daughter pair xxxii, 18, 20,
 90–92, 97, 99
Mothmeister xxii
Munro, Alice xx, 71
museum taxidermy
 of the British Museum 31–32
 children's response to 137–38
 quality of 1, 30–32
 Waterton on 23, 31
museums
 as 'hospitals' for curiosities xi
 and the writing of this book
 137, 139
Mutu, Wangechi 110
The Mysteries of Udolpho (Radcliffe) 12

negative aesthetics xviii, xx, xxii
neoliberalism 123, 129, 133
new materialism xxxviii
Ngai, Sianne xiii
Niesel, Jeffrey xxiv–xxv
The Nightmare (painting) (Fuseli) xxxvii,
 14, 24, 27
nocturnal ontology xxvii, xxxvii, xxxix,
 xlii, 43, 48, 52, 62, 70, 77, 108
 (*see also* animal-object-thing)
 the bottomless gaze 42
 the horror of existence 44
 likened to the *il y a* 142
nothingness 45, 47, 49, 68
noticing the background xxxv, 43, 94, 122
 (*see also* the dark background)

O'Brien, Sarah xxvi, 125
object-oriented ontology 82
the occult 4, 7, 27
occult knowledge 20, 25–27
Olivier, Marc xxxvii, 77n5, 82, 94,
 117n23, 138

ornithologists 35, 104 (*see also* Darwin,
 Charles)
Orr, Mary xxxii, 9
the Other 44, 49, 60, 105, 128
otherness 12, 34, 44, 71, 82n10
Otranto (*see The Castle of Otranto* (Walpole))
The Outside (Amirpour) xii, xxx, xli, xliii,
 52, 62–69

Patchett, Merle 13
the pathological 5, 75, 83, 86
patriarchy xxiv
Peale, Charles Willson 14–16, 55
Peele, Jordan
 on genre of *Get Out* 116
 on location of filming 119n27
 on marginalization 123
 scene cut by 134
perversion
 aligned with taxidermy in Gothic
 texts xxx
 The Cabin in the Woods (Goddard) xxx
 linked with psychopathy 82
 and the monstrous 74, 78
 as *père-version* 76, 89
 polymorphously perverse xxx
 Psycho (Hitchcock) xxx, 81–86
 in psychoanalysis 76–77, 88
 and sexology 77, 80
 Tell Me Your Secrets (series) xxviii, xxx
 and temporality 80–81
 Totem and Taboo (Freud) 88
 as wonder mixed with fear 77
the pervert xxx, 71, 78–80
pets, taxidermied 21, 32, 36, 41–43,
 55–57
phenomenology of taxidermy xxix
physiological responses
 affective asphyxia 112
 in *Get Out* (Peele) 122
 interrupted breath 112, 114
 to systemic racism, 113
 to taxidermy 6, 12, 115
 when reading Gothic fiction 69
Pinedo, Isabel Cristina 117
Ploucquet, Hermann 37–38
Poliquin, Rachel xiii, xviii
Poll, Ryan 133

Polson, John 90
posthumanism xxxviii
Potter, Walter xxvi, xxxii, 1–2, 37–38
prefaces
 The Castle of Otranto (Walpole) 7
 the counterfeit in 7, 34
 Lyrical Ballads (Wordsworth) xxiii
 of taxidermy manuals xxix, 2
psychiatry 76, 97, 98, 118, 123 (*see also*
 psychoanalysis; psychotherapy)
Psycho (Hitchcock)
 the bottomless gaze 53, 54
 Hitchcock xvii, xxiv, xxv, 90,
 91, 99
 shower curtain xxxvii, 82
 taboo 81–86
 taxidermy in xii, xliii
psychoanalysis (*see also* psychiatry)
 and animal fantasies 73
 and hallmarks of the contemporary
 Gothic xliii
 the id xxxvi
 and object-oriented ontology 82
 perversion in 76–77, 88
 surface and close reading xxxv
 theories of xxx
 transitional objects 85
psychoanalysis, post-Lacanian 60
psychotherapy 99, 112, 113 (*see also*
 psychiatry)
Puar, Jasbir 114
punctum xxxix, 48, 51, 70
Punter, David xix, 5, 68
puppets, taxidermy xxxii, 3
Purdy, Anthony xxxviii, 69
purity xvi, xxxv

quacks 27
queerness xxxiii, 73n1

racism 110, 112, 113
racism, anti-black xxxi, 101, 109, 110, 117,
 129, 133
racism, systemic xxv, 108, 110, 113, 129
Radcliffe, Ann xvi, xxxvii, 12, 69,
 89, 141
Rankine, Claudia xxxi, 101, 109,
 112–16
Reeve, Clara 7–8

related "sister" arts of taxidermy xi, 3
repetition xliii, 62, 70, 122, 132
repulsion xxiv, xliii, 8, 32, 70, 142
rogue taxidermy 23, 32, 39, 141
Ross, Alan S. xxix
Roudinesco, Élisabeth 73, 77, 80
Rowlandson, Thomas 24
Rymsdyk, Jan van 12

Saler, Michael 11
satire 24, 39 (*see also* Hogarth, William)
scholarship on taxidermy xiii, xviii–xxii,
 xxiv, xxxix, 1, 69–70 (*see also* critical
 taxidermy studies)
Scott, Joanna xxvi
Scott, Walter 69
Scully, Pamela 107
second chance (second life) 91, 97, 99, 109,
 128, 135
Sedgwick, Eve Kosofsky xxx, xxxvn15,
 68, 90, 122n29
Sedgwick, Laura 141
the sensational 7
sensationalism 8
Seshadri, Kalpana Rahita 137
Sharpe, Christina 129
Shotwell, Alexis xvi, xxiii
Singer, Angela xxii, 141
Sivils, Matthew Wynn xxvii
slavery (*see also* the black body)
 ancestors showing up in a corner
 110–12, 116, 132
 emancipation as a liberal
 fantasy 133
 references in *Get Out* (Peele) 128,
 129, 131
 *Scenes of Subjection: Terror, Slavery, and
 Self-Making in Nineteenth Century
 America* (Hartman) 127
 transatlantic slave trade 126, 129
Sloane, Hans 8, 31
Smith, Adam 14
Smith, Barry 35
social taboos xxx
sound of suffering 113–14
sounds
 acousmatic 61, 82n10
 repetition of 122, 132
 that disable 122–23, 126

INDEX

Southern Gothic xxx, xxxii, xxxiv, 73, 110
the speculative "as if" 10, 11
speculative interspecies physicality xl
speculative taxidermy xviii
Spillers, Hortense 126
Stengers, Isabelle xix, 143
Stockton, Kathryn Bond 138
stuckness
 animal-object-thing xxvii
 of blackness 118
 Citizen: An American Lyric (Rankine) xxxi
 A Classic Horror Story (De Feo and Strippoli) xliii
 and maiming xxvii, 114
 the material encounter with taxidermy 43
 and the monstrous xxvii
 The Phenomenology of Perception (Merleau-Ponty) 94
 private traps 53, 84
 relationship to Levinas's the *il y a* xxix
 and taxidermy xxv, xxxviii, xlii, 48, 70, 109, 114–15
 and the taxidermy mount xv
 translational phenomenology xl
Stuffed (documentary) xvii
Stuffed (short) (Rhys) 72
subjectivity 11
the surface 57, 68–69
surveillance 12, 61
Swainson, William 13n8, 31
systemic racism xxv, 108, 110, 129
systemic violence 123

taboo (*see also* perversion; the pervert; social taboos)
 the animal within xxxvi
 bestiality 87
 bestialization 108, 112
 Beyond the Darkness (D'Amato) xliii
 Beyond the Pleasure Principle (Freud) 96
 in *The Cabin in the Woods* (Goddard) 86–89
 The History of Sexuality (Foucault) 78–79
 incest xxxii, xxxiii, 72, 73

interspecies eroticism 75
interspecies necrophilia 88, 89
manifold sexualities 79
masochism of Bates 84–85
Mostly Dead Things (Arnett) xliii
On Earth We're Briefly Gorgeous (Vuong) 72
paraphilia 77
pedophilia 72
Psycho (Hitchcock) 81–86
psychopathy 84
rape xxx, xxxii, 73, 89, 90, 94, 98
"Secrets of Animals' Intimate Lives" (exhibition) 74
'sexhibitions' 73–75
sexual abuse 91, 97
taxiderm-erotics 73, 75–76, 86, 87
"The Taxidermist (The Father)" (Lazo) 72
The Taxidermist's Daughter (Mosse) 72
Tell Me Your Secrets (series) 89–100
temporality 80–81
Tales from Blackwood (magazine) 20–21
taxidermists (*see also* Ploucquet, Hermann; Potter, Walter; Waterton, Charles)
 body as site for disgust 34–35
 characteristics and personalities of xvii, xxix, 2, 16, 19–21, 82–84
 in contemporary horror film 38n28, 63
 female 17n11, 18
 the hands of 14
 libidinal gaze of 35–36
 as murderer trope xvii, xx, xxxii, 63–64, 85, 95
 representations of 77
 in the storytelling tradition 13
taxidermy xxix (*see also* amateur taxidermy; anthropomorphic taxidermy; contemporary artistic taxidermy; Gothic horror and taxidermy; human taxidermy; manuals, taxidermy; museum taxidermy; phenomenology of taxidermy; scholarship on taxidermy; speculative taxidermy)
 in "About Taxidermy" (*Fun* magazine) 28
 as the ancestor in the corner 136

taxidermy (*Continued*)
 animacy hierarchy xxvi
 attempting to transmit information to
 characters 61–62
 bestialization and thingification 108
 and body horror xxix
 craft of xiii, xxxiv, 15, 36, 97, 141
 defining xiv, xv
 etemology xiii
 fluid haze of fear 137
 golden age of xxix, 1
 in horror films xii, xx–xxi, xxiv
 in horror video games xii
 in literature xx
 materials of xiii, 65, 67, 68, 92–93, 96
 as metaphor xv, xxvi, 42, 110, 135
 and narrative closure 116, 132
 nocturnal ontology of xxxi
 as object of horror not beauty xxix
 in popular literature xiii
 practice in the 19C xxix
 public taste for xvii, xxiii, xxviii,
 2, 36
 recent theorizations of 140
 relationship to narrative closure
 95–97
 as site of fixation xlii–xliii
 smell of 33–34
 to terrify 2
 in tv/streaming series xii
 ugly feelings response to xiii
 as uncanny xiv
 unfashionable and uncanny relic
 125–26, 131
Tell Me Your Secrets (series) xii, xxviii, xliii,
 93–99
temporality xxv, 57, 80–81, 141
terror xvin4, xxxvii, 2, 117 (*see also*
 creature-terror)
The Texas Chainsaw Massacre (Hooper) xiii,
 xxx, 53–57
The Texas Chainsaw Massacre 2
 (Hooper) xxiv
Thorp, Laura 132
threat comes from within 117
Tompkin, J. M. S. 69
Tonsor, Stephen 108
Townshend, Dale 89

trans-corporeality 34
transgression
 in film 65, 86
 and the Gothic 21, 75, 76
 and horror xxxvii
 and perversion xxxn14, 76, 90
 and taxidermy xxvi, 39, 75
transgressive secrets 10
transgressive vision 35
trauma 112–13, 121, 123
Trigg, Dylan xxxvii, 46, 142
"The Triumphs of a Taxidermist" (Wells)
 xxxi, 2, 32, 101, 103
true crime xii
Tsing, Anna xviii
Turner, Alexis xvii

ugly feelings xxii, 2, 137
the unfashionable 4
unheimlich 111

van Dooren, Thom xix
Verreaux, Edouard 107–8
Verreaux, Jules 107–8
vital materialism xxxviii

Wakeham, Pauline 12, 106
Walker, Pete 112
Wallace, Alfred 1
Walpole, Horace
 the invisible hand 14
 relationship to taxidermy xi
 relationship to the Gothic xi, xvi, 141
 relationship with taxidermy 8
 writing style 8
Warner, Harriet 90
Warner, Marina xix
Warren, Calvin L. 48
Warwick, Alexandra xv
Waterton, Charles 21, 33, 39, 93, 103
 call for boldness in taxidermy 21, 22
 Essays on Natural History 23
 on museum taxidermy 23, 31
 The Quacks (print) (unknown) 27
 rogue taxidermy of 23–25
 and satire 24, 38
 technique of 23
 Walton Hall 22–23, 25, 26
 Wanderings in South America 22, 24

INDEX

Wells, H. G. 39, 53, 82, 108 (*see also* "The Triumphs of a Taxidermist" (Wells)
West, Cornel 113
Whedon, Joss 86
White, Laura xli, 141
Wilderson, Frank B. III 133, 134
Williams, Evan Calder xxxv, 43
Willis, Martin 35
Winnubst, Shannon 127

Wolfe, Cary 44
Wunderkammer (*see* cabinets of curiosities)

Wynter, Sylvia 105

Youdelman, Rachel 140
Young, Elizabeth xiii, xxiii, 21

Žižek, Slavojj 59–61, 76n3

Milton Keynes UK
Ingram Content Group UK Ltd.
UKHW042053080924
447997UK00002BA/7